HYBRID PRACTICES

THE PUBLISHER AND THE UNIVERSITY OF CALIFORNIA PRESS FOUNDATION GRATEFULLY ACKNOWLEDGE THE GENEROUS SUPPORT OF THE RICHARD AND HARRIETT GOLD ENDOWMENT FUND IN ARTS AND HUMANITIES.

HYBRID PRACTICES

Art in Collaboration with Science and Technology in the Long 1960s

―――

EDITED BY

David Cateforis, Steven Duval, and Shepherd Steiner

 UNIVERSITY OF CALIFORNIA PRESS

University of California Press, one of the most distinguished university presses in the United States, enriches lives around the world by advancing scholarship in the humanities, social sciences, and natural sciences. Its activities are supported by the UC Press Foundation and by philanthropic contributions from individuals and institutions. For more information, visit www.ucpress.edu.

University of California Press, Oakland, California, in association with Spencer Museum of Art, The University of Kansas.

© 2019 by The Regents of the University of California

Library of Congress Cataloging-in-Publication Data

Names: Cateforis, David, editor. | Duval, Steven, editor. | Steiner, Shepherd, editor.
Title: Hybrid practices : art in collaboration with science and technology in the
 long 1960s / edited by David Cateforis, Steven Duval, and Shepherd Steiner.
Description: Oakland, California : University of California Press, [2019] | Includes bibliographical
 references and index.
Identifiers: LCCN 2018011302 | ISBN 9780520296596 (cloth : alk. paper)
Subjects: LCSH: Art and technology. | Art and society. | Art, Modern—20th century. | Experiments in
 Art and Technology (Organization)—History. | Los Angeles County Museum of Art. Art and
 Technology Program—History. | Artist Placement Group—History.
Classification: LCC N72.T4 H93 2019 | DDC 701/.05—dc23
LC record available at https://lccn.loc.gov/2018011302

Printed in Canada

27 26 25 24 23 22 21 20 19 18
10 9 8 7 6 5 4 3 2 1

CONTENTS

Foreword / vii
Saralyn Reece Hardy and Rebecca Blocksome

Introduction: Reassessing Hybrid Practice / 1
David Cateforis, Steven Duval, and Shepherd Steiner

PART I: FALLOUT: CREATIVITY AND INVENTION IN, AS, OR BETWEEN ART, SCIENCE, AND GOVERNMENT / 21

1. Launching "Hybrid Practices" in the 1960s: On the Perils and Promise of Art and Technology / 23
 Anne Collins Goodyear

2. Identity, Rhetoric, and Method in the Collaborations of Experiments in Art and Technology, the Artist Placement Group, and the Art and Technology Program at the Los Angeles County Museum of Art / 45
 Steven Duval

3. Fallout and Spinoff: Commercializing the Art-Technology Nexus / 61
 W. Patrick McCray

4. Beyond Method and without Object: Subject as Inquiry in the Irwin-Wortz Collaboration / 79
Dawna Schuld

5. Monuments to the Period We Live In / 91
Craig Richardson

PART II: AFFECTIVE FEEDBACK: TIME, PLAY, AND CONTAGION AS SYSTEMS OF PARTICIPATION / 111

6. Sounding *Snows*: Bodily Static and the Politics of Visibility during the Vietnam War / 113
Erica Levin

7. Contagious Creativity: Participatory Engagement in the *Magic Theater* Exhibition (1968) / 125
Cristina Albu

8. Programming and Reprogramming the Institution: Systems Politics in Hans Haacke's *Photoelectric Viewer-Programmed Coordinate System* / 141
John A. Tyson

PART III: THRESHOLDS OF THE VISIBLE: TECHNOLOGIES OF THE EVERYDAY / 163

9. Technologies of Indeterminacy: John Cage Invents / 165
Sandra Skurvida

10. Dramaturgical Devices and Stanley Milgram's Hybrid Practice / 187
Maya Rae Oppenheimer

11. Prostheses or Technical Extensions: Rereading the Work of Bernd and Hilla Becher / 209
Shepherd Steiner

Supplement: The Hale Experiments: Object-Oriented Ventriloquy during the Cold War / 227
An ESTAR(SER) project by the Prosopopoeia Working Group

Acknowledgments / 257
List of Contributors / 259
List of Illustrations / 263
Index / 265

FOREWORD

THE ROOM IS TOO SMALL.
 In 2013, while standing in the grand rotunda of the luminous interior of Frank Lloyd Wright's iconic Guggenheim Museum, unveiling one of the most celebrated works of his lifetime, James Turrell looked at me intently and told me something important. I had just introduced myself. In the midst of a career-affirming opening celebration, he remained focused on the demands of his art, referring to the space we were planning for his *Gard Blue* (1968) in the Central Court of the Spencer Museum of Art. At the time, we were in the early stages of envisioning the optimum viewing space we would eventually build within the heart of the museum as specified by this groundbreaking American artist. Turrell made it clear that the interior gallery would need to grow to accommodate the spatial dimensions of *Gard Blue,* a revelatory work created during one of the most important periods of his career. Three weeks later, the planned room expanded by one foot. Revised dimensions were approved and construction began. Weeks later, the viewing environment conspired with light to create *Gard Blue*; in the end, the room and the art were one.

———

The exhibition of *Gard Blue* at the Spencer Museum of Art in 2014–15 in many ways served as a catalyst for the publication you now hold in your hands. A generous gift from Mark and Lauren Booth, Turrell's early experiment with perceptual art was exhibited alongside other prescient works recently donated to the Spencer Museum—a set of eighteen drawings and one Plexiglas sculpture by Rockne Krebs, an artist who worked exclusively in the ephemeral media of laser and natural light. Together these works evoked a precise moment in history, the 1960s and 1970s, when breakthroughs in science and technology inspired and enabled artists to push the boundaries of accepted artistic practice.

Working at the edges and across boundaries is transgressive by necessity. It requires a knowing disregard for the familiar in favor of a shift, a crossing-over that relies on uncertainty and experimentation to allow play in a new field or to find advancement in a new method. To practice hybridity is to resist purity for the sake of discovery. Work in a hybrid vein appeals to participants in both discrete and immense ways—a small hook and eye in an envelope for Robert Irwin's wire, leaving the rest of the project to us; Cathy Lynn Gasser's twilight warehouse, seen best in a split second; the massive room of light built inside a room to create James Turrell's experience of "seeing yourself see."

I (Saralyn) have been fascinated by such artistic transgressions throughout my career. While I have been director of the Spencer Museum of Art at the University of Kansas (KU), interdisciplinary and transdisciplinary artistic endeavors have become the central focus of my work. As a university art museum, the Spencer is uniquely positioned to explore boundary-blurring work with the deep collaboration of colleagues across campus and with artists/scholars beyond the university. Toward that end, in 2012 we launched the Arts Research Collaboration (ARC) initiative in partnership with the KU Biodiversity Institute, the Information and Telecommunication Technology Center, and the Department of Visual Art. The three-year initiative garnered major support from the Provost's Office and resulted in several research exchanges, exhibitions, and publications, as well as a major international conference, *Hybrid Practices in the Arts, Sciences, and Technology from the 1960s to Today* (March 10–13, 2015).

I (Rebecca) and my colleague Steven Duval were hired to implement the ARC initiative under the direction of Saralyn, Senior Curator Stephen H. Goddard, and Mellon Director of Academic Programs Celka Straughn. As practicing artists ourselves, Steven and I shared a strong commitment to artistic process as well as product. We were interested not just in the grand works of art that made it into glossy publications, but also in the experiments and failures that are much less documented yet have played a vital role in contemporary art. Moreover, from both personal experience and our work with the ARC initiative, we were highly conscious of the many challenges that artists face in attempting to partner with institutions and practitioners in other fields.

The confluence of the Spencer Museum exhibitions mentioned above, as well as external events like the Los Angeles County Museum of Art's launch of the Art + Technology Lab (inspired by the original Art and Technology program), gave us all a strong sense that the

time was right to revisit the ambition and promise of the 1960s and 1970s with a major conference. For the Hybrid Practices conference, we called on scholars and artists to reflect upon research practices from the historical time period and to reconsider the influences that are again emerging with vigor. The conference attracted a committed group of scholars from five countries for four days of rich presentations and informal exchange. It was immediately clear that a publication would be a natural outgrowth of the conference, advancing its strengths and creating a "field guide" for future scholarship.

This edited volume of essays explores interdisciplinary research practices and collaborations among artists, scientists, technologists, businesses, and government bodies from the 1960s through the mid-1970s. In that tumultuous era—shaped by ideologies associated with the space race, the heterodox practices that emerged in the wake of modernism, and the groundswell of the student movement and the New Left—artists working in the United States and allied nations in Europe embraced hybrid forms of practice to push their ideas into new mediums, contexts, and non-art-related goals. In *Hybrid Practices,* eleven essays by historians of art, science, and design thoughtfully explore a number of projects both at the forefront and on the neglected margins of this unprecedented collaboration between the arts and new sectors of industrial society. The resulting publication is unique for its historical treatment of hybrid practice, the range of case studies considered, the depths of scholarship assembled, and the variety of disciplinary specialists included. Editors David Cateforis, Steven Duval, and Shepherd Steiner bring complementary expertise in the related but too often inimical fields of art history, theory, and practice. Their comprehensive introduction to the publication sets out a fresh theoretical framework for understanding and appreciating the complex work that took place in this fascinating era.

The room is too small.

Turrell's critique of the exhibition plans for *Gard Blue* might easily be extended to art institutions more generally, and even to the narratives of twentieth-century art history. Too often we do not have room—either physically or conceptually—to seriously engage with artistic practices that draw heavily on aspects of science and technology. The spaces we have in our buildings and textbooks are not large enough to fully embrace the visions that artists have for their art.

So, how do we make the room bigger? Along with the Arts Research Collaboration initiative, we see this publication as expanding the field in new directions.

Of course, we cannot and do not accomplish this work alone. We are especially grateful for the initial project support from the Terra Foundation for American Art, as well as support from the Kress Foundation Department of Art History, the Research Investment Council, and The Commons at KU. We would also like to express our sincere gratitude to the staff of the Spencer Museum of Art and the participants at the Hybrid Practices conference, who

provided the framework and impetus for all that led up to this publication. The rich content and breadth of thinking are due to the diligence, focus, and vision of editors David Cateforis, Steven Duval, and Shepherd Steiner, as well as to colleagues Rebecca Blocksome and Celka Straughn. The combined efforts of the ARC team have led to new support from the Andrew W. Mellon Foundation for the Integrated Arts Research Initiative, an expansion of the ARC initiative, which will ensure that there will always be space for hybrid practices at the Spencer Museum of Art and KU.

SARALYN REECE HARDY, MARILYN STOKSTAD DIRECTOR,
SPENCER MUSEUM OF ART

REBECCA BLOCKSOME, WRITER/EDITOR,
ARTS RESEARCH COLLABORATION INITIATIVE

DAVID CATEFORIS, STEVEN DUVAL, AND SHEPHERD STEINER

INTRODUCTION

Reassessing Hybrid Practice

THE TIME IS RIPE for a reassessment of hybrid practice—experimental creative work that bridges the domains of art, science, and technology. With institutional backing for such research currently at an all-time high, critical perspective is crucial. The present book aims to provide leverage and a necessary distance on the current motives for hybridity—today, so often driven by market interests, the corporatization of universities, and technocratic and instrumental imperatives—by looking again at the period from 1963 to 1975, which was witness to the greatest flowering of hybrid practices prior to our own day. The period in question, which we call the long 1960s, offers the picture of a tremendously rich ecology of hybrid practices—ranging from collaborative projects between artists and scientists in search of unmediated experience to commercial ventures and experiments in intermedia, to practitioners deliberately working across disciplines, effacing authorship for the purposes of activating the spectator, bridging gaps between art and government, or remapping the landscape of everyday life in terms of technological mediation. The book showcases a set of critical examples drawn from the

period in order to establish a baseline for hybrid practice. It brings into focus a uniquely historical set of tensions driving hybridity and inseparable from the unprecedented levels of technicity saturating everyday life, channeling desire, and mediating experience in both the United States and western Europe. Finally, it captures something of America's claims to empire, for the period in question, while the high moment of US hegemony over half the world, is also that moment when American influence begins to show its cracks and contradictions, insufficiencies and silences.

Hybrid practice in the long 1960s is unthinkable without the backdrop of the Cold War and hence is inseparable from the rhetoric of democracy, which accompanied the period's Manichaean view of a world divided between good and evil. The notion of hybrid practice we put forth is specifically keyed to this history and this global binary, whose ramifications included the technological "fallout" of the aerospace industry, the onset and consolidation of consumer society, the unprecedented resources of corporate capitalism, the looming crisis in Vietnam, the momentum surrounding computing, and democratic capitalism's attempt to outperform communism on its own ground—collective work or collaboration. These are the largest stories within which are woven the smaller narratives of hybrid practice that we unpack.

Theoretically speaking, the baseline of our notion of hybrid practice is keyed especially to the intersection and/or passage between disciplines that the great historian of science Michel Serres calls "the third-instructed."[1] We consider this hybrid terrain, which is not unlike the terra incognita between two speakers where dialogical drift takes hold of the speech act and transforms the thing said into the thing heard,[2] in order to highlight an ecology of the middle where acts are relational, in that they always gesture to an "intercessor," and hence to describe a ground where the evolution of any one practice finds an origin beyond itself.[3] In this sense, we conceive of "the third-instructed" as an identity that one performs while doing something. Once the act is finished, the dominant discipline takes over once again, so that the scientist returns to science and the artist to art. Serres's "third-instructed" is the residue or trace left within the work of this one-time performance. Recuperating this performance involves isolating the means by which something is invented on the spot (and in the present) out of the vast jumble of discourses that constitute any field of action and interaction.

The heterodox practices considered in this book emerged in the wake of painting's dominion, which arguably ended in the mid-1960s when the formalist model of modernism espoused by the influential American critic Clement Greenberg began to lose its authority. But it would be remiss of us to frame this introduction once again in terms of the tidy chain of cause-and-effect relations that art history has tended to unroll as the origin of hybrid practice. A narrow ontology that sees hybridity only as a direct reaction to the medium specificity, rigors, and ivory tower aesthetic of modernism in the arts is particularly inadequate for coming to grips with the tumultuous spirit of interdisciplinarity and collaboration between art and science that fueled so many practices during the period in question.[4]

For instance, as is well enough known, in the United States in the 1950s, the early stirrings of neo-Dada (part of the deep history of hybridity in the arts) were already implicated in the

struggle for hegemony in the art world through the very process of pointing out abstract expressionism's collusion in the Cold War. Jasper Johns's knowing equation between painting and the American flag in *Flag* (1955) is but one example of building critical distance into a fallen medium handed down from the first generation of New York School painters.[5] It would be wise to read hybrid practice itself in this light, as a clandestine attempt to claim an ideological high ground for art by scapegoating an example in the past, and hence as a dry run for the critical moves of the neo-avant-garde.[6] For like the affinity between individualism and gestural abstraction, or the neo-Dadaist movement itself, the rich ecology of hybrid practices in the long 1960s is inseparable from the processes complicating sovereignty and shaping nationhood at this moment. The crucial difference is that the battleground in the long 1960s shifts away from the arch-shibboleth of individualism (vs. totalitarian conformity) and is instead played out on the ragged edge differentiating the democratic community from the communist alternative: precisely as the spirit of collaboration, collective work, communication, cooperation, and broad participation This is perhaps the greatest single problem afflicting reassessments of hybrid and collaborative practice from the period. For if hybridity is partly symptomatic of larger ideological questions then one must isolate hybridity proper. And in this regard it is worth keeping in mind that right at the opening of the decade one of the foremost apologists for liberal capitalism, Daniel Bell, announced in *The End of Ideology* (1960) that both the "radicalism" and the "innovation" of the historical avant-garde had been "absorbed" and "institutionalized" into the very structure of American capitalism, specifically as an in-built motor for continual revolution and technological innovation housed within the research and development (R & D) wings of the corporation.[7]

Given that so much of the history of hybrid practice turns around the paradigmatic event of *9 Evenings*, organized in October 1966 by Billy Klüver under the auspices of Bell Labs and later to emerge as Experiments in Art and Technology (E.A.T.), Daniel Bell's analysis is damning. Yet if the unique picture of hybrid practice that we frame here originates in the particular conjunction of liberal democracy, American capitalism, the consumption-oriented society, and the Cold War, we nevertheless maintain that hybridity's promise of a possible outside remains intact. More than anything this depends on the performative nature of hybrid practice that we emphasize. But nothing about performatives can be stated unequivocally, for once enacted they are reproduced (or literalized) ad infinitum within the cultural crucible. This said, the spectacular ascendency of hybrid forms of practice during the period involves a complicated set of exchanges and substitutions with prior forms of practice that not only demands an approach flexible enough to work across different topographies of knowledge but also defies generalization and avoids the hypercritical trajectory plotted out by the art field's neo-avant-garde. Our aim is, first, to capture the richest and most robust moment of these practices, and second, to establish the formative processes and basic outlines of a range of these practices. In fact, it is tempting to say that taking such an inventory is now more important than critique per se: all that is now left of critique is precisely the performance of difference, for cultural standardization in the 1960s was a breeze compared to the storm that blows now.

Close readings of the examples foregrounded in this book convincingly show that the phenomena of hybrid practice are never merely symptomatic of larger historical processes. Rather, the singular subjects explored in the essays demonstrate that hybrid practice in the long 1960s consistently turns on inhabiting a range of complex contradictions, moving on unstable binaries, and balancing unreconcilable alternatives that exist both inside and outside the art field. Generalization is the enemy here; the only path forward is to focus on specific hybrid practices and the field of interaction and overlap that they presume. Thus the interpretative urgency of focusing on what W. Patrick McCray calls "technological communities," and more interestingly still, "*techno-aesthetic* communities"—temporary groupings of artists, scientists, or engineers galvanized by a "particular project, instrument, or technique." And this holds for the relationships forged between technology and dance as well. Thus we have Yvonne Rainer's *Trio A* (1966), with its grammar of movements keyed to imagined tasks to be performed, using the body as technical instrument; Simone Forti's *Dance Constructions*, where the relationship of bodies to objects like rope or plywood, or even sound and light, always borders on prosthetic extension; and finally Gyorgy Kepes's CAVS (Center for Advanced Visual Studies) project based at MIT, which is not covered in this book. Established a year after E.A.T., the modus operandi of the project echoed Kepes's history as a Bauhaus professor. It might seem that science and engineering were merely employed to bring forth new materials for the arts to work with rather than to foster collaboration, but undoubtedly the situation was more complex. If in fact CAVS marked a new trend in the cross-pollination of art and science, then the genuine value of the discrete projects it facilitated lies elsewhere. In short, hybrid practice never escapes the shadow of American hegemony, but neither does this catch-22 remain unfathomable or without exit. In such examples collaboration is performed, gains traction in the highly coded terrain of culture, and moves practice into a subtle beyond that is all relation.

Admittedly, Cold War capitalism was nowhere near as totalizing and ruthless a juggernaut as we face now, but we think that reassessing hybrid practice in this kind of fine detail and against the horizon of total capture will help. We feel that the modeling we offer here is the best way forward in an interpretative context that is divided between an uncritical celebration of experimentalism in the arts on the one hand and the privileging of the total victory of economic forces on the other. The pages that follow offer ample evidence to suggest that artists and collaborative teams from the period not only were acutely aware of ideological pressure but also actively sought out ways to negotiate the paradoxes of hybrid practice and the collaborative endeavors into which they entered, at times being satisfied that innovation, invention, popularization, and profitability themselves were sufficient guarantors of value. Indeed, in a great many cases it is clear that working through contradictions as much as ignoring them—pushing things toward the rhetorical excesses of absurd performance, the purest kind of experience, or hyperbolic commercial success, or operating within restrictive (governmental, corporate, or aesthetic) parameters—was what motivated practitioners to pursue their projects in the first place. This means that many of the hybrid practices that art historians typically revere acquired a set of problems that were part and

parcel of "aesthetic ideology"—whether these practices involved the artist in managerial decision making, the seeking of long-term over short-term gain, or pure R & D—and hence the same problems as those encountered by art practices that preceded or succeeded them—but we will get to the "politics of the aesthetic" in a moment.[8]

For now, three things should be emphasized. First, "the long 1960s" describes a fairly stable spatial regime governed by the Cold War, circumscribed by the democratic West, and, importantly, breaking down at the level of individual examples. These simultaneously fall within the dominant construct and occupy the silences, variably describing a whole orbit of limit cases within and beyond hegemony. In this regard one need not turn to performance and conceptual art in, say, Yugoslavia for a third way. Within the context of the democratic West there are counterparts to Sanja Iveković and Marina Abramović everywhere if one looks hard enough and close enough; and the terrain simultaneously within and beyond hegemony is still continuously being colonized and expanded. Hybrid practices have actively sought out the gaps and silences in the system, or more succinctly, have performed them, and yes, have lost them to the system as well. In any case, the outside is present in New York at the seminal event of 9 *Evenings* and is present all around the geopolitical periphery. Thus the importance of the examples in this book drawn from Germany and the United Kingdom: outlying phenomena such as these forthrightly acknowledge hegemony. The models of governmentality and industrial process upon which the artists in these NATO countries focused were construed as repressive and as counter to the aims of modernity at the local level precisely because adopted from the United States. In the case of the Artist Placement Group (APG), with which American readers will be less familiar, founders John Latham and Barbara Steveni devised a number of strategic artist placements with industrial companies based in the United Kingdom. The artist, or "incidental person" (in Latham's term), would work in the company in hopes of establishing creative ways forward for the organization that were otherwise occluded by a corporate mind-set. More interesting still is that after 1970 these placements moved from the industrial context to governmental bodies like British Rail and the Scottish Office.

Second, we should say that the intensity and variability of tactics intended to engineer escape from systems of control and total capture come into extraordinary visibility as the 1960s end and as the war in Vietnam moves into the foreground of national consciousness. Indeed, "the long 1960s" is intended to bracket a period in which the early motivations and optimistic forecasts driving attempts to bridge the gap between art and technology turn increasingly sour with the crisis in Indochina. The dawning realization was that "the good life" in America was rooted in its permanent war economy and that the military, industrial, media-based, and colonialist extensions of liberal democracy were not simply a reaction to the incursions and aggressions of the Eastern bloc: rather, aggression in and as technological prostheticization (in the kitchen or living room, on the highways, at Cape Canaveral, in the airspace over Vietnam, orbiting the earth, etc.) was more central to the hegemonic character of things than previously imagined. One can turn to many psychoanalytic and sociological studies of the postwar period to see just how central aggression was to an

understanding of the American character, but rarely does this analysis broach the 1960s and tackle how technics and technology enter into the equation. In this sense, the book is one of a number of attempts to come to terms with the multiple ways in which hybrid practices imagine and reimagine the relationship between technological invention and artistic creativity:[9] seeing creativity and technological innovation as one and the same species of productive output; seeing technological innovation as itself rooted in the kind of aggression that Cold War ideology worked so hard to normalize; seeing creativity as potentially being an antidote; or seeing both creativity and scientific discovery as equally corrupted regimes.

Third, the book raises crucial questions about agency in the period under investigation and does so by exploring a broad range of projects that demonstrate and elaborate on the unique theoretical perspective on hybridity that we have foregrounded. Agency was a very complicated affair in the long 1960s. In the essays that follow, agency is most palpably felt in and as artistic intention—for example, in the case of Carolee Schneemann this amounted to a blend of feminist agency, antimilitarist politics, and parallel bids to identify a limit to the Western perspective and simultaneously to incorporate a Vietnamese perspective. But it is worth keeping in mind that this agency reacted and responded to an ecology or network of actor agents: scientific agency—in a number of cases, NASA, the National Aeronautics and Space Agency—but also the agency of private actors working in the aerospace industry whose inventions were worthy of the patent office. At the same time, these types of agency blurred into more difficult forms of action that were typical of collaborative enterprises, and more complexly still, larger forms of agency that were inseparable from the intensely collaborative (read: managerial) atmosphere of the corporate workplace, the scale of capital investment into research and development, and the period's unwavering faith in science. In this sense, in all of the essays collected here, artistic intention, though emphasized, should at the same time be recognized as something influenced by limits to individual agency and by a whole world of active agents, as actor network theory has highlighted. In this regard, *Hybrid Practices: Art in Collaboration with Science and Technology in the Long 1960s* should be read as an analysis of agency, for ultimately the book reconstructs a map of the complex chain of actors in the period. With this metatheoretical vantage point in mind, we ask the reader to work collaboratively with us to interconnect the specific contributions. Work from the ground up, in the thick of events, alongside the artist, with the interpreter and in parallel with us three editors. What will emerge is a vision of agency all down the line: from individual artists to the military-industrial complex, the spirit of cooperation between industry and the arts, local histories in Europe and America, the new field of computing, the larger conditions of the Cold War, and the pressures of democracy. This is the larger field where hybrid practice happens, where performatives take place under working conditions.

The origins of the book itself are not divorced from these working conditions. It evolved out of a four-day international conference and a one-day colloquium on hybrid practices in the arts, sciences, and technology, from the 1960s to today. It was a rich and diverse conversation that included historians of art and science, artists, curators, designers, engineers, and

scientists of many stripes. The essays represent a selection of the very best scholarship on hybrid practices from 1963 to 1975. Our initial questions were simple. What were the motivating factors for projects like E.A.T., the APG, or the Art and Technology project at the Los Angeles County Museum of Art (LACMA)? How were collaborations between the arts and sciences facilitated and mediated? Why did hybrid practices gain such tremendous traction during the period? Why was it important to demonstrate the fact of hybridity at this historical moment? How does the development of the Cold War intersect and overlap with this history? Do the space race, the gadget-filled kitchens of suburbia, the emergence of the mass media, the threat of the military-industrial complex, and Vietnam suffice to explain the varied interest, engagement, and pressure on technology? Was artistic R & D on the model of the most progressive technology-based corporations conceived of as an unproblematic continuation of that model (Klüver?), a mimetic tactic to bring into visibility what Bell had earlier identified as the institutionalization of the historical avant-garde's radical innovation by liberal democracy (the APG?), or just one more adaptation that a range of artists recognized they had to make if their practice was to keep apace with events (Schneemann?).

Do some examples of collaboration or hybrid practice stand out today as exemplary? And if so, can they be picked up and continued? Did these early collaborative projects lay the groundwork for interdisciplinary and relational work today? How did the performative aspects of participation and viewing back then provide the model for our contemporary notions of usership now?

Over time, these lines of questioning began to take shape as a more comprehensive analytics of hybrid practice. Thus the eleven essays that make up this book offer answers to these questions and variously highlight the main points of hybrid practice. To this end we have divided the book into three parts. Part I, titled "Fallout: Creativity and Invention in, as, or between Art, Science, and Government," turns on five paradigmatic approaches to creativity and innovation. In spite of radical differences in context and aims, all are effectively the inheritance of a very poetic notion of the creative act, nothing less than William Wordsworth's famous definition of the imagination as "an unfathered vapor."[10] In the Anglo-American tradition of the New Criticism, the imagination models absence, ritual, or sacrifice par excellence, precisely because it is used up in the technical or pragmatic act of making and hence has no relationship with ideology or culture—a premise we put under serious pressure. Given imagination's relationship to sublimation—that is, the transformative moment of the aesthetic itself—creativity and invention have a very special relationship to both the space race and its fallout.

The section begins with Anne Collins Goodyear's "Launching 'Hybrid Practices' in the 1960s: On the Perils and Promise of Art and Technology." Goodyear focuses specifically on *9 Evenings* and provides the cultural backstory for the tremendous energy of collaborative work between the arts and sciences in the United States in the late 1960s and early 1970s. For Goodyear *9 Evenings* is inseparable from the history of the period, which witnessed the rapid proliferation of new technologies as well as their application to everyday life. It is seen as part of a landscape that includes the writings of C.P. Snow, Marshall McLuhan, and Reyner Banham, Eisenhower's national education initiatives, the emergence of Fluxus, and a nascent

corporate culture with unlimited resources to channel toward research and development. With the figure of Billy Klüver providing the vital link between the sciences and the arts and *9 Evenings* providing the first and most important connection between them, Goodyear characterizes the origins of E.A.T. as something of a historical inevitability. More importantly, the picture of America Goodyear paints is that of a culture in the grip of the space race, anxious about Soviet advances in technology in the wake of Sputnik—a culture in which the figure of the scientist/engineer was placed on a pedestal (because of the need to gain an advantage in the Cold War by developing technologies superior to those behind the Iron Curtain), yet was marked by an essential lack of humanity that only the arts could amend. Art as complement to science was the free world's answer to the communist menace. In short, Goodyear sets *9 Evenings* in the context of the so-called technology gap that marked the post-Sputnik era and the culture gap that rendered all science and engineering guilty of the atomic bomb, military brinksmanship, and an untempered notion of progress. Goodyear suggests that if the scientific community engaged with the arts for their ability to humanize science and technology, then for artists the key motive for engaging with science was the near exhaustion of the art field. In Goodyear's account, art in the 1960s desperately needed to escape the orthodoxy of media; it demanded venues other than the museum, new, space-age materials, and standards of success very different from those of aesthetic judgment. Ultimately, Goodyear tracks the slow shift in public opinion that would move artists out from under the veil of Cold War ideology. Art as complement to science would quickly become art as antidote to the military-industrial complex.

Steven Duval's "Identity, Rhetoric, and Method in the Collaborations of Experiments in Art and Technology, the Artist Placement Group, and the Art and Technology Project at the Los Angeles County Museum of Art" provides a unique analysis of the three best-known hybrid practices from the 1960s named in its title. Using the question of identity for leverage, Duval argues that the cultural constructions of the scientist, the artist, and the curator respectively lie at the heart of each of these seminal projects. Further, he contends that these constructions mediated the variable dissemination of each project and its methods to the public. In this sense, Duval foregrounds the rhetorical power of "working together" from the perspective of the fields of these representative protagonists of the period. Leaning on Michel Serres's notion of the "third-instructed," which emerges as a cross-disciplinary ideal, Duval distinguishes E.A.T.'s artist-driven projects and its rounded objects from those of the APG's process-oriented placements and from the more careful balance facilitated by the Art and Technology Project and struck between artist and scientist. In each case, the original identity of the practitioners became reinforced rather than dissolved in a new hybrid identity. For Duval, the method of collaboration is the message, and method here is to be understood, not as intrinsic to process, but as mediated by the tensions between artistic, scientific, and curatorial methods and staged for viewers or observers. Given the relativity of method, here authenticity must be questioned and quality proven only by resonance over time.

W. Patrick McCray's "Fallout and Spinoff: Commercializing the Art-Technology Nexus" focuses upon the ways in which "hybridized professionals" closed the gaps between arts,

science, and technology. More specifically, McCray explores the commercial applications that resulted from hybrid art and science endeavors. The term used by the science community for the potential commercial application of these collaborations was *fallout*, and it was a driving force motivating engineers and companies to engage in collaborations with artists. McCray skillfully outlines the "technological community" that made up a research team and describes how this evolved into some of the techno-aesthetic communities we see today. Perhaps his most important insight, however, is that scientists consciously sought to collaborate with artists on "spinoffs" that would produce actual commercial success. From Frank Malina's patents for aesthetic experiments to the collaborations between Tom Mee and Fujiko Nakaya for E.A.T.'s Tokyo pavilion, and finally Elsa Garmire and Ivan Dryer's work to develop the laser light show, McCray traces out a set of unique hybrid collaborations that produced viable commercial results from what was initially an artistic pursuit. In McCray's account of these E.A.T.-inspired collaborations, creativity and imagination find an equal footing in the realm of art and the realm of engineering and science. In fact, creativity equals inventiveness. His essay shows that to appreciate the impact of hybrid collaboration we must have a very elastic notion of results and impact that does not preclude popular forms of spectacle set to the beat of classic rock and installed in the planetarium.

If commercial application was the result of some collaborations, then its opposite, that of pure inquiry, was the outcome of a collaborative project between artist Robert Irwin and behavioral psychologist Ed Wortz for the Art and Technology Project at LACMA. This collaboration is the subject of Dawna Schuld's essay, "Beyond Method and without Object: Subject as Inquiry in the Irwin-Wortz Collaboration." Schuld teases out the unique imperatives that grounded inquiry for these two collaborators from the fields of art and science and outlines their radically singular research interests in perceptual experience that required them both to work from a clean slate. Schuld adeptly shows that Irwin's method of inquiry required all involved to drop any preconceived notion of an outcome and to privilege process over product. In Schuld's account the freedom of this methodless method allowed the pair, along with their sometime collaborator James Turrell, to engage with their object of knowledge: phenomenological experience. With no objective other than inquiry into the experience experienced, collaborative process and phenomenological experience collide and interact. Despite devising a work that was never realized for the Art and Technology exhibition, the collaboration's openness to pure inquiry has become the stuff of legend, its influence on the experience-heavy practices of Irwin and Turrell clear enough, and its impact on LACMA's *Art and Technology* report widely acknowledged. Following Michael Polanyi, Schuld argues that this is because the collaborators were invested not only in experimenting on themselves and acting on the knowledge acquired but also in restaging the results in the exhibition context. Evolving at a late moment in the 1960s when public opinion had swung decidedly against the military-industrial complex and the technophilia of the earlier part of the decade, an ideologically nonaligned alternative was the only option for practice. With the anechoic chamber and the Ganzfeld sphere providing the paradigmatic models of deep visual and aural experience, the aesthetic was conceived of as a value-free terrain uncor-

rupted by ideology, untouched by power politics, and blessedly devoid of the inherited prejudice of art or history. This precinct, reduced in the extreme, inoculated from the world, and evacuated of its noisy distractions, became the archetypal space to inhabit for a whole generation of artists associated with the California light and space movement. With a healthy suspicion of inherited knowledge, and with the naïveté of a hippie love dream, the project's open-ended goal turns out to be a reinvention of Romantic *Erlebnis Kunst*—an art based on experience. What Schuld brings into surreal focus is the space, the moment, and one's dizzying closeness to the light at the end of the tunnel.

In "Monuments to the Period We Live In," Craig Richardson explores the legacy of the London-based APG. Richardson's account reveals the protocols for fostering hybrid practice that the APG developed through the 1960s and 1970s as one of the strongest and earliest formalized methodologies for working between the sphere of art and the spheres of economics, industry, and government. In effect, the APG strategically positioned itself as an intermediary or go-between. Richardson shows that this position hinges on a notion of poetic invention with the artist functioning as a locus of imagination, crossing the 1960s' economic, cultural, and social gaps. At the crux of the APG's project is a movement that uniquely combines "analysis and synthesis." Springing from the inhospitable bureaucratic environment of the postwar period and drawing on a Romantic theory of the imagination, the APG's great contribution to methodology consists of a tenuous extension of a reason-based perspective in which the basic "facts" of existence provide a platform for imaginative "acts" to take place. Here the artist's aesthetic project is a thoroughly mixed terrain where subject and object mingle in chemical fashion, fact is extended by fiction, and the worlds of nature and culture are "interwoven" and made mutually responsive. With its emphasis on dialogue, feasibility studies, the long-term work placement, and the open brief—a variable protocol much like Irwin's "open inquiry," which allowed the artist to enter and operate within the institution in such a way as to escape being confined to producing an object—the APG's project is shown by Richardson to be nothing less than the poetic reimagination of bureaucracy and governmentality itself. As Richardson argues, mining these stale processes for possibility became Latham's life work. In particular the author traces Latham's placement at the Scottish Development Agency in Edinburgh in 1975. Latham's project turned upon the repurposing of a series of derelict shale bings in the Western Midlothian region, one of them now known as *Niddrie Woman*. He imagined these massive mounds of once oil-bearing shale—the traces of an earlier industrial era—as a type of process sculpture, or monumental land art, which was the cumulative unconscious act of many anonymous souls. Latham's effort to get the bings recognized as public monuments was integral to both his larger concept of duration and his attempts at persuading industry and government to measure their success or failure over stretches of time that far exceeded the pragmatic utility of any one of their initiatives. In this final regard, and with a gesture borrowed from Latham's own logic of scale, Richardson focuses on a span of time that extends beyond Latham's death and into *Niddrie Woman*'s present status as a national heritage site. In short—and time is always short for Latham—Richardson sheds light on the artist's notion

of historical time, a time when the apparent stability and stasis of being, bureaucracy, and the world dissolve and change becomes a possibility. Latham emerges as moral barometer, ecological champion, and historical visionary.

Part II of the book, titled "Affective Feedback: Time, Play, and Contagion as Systems of Participation," hinges on time-based, ludic, and parasitic models of aesthetic effects. All of the essays gathered here zero in on models of hybrid practice that foreground willful consumption and audience participation. These models are inseparable from the paradigm of the passive consumer of the 1960s, the hegemony of the image, and the problem of total capture by ideology.

The work of filmmaker and performance artist Carolee Schneemann is the subject of Erica Levin's "Sounding *Snows*: Bodily Static and the Politics of Visibility during the Vietnam War." Levin focuses on two of Schneemann's works made in the highly charged atmosphere of America's involvement in Vietnam. In Levin's subtle interpretation, *Snows* (1967) and *Viet Flakes* (1965) are to be read against the backdrop of antiwar protests, the saturation of images of war by the mass media, and what Schneemann believed to be the unproblematized role of technology in the arts and the spectacularized position of the viewer or audience. Isolating the technological impediments to civil disobedience and social activism appears to have been the crux of these works. Through close readings of Schneemann's use of durational montage and by virtue of extrinsic evidence, Levin shows the artist countering the problem of image saturation by rewiring the established circuitry of reception. With viewers drawing on their everyday experiences of a photojournalism that serves the purposes of hegemony, this short-circuiting of the perceptible content of the artist's films is shown to create poetic ambiguity. In the example of *Snows* specifically, Levin isolates performance cues triggered by hidden movement sensors in the audience's seats and transmitted to performers as part of a barely tangible feedback loop that the artist hoped would aid viewers in recognizing looking as an embodied activity. More complexly, Levin argues that in specific instances Schneemann's signature work on the limits of visibility manages to actually reverse the gaze of war photography. Rather than being by and for Western audiences, visibility is pushed to such an extent that the silent other is given the possibility to look back in return. Ultimately, Levin suggests that Schneemann's symptomatic use of technology must be seen as a critical riposte to *9 Evenings*' happy accord struck between audience and performer and its uneasy embrace of hybrid practices.

Cristina Albu's "Contagious Creativity: Participatory Engagement in the *Magic Theater* Exhibition (1968)" focuses on a landmark exhibition at Kansas City's Nelson Gallery of Art. Albu draws our attention to the staging of artworks as drivers of experience, a kind of framing of hybrid art practices to which gallery-goers of the time were unaccustomed, but in which counterculture enthusiasts were well versed. At the crux of matters for Albu is the way in which the objects and installations literalized real-time behavior, interactions, and responses by spectators. Her account distinguishes the curatorial intentions of Ralph T. Coe from the artistic contributions of Howard Jones, Boyd Mefferd, Terry Riley, and James Seawright, analyzes a range of critical responses to the exhibition, and finally reconstructs the terms of

pragmatic involvement with works by the museum audience. Grounded in an understanding of systems aesthetics—in particular Jack Burnham's notion of "change" that "emanates, not from things, but from the way things are done" (*Artforum*, September 1968)—Albu extends orthodox readings of the processually lived environments animated through interactions between audiences and the technology-heavy works to encompass what she describes as entanglements in shifting affective fields. In effect, she makes system aesthetics inclusive of interpersonal relationships transpiring in the gallery space. At the heart of her argument is a new reading of the delayed feedback loops upon which the works in question relied. Albu argues that with the clarity of cause-and-effect relationships between humans and machines disrupted, not only is the body hot-wired directly into the circuitry of the art encounter, but this new modulation has effects. This is an ontological argument for a type of experience that emerges through creative engagement with technology and hinges on lived interpersonal dynamics not prepackaged by culture. Set against the era's transitory experiences and positioned as an alternative to psychedelic mass culture, the select works in the *Magic Theater* exhibition emerge as a special variety of creative involvement that is specifically collective. One comes away with a notion of hybridity tuned to the environment as well as the other. In it, one's notion of self in the world flows into the body's sense of environment. Ultimately Albu identifies and isolates a "theater within the mind" that might provide an antidote to the falsely substitutive and exterior affects of technology and the crowd.

John A. Tyson's "Programming and Reprogramming the Institution: Systems Politics in Hans Haacke's *Photoelectric Viewer-Programmed Coordinate System*" argues for the technological agency of a particularly revealing, if relatively unknown, 1968 work by Haacke. Through recourse to contemporaneous developments both inside and outside the art field, Tyson reconstructs a rich working context for Haacke's project that includes radical politics, contemporary dance, and technological developments in computing, as well as systems aesthetics, minimalism, and performance and kinetic art. He reveals the way in which Haacke's version of the minimalist grid and the artist's worries about technological control are imbricated in his unique version of systems aesthetics. Most importantly Tyson raises the subject of play and the limits of control that are constantly courted through the playful interaction between viewers' movements in the gallery space and the battery of photoelectric cells and infrared beams that react by variously lighting up a modular grid of twenty-eight evenly spaced white light bulbs. Tyson wants us to see *Photoelectric* as a space for an emancipatory and ludic edge to action and Haacke's intent as a reprogramming of power structures within and as the institution. Slightly reminiscent of contemporary attempts to free up the institution from repressive notions of viewership to alternative models of user-ship, Haacke's ultimate hope is that museum "spectators" will be transformed by this participatory experience and will hence contribute to kinds of agency that might be politically reenacted in the world.[11]

Part III of the book, titled "Thresholds of the Visible: Technologies of the Everyday," gathers together essays concerning the ways in which hybrid practice in the 1960s worked to make technology's invisible place in the landscape visible. As the essays make clear, the

problem of visibility is tethered not only to the opening up of art to the concept of the everyday but also to one of the crucial tasks of documentary photography, as well as to the powerful rhetoric of science that prevailed during the period.

The section's opening essay, Sandra Skurvida's "Technologies of Indeterminacy: John Cage Invents," focuses on Cage's practice as that of a contemporary curator with an eye to creating situations or events rather than fulfilling the requirements of an exhibition. With emphasis on Cage's *Water Walk* (1959), *Variations VII* (1966), *Musicircus* (1967), and *Rollywholyover* (1993), Skurvida finds Cage's consistent reliance on chance operations to be at the heart of the artist's ever-expanding notion of the media circus. With an emphasis on transdisciplinarity, she traces the emergence of Cage's notion of the performative installation, his erasure of authorship and the activation of viewers, and finally his shift from using the *I Ching* to using computational protocols that replicate it. Most compelling, however, is the way in which Skurvida describes the core logic of Cage's works: "indefinite expansion of the field for chance to operate within and diminishment of the differences between components within a given composition, to the point where they may become sensorially indistinguishable, as in microtonal music." Given that Cage's notion of composition was totalizing and that his project ultimately hinged on flattening the hierarchy between art and the everyday, breaking down the borders between artist and engineer, subject and object, and artist, performer, and audience, it is clear that what Skurvida uncovers is both the high road to Cage's theater of equivalence and the essence of his legacy for hybrid practice today. Ultimately, what the essay begins to illuminate is that the most difficult labor confronting the viewer/listener of Cage's works comes tragically bound up with making logical sense of the random juxtaposition of technological objects and the absurdity and contingencies that are constitutive of life in the 1960s, for never have the elements of the soundtrack of our lives been so conscientiously rounded up, given the status of objecthood, and put on view.

Maya Oppenheimer's "Dramaturgical Devices and Stanley Milgram's Hybrid Practice" offers a very different perspective on hybridity. Oppenheimer looks at Milgram's experiments on authority from the perspective of the history of design. She focuses specifically on the design of Milgram's instrumentation, which coded within it an entire era's expectations, hopes, and belief in scientific method, and a recurrent set of worries that Milgram himself harbored about totalitarianism. Oppenheimer's account hinges on the instrumentation panel of Milgram's shock generator, specifically on how the user interface, with its array of switches, was designed to elicit the sought-after obedient behavior. Relying on Milgram's journal diagrams, unpublished notes, and contemporary design, Oppenheimer sees the shock generator as not simply one object of many in the experimental setting but the central prop or agent in an elaborately staged theatrical production. Oppenheimer shows that along with the performative roles played by experimenter and participants, the "scientific" look of the instrumentation operated as an integral part of a larger dramaturgy of power. In her view, the object functions not as a neutral piece of experimental equipment but as both prop and active agent. At stake are the truth effects that the object and its synecdochal network of historical associations galvanize in the minds of participants. Oppenheimer

shows how Milgram's experiment, playing subjective fears of totalitarianism off the widely held view of the objectivity of the experimental method, operates at what we might call the intersection between the rhetoric of science and history—a peculiar locus of the imaginary. No reader of this essay will fail to feel the mixed tensions to which the hapless scientific participants were subject. Like the subjects in these experiments before us, we act upon our highest hopes for science and our worst fears of totalitarianism. Even with the decreased visibility today of the disciplines of psychology and sociology, it seems that we are still very much in the shadow of this moment.

Shepherd Steiner's "Prostheses or Technical Extensions: Rereading the Work of Bernd and Hilla Becher" problematizes the well-known objectivity of the collaborative photographic practice of the German couple. The scientific truth claims of their signature black-and-white photographs of technical buildings and by extension their notion of typology are shown to veer into the realm of "technical knowledge"; the object becomes inseparable from the subject, and an insistence on the free play of the signifier sheds light on a politics rooted in the organic architecture of an organic community. At the crux of these operations lie two interpretative spring points: first, the recognition that the bulky view camera used by the Bechers should be understood as an extension of the historical system of nineteenth-century industrialism that was their primary object of study; second, that the *Fachtwerkhäuser* of the Siegen industrial region of Germany, which constituted the first comprehensive collection of technical structures photographed by the team, are a prosthetic extension of the region's long tradition of technological development and a veritable appendage of Bernd Becher's own identity. Expanding on this systematic logic, the author argues that the integration of the framework houses into the geology, social geography, and technological history of the region provided a platform for the Bechers to begin documenting technical structures outside Germany. Finally, the author shows that these terms of identification evidence a subtle analysis of difference that allows interpretation to go some distance into uncovering a kind of Pan-European industrial culture, where the technologies for coal and ore extraction as well as the production of steel in the unique microcultures of the Pas-de-Calais region, Terre Rouge in Luxembourg, or the Ruhr and Saar regions of Germany can be both compared and contrasted.

The book concludes with a literary supplement written by ESTAR (SER)—the Esthetical Society for Transcendental and Applied Realization—a collaborative that includes D. Graham Burnett, Sal Randolph, Jeff Dolven, and others. ESTAR (SER)'s original contribution to the conference involved one of the group's signature "attention labs" and the reading of a fictional narrative set against the backdrop of the early Cold War and focused on a psychological investigation known as the Hale Experiments. ESTAR (SER)'s work is a complex interlacing of fact and fiction, performance and participation, art and science, poetry reading and art encounter, all oriented around the study of the Order of the Third Bird. Constructing a sort of origin myth, the group revises Pliny's tale of the Greek painter Zeuxis, whose technical prowess in his art was the equal of nature. In Pliny's original text, Zeuxis has painted a picture of a child carrying grapes so lifelike that birds fly down to peck at them. This leads

Zeuxis to conclude that he has painted the fruit more convincingly than he has the child, or the latter would have scared the birds away from the grapes. In ESTAR (SER)'s retelling of this narrative on painting as the queen of the mimetic arts, three birds encounter Zeuxis's picture. One bird takes flight in fear of the child, while the second bird pecks furiously at the grapes. "But the third stopped before the tablet and stood in the sandy courtyard, looking fixedly at the image, and seemingly lost in thought." It suffices to say that the story of the third bird, as the radix of the group's name, is a narrative of absorption, with the figure of the third standing as the very embodiment of an absorptive mode of beholding—what we should mark here as the key mode of engagement encountered in this book, a paradigm of close reading and a key model for generating the performative.[12] Losing oneself in the thick description and intense details of the Hale Experiment proves the point.

The Order of the Third Bird uses the absorptive mode as a means to expand the boundaries of our presuppositions regarding what constitutes the object, experience, performance, and event. Hence the content-rich area of research that is the pragmatic focus of every one of the Order's appearances: their so-called "attention labs" that assemble a group of viewers around a single object and lavish upon it the kind of singular concentration that only a handful of adepts of art history have afforded art for the last two hundred years. The structure and protocols of these sessions in the sustained practice of attention are nothing if not strict: beginning with an open "encounter" phase, proceeding to a scrupulously absorptive "attending" phase, and then moving on to a "negating" and finally "realizing" phase. Participants are instructed to "refrain from judgment, forego *studium,* resist interpretation, be generous." In all phases we give ourselves completely to the object under scrutiny: (1) we observe the object's immediate syntactical context—floor, ceiling, placement in the room, proximity to other objects; (2) we attend to the intricacies of the object itself; (3) we forget or negate the object; (4) and finally we look at the object anew. And yet even with everything in the object's favor we come up against very tangible limits beyond which movement is impossible. The conditions enabling bourgeois experience itself seem capable of being moved only so far, for what is truly extraordinary about these attention labs is the incredible fidelity the participant feels to the individual experience experienced, something we hold onto with a death grip, and for good reason. For the Order of the Third Bird, the work of aesthesis, or the ability to feel or perceive, is a collaborative enterprise. Nothing is owned by the subject, no property is proper to the subject, it is all borrowed from the object, something that is painfully realized through a final phase of democratic discussion where the very terms of individual intelligibility are voiced, surveyed, tested, and reorganized along lines of working conditions effecting the whole.

It would be in keeping with the theory of hybrid practice we put forth here not to provide a final, concluding statement. Hybrid practice proper must remain a thorn in the side of discourse, escaping total capture—a tattered edge—no matter whether that discourse hails from the arts, the sciences, or a hybrid combination of the two. In this regard, hybrid practice is most ably figured by what Serres calls the patchwork cloak of Harlequin. But lest

we fall victim to a criticism that merely luxuriates in polyvalence and bottoms out in a theory that provides little more than a thematic of bricolage—a secondhand copy of Serres's *Le tiers-instruit* handed down in turn from Claude Levi-Strauss's notion of the bricoleur—it is no doubt best to remain on topic, keep specificity intact, use the technical vocabularies put forth in each study, and briefly frame the analysis of hybrid practice put forth to discover a through line that connects the set of singular gaps and connectors we have identified into an assembly of sorts. Framed thus, the topos in question gains an important ethico-political edge and becomes subject to rapid multiplication.

To this end, we editors ask six things of our readers:

1. Think of hybrid practice as the essential category of the aesthetic, the "stability" on which each and every example hinges.[13] The chiasmic inversions, crisscrossings, and exchanges between inside and outside that happen in and as hybrid practice perform all of the basic gymnastic routines that we have come to expect of twentieth-century art and literature.

2. With E.A.T. in mind, consider hybrid practice as a theory of the creative act fully integrated into the technical environment of the Cold War, working to close the missile gap as much as the culture gap and inspiring collaborations between art and industry with the eureka of invention finding an equal footing in both arenas.

3. With the collaboration between Robert Irwin and Ed Wortz in mind, remember hybrid practice as the arena of pure experience unmediated by history and safe from ideologically corrupted regimes of knowledge.

4. With Bernd and Hilla Becher's *Framework Houses of the Siegen Industrial Region* in mind, picture hybrid practice as a kind of technical knowledge passed down from generation to generation and hence kept safe from the technological upheavals and dislocations of modernity.

5. With the APG and specifically John Latham's placement at the Scottish Development Agency in mind, evaluate hybrid practice as the poetic work of reimagining bureaucracy and governmentality; as the work of bridging economic, cultural, and social gaps; and hence as an imaginative act that pragmatically solves urgent problems on the spot or cobbles meaning together out of the barest elements. This kind of work, resting upon the category of the aesthetic or not, is needed now more than ever.

6. With Cristina Albu's account of "contagious creativity" at the *Magic Theater* exhibition at Kansas City's Nelson Gallery of Art in mind, think of hybrid practice as the very center of the book—not only because Kansas City is so near to the University of Kansas in Lawrence, where the original Hybrid Practices conference took place under the sponsorship of the Spencer Museum of Art, but also because in Albu's account of contagion—and no less in Levin's reading of duration in Carolee Schneemann and Tyson's analysis of play in Hans Haacke—we see the first stirrings of interest in what a number of contemporary political theorists identify as the affective economy of US neoliberalism.[14] The aesthetic effects, which are the center of Part II, are intended to reverberate throughout the book. And like any good center, it is displaced by echoes and analogues from the side.[15] Ideally, these byplays or actions in the wings—which make the center nothing other than the

beginning of a detour—should be conceptualized as so many extensions and literalizations of hybridity.

Our paradigm for traversing this uneven topography is provided by Gilles Deleuze and Félix Guattari, especially Guattari's *The Three Ecologies,* where the philosopher and psychoanalyst of 1989 lays the groundwork for "transversal thinking."[16] For Guattari, transversality is precisely the ability to think across what he describes as the "existential territories" of individual mental life, of social or group-being, and of ecology or environment. If we were to take our departure for thinking hybrid practice in the long 1960s from *The Three Ecologies,* our aim would be to find "*dispositifs* for the production of subjectivity, which tend toward individual and collective resingularization."[17] More precisely, our book works to distinguish this notion of collective or collaborative singularization from Daniel Bell's corporate modeling. Our hunch, like Guattari's, is that it may be possible to reanimate or reenact forms of participation, collaboration, and collective practice that escape Cold War rhetoric, corporate culture, and the manufacturing of consent. Indeed, what if the evolution of hybrid practice in the long 1960s itself spurred the likes of Guattari and others to rethink the pathways of power?

For far too long now the politics of the crypto-Deleuzians in the world has remained out of reach to the uninitiated, since the ecstatic language of Deleuze and Guattari's *Anti Oedipus* (1972) and *A Thousand Plateaus* (1980) is a stumbling block to both analysis and work in parallel for those not willing to learn the vocabulary or to accept the claim that the affective content of art—that unimpeachable essence of aesthetic experience—has been adopted and mobilized as the crucial content of governmentality. In this regard, *Hybrid Practices: Art in Collaboration with Science and Technology in the Long 1960s* provides a new entrance to the collaborative work of Deleuze and Guattari, effectively a means to crack their code by keying scholarship to a series of unique art-historical examples, identifying the hybridity proper to these, and acting on ways to move between examples. From this metatheoretical perspective oddly enriching things happen to the real content of the book. Even the most comprehensive summaries of the complex arguments of our authors necessarily fall short because they cannot adequately convey the hybridity that the form of the book itself sheds light on. For with "discourse conceived of as the bearer of a non-discursive relation," the crucial content of hybridity is no longer found within the form of the various examples but alongside and between them, and the micro-oppositions between form and content in any one example become nullified.[18] Crucial differences between Carolee Schneemann, John Cage, and the project of E.A.T. fall away to reveal correspondences between them. But then in the contemporary context to understand an object, practice, performance, or event one must not only situate the agent in an ecology but define it in and as its network. Thus the book's overarching editorial aim is not to work in and as depth (leave that to the scholars) but to introduce readers to working in and as breadth, across disciplinary practices where the real questions of hybridity are determined. This is not context: this is about ecology.

So listen for the echoes. Analogues of agency at the periphery are the deepest truths of the object, performance, or event.[19] Read the book with this horizontal extension in mind.

These detours away from the thing itself are now as important to moving forward as recuperation of the complexities of the practices themselves. Read the three sections of the book as organized according to a "logic of intensities" around which things gravitate.[20] But also recognize that Haacke's and Schneemann's special investments in thinking the affective economies of participation are as much shot through with the Bechers' and Cage's attachments to technology as with as the APG's willingness to work within structures of government. Learn to think with singular hybridities in mind, note the special bonds of attachment between hybridities in each section, and move fluidly between these with us.

NOTES

1. Michel Serres, *The Troubadour of Knowledge* (Ann Arbor: University of Michigan Press, 1997).

2. Mikhail Bakhtin, *The Dialogical Imagination* (Austin: University of Texas Press, 1981).

3. Erin Manning and Brian Massumi, *Thought in the Act: Passages in the Ecology of Experience* (Minneapolis: University of Minnesota Press, 2014).

4. See especially Clement Greenberg, "Modernist Painting," in *Modernism with a Vengeance, 1957–1969*, vol. 4 of *The Collected Essays and Criticism,* ed. John O'Brian (Chicago: University of Chicago Press, 1993), 85–93.

5. Anne Wagner, "Jasper Johns's *Flag*," in *A House Divided: American Art since 1955* (Berkeley: University of California Press, 2012), 11–24.

6. See Hal Foster, *The Return of the Real: The Avant-Garde at the End of the Century* (Cambridge, MA: MIT Press, 1996).

7. Daniel Bell, *The End of Ideology: On the Exhaustion of Political Ideas in the 1950s* (Cambridge, MA: Harvard University Press, 1988), 235, 242, 313.

8. Paul de Man, *Aesthetic Ideology* (Minneapolis: University of Minnesota Press, 1996); Jacques Rancière, *The Politics of Aesthetics,* trans. Gabriel Rockhill (New York: Continuum, 2006).

9. See Caroline A. Jones and Peter Galison, eds., *Picturing Science, Producing Art* (London: Routledge, 1998); Pamela M. Lee, *Chronophobia: On Time in the Art of the Late 1960s* (Cambridge, MA: MIT Press, 2006); Marissa Jahn, ed., *Byproduct* (Toronto: YYZ Books, 2011); Edward Shanken, ed., *Art and Electronic Media* (London: Phaidon, 2014); Christine Filippone, *Science, Technology, and Utopias: Women Artists and Cold War America* (New York: Routledge, 2016).

10. William Wordsworth, "The Prelude," book 6, "Cambridge and the Alps," 1850 version, *The Complete Poetical Works of William Wordsworth* (London: Macmillan, 1888).

11. See, for instance, Steven Wright's *Towards a Lexicon of Usership* (Eindhoven, Netherlands: Van Abbemuseum 2013), http://museumarteutil.net/wp-content/uploads/2013/12/Toward-a-lexicon-of-usership.pdf.

12. See Michael Fried, *Absorption and Theatricality: Painting and the Beholder in the Age of Diderot* (Berkeley: University of California Press, 1980).

13. See Andrzej Warminski, "Introduction: Allegories of Reference," in de Man, *Aesthetic Ideology*, 1–33.

14. See Antonio Negri, *Insurgencies: Constituent Power and the Modern State,* trans. Maurizia Boscagli (Minneapolis: University of Minnesota Press, 1999); Brian Massumi, *Ontopower: War, Powers, and the State of Perception* (Durham, NC: Duke University Press, 2015).

15. Here we abbreviate Maurice Blanchot's notion of the center in *The Space of Literature* (Lincoln: University of Nebraska Press, 1982).

16. Gilles Deleuze and Felix Guattari, *A Thousand Plateaus: Capitalism and Schizophrenia,* trans. Brian Massumi (Minneapolis: University of Minnesota Press, 1987); Gilles Deleuze and Félix Guattari, *Anti-Oedipus: Capitalism and Schizophrenia,* trans. Robert Hurley, Mark Seem, and Helen Lane (London: Continuum 2004); Félix Guattari, *The Three Ecologies,* trans. Ian Pindar and Paul Sutton (London: Continuum, 2008).

17. Guattari, *Three Ecologies,* 23.

18. Ibid., 26.

19. This is the equivalent of what Guattari calls the "assemblage of enunciation" (ibid., 25–26).

20. Ibid., 30.

PART ONE

FALLOUT

Creativity and Invention in, as, or between Art, Science, and Government

ANNE COLLINS GOODYEAR

1

LAUNCHING "HYBRID PRACTICES" IN THE 1960s

On the Perils and Promise of Art and Technology

IN A DRAFT FOR A TALK that she was to deliver at Rutgers in the spring of 1968, Lucy Lippard contemplated the deep interconnection of new media and new attitudes toward art itself. "The whole question of new media and [the] new esthetic turns out to be one of those chicken and egg problems," she wrote.

> Both media and esthetic are a product of the times and of the society, of the artists['] response to [the] times and society.... The emphasis on new media has arisen because the old media were not the right vehicles for the new esthetic, but the new esthetic ... wasnt [sic] consummated until media and materials were discovered that were the proper vehicles for it. Most of the work done in new media in the 60's [sic] is clearly marked as from the 60's [sic] and many of the artists like that idea. HYBRID.[1]

Lippard emphasized the passage with two stars and capitalized the term *hybrid*, signaling the significance of the advent of a hybrid art-technology practice in the critical discourse of the late 1960s.

Lippard's attempt to disentangle any apparent causality between the emergence of new media and new approaches to making art, between the means and motivations on the part of artists to engage with new technologies, and her acknowledgment of the complexity, if not the impossibility, of this task are at the heart of the nature of the hybridity that intrigued her. A genuine hybrid, after all, resists ready dissection, rendering technological and artistic practice, philosophically and technically, one and the same. Lippard's words offer an eloquent point of departure for my own, signaling perhaps, both literally and metaphorically, that we are now at a very good moment to reengage her provocation as we explore the question of how hybrid practices in the arts, sciences, and technology have evolved from the 1960s to the present.

Lippard was not alone in noting a sea change in understanding the extraordinary potential for collaboration. Indeed, from 1957 to approximately 1971, the art world witnessed an extraordinary burst of activity uniting art, science, and technology. Among the most significant events were the establishment of the Artists' Cooperation Program by the National Aeronautics and Space Administration (NASA) in 1962, the creation of two key institutions—Experiments in Art and Technology (E.A.T.) in 1966 and the Center for Advanced Visual Studies (CAVS) at the Massachusetts Institute of Technology (MIT) in 1967—and the organization of several major exhibitions, including *The Machine as Seen at the End of the Mechanical Age* at the Museum of Modern Art in 1968 and *Art and Technology* at the Los Angeles County Museum of Art in 1971.[2]

As a means of delving deeper into the factors that converged to foster the development of hybrid art and technology practices during the 1960s, this study focuses on an event with a special place in this history, *9 Evenings: Theatre & Engineering*. Presented in October 1966, *9 Evenings* served as the catalyst for the foundation of E.A.T., the following month, by the engineers Billy Klüver and Fred Waldhauer and the artists Robert Rauschenberg and Robert Whitman. Published studies thus far of this important event have tended to focus on a close analysis of the ten works it presented.[3] While this scholarship represents a critical contribution to the literature, the present study aims to put the event into a broader historical context. As I shall demonstrate, a close investigation of *9 Evenings,* understood within the moment in which it unfolded, provides an excellent framework not only to explore the rise of hybrid practices but also to reflect on the challenges that these endeavors encountered in the early 1970s and, even more important, the long-term achievements they helped nurture.

9 Evenings emerged during a period characterized by an intense consciousness of revolutionary social and political change resulting from the rapid proliferation of new technologies, the application of which to everyday life promised profound and unprecedented transformations that both excited and concerned contemporaries. The British historian and theorist Reyner Banham, for example, had recently rooted his groundbreaking study *Theory and Design in the First Machine Age,* published in 1960, in the cultural circumstances of his own era.[4] As Banham explained: "This book was conceived and written in the late years of the Nineteen-fifties, an epoch that has variously been called the Jet Age, the Detergent

Decade, the Second Industrial Revolution. Almost any label that identifies anything worth identifying in the period will draw attention to some aspect of the *transformation of science and technology,* for these transformations have powerfully affected human life, and opened up new paths of choice in the ordering of our collective destiny."[5] Indeed, the very title of Banham's book was based on the observation that he and his contemporaries had entered what he identified as the "Second Machine Age."[6] Marshall McLuhan's seminal *Understanding Media: The Extensions of Man,* first published in 1964, was inspired by similar perceptions of fundamental technological and attendant cultural change. According to McLuhan: "After three thousand years of explosion, by means of fragmentary and mechanical technologies, the Western world is imploding. During the mechanical ages we had extended our bodies in space. Today, after more than a century of electric technology, we have extended our central nervous system itself in a global embrace, abolishing both space and time as far as our planet is concerned."[7] What accounts for this pervasive sense of profound change? Perhaps more than any other factor, the launch of Sputnik by the Soviet Union on October 4, 1957, deserves credit.

As *Newsweek*'s "Listening Post," published three weeks after Sputnik's launch, indicates, the Soviet achievement proved to be a major psychological victory, capitalizing on American fears of global Soviet domination. *Newsweek*'s report, under the heading of "What do they think should be done?," states: "Most [Americans] are in favor of a speed-up, an all-out effort, a 'crash' program, if necessary, to put the U.S. ahead." This proved to be prophetic.[8] The United States responded with just such an "all-out effort" to overcome its perceived lag in military technology—the ultimate result of which would be the American drive to beat the Soviets to the moon during the 1960s. The pursuit of scientific and technological superiority on the part of the United States, as a means to overcome menacing Soviet achievements, had an immediate impact on popular culture, with coverage of scientific topics in the mass media increasing substantially in the wake of Sputnik.

The comic strip *Penny*, which chronicles the adventures of a high school girl, humorously attests to a national reordering of priorities. In a March 1958 episode, Penny refuses a date with the captain of the football team to go out instead with a brainy science student who squelches her flirtatious overtures with his dry, analytical observations. "Isn't the moonlight romantic, Andrew?," she asks. "Scientifically, moonlight does not exist," he responds. "It's only reflected light from the sun." Returning home in the final frame, Penny reports to her mother: "Encouraging the scientific mind in our national emergency may be patriotic, but it sure is a strain on a girl!"[9] Some six months after the strip's publication, President Eisenhower signed the National Defense Education Act into law, legislating increased training for American students in science and mathematics (as well as foreign languages).

Yet despite an increased emphasis placed on scientific education, public perceptions of the scientist continued to indicate that exclusive pursuit of scientific research lacked a "human" dimension, just as Penny's date suggested. One 1961 study reported that despite a respect for the intelligence of the scientist, college students saw him "as socially withdrawn [and] indifferent to people.... There is an air of strangeness about him; he is hard to like

and to comprehend.... The scientist is believed to be highly intelligent," the study concluded, "but not interested in art."[10]

The comment on the scientist's view of art is especially revealing. In a society bent upon supporting scientific study, art was seen as an antidote to the potentially inhumane tendencies of science. It is no coincidence that C.P. Snow's famous study *The Two Cultures and the Scientific Revolution,* which contrasts the culture of science to that of the arts and humanities, appeared a year and a half after the launch of Sputnik. Snow's advocacy of education as a tool to bridge the two cultures instantly drew an immense, and largely favorable, response. As Snow himself recognized, the "flood of literature" published in the wake of *The Two Cultures* indicated two things. First, his ideas were not unique to himself nor his native England. Second, as he put it, "Contained in them or hidden beneath them, there is something which people, all over the world, suspect is relevant to present actions."[11] Indeed, in the early 1960s, art came to be seen as a necessary complement to science. If science was seen as an engine of social and political well-being, art had to inform and temper it, helping to ensure that scientific advancement did not result in human devastation.

Even the foundation of the National Endowment for the Arts and the National Endowment for the Humanities by Lyndon B. Johnson in 1965 was motivated by the belief that federal funding for the sciences demanded analogous support for the arts. Signing the NEA and NEH into existence, Johnson remarked, "We have not always been kind, in America, to the artists and scholars who are the creators and keepers of our vision. Somehow, the scientists always seem to get the penthouse, while the arts and humanities are always down in the basement."[12]

This cultural background provided a critical foundation for the emergence of *9 Evenings: Theatre & Engineering* and the related activities that would follow in its wake. In a statement describing the need for E.A.T., which would grow out of *9 Evenings* in the fall of 1966, its cofounder, the Bell Labs laser specialist Billy Klüver, would employ language strikingly similar to that used by the president in establishing the NEA and NEH: "We give many billions to scientists; we should give at least a few to artists. Of course, no one would dare tell a scientist what to do. But we hamper the artist with our preconceived notions."[13]

As Klüver's remark suggests, E.A.T., and *9 Evenings: Theatre & Engineering,* which sparked its establishment, aimed not only to provide a corollary to science but also to break down traditional ideas about what art could be. Indeed, key to the long-term significance of *9 Evenings* was its sensitive response to specific developments within the art world, perhaps most notably a widespread rejection, or at least questioning, of traditional artistic categories such as painting, sculpture, and "theater"—that is, an appetite for the development of a new hybrid approach to art making. This series of performances, held between October 13 and 23, 1966, demonstrated how the goals of young avant-garde artists could be linked with the emerging technologies and scientific culture of the 1960s. Unlike NASA's Art Program, launched three years earlier, which cast artists in the relatively traditional role of chronicler of technological achievements, rather than creative partner, *9 Evenings*

represented a revolutionary approach in recognizing the importance of the intellectual contribution made by artists as collaborators with their engineer counterparts.

Perhaps not surprisingly, then, *9 Evenings* owed a great deal to the unusual background of Billy Klüver, which combined scientific and technical expertise with a deep engagement with contemporary art practice. As a film enthusiast who became, in his youth, president of the Stockholm Film Society, the Swedish-born engineer became acquainted with many members of Sweden's artistic avant-garde, including the curator Pontus Hultén, with whom he would renew his ties upon arriving in the New York area in 1958 to take a job with Bell Labs, a division of AT&T.[14]

Considered a "regulated monopoly" at the time, AT&T had virtually unlimited resources to dedicate to research and development, and, as Billy Klüver later reflected, "Like any good research laboratory, [Bell Labs] left us alone to carry on our own experimental or theoretical research."[15] Pursuing his own innovations, Klüver noticed that "there was a tremendous amount of ENERGY in the art world"—energy that he felt would both invigorate and benefit from work being conducted at Bell Labs.[16] Klüver was not alone in his belief that artistic practice could positively stimulate scientific thought. As the scientist Jacob Bronowski argued in an article entitled "The Creative Process," published in *Scientific American* in 1958, the year Klüver received his doctorate from Berkeley: "We expect artists as well as scientists to be forward-looking, to fly in the face of what is established, and to create not what is acceptable but what will become accepted."[17]

Pontus Hultén encouraged his friend, and Klüver quickly became an integral part of the New York scene, offering new ways to conceive of and realize works of art. Between 1960 and 1966, when he organized *9 Evenings,* Klüver worked with many well-known artists, including Jean Tinguely, Robert Rauschenberg, Marcel Duchamp, Jasper Johns, and Andy Warhol, giving them access to the new technologies that nonscientists and nonengineers could typically only read about.[18]

For artists who wished to renegotiate the limits of sculpture and painting, and the relationship of art to life, discourses far removed from the fine arts offered inspiration. As Newton Harrison later remarked: "In art, if you wanted to get out of the image what were your options? Where were you going to go?"[19] Indeed, in response to a survey circulated by Barbara Rose in the spring of 1966, intended to assess "the Sensibility of the Sixties," a number of leading young artists attested to the attraction of new technology. Dan Flavin reported that "it would not surprise me to see the evolution of a type of scientist-artist, or engineer-artist."[20] Robert Morris affirmed: "Some kind of center is needed. . . . Even with a few machines for working plastics and metal the artists themselves could experiment. Since this doesn't happen in industry it would undoubtedly lead to new ways of working materials."[21]

Allan Kaprow, who harbored his own plans to form such an "experimental research" center for the arts, observed: "Although there is good work being done in the conventional arts—painting, sculpture, music, dance, poetry, etc.—the newest energies are gathering in the cross-overs, the areas of impurity, the blurs which remain after the usual boundaries have been erased. This zone is increasingly referred to as the 'intermedia,' Dick Higgins' term

for the media between the media."[22] Allan Kaprow's invocation of Higgins's concept of intermedia also suggests the intriguing relationship of the art and technology movement to other experimental artistic initiatives during the period, such as Fluxus; inspired, as was Klüver, by the examples of Marcel Duchamp and John Cage, Fluxus stressed the need to break down the boundaries between art and life and to challenge conventional art forms to accomplish this end. While neither *9 Evenings* nor E.A.T., which resulted from it, had an official relationship to Fluxus, a number of avant-garde artists participated in all three, and many influential Fluxus artists, such as Nam June Paik and Dick Higgins, had a deep interest in the use of new technologies, such as the digital computer, film, and video, for the creation of new art.[23]

The very international network of artists involved with Fluxus, together with the ethos of festivals and happenings associated with the movement, may, in fact, have helped lay the groundwork for *9 Evenings*. The impetus for the event grew out of efforts to organize a Festival for Art and Technology, entitled "Visions of the Present," in Stockholm in September 1966.[24] The initiative came from Knut Wiggen, who served as both the chairman of Fylkingen and the executive director of EMS, the Electronic Music Studio at Radio Sweden. Having organized several avant-garde art and musical performances at Fylkingen, many with ties to Fluxus, Wiggen contacted contemporary artists he knew to be sympathetic to working with electronic media, including Öyvind Fahlström, John Cage, and Robert Rauschenberg. In the fall of 1965, he reached out to colleagues who could help him to develop a program featuring technologically innovative artwork.[25] Robert Rauschenberg and Billy Klüver quickly took the lead. Together the two decided for the sake of expediency, as Klüver explained, "to include only artists who were already friends, and for them to work with engineers of their choice at Bell Labs."[26] The group came to include the musicians John Cage and David Tudor; the artists Yvonne Rainer, Öyvind Fahlström, Robert Whitman, and Robert Rauschenberg; and the dancers and choreographers Lucinda Childs, Deborah Hay, Alex Hay, and Steve Paxton. Whitman's wife, the artist Simone Whitman (later Simone Forti), would become "secretary" to the *9 Evenings* effort.[27] Approximately thirty engineers from Bell Labs, recruited by Billy Klüver, collaborated with them. However, discussions between the American artists and the Swedish organizers broke down in July of 1966 when, from the perspective of the American organizers, it appeared that their Swedish counterparts did not fully appreciate the contributions of the collaborating engineers, and plans were made to transfer the performances to New York.

From the first, Klüver and Rauschenberg recognized that this event could be used to publicize the potential of partnerships between artists and engineers as well as to help make new technologies palatable to a large audience, emphasizing the new possibilities they offered for creative expression. According to Klüver, "Behind *9 Evenings* was the notion of getting the best art and reaching the largest public possible. This involved two things: advertising and the idea that art could humanize technology, which was very urgent."[28]

In the quest to find a venue for *9 Evenings*, Simone (Whitman) Forti, discovered that the Sixty-Ninth Regiment Armory was available.[29] Though Klüver stressed that the selection of the

Armory "was only a coincidence," contemporary accounts of *9 Evenings* indicate that the participants were well aware of the venue's symbolic significance.[30] The Armory had played host to the tumultuous 1913 Armory Show, which announced the entrance of modern art into the United States. A group photograph of the artists and engineers who took part in *9 Evenings* in front of the Armory suggests the historical parallel that the participants wished to draw (figure 1.1). The group stuck with the Armory despite obstacles it created. For example, Forti reported that the structure, rather than protecting the wireless broadcast system the performers intended to use, "acted like a giant antenna, bringing us all kinds of extraneous signals.... [Billy] said the engineers would deal with it somehow. Next the engineers ran an acoustics test on the building.... The place was like an echo chamber. You couldn't get a coherent sound. The decision was made to stick with the Armory anyway. The space itself was beautiful."[31]

In his *9 Evenings* performance, *Variations VII* (figure 1.2), John Cage ingeniously turned to his advantage the Armory's capacity to capture sound by making this aspect of the space an intrinsic part of his piece. He explained in the program for the show that the work deliberately made "use of the sound system that has been devised collectively for this festival ... using as sound sources only those sounds which are in the air at the moment of the performance, picked up via the communication bands, telephone lines, microphones, together with, instead of musical instruments, a variety of household appliances and frequency generators."[32] As Cage well understood, it was precisely the ability of artists and engineers to work together to overcome and harness unanticipated challenges that gave larger meaning to this undertaking, requiring and inspiring real innovation. At a press briefing, approximately two weeks before *9 Evenings* opened, Cage observed that "the technical problems involved in any single project tend to reduce the impact of the original idea, but in being solved they produce a situation different than anyone could have pre-imagined."[33] As though seeking to demonstrate the strategies at play to nurture such creative thinking, Cage welcomed members of the audience to investigate his unusual, and innovative, instrumentation, removing the stanchions that had been put up to protect his piece and inviting those who were curious to study his equipment. "It was a way of getting them involved, participating," Cage told the reporter Grace Glueck.[34]

Enthusiastic anticipation built for the undertaking, thanks in large part to the efforts of the publicity firm Ruder Finn, which stressed the marvelous potential of art engaging new technologies. *9 Evenings* opened to a packed house on October 13, 1966.[35] Each evening featured the performances of two or three artists. In the eyes of the participants, collaborations between artists and engineers seemed to have the potential to destroy preconceptions of what art—or technology—should be. As Robert Whitman put it: "It's a genuinely vanguard situation and a lot more demanding than most situations.... One thing that could happen is that our ideas of what an image is will change."[36] Several of the works in *9 Evenings* did indeed attempt to play with new approaches to the image, making use of new breakthroughs in filming and broadcasting.

Whitman's *Two Holes of Water—3* (figure 1.3) used a total of nine television cameras and four projectors. The work consisted of a series of seven plastic cars driven out onto the

FIGURE 1.1

Peter Moore, Artists and Engineers involved in *9 Evenings: Theatre & Engineering* from the accompanying program, 1966. Page 14 of the catalog published for *9 Evenings: Theatre & Engineering*. Edited by Pontus Hultén and Frank Königsberg. New York: Experiments in Art and Technology, The Foundation for Contemporary Performance Arts, 1966. Daniel Langlois Foundation, *9 Evenings: Theatre & Engineering* fonds. Courtesy Experiments in Art and Technology, and the Daniel Langlois Foundation. © Barbara Moore/Licensed by VAGA, New York, NY. Courtesy Paula Cooper Gallery, New York.

FIGURE 1.2

John Cage, *Variations VII*, 1966, performed October 15 and 16 as part of *9 Evenings: Theatre & Engineering*, Sixty-Ninth Regiment Armory, New York, NY, October 13–23, 1966. Still from the factual footage shot in 16mm film by Alfons Schilling. Daniel Langlois Foundation, *9 Evenings: Theatre & Engineering* fonds. Courtesy Experiments in Art and Technology and the Daniel Langlois Foundation.

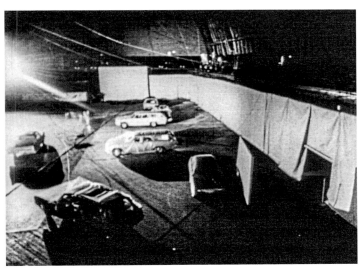

FIGURE 1.3

Robert Whitman, *Two Holes of Water—3*, 1966, performed October 18 and 19 as part of *9 Evenings: Theatre & Engineering*, Sixty-Ninth Regiment Armory, New York, NY, October 13–23, 1966. Still from the factual footage shot in 16mm film by Alfons Schilling. Daniel Langlois Foundation, *9 Evenings: Theatre & Engineering* fonds. Courtesy Experiments in Art and Technology and the Daniel Langlois Foundation.

floor of the Armory. Six of the cars contained monitors to project both live television footage of the event and film that Whitman had recorded previously. The seventh held a man and a woman. As this car came to a stop, both people stepped out, with the man training a television camera on his companion. The image it recorded was transmitted to a screen.[37] The performance deliberately juxtaposed past and present and contrasted the mutability of the performance with the (seeming) permanence of material already recorded on film. According to Whitman: "I am after a work around the stability of a film image and the immediacy of the newsflash. The images are concerns. The whole piece makes an image.... Film is a rock solid steady unchangeable record of someone looking at something past."[38]

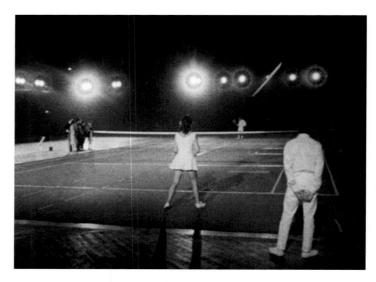

FIGURE 1.4
Mimi Kanarek and Frank Stella (tennis players) in Robert Rauschenberg's *Open Score*, 1966, performed October 14 and 23, as part of *9 Evenings: Theatre & Engineering*, Sixty-Ninth Regiment Armory, New York, NY, October 13–23, 1966. Still from the factual footage shot in 16mm film by Alfons Schilling. Daniel Langlois Foundation, *9 Evenings: Theatre & Engineering* fonds. Courtesy of Experiments in Art and Technology, and the Daniel Langlois Foundation.

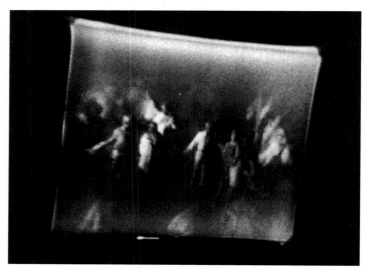

FIGURE 1.5
Robert Rauschenberg, *Open Score*, 1966, performed October 14 and 23, as part of *9 Evenings: Theatre & Engineering*, Sixty-Ninth Regiment Armory, New York, NY, October 13–23, 1966. Still from the factual footage shot in 16mm film by Alfons Schilling. *9 Evenings: Theatre & Engineering* fonds. Courtesy of Experiments in Art and Technology, and the Daniel Langlois Foundation.

Robert Rauschenberg's *Open Score* (figures 1.4 and 1.5) made use of a relatively new technology of visualization: infrared photography. Following a tennis game between Frank Stella and Mimi Kanarek, during which the Armory had been progressively darkened with each bong of the ball hitting a racket, a group of between three hundred and five hundred volunteers entered the Armory, following instructions scripted by Rauschenberg.[39] In the darkness, infrared light was directed around the crowd. An infrared camera sent the image to a large monitor, as seen on the right. Rauschenberg explained: "The darkness is illusionary.... The conflict of not being able to see an event that is taking place right in front of one

except through a reproduction is the sort of double exposure of action."[40] By taking advantage of infrared cameras, the first documented use of the classified technology by an artist, Rauschenberg explored the limits of human perception and the manner in which technology, quite literally, restructures vision.

Even more important than the final product was the process behind it, documentation of which appeared in the program and in a February 1967 article in *Artforum*. As Simone Forti observed about two weeks prior to the opening of the event: "I'm beginning to feel that the main function of the performances is not so much the presentation of art pieces, but a step towards the creation of a situation which will later be important to the making of art."[41] Rauschenberg concurred, stating on opening day, "We should make an announcement to the audience that they are welcome to watch the set-up from the chairs. They should understand that we're involved in a process and not in presenting finished products."[42]

The detailed program paid tribute to the collaborative efforts between artists and engineers that went into each of the performances. An engineer's diagram of the Armory graced the program's cover (figure 1.6), and each piece was documented with a plan of the technical systems it involved, along with a picture of the artist working on the piece. Billy Klüver's introductory remarks closed with the announcement that "the objectives of *9 Evenings* will be continued by Experiments in Art and Technology, Incorporated.... *9 Evenings* is an experiment in the true sense of the word: its results are open for the future."[43]

9 Evenings did not succeed by the conventional standards of theater. Performances started late, intermissions ran long, and the equipment did not always function as its designers had intended, leading to blistering reviews. Some critics, such as Clive Barnes of the *New York Times,* condemned the whole event, largely on the basis of its technical flaws. Barnes opened his first of three reviews of the event with the following jibe:

> Last night's performance of "Theater and Engineering" [*sic*] at the 69th Regiment Armory proved, to my mind, one thing fairly conclusively: If American engineers and technologists participating in this performance were typical of their profession, the Russians are sure to be first on the moon.... The level of technology was such that the performance started forty minutes late, a fifteen-minute intermission lasted thirty-five minutes and even a loud speaker announcement [was] so indistinct on the apparently unsound sound equipment that it became unintelligible. God bless American art, but God help American science.[44]

Even friendly critics, like Grace Glueck, voiced concerns. Much of what had been advertised to be spectacular was difficult for the audience to appreciate. The conviction that nothing should be explained to the audience—stemming from the expectation that this would not be necessary—created confusion and dissatisfaction. According to Glueck, "Some of the backers had ... ambivalent feelings. 'There was a real failure of communication between the artists and the audience,' said one, anonymously. 'If you want big audiences, you must at least tell them what you are up to.'"[45]

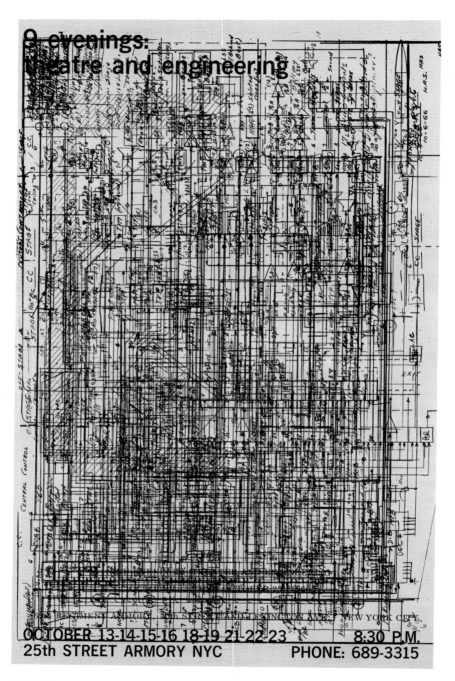

FIGURE 1.6

Front cover of the catalog published for *9 Evenings: Theatre & Engineering*. Edited by Pontus Hultén and Frank Königsberg. New York: Experiments in Art and Technology, The Foundation for Contemporary Performance Arts, 1966. Daniel Langlois Foundation, *9 Evenings: Theatre & Engineering* fonds. Courtesy Experiments in Art and Technology, and the Daniel Langlois Foundation.

Although cognizant of the shortcomings of the event, the artists embraced failure in pursuit of a higher end, bolstering the spirits of the engineers with whom they collaborated. Simone Forti noted in her journal on opening night: "The audience was incensed. There was a feeling of disaster. Robbie [sic] [Robinson] (tech) [one of the supporting Bell Labs engineers] said to me 'You guys are emotionally prepared for this. We aren't.' I tried to tell him that we're used to having audiences boo, hiss, and walk out. That the history books are full of accounts of performances at which the audiences were incensed and which later were recognized to be important achievements."[46] Robinson eventually came to see Simone Forti's point, writing in a memoir: "No one can deny that we passed the first milestone in a road that will eventually lead to a more brightly illuminated world of art. If our efforts were crude and the results imperfect, this should encourage other engineers and artists to come forward to improve upon that which was started. When they do, the real purpose of 'Nine Evenings' will have been realized."[47]

Looking back on the event, Robert Breer noted, "*9 Evenings* everybody considered an enormous failure. It was the enormity of it that was impressive."[48] In 1970 Rauschenberg wrote to Douglas Davis, "Successful is not an artistic consideration. Works and don't works are part of development."[49] In an interview conducted the same year, Rauschenberg commented further about what the performances had achieved: "The best things that came out of *9 Evenings* were personal involvements [of artists] with engineers and scientists, plus some physically important breakthroughs in research."[50]

Despite the mixed reviews *9 Evenings* received, the participants remained optimistic about what had been accomplished. As Rauschenberg suggested, it was the personal relationships of artists with engineers and scientists that were most important, as well as the sense that these partnerships had generated new creative potential. In this Billy Klüver concurred: "The number of things we did in '9 Evenings' was quite extraordinary. It was the energy and the availability of all those people from Bell Labs who thought of different ways of doing things, of implementing the artists' ideas. Everybody was full of energy."[51]

The enthusiasm generated by this event would prove to be infectious, leading to the immediate establishment of E.A.T. Over three hundred artists came for the launch of the organization in November 1966 at the Broadway Central Hotel.[52] Despite the intense excitement generated by E.A.T., Klüver, Rauschenberg and others felt strongly that it should not become a destination in itself.[53] Instead, its organizers believed that it could function more effectively as a matching agency that could facilitate collaborations between artists and engineers—and industry. E.A.T. was to serve as both a catalyst and a means of bringing interested parties together.[54]

Almost immediately, E.A.T. devised an "Artists in Residence Program." In the fall of 1968, the Singer Company announced that it would take on Mel Bochner as part of this program.[55] This gesture was soon imitated by CBS, which agreed to set up two residencies for artists—one for a painter and one for a sculptor—in 1968.[56] Shortly thereafter, Klüver announced that "Local One of the Amalgamated Lithographers of America has set up an experimental lithographic workshop for artists to use their advanced equipment."[57]

Membership in E.A.T. expanded rapidly, with the organization reaching 2,500 member artists and 2,500 member engineers by 1970.[58] Chapters existed in numerous cities from the East Coast to the West Coast. In addition to individuals, the organization boasted corporate members, including AT&T, IBM, and RCA.[59] Ruth Fine, a practicing artist in the late 1960s, recalls the energy generated by the meetings she attended of the Philadelphia branch of E.A.T.[60] Richard Serra similarly recalled attending meetings of E.A.T. run by Klüver "in the early days" because of the stimulation they provided.[61]

In 1967, Klüver would suggest to Douglas Davis that among the important early contributions of E.A.T. was "the beginning of a serious and honest communication with industrial leadership."[62] This model would play a key role in E.A.T.'s own large-scale collaboration with Pepsi-Cola to create *Pavilion,* which debuted at the 1970 Osaka World's Fair, as well as in the development of the Art and Technology (A&T) program undertaken by Maurice Tuchman at the Los Angeles County Museum of Art in 1967, which sought to pair seventy-six leading artists with collaborating corporate partners who promised to host them as artists in residence. Tuchman's A&T project led to exhibitions at the American Pavilion at the 1970 Osaka World's Fair and at LACMA in 1971. It is worth noting that the significance the organizers recognized these undertakings to have is reflected in the meticulously detailed publications that resulted from each—invaluable resources for historians, curators, and artists today.[63]

Yet the reception of these undertakings and even their realization in the early 1970s was far from triumphant. Much of the goodwill between cooperating partners eroded in the early 1970s because of the combined impact of public concerns about the war in Vietnam and an economic recession.[64] The political, economic, and social "establishment" that was protective of new technologies and material resources and the "counterculture" with which most advanced artists aligned themselves seemed opposed, leading to a breakdown of many of the organized efforts to bring artists together with engineers, scientists, and the industrial, educational, and federal institutions that supported large-scale research. If the artists participating in their programs wished to use technology to escape the constraints of modernist practice, this became more difficult as "technology" took on a negative connotation during the intensification of the Vietnam War and the civil rights movement. An observation made by Serra in 1969 during his residency at Kaiser Steel as part of LACMA's A&T program, and included in the resulting "report" on the exhibition that served as its catalog, suggests the term's negative associations: "Technology is what we do to the Black Panthers and the Vietnamese under the guise of advancement in a materialistic theology."[65] Tuchman would later recall that A&T was, in his words, "undermined by the Vietnam War almost month to month."[66] Only sixteen of the seventy-six envisioned collaborations between artists and corporate partners in A&T ultimately came to fruition. The deterioration of the E.A.T.-Pepsi collaboration on *Pavilion* in 1970 reflected financial concerns, as E.A.T. overspent its agreed-upon budget.[67] Indeed, E.A.T. was virtually bankrupt by the time its collaboration with Pepsi ended. On December 16, 1970, Klüver declared

before E.A.T.'s board that "art and technology was dead."[68] After forging ahead with a range of unconventional "projects outside art," Klüver concluded in 1974 that E.A.T. had been "put asleep."[69]

Such developments no doubt contributed to a dearth of serious scholarly attention devoted to these undertakings for nearly a quarter century. Today it is possible to reevaluate, from the perspective of half a century, the deeper significance of the pioneering work done in the 1960s through *9 Evenings,* E.A.T., A&T, and other initiatives to catalyze and model innovative hybrid practices.[70] While these activities marked a point of convergence between a desire on the part of innovative artists to rethink the objectives and possibility of arts practice and to take advantage of new technologies, and a willingness, even a sense of urgency on the part of government and private industry to support creative collaborations between artists, scientists, and technologists, their larger significance continues to resonate. If political turbulence and economic shortfalls in the early 1970s contributed to disillusionment with what superficially appeared to be a failure, such short-term setbacks did not disrupt the deeper and more important spread of a fundamentally new relationship between the creative practices of art, science, and technology. The power of this legacy is increasingly obvious in the overlapping arenas of private industry, the academy, and the museum.

As Billy Klüver noted in 1967, "One area in which E.A.T. has made an impact is in establishing and making acceptable the collaboration between artist and engineer-scientist as a functional means of producing art."[71] His prescient observation at the time that "a whole new language for communication has to be developed" in order for artists to gain access to the technological resources of industry might well be understood to have been realized in large part through the implementation of the Internet, which, growing out of innovations dating back largely to the 1960s, became public through the World Wide Web in the early 1990s. Indeed, in 1998, Klüver could remark to me, recognizing the shift in attitudes and informational resources that had occurred in the course of three decades, "E.A.T. was successful. It has disappeared. Now artists have become a lot more sophisticated. They can find the engineers themselves."[72]

In the present era, it is no longer surprising to hear of the important role played by artists. Robert Wong, executive creative director of Google's New York office, asserts, "Artists can invent the future."[73] His remark echoes the observation made by Robert Irwin and James Turrell in the midst of the collaboration they carried out with physicist Edward Wortz during the course of Tuchman's A&T program that the difference between art and science and engineering has less to do with materials and methods than with a point of view: "Perhaps this is all 'art' means," they speculated—"this Frame of Mind."[74] Today "this Frame of Mind," manifested in *9 Evenings* and in the numerous collaborations it helped generate, bespeaks a deeper and more pervasive appreciation of art itself as an intellectual practice, one of the key insights of early innovators in the art and technology movement of the 1960s.

NOTES

ABBREVIATIONS USED IN THE NOTES

AAA	Archives of American Art, Smithsonian Institution, Washington, DC
GRI	Getty Research Institute, Los Angeles, CA
	Barbara Rose Papers: Barbara Rose Papers, 1940–93, bulk 1960–85, accession no. 930100
	Experiments in Art and Technology Papers: Experiments in Art and Technology Records, 1966–93, accession no. 940003
NASA	National Aeronautics and Space Administration

This essay is dedicated to the memory of my father, Dr. John J. Collins Jr. (1934–2010), a pioneering transplant surgeon who shifted gears at the conclusion of his career to organize a medical archive, and who wisely observed: "The study of history is designed to improve our access to the future, not to enshrine the past." Special thanks is due to Julie Martin, Billy Klüver, and Maurice Tuchman, who have done so much, through their innovative imaginations, their perseverance, and their careful documentation of their activities, to improve our access to the future. I am grateful for all they have each done to support the research represented here. Finally, I wish to express my appreciation to Steven Duval, Saralyn Reece Hardy, and Rebecca Blocksome for their work in organizing the symposium "Hybrid Practices in the Arts, Sciences, and Technology from the 1960s to Today," which provided the occasion to develop this essay. I also thank Ben Rosenthal, D. Graham Burnet, Celka Straughn, and David Cateforis for their encouragement.

1. Lucy Lippard, notecard, numbered "1," for untitled talk on art and technology, ca. April 1968, Rutgers University, box 8, folder 19, Papers of Lucy Lippard, AAA. The timing and location of this presentation are indicated by a letter from Donald M. Zanfanga, chairman of the University Lecture Series at Rutgers, requesting information in order to pay Lippard. Donald M. Zanfanga, Chairman, University Lecture Series, Rutgers University, to Lucy Lippard, April 3, 1968, box 8, folder 19, Papers of Lucy Lippard, AAA.

2. Another noteworthy exhibition of this type was *Software Information Technology,* curated by Jack Burnham at the Jewish Museum, September 16–November 8, 1970. While the NASA Art Program represents the first of the programs mentioned here, given its emergence in the early 1960s, it is worth noting that its aim was primarily descriptive, inviting artists to serve as witnesses to the advent of American space travel rather than as partners in its development. Thus, while indicating an emerging recognition that art had a role to play in partnering with the new technologies of the space age, NASA's initiative did not constitute a new way of understanding artistic practice per se. Indeed, it was precisely in recognizing the potential for artists and technologists to serve as mutually supportive and equal collaborators that E.A.T., launched by the groundbreaking achievements of *9 Evenings: Theatre & Engineering*, represented a sea change in the conception of the relationship of the arts to science and technology.

3. Recent publications on *9 Evenings* include Catherine Morris, ed., *9 Evenings Reconsidered: Art, Theater, and Engineering, 1966* (Cambridge, MA: MIT List Visual Arts Center, 2006). Films of

many of the performances delivered during the event have now been made publicly available as DVDs, jointly produced by Experiments in Art and Technology and ARTPIX: *Open Score*, by Robert Rauschenberg (2007); *Variations VII*, by John Cage (2008); and *Bandoneon! (a Combine)* by David Tudor (2009). Recent dissertations include Susanne Naima Hillman, "Robert Rauschenberg, Robert Whitman and Billy Klüver: From '9 Evenings' to 'Experiments in Art and Technology'" (PhD diss., Rutgers University, 2007); and Robin Oppenheimer, "The Strange Dance: *9 Evenings: Theater & Engineering* as Creative Collaboration" (PhD diss., Simon Fraser University, 2011). The author's own dissertation, "The Relationship of Art to Science and Technology in the United States, 1957–1971: Five Case Studies" (PhD diss., University of Texas at Austin, 2002), includes a substantial discussion of *9 Evenings* and E.A.T. more broadly. The sheer number of Web resources, such as the excellent archival material made available by the Daniel Langlois Foundation and now housed by the Cinémathèque québécoise, demonstrates its ongoing importance. The primary archive of materials documenting *9 Evenings* and E.A.T. is now housed by the Getty Research Institute. In honor of the fiftieth anniversary of *9 Evenings*, in October 2016, a broad range of events was organized in New York by Chris McIntyre and Lauren Rosati under the moniker of *After 9 Evenings: A 50th Anniversary Celebration,* from September 25 to October 1, with programming at ISSUE Project Room, New York University Tanden School of Engineering (see ISSUE Project Room, "After *9 Evenings*: A 50th Anniversary Celebration," n.d., accessed September 30, 2016, http://issueprojectroom.org/program/after-9-evenings-50th-anniversary-celebration.) This author contributed the presentation "'An Experiment in the True Sense of the Word': *9 Evenings* and Its Future," to the NYU Tanden School's symposium "After *9 Evenings*: Object Field: A Symposium on Current and Historical Experiments and Art and Technology," October 1, 2016.

4. Banham was a member of the British Independent Group (IG), a loose coalition of artists and intellectuals united by their common interest in contemporary culture. On Banham's links with the IG, see Nigel Whiteley, *Reyner Banham: Historian of the Immediate Future* (Cambridge, MA: MIT Press, 2002), 82–139.

5. Reyner Banham, *Theory and Design in the First Machine Age* (1960; repr., New York: Praeger, 1975), 9–10 (emphasis added). Interestingly, this introduction was rewritten for the edition published by MIT Press, significantly downplaying the excitement of the 1950s that helped inspire Banham to undertake his study originally; see Reyner Banham, *Theory and Design in the First Machine Age,* 2nd ed. (Cambridge, MA: MIT Press, 1989).

6. See Banham, *Theory and Design* ([1960] 1975 ed.), 10–12. For a more extended discussion of how Banham's theory of the First Machine Age reflected his views toward the Second, see Whiteley, *Reyner Banham*, esp. 142–85. Pierre Francastel's nearly contemporary study of the impact of technology on art and architecture of the nineteenth and twentieth centuries was similarly motivated by the context of his own era; see Pierre Francastel, *Art and Technology in the Nineteenth and Twentieth Centuries,* trans. Randall Cherry (1956; repr., New York: Zone Books, 2000).

7. Marshall McLuhan, *Understanding Media: The Extensions of Man* (1964; repr., Cambridge, MA: MIT Press, 1995), 7.

8. "The Listening Post," *Newsweek,* October 28, 1957, 31.

9. *Penny* comic strip, *Austin American Statesman,* March 16, 1958.

10. David C. Beardslee and Donald D. O'Dowd, "The College-Student Image of the Scientist," in *The Sociology of Science,* ed. Bernard Barber and Walter Hirsch (New York: Free Press, 1962), 249.

11. C. P. Snow, "The Two Cultures: A Second Look (1963)," in *The Two Cultures,* introd. Stefan Collini (196; repr., Cambridge: Cambridge University Press, 1998; e-book), 215–16. C. P. Snow's *The Two Cultures* was originally published in 1959, shortly following the delivery of his eponymous Rede lecture at Cambridge. Part II, offering a reflection on the significance of his comments, was prepared in 1963 and first published in 1964.

12. Cited in Mary Eleanor McCombie, "Arts and Policy: The National Endowment for the Art's Art in Public Places Program, 1967–1980" (PhD diss., University of Texas at Austin, 1992), 39.

13. Billy Klüver, interview by Douglas Davis, 1968, in Douglas Davis, *Art and the Future: A History/Prophecy of the Collaborations between Science, Technology, and Art* (New York: Praeger, 1973), 140.

14. Billy Klüver, interview by author, January 13, 1999.

15. Billy Klüver with Julie Martin, "Working with Rauschenberg," in *Robert Rauschenberg: A Retrospective,* ed. Walter Hopps and Susan Davidson, exh. cat. (New York: Guggenheim Museum with Harry N. Abrams, 1997), 312.

16. Billy Klüver, interview by author, January 13, 1999. Although Klüver sought the stimulation of the professional arts world beyond Bell Labs, experimentation with the visual arts was occurring in other areas of Bell Labs as well. See, for example, Zabet Patterson, *Peripheral Vision: Bell Labs, the S-C 4020, and the Origins of Computer Art* (Cambridge, MA: MIT Press, 2015), and note 23.

17. J[acob] Bronowski, "The Creative Process," *Scientific American,* September 1958, repr. in "Science and the Arts," special issue, *Scientific American,* 1995, 10.

18. Billy Klüver, interview by Suzanne Ramljak, *Sculpture* 10, no. 3 (May/June 1991): 32.

19. Newton Harrison, interview by author, February 5, 1999.

20. Dan Flavin to Barbara Rose, June 13, 1966, "Sensibility of the Sixties" folder, Papers of Barbara Rose, AAA.

21. Robert Morris to Barbara Rose, August 12, 1966, "Sensibility of the Sixties" folder, Papers of Barbara Rose, AAA.

22. Allan Kaprow, response to questionnaire about "The Sensibility of the 1960s," ca. fall 1966, "Sensibility of the Sixties" folder, Barbara Rose Papers, AAA. His remarks were cited in the resulting article: Barbara Rose and Irving Sandler, "Sensibility of the Sixties," *Art in America* 55, no. 1 (January–February 1967): 45. In his reply to Rose's questions about the needs of contemporary sculptors, Otto Piene referred the critic to Allan Kaprow regarding the question of "a center for experimental research in sculpture," suggesting, "Ask Kaprow (he has been planning one for a long time)." Otto Piene to Barbara Rose, July 3, 1966, "Sensibility of the Sixties" folder, Papers of Barbara Rose, AAA.

23. Indeed, between 1967 and 1968, Nam June Paik enjoyed a residency at Bell Labs with Michael Noll; and in 1968 Dick Higgins would testify to the emerging role of new computational technology for the arts in his essay "Computers for the Arts." See Hannah Higgins and Douglas

Kahn, *Mainframe Experimentalism: Early Computing and the Foundations of the Digital Arts* (Berkeley: University of California Press, 2012) for related essays. Those with Fluxus connections included not just musicians John Cage and David Tudor but also Yvonne Rainer, Öyvind Fahlström, Robert Whitman, and Whitman's wife, Simone Whitman (later Simone Forti, as I generally refer to her in this essay).

24. The festival was reprised by the Stockholm Festival for Art and Technology: Visions of the Now, held May 24–26, 2013; see the announcements for the original 1996 and the 2013 festivals and the program and participant descriptions for the 2013 festival at www.visionsofthenow.com/, accessed August 21, 2015.

25. According to Billy Klüver, Wiggen asked him to organize the festival (see Klüver with Martin, "Working with Rauschenberg," 314); Julie Martin, who was married to Klüver, confirms this account (Martin to author, pers. comm., October 1, 2016). Knut Wiggen recalls contacting John Cage and Robert Rauschenberg and suggests that it was they who reached out to Klüver (see "Knut Wiggen: Art and Technology," n.d., accessed October 3, 2016, www.knut-wiggen.com/english/eng-artntech_read_more.php).

26. Billy Klüver, "What Are You Working on Now?," statement in *Abstract Painting: 1960–69*, ed. Donald Droll with Jane Necol, exh. cat. (New York: P.S. 1 Institute for Art and Urban Resources, January 16 to March 13, 1983), n.p.

27. The participation of these artists, with the exception of Yvonne Rainer, and Klüver's leadership of the effort are indicated by the undated draft press release announcing the event, which appears to have been written in the spring of 1966. At that time, Claes Oldenburg was listed as a performer, though he was not part of *9 Evenings: Theatre & Engineering*, suggesting that Rainer may have come in as his replacement. The document is reproduced on the website for the Stockholm Festival for Art and Technology: Visions of the Now, held May 24–26, 2013; see www.visionsofthenow.com/, accessed August 21, 2015.

28. Klüver, interview by Ramljak, 32.

29. Letterhead used by Billy Klüver in conjunction with the Stockholm Festival for Art and Technology identifies Simone Whitman (later Simone Forti) as secretary. See, for example, Billy Klüver to supporters of the Stockholm festival, announcing its cancellation, July 28, 1966, "Documents, 12/17/65–12/20/67," Papers of Experiments in Art and Technology, AAA. She describes her investigation of the Armory in Simone Whitman, "Theater and Engineering: An Experiment, 1. Notes by a Participant," *Artforum* 5, no. 6 (February 1967): 28.

30. Klüver and Martin, "Working with Rauschenberg," 315.

31. S. Whitman, "Theater and Engineering," 28.

32. John Cage, program notes to *Variations VII*, in *9 Evenings: Theatre and Engineering*, ed. Pontus Hultén and Frank Königsberg (New York: Experiments in Art and Technology, 1966), 4, www.fondation-langlois.org/html/e/docnum.php?NumEnregDoc=d0001430&page=4.

33. John Cage, "Remarks, 9 Evenings: Theatre & Engineering," press release, September 29, 1966, Papers of E.A.T., AAA.

34. Grace Glueck, "Disharmony at the Armory," *New York Times*, October 30, 1966, sec. 2, D-28. Julie Martin, Billy Klüver's future wife, who assisted with the organization of the performance,

notes that Glueck's account reflects a misinterpretation of Cage's tactics. Martin recalls that Cage did not deliberately plant "stooges" in the audience, as Glueck reports, but rather welcomed curious spectators to investigate his equipment during his first performance on October 15, 1966, and insisted on discarding the stanchions altogether during the work's second performance on October 16. Julie Martin to author, pers. comm., October 1, 2016.

35. At least three press releases were sent out by the public relations firm Ruder Finn, on August 29, September 14, and September 28, 1966. A press conference was held at Robert Rauschenberg's studio at 381 Lafayette Street on September 29. *9 Evenings* opened on October 13, 1966 (Papers of E.A.T., AAA). As Billy Klüver noted, the PR firm highlighted some of the artist's most fantastic hopes, including floating through the air (Billy Klüver, interview by author, January 13, 1999). In so doing, the PR firm may unwittingly have set unrealistically high expectations among audience members, leading to disappointment when the technology failed to function as anticipated.

36. Robert Whitman, quoted in S. Whitman, "Theater and Engineering," 26–27.

37. Norma Loewen, "Experiments in Art and Technology: A Descriptive History of the Organization" (PhD diss., New York University, 1975), 81.

38. Robert Whitman, program notes to *Two Holes of Water—3*, in Hultén and Königsberg, *9 Evenings*,13,www.fondation-langlois.org/html/e/docnum.php?NumEnregDoc=d00001430&page=13.

39. The instructions are published in Michelle Kuo, "9 Evenings in Reverse," in Morris, *9 Evenings Reconsidered,* 36–37.

40. Robert Rauschenberg, "Note, 9 Evenings: Theater and Engineering," press release, September 29, 1966, Papers of Experiments in Art and Technology, AAA.

41. Simone Whitman, "A View of 9 Evenings," 16, quoted in Loewen, "Experiments," 70.

42. Robert Rauschenberg, quoted in S. Whitman, "Theater and Engineering," 30.

43. Billy Klüver, "9 Evenings: Theater and Engineering," in Hultén and Königsberg, *9 Evenings*, 3, www.fondation-langlois.org/html/e/docnum.php?NumEnregDoc=d00001430&page=3, Papers of Experiments in Art and Technology, AAA.

44. Clive Barnes, "Dance or Something at the Armory," *New York Times*, October 15, 1966, 33.

45. Glueck, "Disharmony at the Armory."

46. Simone Whitman, "Theater and Engineering," 30.

47. Robby Robinson, "What Really Happened at the Armory," March 16, 1967, 1, box 2, folder 17, E.A.T. Papers, Special Collections and Visual Resources, GRI.

48. Bob Breer, interview by Nilo Lindgren, December 4, 1969, 5, box 2, folder 12, Barbara Rose Papers, GRI.

49. Robert Rauschenberg, quoted in Davis, *Art and the Future,* 144.

50. Ibid., 145.

51. Klüver, interview by Ramljak, 32.

52. Klüver with Martin, "Working with Rauschenberg," 317.

53. Although it would later inhabit Automation House (see Loewen, "Experiments," 181).

54. Klüver, interview by Ramljak, 33.

55. E.A.T., "Press Package," September 18, 1968, n.p., Papers of E.A.T., AAA.

56. Frank Stanton, President, Columbia Broadcasting System, Inc., script for "Remarks for the North Carolina State Art Society," November 29, 1968, 13, Papers of E.A.T., AAA. In his speech, Stanton remarked that "in the past year, two significant developments have occurred that can strengthen greatly the relationship of art and science through the agency of business and industry. One was the establishment of the Business Committee for the Arts [by David Rockefeller], which would broaden the base of support of the arts by business. . . . Almost simultaneously another promising organization, called Experiments in Art and Technology, was founded by artists and scientists for, among other things, building an awareness among scientists of the artist's role in contemporary life."

57. Billy Klüver, "The Artist and Industry," talk given at the Museum of Modern Art, New York, December 16, 1968, published as *E.A.T. Proceedings,* no. 4 (December 16, 1968): 5, Papers of E.A.T., AAA. For general comments on the artist-in-residence programs, see Klüver, "Artist and Industry," 4.

58. Loewen, "Experiments," 182.

59. Note that according to Loewen, these were the only organizations to renew their membership in 1969. (ibid., 184).

60. Ruth Fine, conversation with author, September 10, 2001.

61. Richard Serra, conversation with author, February 28, 2001.

62. Davis, *Art and the Future,* 140.

63. See Maurice Tuchman, ed., *Art and Technology: A Report on the Art and Technology Program of the Los Angeles County Museum of Art, 1967–1971* (Los Angeles: Los Angeles County Museum of Art, 1971), and Billy Klüver, Julie Martin, and Barbara Rose, eds., *Pavilion by Experiments in Art and Technology* (New York: E.P. Dutton, 1972).

64. For a detailed discussion of this phenomenon, see Anne Collins Goodyear, "From Technophilia to Technophobia: The Impact of the Vietnam War on the Reception of 'Art and Technology,'" *Leonardo* 41, no. 2 (2008): 169–73, and "Expo '70 as Watershed: The Breakdown of Collaborations between American Art, Technology, and Cold War Politics at the American and the Pepsi Pavilions," in *Cold War Modern: Art and Design in a Divided World,* ed. David Crowley and Jane Pavitt (London: V&A, 2008), 198–203, 285–87.

65. Richard Serra, quoted in Gail R. Scott, "Richard Serra," in Tuchman, *Art and Technology,* 300.

66. Maurice Tuchman, interview by author, February 2, 1999.

67. As Alan Pottasch complained to Calvin Tomkins: "If we hadn't been presented with a programming bill that was so far in excess of anything previously suggested, we would still have gone along with their evolving concepts. But when that happened—and it has to be seen in context, as part of a pattern of constantly escalating costs that had been a problem right from the beginning—we had no alternative." Calvin Tomkins, "Onward and Upward with the Arts (Pepsi-Cola Pavilion, Expo '70)," *New Yorker,* October 3, 1970, 132–33, republished as "Outside Art" in Klüver, Martin, and Rose, *Pavilion,* 105–65.

68. Loewen, "Experiments," 200.

69. Ibid., 217.

70. One indication of the ongoing significance of *9 Evenings* is the extensive program, *After 9 Evenings: Theatre & Engineering*, organized from September 25 to October 1, 2016, by Chris McIntyre and Lauren Rosati in honor of its fiftieth anniversary, with events at the ISSUE Project Room, New York University, Tanden School of Engineering; see ISSUE Project Room, "After *9 Evenings*."

71. Quoted in Davis, *Art and the Future,* 140.

72. Billy Klüver, telephone conversation with author, December 21, 1998.

73. Robert Wong, presentation to Fellows at the Center for Curatorial Leadership, January 14, 2015.

74. Robert Irwin and James Turrell, quoted in Jane Livingston, "Robert Irwin, James Turrell," in Tuchman, *Art and Technology,* 131.

STEVEN DUVAL

2

IDENTITY, RHETORIC, AND METHOD
IN THE COLLABORATIONS OF
EXPERIMENTS IN ART AND TECHNOLOGY,
THE ARTIST PLACEMENT GROUP,
AND THE ART AND TECHNOLOGY PROGRAM
AT THE LOS ANGELES
COUNTY MUSEUM OF ART

MICHEL SERRES BEGINS HIS CLASSIC treatise on interdisciplinarity, *The Troubadour of Knowledge,* by focusing on the figure of Harlequin, who has returned from his travels to the moon and is asked what wonders he has seen.[1] He replies, "Everywhere everything is the same as it is here."[2] This response is unacceptable for a crowd primed for tales of marvels. Someone in the crowd shouts, "You who say that everything is just the same as it is here, can you also make us believe that your cape is the same in every part, for example in front as it is back?"[3] Harlequin reluctantly reveals his cape to be a haphazard blend of different materials and composed in an irregular way. In effect, through the figure of Harlequin, Serres presents us with the heart of the matter with regard to hybrid practice: "Pure and simple language or a composite and badly matched garment, glistening, beautiful like a thing: which to choose?" It is through language that we can tell who belongs and who doesn't in the world of knowledge: language is the gatekeeper, and to "belong" to a variety of fields would be to use language that is much like the cloak of the Harlequin. Knowledge identity is built upon this model as well.

Experience, skill, and knowledge have many homes. But the clarity of language and of identity demands a monocultural focus within disciplines. For Serres, the "third-instructed" artist or scientist leaves the monoculture of a discipline and enters a "third place" that is neither, a culture that is literally pluralist, from many disciplinary homes. That pluralist culture changes the identity of the practitioner and, as we will see from the case studies to be considered here, is much more rare than we might assume.

As the Cold War kept things on the brink of crisis and as the Vietnam conflict raged, several collaborative projects of the late 1960s and early 1970s aimed to fuse art, science, and technology in an idealist vision that mirrored much of the optimism of the period. Three different projects active during this time—Experiments in Art and Technology (E.A.T.), the Artist Placement Group (APG), and the Art and Technology (A&T) program at the Los Angeles County Museum of Art (LACMA) embodied the age's Cold War politics and optimism about technology.[4] The possibility of creative freedom married to technological innovation was seen as the brave new world, and only democracy could produce it, although the idealistic view of that freedom did not always mesh with the reality of practical engagement. These projects were all interested in various forms of collaboration that could be called rhetorical, theorized, and representational. Each of these endeavors embodied different identities that informed the rhetorical method of collaboration because each saw in collaboration a different panacea.

EXPERIMENTS IN ART AND TECHNOLOGY

In 1965 the Bell Labs engineer Billy Klüver was working on the American contribution to a Swedish festival on art and technology. Klüver had already worked with Robert Rauschenberg, Jean Tinguely, and Andy Warhol on projects prior to his involvement with the festival, so he was the natural choice for the assignment. When the festival was cancelled because of funding problems, the artists and engineers working on the project decided that they would do a series of performances at New York's Sixty-Ninth Regiment Armory instead. These performances would be called 9 *Evenings: Theatre & Engineering*. The collaboration between art and technology, despite being panned by many in the mainstream media like *New York Times* critic Clive Barnes, was successful enough to the participating artists and engineers that E.A.T. was born as an organization, with Klüver, fellow engineer Fred Waldhauer, and the artists Robert Whitman and Robert Rauschenberg as its founders.[5]

E.A.T.'s method is described in the first bulletin: "The artist must have access to the people who are creating technology. Thus it was decided that E.A.T. act as a matching agency through which an artist with a technical problem, or a technologically complicated and advanced project be in touch with an engineer or scientist who could collaborate with him. E.A.T. not only matches artists and engineers to work on collaborative projects but also works to secure industrial sponsorship for the projects that result from collaboration."[6]

This important statement brings up some questions regarding authorship and method. Clearly this was a project for artist-driven endeavors, and artists would be in charge of the vision. Regarding these collaborations Whitman said, "You have to be careful or the engi-

neer will insert his own aesthetic into the project."[7] Whitman, who participated in E.A.T. projects as well as the A&T program at LACMA, was very transparent about his method of working with scientists or engineers who were only a part of the process to facilitate the actualizing of an artwork. For Whitman collaboration was defined by knowledge and skills-based roles that the artist and the scientist had in their medium or field of endeavor, and the contribution of each would be confined to the area of his or her competence. Whitman saw the artist as the driver and disciplines as crossing only within the artwork, which was authored by the artist. In this method of collaboration, becoming third-instructed was not encouraged or allowed. The artist did art and the scientist did science.

Robert Rauschenberg talked about the technology as more of a collaborator than the scientist. Regarding the preparation for *9 Evenings,* he said, in a quote that anticipates actor-network theory, "When you're working with something that's as physical as radio equipment, what's absurd to do is very quickly determined. The machine has no tolerance for getting outside a particular radio wave or whatever it is you're working with. The kind of equipment we're inviting has its own integrity built into it. Whereas an artist has to somehow assume integrity or not. I think just that experience of dealing with these kinds of material that have a particular character is going to end up being an enormous influence on the work esthetically."[8]

Seeing technology as a new medium was probably a more prescient observation than seeing collaboration as a new methodology. As we see today, artists are often able to write code and do much of the engineering of their projects and in many ways embody the third-instructed. By contrast, the unavailability of these technologies to the layman in the years around 1970 meant that artists and scientists had to cooperate for work with these tools to be realized. This is reinforced by the working method in *9 Evenings*, where an artist was paired with a team of engineers whose lead engineer would interact with the artist.[9]

What is interesting about the power dynamic that E.A.T. set up is that the artist had the control over the project, for this made the artist into a project manager. The final outcome for these projects was an artwork, and that artwork had to be authored by an artist, not coauthored by the artist and the team of engineers. This made the engineer into a technician to be consulted on technical issues but never given control over content. It should not be surprising that scientists, who coauthor papers on a regular basis, were familiar with this structure and willing to play this role. The model of collaboration often found in academic research projects, where there is a principal or lead investigator and others fill roles as the project dictates, is the one we find Klüver and E.A.T. using through most of their projects.

Of course E.A.T. and those associated with them had a definition of collaboration that suited their own culturally specific rhetoric. This perspective held that an artist had creative expertise and an engineer had technical expertise and therefore the former should be in charge on the basis of a natural order of skill in making a work of art. Barbara Rose wrote in *Pavilion,* the document of E.A.T.'s Osaka collaboration with the multinational corporation Pepsi (figure 2.1), that "the collaborative process by which the pavilion was realized was a specifically American experiment in democratic interchange. The process by which it was

FIGURE 2.1
E.A.T.'s Pepsi Pavilion at Expo '70, Osaka, Japan, March 18, 1970. Photograph: Shunk-Kender © J. Paul Getty Trust. Getty Research Institute, Los Angeles (2014.R.20).

created … [was one] of people taking responsibility without an authoritarian chain of command, acting within their own competence as the need arose."[10] This was certainly a perspective that smacked of nationalistic exceptionalism, despite international examples such as the APG in England proving the contrary, and was also contrary to statements by Whitman and others regarding a "chain of command."

Klüver and others in E.A.T. did feel, however, that there was an imperative for engineers to work with artists that went beyond Rose's nationalistic rhetoric. The collaborators could learn from each other, and inevitably they would be transformed by the experience. As the artist Bill Paxton put it: "We had become interested in the process we were involved in, which was the meeting, marrying, and mating of artists and scientists that was a kind of coupling, some form of, hopefully, a synergistic new wrinkle in artistic thought and scientific thought. That they would repel each other, and attract each other in some strange dance, and we would get out of that the flowering, the explosion, the evolution of something for the future."[11]

Such energy and desire for engagement was at the heart of the collaborations. Hierarchies were still embedded in the process, and much of the actual work would be seen today

as consultation or fabrication services, but Paxton's quote illustrates that like many of his contemporaries he was optimistic that through collaboration new thinking could emerge. What these collaborations held up for Paxton and others was the possibility that, like other modernists before them, they were onto a new, inherently modern way of making art that signaled a new age of creativity. Perhaps he was right and the age of collaboration really started at this time, but in terms of its *broader impacts,* to use a National Science Foundation term for the role of art in a science-oriented research project, it has yet to reach its full potential.[12]

THE ARTIST PLACEMENT GROUP

In 1966, when a group of young artists were out looking for materials on the outskirts of London, in service of the Fluxus artists Daniel Spoerri and Daniel Filliou, one of them, Barbara Steveni, realized that it might be more "socially useful for artists to work on the inside of these factories" than to retrieve their refuse.[13] Steveni's then husband, John Latham, was well known in the arts scene for his performance *Still and Chew,* in which he and some of his Central St. Martin's students chewed up the school's copy of Clement Greenberg's *Art and Culture.* They returned the masticated book to the library in a vial and Latham was then fired for the action. This bodily response to the theory of art marked the Artist Placement Group (APG), started by Latham and Steveni, as different from E.A.T. and Art and Technology, for they infused the project with a theoretical methodology that was not to be found in either of the American projects. From its very inception the APG was a knowing virus infiltrating the system in an attempt to alter the institutions.

The APG as a project started in earnest when Steveni met the influential Sir Robert Adeane, the chairman of several companies including Esso and ICI, who agreed to serve on the board of APG.[14] Adeane's connections opened doors for the APG and gave them a currency. This kind of sponsorship allowed Steveni to start the process of placing an artist in an institution, but the APG weren't going to create a run-of-the-mill residency program—they conceived of the residency as an artwork unto itself. This meant that they needed to articulate a method that both the artist and the institution would agree to.

First, a feasibility study had to be done, which would take around a month: the institution would pay the APG a fee, and in return the group would send three artists' CVs over to the company and arrange for each artist to visit the company.[15] This interaction would produce a report on the possibilities for each placement. Then the organization and the APG would agree on an artist, who would be paid 2,000–3,000 GBP, and on all of the legalese regarding ownership of any work produced. This second phase often required a large amount of faith on the part of the organization and the artist because the artist's brief, called "the open brief," allowed for the possibility that nothing would be produced. The third phase, if there was one, was an exhibition. This process meant that the artist was under no obligation to do anything other than be present in the organization. Of course, most artists wanted to produce something, and many of them did with the aid of their host, but other artists were more reactive to their context and did not produce what was expected of them.

The artist couldn't be given the title of "artist" in the organization or he or she would have to produce art, and for the APG the artist being in the organization was itself part of the art. The artist had to be a free agent or, as Latham would term it, an "incidental person."[16] The artist, given this new organizational title, would be free to work in various departments with no clear objective in terms of productivity. The artist was in the organization to communicate, solve problems, think "out of the box," and most importantly undermine the logic of production.[17] This is why an IBM official famously responded to Steveni: "If you [APG] are doing what I think you are doing, I wouldn't advise my company to have anything to do with you. And if you aren't, you're not worth taking into account anyway."[18]

Latham and Steveni weren't uninterested in making money, however, and Latham fought the Scottish Office for years to be paid for his nominalist work *Niddrie Woman,* where he named an existing shale bing an artwork. They were also both criticized for being managerial by Gustav Metzger and by APG artists like Stuart Brisley.[19] But both the IBM official and Metzger et al. misread the intentions of Latham and Steveni. Their real motivation was to change organizations from thinking about their business in the short term of quarterly reports and annual profits to thinking in a much more extended period of time and looking at the big picture. This is explored in Latham's theory of "event structure" and "least event."[20]

Latham developed his concept of time with two physicists, Clive Gregory and Anita Kohlsen, with whom he worked at the Institute for the Study of Mental Images. According to the theory of "event structure," everything that existed could be explained as a recurring time-based "event" of finite duration, and the "least event" was the briefest of such events. The "Delta unit" was a measure of human development and the value of an artwork, not in terms of monetary value, but in terms of the amount of awareness produced in society over a sustained period of time. The APG weren't interested in destroying a large part of the social system that industry accounted for but sought to change that system for the better. The "incidental person" at the organization was to be that agent of change.

Considering the self-imposed hurdles, it was quite extraordinary that Barbara Steveni was able to get these companies to agree to host an artist. Reading the correspondence between Steveni and these companies reveals the tenacity of a committed facilitator. The artists involved, for their part, were not as true to the inherited ideological underpinnings of the project and were quite keen to produce art with their new collaborators. As in many of the projects during this time, artists would often enter the host institution with a project in mind and with the help of the institution would make a sculpture, film, or image. The framing of the work as radicalism was predominantly Latham's, and many of the artists involved began to reject the APG's ideology.[21]

If having the artist placed in the institution was the artwork, where did that leave the artist, or incidental person in the APG's case? An artist who understood the dynamics of hierarchy within these projects was Stuart Brisley, a member of the APG's project committee who did a placement at S. Hille and Co. Ltd. Hille was known in the United Kingdom for manufacturing the famous chairs designed by Robin Day. Brisley's placement was unusual in the sense that he did not want to extract technical knowledge from the company to

FIGURE 2.2
Stuart Brisley at his Hille placement with his sculpture of Robin Day chairs, 1970.

help him make a work. He was interested in the social structure and class divide that was ingrained in the business model of the company. He knew that he had to win the workers over and so started by making a sculpture with them that used the Robin Day chairs, which were stackable by design, to make an interlocking circle (figure 2.2). After winning over some of the workers, he proceeded to ask them how their work environment could be improved and responded by painting some of the machinery the colors of the favored football team. In his third project he created a bulletin board for workers to post information about "sports activities, exchange and sale of goods, social notices, grievances, etc."[22] By this time it was clear to those running Hille that Brisley was exactly the kind of artist that the IBM official was talking about who would be raising issues of class consciousness. For Brisley class distinctions were not operating only at Hille; he also saw Latham and Steveni as managers within the capitalist system.[23] The issue of social relations, which is so often excluded from the historicizing of these projects, comes front and center here. Although the APG were managing the project, like the upper echelon of a company, they did it in a way that a curator, museum director, or principal investigating scientist would not. When discussing the issues that arose during the project, Steveni alluded to her understanding of how a socially conscious artist like Brisley would act as a disruptive force within the company,

saying that Brisley "raised a lot of issues and they would have been very social issues, being Stuart."[24] Not only were she and Latham aware of the possibility of conflict, they were clearly fostering it, even though their role would be to negotiate between company and artist. This placement also brought into stark relief the role of power relations in collaboration.

If we see the APG as providing a service in the way that E.A.T. did, then that service was to help a company evolve beyond focusing on the production of goods and services into being interested in its holistic contribution to society. The APG's exhibition *INN70*, also known as *Art and Economics*, at the Hayward Gallery in London proved not only that companies were not prepared for this kind of interaction but also that the art world was not.[25] Like *9 Evenings* before it, *INN70* was panned by artists as an exhibition and criticized as collaboration with capitalism, the enemy of the counterculture. The poor critical reception of the exhibition signaled the end of the APG's placements in industry, and eventually they would begin placements in the left-leaning Labour government offices.

THE ART AND TECHNOLOGY PROGRAM AT THE LOS ANGELES COUNTY MUSEUM OF ART

In 1966, Maurice Tuchman, head curator of LACMA, initiated the A&T program. Tuchman was then contacted by Marilyn (Missy) Chandler, wife of the *Los Angeles Times* publisher Otis Chandler, who had seen a newspaper article on Tuchman's endeavor and had consequently approached her friends in industry to facilitate the collaborations. Tuchman wanted to "bring together the incredible resources and advanced technology of industry with the equally incredible imagination and talent of the best artists at work today."[26] Like the APG and E.A.T., this project had a vision of how influential such collaborations could be, and unlike the other two projects it was to be led by an established institution.

Guided by three curators, A&T was different from the other two projects because the museum was used to facilitating artists' needs as well as those of funders. Tuchman, with the aid of Missy Chandler, was able to contact 250 companies, with 37 of them agreeing to participate in the project. The task then became to match artists up with the companies. Artists would visit companies and either arrive at an agreement to work with that company or move on to another. This was very much akin to the method employed by the APG. Once paired up, they would draw up the contracts and time lines to begin work.

Three types of collaborations developed. The most common collaboration was the one that E.A.T. did so well, where the artist was in charge of the project and asked the company and its employees to fabricate the work of art. The second method was very much like the one employed by the APG, where the artist was embedded in the company and whatever came from that "residency" was the work because A&T was going to be documented in a published report. The third and least likely collaboration was the closest to ideal: the artist and scientist would meet and pull apart ideas together in a thoughtful and truly equal fashion. This is exemplified in the Robert Irwin, James Turrell, and Ed Wortz collaboration at the Garrett Corporation.

The first collaboration was exemplified in A&T by Claes Oldenburg's project with Disney, where the artist proposed to make a hydraulic ice pack with the amusement park "imagineers." This is clearly a case of the artist having an idea that is not hard to imagine a company known for animatronics being able to accomplish, which they did. One would be hard pressed to see this as a collaboration, as in actuality it was Disney fulfilling Oldenburg's vision and paying $7,000 for the privilege. Of course, we will never know what residual impact working with Oldenburg had on the people at Disney, who, it must be pointed out, worked with creative people regularly. Oldenburg forthrightly noted: "The practical way to approach working with any corporation or any material or technique supplier is to see where their services fit with your needs."[27]

Oldenburg could easily have hired out Disney's service for all of the collaborating that was evident in this work and interaction. Many visual artists did not contract out services at this period of time and dare to call it their work. The crutch of collaboration needed to be there to justify it. Today artists like Jeff Koons hire artisanal wood carvers to make their work with little to no complaints from critics. During the time of A&T this practice was only beginning to make itself known with the re-emergence of Marcel Duchamp's Readymade and the fabricated works of minimalists like Donald Judd, who was also an A&T artist.

An example of an A&T project where the artist was clearly influenced by and benefited from the collaboration was Rockne Krebs's work with Hewlett-Packard (HP). The company had a division that specialized in lasers, and the curators were keen to have an artist with interest and experience in lasers placed there.[28] Krebs was already working with lasers, and when placed in HP he said, "At the time I wanted very much to make a piece. This is not the cool, think tank theme that might be popular to peddle, but several years of ideation and attempts to visualize pieces that were beyond my resources, both technically and financially, had preceded my initial visit."[29] When asked to do a presentation at the company Krebs found an appreciative audience. One scientist, Egon Loebner, approached Krebs about patenting some of the artist's ideas on architectural photon structures, and although Krebs had been doing them for some time he was not aware that they might constitute a patentable invention.

Krebs and HP were asked to create a laser light sculpture for the US pavilion at Osaka. Given that E.A.T.'s work with Pepsi was also at Osaka, it is clear that these collaborations had a rhetorical value to the US government. Although HP would lament the "lack of technical breakthroughs" on the Osaka project, they would also say "artist and engineers proved they could collaborate to produce a new dimension through which to view the world and some of the wonders therein."[30] Krebs would say, "My mind was stimulated in a way that it never had been before, and probably never would be, particularly by art."[31] This was a well-planned collaboration where the curators had a good idea of what the outcomes would be. Krebs would get the technical assistance he needed, and by offering them a space in the US pavilion the curators gave HP the publicity it wanted with the possible added benefit of stimulating their workforce.

Elsa Garmire, whose foray into lasers as art Patrick McCray describes in detail elsewhere in this book, was coming from the other side of the ledger. Garmire, an extremely

FIGURE 2.3
James Lee Byars, *putting byars in the hudson institute is the artistic product*, 1969. © The Estate of the Artist.

accomplished scientist, had decided, after working with E.A.T. on their Pepsi Pavilion, that she might make art that used lasers. She would not face the problems that Krebs had to overcome in terms of technical knowledge, and although she lacked Krebs's aesthetic training she had her own aesthetic. She would go on to do gallery exhibitions of her "laser photographs" and help found Laserium,[32] but the drive to be an artist did not take hold of her, and she eventually returned to science, where she has gone on to have a remarkable career. When interviewed for the film *Peer Review* Garmire was reluctant to claim any influence art might have had on her until she started to talk about the use of play in her teaching, eventually saying, "I guess I did learn something from the artists I palled around with."[33]

Two residencies at military think tanks exemplified the embedded collaboration: John Chamberlain at RAND Corporation and James Lee Byars at the Hudson Institute. Chamberlain, known for his use of automobiles in assemblages, had an antagonistic relationship with the people at RAND and through a series of memos, which became a bookwork, illustrated that relationship. Byars, on the other hand, came into the Hudson Institute, talked with people there, and promptly disappeared. Before he disappeared, though, Byars did a piece where he typed the words "Putting Byars in the Hudson institute is the artistic product" on several slips of paper (figure 2.3). These pieces of paper were photographed and became part of LACMA's report on the program. Byars's actual engagement in the Hudson Institute seems to have been quite limited, and he certainly was not as antagonizing as Chamberlain, but clearly he, like John Latham, understood that the placement itself was the work and that he needed only to represent to the world that he had engaged with a think tank. His subsequent work, *The World Question Center*, was born out of this residence, and ultimately Byars used his time at the Hudson to produce his own work. His work was therefore not really collaboration but more of an inspiration and collaboration as rhetoric and representation.

The third and final type of collaboration that A&T facilitated was between artists Robert Irwin and James Turrell and experimental psychologist Ed Wortz. This collaboration was idiosyncratic in the sense that it was an actual collaboration where all parties involved worked together on a project as equals and made something; it just was not an art project. This project has justifiably become the best known of those carried out by A&T because of its great influence on the subsequent work of both artists, although it should be noted that it also had a tremendous influence on Wortz as a person, if not as a scientist.[34] The three protagonists of this collaboration worked together on creating a Ganzfeld that they had initially thought to exhibit in the A&T exhibition, but at some point before the exhibition Turrell dropped out of the project, and in the spirit of collaboration they decided not to proceed with the project as art. Before Turrell left, though, the team created an installation in Irwin's studio that was designed for a NASA conference on spatial psychology. This installation devised a space made to create an experience—a person entering the space was made aware of its psychospatial dynamics. Irwin, Turrell, and Wortz did this through altering elements of the space, such as seating, which people approached with certain expectations. Importantly this project was not considered art. It was part of a conference. Taking the project out of the art context allowed it to exist as an experience for scientists and nothing more. Today this might be a practice-led research project with the space being the thesis work, as their research took no other output other than the eighteen pages describing it in the report. It should be noted that E.A.T. tried something similar in "Projects Outside of Art," but as the projects were part of an exhibition and supported by the National Endowment of the Arts they were still firmly within an art context.

The three methods employed in A&T's projects were driven less by the curatorial team's lack of methodological dogma and more by the rapport between each artist and company. This might be because, like James Lee Byars, the artists knew that by merely being in the institution and creating work under the auspices of collaboration the work would hold representational currency for the viewer. The *Report on the Art and Technology Program* was the medium through which audiences became familiar with the project, and very few if any images of the actual exhibition were ever circulated or became part of the historical discourse. The project in rhetorical terms was the report, and the way that the collaborations were mediated was vital to the project. For instance, Bruce Nauman, who submitted a letter of interest to LACMA but was never invited to participate in the project, would eventually go on to fulfill his proposal of making holograms using his face, but the inclusion of this proposal, eventually realized by Nauman on his own, into the report is perplexing. Was every unsolicited proposal put into the report? What was the purpose of including it and others if not to show that the process of the project was meant to be experimental and therefore open to failure? The unfulfilled projects served the narrative of the project as experimental and risking "failure." The process and the projects that were fulfilled would lose their power if they were not contextualized within the project as a whole. What we end up with is a curated publication of process via experiences and relationships that ultimately had more currency than the exhibition or "product." The enduring product was then the report, which has grown in value over time.

THE END AND A BEGINNING
At the end of this era only a handful of projects could be said to have worn Harlequin's cape. There is no doubt that the Wortz-Irwin-Turrell project was done with the intent of collaboration in pursuit of knowledge. Wortz would eventually even cross over into the lands of art, and it could be said that both Turrell and Irwin have proceeded to rigorously explore the psychological and physiological perception of light. Another scientist, Elsa Garmire, who worked with E.A.T. on the US pavilion, briefly ventured into art practice by creating laser pieces and holograms before returning to a very successful scientific career.[35] Harlequin's cape in Serres's analogy is often hidden, so it is difficult to tell how much any of these participants have sewn onto their own capes. The cross-contamination of disciplines will always leave a trace, but the measure of that significance is another matter. The APG and LACMA had the foresight to archive postproject feedback from participants, but no data were obtained from participants before the projects began. Most of the feedback is mixed, offering stories of both enlightenment and frustration. Can we say of these projects what the Harlequin originally told the crowd, "Everywhere everything is the same as it is here"? Regardless of discipline, collaborations will always be difficult, messy, and full of conflicts, with some expectations being met and others not.

It is important to frame the formative collaborations of the 1960s and 1970s within the contemporary. At the moment we are seeing a proliferation of art, science, and technology collaborations driven by universities in both North America and Europe. How can these historical exemplars of interdisciplinary practice serve today's collaborators? I would posit that while the contexts are very different the one thing that has not changed is the performative nature of collaboration and the importance of identity when these collaborations are interdisciplinary. The importance of collaboration as performance is poignantly discussed in Erin Manning and Brian Massumi's book *Thought in the Act*. Their concept of "immanent critique" describes how research is created between fields of knowledge through real-time collaboration from the genesis of a project onward.[36] This concept flies in the face of separating duties according to knowledge or hiring specialists to perform preconceived research agendas. It also flies in the face of expectations of funding bodies that research produce specific kinds of outcomes that may have monetary value. This conflict between a model in which genuine engagement between fields generates its own agenda and a model in which researchers perform knowledge-specific duties in the service of a preconceived agenda, whether originating in either science or art, has been an issue since these projects began, and the potential for becoming, or not becoming, third-instructed lies at its core. Regardless of the intent of a project, the remaining similarity between historical projects and those of today is that they are representations of an idea that have rhetorical uses for many of the people who wish to fund projects and participate in them. The ideal of interdisciplinary collaborations that have the potential to reach new lands of knowledge is still powerful, and those who fund such projects are often as interested in the rhetoric as they are in the outcomes.

Participants in these three organizational projects were all extremely aware of how they were perceived by a wider audience. The critical response to the projects has evolved over

the decades. Initially the press and their peers criticized them. Max Kozloff called A&T "the Multimillion Dollar Art Boondoggle" in *Artforum*,[37] while Gustav Metzger called the APG's approach the "middle-way" because of the perception of Latham and Steveni as managers whose objectives were aligned with the host company.[38] Even Jack Burnham, whose *Systems* exhibition is grouped with these projects by art historians, was critical of *9 Evenings*, calling the work "drawn-out repetition of unstructured events."[39] For Latham, such critiques would be "least events"; the projects, in the relatively short span of time since they were executed, have weathered well, and their stature in art history has grown dramatically. This is because while many of the technological gadgets of *9 Evenings* may not have worked as intended, they revealed the possibilities of the "new media" of technology, which have continued to move forward from Nam June Paik to Blast Theory. While the impetus for how and why we collaborate has changed dramatically, collaboration as a method has become increasingly important, whether in the form of the long-term engagement of Rick Lowe or Project Row Houses or Eduardo Kac's genetically modified, bioluminescent green *GFP Bunny*. The late 1960s-early 1970s era of collaborations between art, science, and technology will continue to provide cases that inform and influence contemporary practitioners. Whether the practitioners of today encounter the same pitfalls or find new solutions, it is certain that hybrid collaborations between the arts and sciences will continue to promise the possibilities of a new horizon.

NOTES

1. Michel Serres, *The Troubadour of Knowledge,* trans. Sheila Faria Glaser and William Paulson, 3rd ed. (Ann Arbor: University of Michigan Press, 1997), xiv.

2. Ibid.

3. Ibid.

4. Anne Collins Goodyear, "From Technophilia to Technophobia: The Impact of the Vietnam War on the Reception of 'Art and Technology,'" *Leonardo* 41, no. 2 (April 2008): 169–73, doi:10.1162/leon.2008.41.2.169.

5. Clive Barnes, "Dance or Something at the Armory," *New York Times,* October 15, 1966.

6. E.A.T., *E.A.T. News* 2, no. 1 (March 18, 1968): 2, Art and Technology Archives, LACMA, Los Angeles.

7. *Peer Review: Hybrid Collaborations in the 1960s & 70s,* dir. Steven J. Duval and Ryan Waggoner, perf. Jane Livingston and Julie Martin, Hybrid Practices Conference, Spencer Museum of Art, Lawrence, KS, March 15, 2015, recorded as part of conference proceedings at http://spencer-conferences.res.ku.edu/hybrid-practices/watch-peer-review.html.

8. Bruno Latour, *Reassembling the Social: An Introduction to Actor-Network-Theory* (Oxford: Oxford University Press, 2007), 63; Simone Whitman, "Theater and Engineering, An Experiment: 1. Notes by a Participant," *Artforum* 5, no. 6 (February 1967): 27.

9. Marga Bijvoet, "How Intimate Can Art and Technology Really Be? A Survey of the Art and Technology Movement of the Sixties," in *Culture, Technology and Creativity in the Late Twentieth Century,* ed. Philip Hayward (London: University of Luton Press, 2003), 32.

10. Barbara Rose, "Art as Experience, Environment, Process," in *Pavilion: Experiments in Art and Technology*, ed. Billy Klüver, Julie Martin, and Barbara Rose (New York: E. P. Dutton, 1972), 102.

11. Steve Paxton is speaking in the film *Open Score, by Robert Rauschenberg*, dir. Barbro Schultz Lundestam, vol. 1 in the *9 Evenings: Theatre and Engineering* series produced for E.A.T. by Julie Martin, DVD, 2008 (performed in 1966).

12. National Science Foundation, "Broader Impacts: Improving Society," n.d., accessed February 21, 2018, https://www.nsf.gov/od/oia/special/broaderimpacts/.

13. Claire Bishop, *Artificial Hells: Participatory Art and the Politics of Spectatorship* (London: Verso, 2012), 164.

14. Ibid.

15. Ibid., 165.

16. John Latham, *Report of a Surveyor* (Stuttgart: Hansjörg Mayer; London: Tate Gallery Publications, 1984), 7–11.

17. Gustav Metzger, "A Critical Look at Artists Placement Group," *Studio International* 183, no. 940 (January 1972): 4.

18. Peter Eleey, "Context Is Half the Work," *Frieze*, no. 111 (November 2007).

19. Metzger, "Critical Look," 4.

20. Latham, *Report of a Surveyor*, 7–11.

21. Bishop, *Artificial Hells*, 168.

22. Stuart Brisley, "Statement on Placement at Hille Furniture Factory," 2013, stuartbrisley.com, www.stuartbrisley.com/pages/27/70s/Works/Hille_Fellowship/page:4.

23. Stuart Brisley, "The Artist and Artist Placement Group," *Studio International* 183, no. 943 (April 1972): 95–96.

24. Barbara Steveni, interview by Melanie Roberts, *National Life Stories,* British Library, audio, 1998.

25. Caroline Tisdall, "Profit without Honor," *Guardian,* December 18, 1971.

26. Maurice Tuchman, *A Report on the Art and Technology Program of the Los Angeles County Museum of Art, 1967–1971* (Los Angeles: Los Angeles County Museum of Art, 1971), 8.

27. Ibid., 141.

28. Ibid., 165.

29. Ibid.

30. "Art—with a Touch of Technology," *Measure Magazine* (HP Newsletter), February 1970.

31. Tuchman, *Report,* 166.

32. *Peer Review,* dir. Duval and Waggoner.

33. Ibid.

34. Lawrence Weschler, *Seeing Is Forgetting the Name of the Thing One Sees: Expanded Edition, Over Thirty Years of Conversations with Robert Irwin* (Berkeley: University of California Press, 2009), 136.

35. *Peer Review,* dir. Duval and Waggoner.

36. Erin Manning and Brian Massumi, *Thought in the Act: Passages in the Ecology of Experience* (Minneapolis: University of Minnesota Press, 2014), 86.

37. Max Kozloff, "The Multimillion Dollar Art Boondoggle," *Artforum* 10, no. 2 (October 1971): 72–76.

38. Metzger, "Critical Look," 4.

39. Jack Burnham, *Beyond Modern Sculpture: The Effects of Science and Technology on the Sculpture of This Century* (New York: George Braziller, 1968), 359.

W. PATRICK MCCRAY

3

FALLOUT AND SPINOFF
Commercializing the Art-Technology Nexus

PREAMBLE

This essay explores the intersections of artist and technologist communities of the 1960s through the lens of commercialization and engagement with the corporate world. It is part of my larger interest in the experiences of engineers and scientists who participated in formal collaborations like Experiments in Art and Technology (E.A.T.) and the Art and Technology (A&T) program at the Los Angeles County Museum of Art. My larger goal is a consideration of the emergence and maturation of what C. P. Snow in 1963 called the "third culture," in which hybridized professionals closed traditional gaps separating artists, engineers, and scientists.[1] Most recently, a version of this sentiment has surfaced in calls for a "STEM to STEAM" movement in which art and design are integrated with education in science, technology, and medicine.[2]

I originally intended this essay as a modest historical intervention. In the 1960s and 1970s, contemporary art critics and theorists writing about the "art and technology" movement (a label that I think is fair, given the scale, scope, and duration of these formal artist-engineer

collaborations) gave very little, if any, consideration to the engineers who contributed time, technical expertise, and sometimes aesthetic input to their artist colleagues. They were, to most observers from the art world, simply "invisible technicians."[3] While the art and technology movement has received little attention in traditional historiography, the contributions to it by engineers and scientists remain even less examined, with barely any consideration given to their experiences or motivations.[4]

When contemporary art critics responded to the art and technology movement, their focus was primarily the *products* of artist-engineer collaborations. Here, the view was evaluative, considering whether the art produced was innovative and aesthetically pleasing: that is, whether the artist-engineer/scientist collaboration was "successful" on the basis of what they made. My point is not to condemn this perspective—art critics and theorists, not surprisingly, directed their gaze to the outcome and the object. But fifty years later we are not obliged to take the same approach, and we can expand our frame accordingly. We can instead shift our focus of inquiry to the *processes* and *practices* inherent in interdisciplinary efforts like E.A.T.'s *Pavilion* or a journal like *Leonardo*. The "E" in E.A.T. stood for "experiments." For example, what if we actually approached artist-engineer collaborations *as experiments* and adopted ideas from the history of science to treat them thus?

Obviously, historians of science and technology have a good deal of expertise on topics such as the nature of experiment, the "goodness" of research results, and the evaluation of technologies as successes or failures. Starting with these sorts of perspectives, I wish to see how perspectives from the histories of science and technology will contribute to new ways of thinking about the interactions and exchanges between artistic and engineering communities. I'm hoping that this essay might serve as an experiment in its own right—a sounding rocket, if you will—to explore these hybrid practices from a different vantage point and spark discussion about how the histories of technology, art, and science might better inform each other.

SEEING THE INVISIBLE TECHNICIAN

In June 1958, Frank J. Malina, an American living in Paris, requested patent protection for an invention he had made in France. Requesting a patent was nothing new for Malina. As one of the founders of Aerojet, a pioneering aerospace company, and then the Jet Propulsion Laboratory, Malina already had his name on several patents. This time, however, Malina's patent application was not about aerospace but art. Titled "Tableau d'aspect changeant"—the American version read "Lighted, Animated, and Everchanging Picture Arrangement"—it described the use of "illuminated stationary and movable transparent elements" that could "produce a pleasant and always changing composition of shapes and colors."[5]

A rocket engineer with degrees from Caltech, Malina had lived in Paris since 1947. His Aerojet stock, its value enhanced by Cold War tensions, gave him financial independence. In 1953, he began to transition from engineer to professional artist, a process further catalyzed by McCarthy-era harassment. A sketcher since boyhood, Malina quickly tired of the "nudes, flowers, landscapes, and dead fish" he found in Parisian galleries.[6] In 1955, he began

to experiment with electric light as a medium in conjunction with moving parts to produce electro-kinetic paintings. Eventually, he began to refer to the technique he developed as his "Lumidyne system." His patent application represents just one of the outcomes of his engineering/art experimentation.

I had long been familiar with Malina's work as an aerospace engineer. Doubtless, Malina's earlier career as an engineer had taught him the importance of protecting one's intellectual property. However, while examining his papers at the Library of Congress, I was startled to discover his attempts to patent his *aesthetic* experiments. Further archival digging revealed some reasons why he chose this path. At about the same time as he sought patent protection, Malina also launched a start-up company. Electra Lumidyne International was based in Paris. Malina's goal was to adapt his art system to create displays for shop windows and airport terminals. Despite some interest from General Electric in the early 1960s, the effort didn't pan out, and Malina closed the company a few years later.[7]

Moreover, as he was refining what became his Lumidyne system, Malina learned "around 1957" through a friend about the "lumia" works made by the Danish-born artist Thomas Wilfred.[8] Although he didn't have the opportunity to see one of Wilfred's works until 1959—Malina's passport was suspended by the State Department for much of the 1950s, rendering him unable to leave France—he could have sought out articles and other descriptions of them. The engineering-as-art techniques Wilfred developed well before World War II startled Malina with their similarity to his own work. Malina eventually learned of Wilfred's patents, and it's likely that this furthered his interest in seeking his own intellectual property protection.

Malina's experiences—this was several years before he founded the seminal art-science-technology journal *Leonardo*—offer us one instance of engineers' engagement with artists during "the long 1960s." This time period, from roughly 1957 until 1974, coincided with engineers' growing concerns about the changing nature of their profession and their complicity in helping build the modern technological world, with all of its promise and peril.[9] The diverse practices reflected in the artist-engineer collaborations of this era, as well as people's reactions to them, have to be understood in light of this era's optimism and ambivalence about technology.

A constructive unit of analysis for thinking about the hybrid practices found in artist-engineer collaborations is that of *technological communities*. By this, I mean an assembly of people larger than a lab group yet smaller than a professional society. Frequently interdisciplinary in its outlook and practice, a technological community is often oriented around a particular project, instrument, or technique. Such communities possess distinct forms of knowledge, expertise, and objectives, be they aesthetic or technical or both.[10] Narrowing the focus further, we can think of artists and engineers forming hybridized *techno-aesthetic* communities that stabilize, dissolve, or persist over time. My special interest in these techno-aesthetic communities is experiences and motivations of the often-unrecognized engineers and scientists—what one historian, in a different context, called "invisible technicians"—who were nonetheless essential to the collaboration.

As I began to explore the archives that document formal artist-engineer-scientist collaborations—E.A.T., LACMA's Art and Technology program, and so forth—I started to notice more and more ventures like Frank Malina's—experiments not just in art but in entrepreneurship. Maybe this isn't surprising—why *shouldn't* artists or musicians try to patent or commercialize their ideas just as engineers do? But these activities suggested a framework in which to consider the intersections of the artists and engineers who made up these techno-aesthetic communities. One way to approach the question of mutual engagement is to be aware of shared practices. Direct engagement with the marketplace as evidenced by commercialization and patenting is one such practice.[11]

Actors from this period used some curious words to describe these interactions. One term, ominous given the era's thermonuclear threats, alluded to the technological fruits one might gather if the tree of artist-engineer collaborations was shaken—*fallout*. At a speech in 1966, some months before he cofounded E.A.T., Bell Telephone Laboratories engineer Billy Klüver observed that for too long "art has only been interested in the fallout . . . of science and technology."[12] Artists, in other words, had benefited from the research done by engineers and scientists. However, after *9 Evenings: Theatre & Engineering* debuted in October 1966, Klüver reversed the equation. Now he highlighted the "technical 'fallout'" that artist-engineer collaborations could generate.[13] In the words of John R. Pierce, Klüver's boss and a research director of communication sciences at Bell Labs, it was now industry's turn "to gain from the arts." Pierce noted that artist-engineer collaborations weren't just about burnishing the "public image" of corporations but extended toward imagining "new products." E.A.T. cofounder and fellow Bell Labs engineer Fred Waldhauer expressed similar thoughts, calling artists an "underdeveloped resource." The main payoff for industry would be "new ways of looking at and doing things."[14] Likewise, on the West Coast, LACMA curator Maurice Tuchman predicted that "collaborating personnel" (i.e., engineers and other technicians working with artists) could "gain experience directly valuable to the corporation."[15]

Another term—*spinoff*—that was part of the vernacular in the 1960s also speaks to the commercialization of the artist-engineer nexus. Popularized as larger corporate entities gave rise to new smaller companies, it soon became associated with the space race. For example, in 1962, NASA's head, James E. Webb, lauded the "spinoff benefits" that the Apollo program would generate for the American economy and society.[16] New business enterprises offered one such spinoff. Together, *fallout* and *spinoff*, two linguistic products of the Cold War, reflected some of the aims expressed by the art and technology movement and its supporters. Engineers could help introduce artists to the possibilities, processes, and products of modern industry while the experimental collaborations that resulted might prove profitable.[17]

This essay considers, using two examples, how the hybrid practices of the art and technology movement encountered the market, produced patents, and catalyzed the creation of new companies. Issues such as industrial sponsorship, funding sources, commercialization, and intellectual property have long engaged the attention of historians of modern science, while art historians have thoroughly investigated questions of patronage. My

metapoint here is that practitioners' direct engagement with industry and the marketplace offers a useful vehicle for understanding collaborations between artists and engineers in the long 1960s. At the same time, it also suggests a patch of common ground for historians of art and science.

"ALL WE DID WAS SELL A CLOUD . . ."

Both examples explored here have a common origin—E.A.T.'s commitment to building a multimedia experimental art environment for PepsiCo as part of the Expo '70 fair in Osaka. Better known simply as the Pavilion, this was the apogee of the era's art and technology movement.[18] For the Pavilion building itself, Klüver and his E.A.T. colleagues had inherited an architectural design they disliked: a crumpled, false-geodesic dome.[19] Displeased with its appearance, they felt that the next best alternative was to try to artfully conceal it. To realize the effect of a "pavilion that could disappear," Klüver turned to Japanese artist Fujiko Nakaya.[20]

Born in Sapporo, Nakaya was the daughter of Japanese physicist Ukichiro Nakaya. During the mid-twentieth century, the elder Nakaya achieved prominence for his scientific investigations of snow. His research blended careful laboratory experiments in which he made artificial snowflakes with an aesthetic sensibility toward classifying their structure.[21] His daughter Fujiko came to the United States in the late 1950s to attend Northwestern University. She went on to study at the Sorbonne, where her interest was initially painting—she was especially fond of capturing the look of clouds. Around 1966, she met Klüver when she participated in the *9 Evenings* show. For the Osaka exhibition, besides handling logistics and smoothing over Japanese-American interactions, she designed the remarkable fog sculpture that would surround the building.[22]

For aesthetic as well as safety reasons, Nakaya insisted the fog be generated using pure water instead of some type of chemical.[23] Producing fog from pure water isn't easy, however. In nature, fog can occur when the temperature drops until the air is saturated with water and droplets condense. This could be done by dramatically cooling the Pavilion's roof. Another way to generate fog would be to heat water, which, when surrounded by cooler air, condenses. This is what gives rise to the fog that forms on a cold morning over a warm body of water. Both of these approaches, however, would require huge amounts of energy. But there was a third method. Fog can also be made by atomizing water—basically spraying tiny droplets of water into the atmosphere. In 1969, Nakaya learned of a scientist based near Pasadena who might be able to do this on the scale she wanted.

Thomas R. Mee was born in 1931 and grew up in Louisiana, where he received a bachelor's degree in physics. After a short stint as a naval aviator, he returned to Louisiana State University in 1957 for an advanced degree in physics. He was especially interested in oceanography and atmospheric science. Three years later, the Cornell Aeronautical Laboratory recruited him to work on a variety of projects related to weather modification.[24] In 1964, he accepted a research position at Meteorological Research Inc., a small company based in nearby Altadena, where he continued investigating ways to modify and control

meteorological phenomena.[25] In 1969, Mee set out to start his own company, initially planning to make niche instrumentation for weather and pollution studies.

For several months in early 1969, Nakaya collected weather data at the Osaka site and carried out fog-generating experiments in Japan. Unsatisfied with her results, in June Nakaya contacted Mee at his brand-new company, Mee Industries Inc. He had never heard of E.A.T. but was "impressed by her knowledge of cloud physics." Moreover, he had met Nakaya's father at scientific conferences and was well aware of his snow research.

Mee was initially skeptical about generating enough fog to create an environmental sculpture that would envelop the entire 120-foot diameter Pavilion. But he agreed to experiment with Nakaya on a method to spray pure water under high pressure through very narrow nozzles and produce dense clouds of tiny water droplets. Mee took into consideration Nakaya's aesthetic preference for a "dense, bubbling out fog . . . [something] to walk in, to feel and smell, and disappear in."[26] A few months later, she and Mee met again and set up the equipment in his Altadena backyard. The heart of Mee's system consisted of stainless steel nozzles with openings about 160 microns wide (1 micron is a millionth of a meter). Pumps moved water through the system and kept it compressed at high pressure throughout a network of copper lines. At the tip of each nozzle was a tiny pin that broke up the water into an ultrafine cloud of water particles and created, to Mee and Nakaya's delight, a large cloud of fog that partially obscured Mee's house when they first tested it.

Wind-tunnel tests with a scale model of the Pavilion building followed to optimize placement of the system on the building's roof. In March 1970, Mee met Nakaya in Osaka to help supervise installation of a full-scale system. Ultimately, 2,520 of Mee's specially crafted nozzles atomizing some eleven thousand gallons of water an hour could enshroud the entire Pavilion in an ever-changing fog sculpture. The pure white fog that Mee's system generated poured down over the structure's irregularly angled and faceted roof and out over the fairground. A control system allowed Nakaya to vary its density, with wind and humidity further varying the effect.

Nakaya and Mee's fog became the Pavilion's most visually striking exterior feature, the "symbolic guide" to the entire concept of the Pavilion.[27] One Pepsi executive observed that the "quietness, the fog around the dome" was "like the cloud that hovers near the top of Fujiyama."[28] Others more familiar with art history might have drawn comparisons to the mist and clouds commonly found in pre-eighteenth-century Japanese landscape paintings.

Mee had originally planned for his nascent company to make instrumentation for meteorological applications. However, his collaboration with Nakaya and the success of the Osaka system prompted him to think about other directions. The era's utopian and ecological leanings also drove Mee's interest in commercializing his fog system. As he told one interviewer in December 1969, "I'm totally involved in this environmental thing now. . . . It opens up a possibility of farming the desert, literally."[29] Nilo Lindgren, a writer from *IEEE Spectrum* who was documenting the Pavilion collaboration, asked Mee if he had signed away his patent rights to Pepsi. Mee brushed the concern aside, stating that "all we did was sell a cloud." Meanwhile, he said, "some attorneys" were exploring whether he had a "pat-

entable product."[30] After Expo '70 ended, Mee filed for patent protection to cover an "Environmental Control Method and Apparatus" derived from his Pavilion work.[31] The system, he imagined, had many possible uses. His patent application cited the possibility of using it for agricultural purposes, either for cooling farm areas or for preventing frost, as well as for producing a "visible cloud" that gave a "highly decorative and entertaining effect."[32]

Artist Nakaya also pursued protection for her intellectual property. In the late 1980s, she applied for a patent in Japan covering a "system/apparatus for making a cloud sculpture from water-fog." But whereas Mee's interests were directed toward his commercial interests, Nakaya was more interested in having the patent serve as a record of her experimental techniques. As she later explained, this was an opportunity to describe and define the "seemingly amorphous fog sculpture in the hardest language of law." She worked with a Japanese scientist and a patent lawyer from Sony to develop language that would express "the structure and physical properties of this visually ephemeral phenomenon."[33] Unlike Mee, Nakaya never realized any profit from her patent.

Mee's patents directly resulted from his collaboration with Fujiko Nakaya. In 1971, Mee took his small company public and moved his manufacturing operations from his garage to a larger building in San Gabriel, employing some thirty people. By 1985, sales by Mee Industries were approaching $2 million. After some rough financial times, the company rebounded when Mee's children took over the business and secured a controlling interest in the firm. Originally providing equipment for environmental applications, the company saw a big expansion in 1997 when the Tennessee Valley Authority decided to install fog systems on its electric power turbines to improve their efficiency. Similar orders followed, and the company expanded into other areas such as providing cooling for data server installations. By 2014, some eighty people worked for the company and sales were over $10 million annually.[34]

Even as his company gradually grew, Thomas Mee continued his collaborations with Nakaya. These interactions continued after his death in 1998. Mee Industries contributed hardware to installations Nakaya designed for sites like the Guggenheim Museum in Bilbao. More recently, her *Fog Bridge* was integrated into the new site for the Exploratorium in San Francisco. Although most of the company's hardware was used for industrial purposes, Nakaya's environmental sculptures allowed "millions of people around the world to appreciate fog's natural beauty" and perhaps sense what the many visitors to the Pavilion had once experienced.[35]

"THE VISUAL ART OF THE FUTURE"

Although Klüver and E.A.T. were based in New York City, a good deal of the work that went into making the Pavilion a reality happened in Los Angeles, where there was a strong local E.A.T. chapter. One of its most active members was Elsa M. Garmire. Originally trained at MIT, where she received her doctorate in physics, she moved to California in 1966 for a postdoctoral position at Caltech. Caring for two young children and unimpressed by the school's treatment of women faculty, Garmire began to consider other career paths. The possibility of using technology "in a non-logical, artistic way" intrigued her, and, in the

summer of 1968 she approached E.A.T. about serving as the "part-time technical director" for the group's West Coast efforts.[36] Klüver, impressed by her research credentials and enthusiasm, invited her to participate in a panel on art and science at the American Association for the Advancement of Science's annual meeting. Over the next several months, Garmire also became increasingly involved with E.A.T.'s Pavilion project.

Garmire's research specialty—like Klüver's—was laser physics. The first optical laser had been demonstrated only in 1960. Garmire's adviser at MIT was Charles H. Townes, who shared the 1964 Nobel for research leading to the invention of the laser. When she arrived at Caltech, lasers were still expensive, delicate, laboratory-based devices that required experts to build and operate. Working with lasers in the 1960s was cutting-edge science that had a hint of glamour and a high-tech futuristic sheen.[37] Press releases and newspaper articles about Klüver, for example, often highlighted his field of expertise at Bell Labs.[38] The relative novelty of the laser, Garmire's position as a woman in a male-dominated field, and the high visibility of her graduate adviser all put her in a unique position circa 1968 when E.A.T.'s involvement with the Pavilion got started.

An active member of the E.A.T. branch in Los Angeles, Garmire organized a "Cybernetic Moon Landing Celebration" in mid-July 1969 at Caltech.[39] In addition to dance performances and multimedia demonstrations, Garmire helped build a "laser wall" in which a low-power argon laser beam was spread out into multiple lines of color that people could walk through.[40] A broader goal of the festival was to directly involve the "industrial community in the collaborative process of art and technology."[41] A short piece Garmire wrote for her local E.A.T. chapter's newsletter expresses her thoughts on the relationship between technology and art. "Technological art," she explained, "is the first step toward eliminating this divinity of technological wonders.... The technological artist approaches and utilizes the incomprehensible for his own ends in ways often irrelevant to the original 'purpose' of the device."[42] Her modification of the laser for artistic purposes was an extension of this idea.

For the Pepsi Pavilion, Garmire's main contribution was helping design the giant spherical mirror that nestled inside the building's crumpled exterior. Besides helping oversee its construction and testing in California, she traveled to Japan to oversee its installation.[43] Back in Pasadena, though, she was becoming more interested in lasers as an artistic medium. Initially, Garmire created what she called "lasergrams"—photographs of images made by shining blue and red laser lights through diffraction media. A variation on this was a live laser show she made using a helium-neon laser, which produced a red beam of light, and rotating diffraction wheels. Caltech's public relations department stirred up attention for her artwork. Unfortunately, the San Fernando earthquake of February 1971 overshadowed Garmire's opening at a local gallery and also damaged some of her pieces.

However, Garmire's live laser show—she displayed it at a conference on art and technology at the University of Southern California in May 1970—caught the attention of Ivan Dryer. A Los Angeles–based filmmaker, Dryer was also an "astronomy freak" but one more interested in the "mystiques of space ... not the mechanics of it."[44] Before moving into the film industry, Dryer also worked as a guide at Griffith Observatory in Los Angeles. After see-

ing Garmire's presentation, Dryer and his colleague Dale Pelton visited her Caltech lab and filmed the "marvelous shapes and forms" that Garmire's laser system generated.[45]

Dryer soon realized that filming Garmire's laser images was aesthetically inferior to seeing the intensity and purity of their colors in person. In the fall of 1970, he arranged for a live and—to his eyes—captivating demonstration of Garmire's system, accompanied by classical music, for Griffith staff in the observatory's planetarium dome. The observatory management—seeing entertainment, not education—was less enchanted. Undaunted, Dryer, Pelton, and Garmire cofounded a company in February 1971 called Laser Images Inc. Riffing on the popularity of planetarium shows, they called their product "Laserium."[46]

For the next few years, Dryer and Garmire worked intermittently to perfect their laser show and attract interest. A representative from Spectra-Physics, a Southern California company that made some of the first commercial lasers, loaned them a krypton laser system that could produce multiple colors.[47] In June 1973, they invited Griffith Observatory's new director, William Kaufmann III, to see an improved demonstration. Kauffmann, then in his early thirties, had a more liberal view of what the public might want to see at the observatory, and he arranged for Dryer and McDonald to have access to the planetarium dome.

In mid-November 1973, spurred by Dryer's appearance on a morning television show, some seven hundred people showed up at Griffith for the debut of what became known simply as Laserium. Classical music and art rock provided the soundtrack for watching multicolor laser images projected in real time on the planetarium's starry background. For a few dollars, attendees received a stimulating audio and visual experience. For many of them, it was likely the first time they had seen a laser's light effects. With its multisensory nature, one might compare Laserium to other projects like Stan VanDerBeek's earlier experiments with his Movie-Drome.[48] VanDerBeek had a loose affiliation with E.A.T. and even gave a presentation of his work to artists and engineers in 1968.[49] While no evidence in the historical record suggests that Garmire and company were aware of his work, we might think of Laserium and Movie-Drome as parallel attempts to create a multimedia experience for an audience.

After Laserium's debut, word of mouth helped expand the audience, and, by the time the initial four-week engagement ended, hundreds of people were being turned away for laser shows at Griffith. A year after it opened, Los Angeles's mayor proclaimed "Laserium month."[50] Around this time, Garmire began shifting her creative energies back to science and left Laser Images Inc. amicably. Before doing this, however, Garmire contributed technical input and imagery to a short film, filled with "hallucinogenic visuals," that Pelton created called *Death of the Red Planet*.[51] After leaving Caltech and overcoming the sexism young women scientists encountered, Garmire went on to have a very successful scientific career in laser science and physics at the University of Southern California (1974) and then Dartmouth College (1995), eventually becoming a dean of engineering at Dartmouth and president of the Optical Society of America.

By 1977, Dryer's growing team of live laser performers was putting on shows in more than fifteen cities and Laserium was a registered trademark. After starting with custom-designed

equipment, eventually Dryer and his colleagues based Laserium around a standard system. The details of this are preserved in the patent application Dryer and two colleagues filed in July 1975. It described a "laser light image generator" that can create a "plurality of light images in different colors from a single laser light."[52] The heart of the system was a one-watt krypton gas laser that would be split by prisms into four colors. Other optics, scanners, and oscillators allowed for rapid image movement, closed linear shapes, Lissajous figures, and so on. An operator sat at a console where she could access the variety of switches and joysticks used play the laser "instrument." A four-track tape deck had music in stereo as well as audio for the show's introduction and narration synched to the visuals. For new operators, a "teach track" could help them learn the system and the best timing for performances. The basic format of each show was preprogrammed by the "laserist," but this person had considerable opportunity to vary and change the tempo and image sequences. Since Laserium shows were live performances, their quality, as well as the audience's response, depended on the skill and imagination of the system operator.

Laserium represents an extreme form of commercialization that began with Elsa Garmire's involvement with E.A.T. and her personal desire to connect her scientific research to art and aesthetics. Just as planetarium shows helped popularize astronomy in the twentieth century, Laserium can be interpreted as a public display of laser technology, its roots traceable back to nineteenth-century displays of electricity and electrical effects.[53] Unconventional to be sure, Laserium was not without some aesthetic admirers. One art writer, for example, referred to experiments with laser projection as the "seeds of what will become the high, universally acclaimed visual art of the future."[54] Given Laserium's penchant for attracting attendees whose appreciation of choreographed laser light was chemically enhanced, "high" visual art assumes another meaning as well.

After peaking in the late 1970s, when some seventy people worked for the company, Laserium slowly faded in popularity.[55] Often lampooned as the preferred entertainment of potheads and LSD trippers, Laserium can be understood as the somewhat disreputable cousin of the venerable planetarium show.[56] Nonetheless, by 2002, some twenty million people around the world had seen a Laserium show—its run at Griffith lasted some twenty-eight years—and its idiosyncratic blend of music and spectacle had become part of popular culture. Was Laserium art?[57] It's debatable but not germane to the argument here. While maybe not quite the "technical fallout" that laser scientist Klüver had imagined, Laserium, like Mee's fog, was a commercially successful result from the productive artist-engineer collaborations of the late 1960s.

IS ART WHAT ARTISTS DO?

Like engineers and scientists, artists in the 1960s struggled to fathom societal changes catalyzed by new, more pervasive, and more powerful technologies.[58] Both communities were repositioning and redefining themselves in the midst of great technological change as well as reevaluating their place in society and their relevance to it. Like their engineering counterparts, they looked to writers like Lewis Mumford, Jacques Ellul, Herbert Marcuse,

C.P. Snow, and Thomas Kuhn for ideas, critiques, and explanations. And, like engineers, artists in the 1960s faced the opportunity and challenge of satisfying new patrons with their work. Corporate sponsors, state arts programs, and the federal government all helped create a "new paradigm" for funding, making, and collecting art.[59] E.A.T. and LACMA's A&T program both stand out as formal efforts to link artists not just to engineers but also to corporate sponsors.

Since the 1980s, historians of science have developed a robust historiography that explores the relationships between scientists, engineers, and the patrons—military, industrial, governmental, and academic—that supported so much of their work. A classic perspective on this relation, familiar to historians of science but perhaps not of art, was formulated by Paul Forman in the 1980s as the Cold War newly intensified. Refined, affirmed, and occasionally challenged by scores of scholars since, Forman's argument was that the Cold War distorted the very nature of technical and scientific knowledge that researchers produced. Scientists and engineers increasingly oriented their research and projects to conform with the interests of their patrons. As Forman provocatively claimed, scientists lost control of their disciplines, sacrificed autonomy, and made ethical and intellectual compromises.[60] Those scientists and engineers who maintained otherwise were self-deluded.[61]

We can find parallels to this historical interpretation in the contemporaneous negative reactions of art critics to both artist-engineer collaborations and the corporate sponsorship that underwrote the art and technology movement in general.[62] Articles in major art magazines excoriated, as one vociferous critic labeled it, the "multimillion dollar art boondoggle" that this "experiment in patronage" had produced.[63] While this invective focused specifically on LACMA's A&T program, it spilled over to stain artist-engineer collaborations in general.

In these critiques, if not outright condemnations, of partnerships underwritten by corporate patrons, one detects a sense that writers lamented a loss of purity on the part of the artist. At the very least, writers like David Antin, Amy Goldin, and Max Kozloff described artists as morally and aesthetically compromised by their encounters with engineers and the corporate world. Kozloff, in the heated language common to the Vietnam protest era, charged artists with not hesitating "to freeload at the trough of that techno-fascism that had inspired them." Abetted by their engineer collaborators, artists were nothing but "would-be magi, con-men, fledgling technocrats, acting out mad science fiction fantasies."[64] What resulted, in other words, was impure art.

Historians of science have devoted much attention to the question of "pure science"—the illusory idea that certain research might be free of commercial interest, corporate sponsorship, military ties, or even practical applications.[65] "Pure science" is primarily an actors' category, not a fixed historical entity. But, while art critics of the early 1970s were not so naive as to speak of "pure art," when we look past the florid language, critiques about art and technology around 1971 bear more than a passing resemblance to Forman's thesis. Just as historians castigated certain forms of Cold War science, critics and artists asked whether art was being diverted from a truer, purer path by corporate patrons and their engineer

employees. Of course, this interpretation is limited by the assumption that there is some *natural* path that science in its pursuit of Truth, or Art in its pursuit of Beauty, should develop along.

But there were, of course, other ways of reading the evidence that Forman and others used to buttress their Cold War–driven "distortion thesis." Daniel J. Kevles, then a historian at Caltech, rejected claims that military largesse and patronage had somehow "seduced" researchers. Alliances that new patrons and accommodation of military needs gave scientists expanded opportunities and opened new research paths. Kevles came to the somewhat opaque conclusion that "physics is what physicists do."[66] Given that artist-engineer collaborations blossomed in the same Cold War environment that yielded missiles, MIRVs, transistors, and Telstar, perhaps we could make the symmetrical claim that "art is what artists and their engineer collaborators did."[67]

Artists collaborated with engineers and accepted corporate patronage with open eyes; they were neither duped or deluded. Moreover, the partnerships with industry that LACMA and E.A.T. encouraged *did* offer artists new opportunities and access to new technologies. Instead of thinking about concepts like purity and distortion, maybe one can ask a different question—does the *history* of a particular technology (such as lasers, computers, artificial fog) matter for how we think about the *artistic* ends it was used for?[68]

Frank Malina's short-lived Electra Lumidyne International, Mee Industries, and Laser Images Inc. are just three instances where the intermingling of art and engineering led to the marketplace. Examples like these—and there are many more—offer potentially valuable entry points for exploring the mutual interests that artists and engineers shared.[69] In these commercial activities, we also find the planting of seeds that would flower into a new "third culture" of even more market-minded hybrid artist/technologists in the late 1980s and 1990s.[70] Then and now, the desirable outcomes of fallout and spinoff helped drive art-technology collaborations and inspire the formation of new techno-aesthetic communities.

NOTES

I've benefited from suggestions by Michael D. Gordin, Anne Collins Goodyear, Douglas Kahn, and Roger Malina. I would also like to thank the organizers and sponsors of the Hybrid Practices conference for inviting me to the conversation.

1. Charles Percy Snow, *The Two Cultures and a Second Look* (Cambridge: Cambridge University Press, 1969).

2. See, for example, ideas presented at "Stem to Steam," n.d., accessed June 2015, http://stemtosteam.org/.

3. Steven Shapin, "The Invisible Technician," *American Scientist* 77 (1989): 554–63. For example, when critic Barbara Rose—who was generally sympathetic to art-technology collaborations—wrote about artist Robert Whitman's work in 1974, she neglected any mention of Whitman's frequent collaborator, engineer John F. Forkner; Barbara Rose, "Considering Robert Whitman," in *Projected Images: Peter Campus, Rockne Krebs, Paul Sharits, Michael Snow, Ted Victoria, Robert Whitman* (Minneapolis: Walker Art Center, 1974), 38–45.

4. Edward A. Shanken, "Historicizing Art and Technology: Forging a Method and Firing a Canon," in *MediaArtHistories,* ed. Oliver Grau (Cambridge, MA: MIT Press, 2007), 43–70.

5. Quotes from the US version. Malina received the French patent on June 29, 1959. Malina also applied for and received similar legal protection in the United States (requested on December 11, 1961; received December 15, 1964) and the United Kingdom (received 1962) as well. Folder 6, box 41, Frank J. Malina Papers (MSS61793), Manuscript Division, Library of Congress, Washington, DC (hereafter, FJM).

6. Frank J. Malina, "Electric Light as a Medium in the Visual Fine Arts: A Memoir," *Leonardo* 8, no. 2 (Spring 1975): 109–19.

7. Malina's correspondence shows that he was starting to think about founding the company around October 1958; folder 13, box 22, FJM; see also Malina, "Electric Light," 115–17.

8. Malina to Martin Summerfield, May 25, 1962, folder 7, box 39, FJM.

9. Matthew Wisnioski, *Engineers for Change: Competing Visions of Technology in 1960s America* (Cambridge, MA: MIT Press, 2012).

10. Ann Johnson, "Revisiting Technology as Knowledge," *Perspectives on Science* 13, no. 4 (Winter 2005): 554–73.

11. A corollary to this, although beyond the scope of this essay, is the question of how the art market and patronage opportunities for artists were themselves changing in this period.

12. Billy Klüver, "The Great Northeastern Power Failure," talk given January 28, 1966, Experiments in Art and Technology, 1966–77 collection, Archives of American Art, Smithsonian Institution (hereafter E.A.T./AAA).

13. Billy Klüver to E.A.T. board members with general note to E.A.T. members, Billy Klüver, "Interface: Artist/Engineer," talk presented at MIT, April 21, 1967, and Billy Klüver, "Theatre and Engineering: An Experiment. 2. Notes by an Engineer," *Artforum* 5, no. 6 (February 1967): 31–33, all in E.A.T./AAA. In the introduction for the *9 Evenings* program that accompanied the show, Klüver, in discussing the show's equipment, noted "commercial potential of discoveries made as a result of its development."

14. John Pierce, statement, n.d. but ca. early 1967, folder 18, box 4, Experiments in Art and Technology Records, Getty Research Institute, Los Angeles (hereafter E.A.T./Getty). Also, Fred Waldhauer to Emmanuel Piore, draft letter, June 12, 1967, folder 18, box 4, E.A.T./Getty.

15. The language appeared in the original promotional brochure for the LACMA program that was distributed to industry executives; the excerpt from this is on p. 11 of Maurice Tuchman's *Art and Technology: A Report on the Art and Technology Program of the Los Angeles County Museum of Art, 1967–1971* (New York: Viking Press, 1971). However, even as artists were seen as new sources of corporate creativity, with the supposed benefits of artist-engineer collaborations flowing in both directions, according to E.A.T.'s policy at least, any "patents and commercial ideas" would still "belong to the industrial laboratory." *E.A.T. News* 1, no. 1 (1967): 2, folder 6, box 138, E.A.T./Getty.

16. James E. Webb, "The Role of Government in Scientific Exploration," in "Proceedings of the Second National Conference on the Peaceful Uses of Space, May 8–10, 1962," 21, NASA Technical Report, https://ntrs.nasa.gov/search.jsp?R=19630001263. In that same year, NASA started an "Industrial Applications Program," later renamed the NASA Technology Utilization Program. Its goal was

to "increase the return on national investment in aerospace research" by encouraging "additional use" of the knowledge and experience gained. In 1976, the reports from this program were named *Spinoff.*

17. Christopher R. De Fay, "Art, Enterprise, and Collaboration: Richard Serra, Robert Irwin, James Turrell, and Claes Oldenburg at the Art and Technology Program of the Los Angeles County Museum of Art, 1967–1971" (PhD diss., University of Michigan, 2005).

18. The Pavilion's history—its origins in 1967, the effort by scores of E.A.T.-coordinated artists and engineers to build it, its debut in March 1970, and its ignominious denouement when Pepsi terminated its relationship with E.A.T. just weeks later—is preserved in several boxes at the Getty Research Institute and is well documented by art historians. Three key references are Billy Klüver, Julie Martin, and Barbara Rose, *Pavilion* (New York: E.P. Dutton, 1972); Norma Loewen, "Experiments in Art and Technology: A Descriptive History of the Organization" (PhD diss., New York University, 1975); and Anne Collins Goodyear, "The Relationship of Art to Science and Technology in the United States, 1957–91: Five Case Studies" (PhD. diss., University of Texas at Austin, 2002).

19. Frosty Meyers, interview by Nilo Lindgren, December 4, 1969, box 140, E.A.T./Getty.

20. John Pearce, "An Architect's View," in Klüver, Martin, and Rose, *Pavilion*, 256.

21. Snowflakes, he wrote, were "hieroglyphs sent from the sky." The quote comes from the September 1962 obituary of Nakaya in *Arctic*. See also Ukichiro Nakaya, *Snow Crystals: Natural and Artificial* (Cambridge, MA: Harvard University Press, 1954).

22. Anne-Marie Duguet, ed., *Fujiko Nakaya—Fog* (Paris: Éditions Anarchive, 2012).

23. Dry ice, for example, was considered but was ruled out by the Expo Association's Health Department on the grounds that the excess CO_2 produced would attract mosquitoes to the fair grounds. Fujiko Nakaya, "Making of 'Fog' or Low-Hanging Stratus Clouds," in Klüver, Martin, and Rose, *Pavilion*, 207–23. Also, Marina McDougall, "Learning to Love the Fog," in Exploratorium, *Over the Water: Fujiko Nakaya* (San Francisco: Exploratorium, 2013), 8–19.

24. A number of these projects were funded by the Department of Defense; these included Project Whiteout, an army-funded effort in the early 1960s to see if it was possible to dissipate blizzard whiteouts in Arctic conditions.

25. This company was started in 1951 by Paul MacCready (1925–2007), a Caltech graduate who later became famous for designing and building the Gossamer Condor, a human-powered aircraft. MacCready later started another company, AeroVironment, which today is one of the largest manufacturers of unmanned aerial vehicles ("drones").

26. Nakaya's experimental approach is well documented in her "Making of 'Fog'" essay. Also, see Nilo Lindgren's essay "Into the Collaboration" in Klüver, Martin, and Rose, *Pavilion*, 40–48.

27. Pearce, "Architect's View," 257.

28. Lindgren, "Into the Collaboration," 48.

29. Tom Mee Jr., interview by Nilo Lindgren, December 10, 1969, folder 5, box 140, E.A.T./Getty.

30. Ibid.

31. Thomas R. Mee, "Environmental Control Method and Apparatus," US Patent 3,788,542, filed December 31, 1970, issued January 29, 1974.

32. Thomas R. Mee, "Nozzle for Producing Small Droplets of Controlled Size," US Patent 3,894,691, filed January 7, 1974, issued July 15, 1975. In 1974, when his initial patent was awarded, Mee applied for another to specifically cover the design of his system's nozzles.

33. Fujiko Nakaya to author, pers. comm., December 12, 2014. Nakaya noted that she had considered applying for a US patent but had found the process too expensive.

34. "The Histories of Mee Industries Inc.," unpublished document, n.d., in author's personal files; Brian Keppel, "Cools, Humidifies: Tom Mee's Fog Machine Winning Place on the Farm," *Los Angeles Times,* May 2, 1985, H1; D'Arcy Sloan to author, pers. comm., November 11, 2014.

35. Mee Industries Inc., *MeeFog™ Sculpture Welcomes Visitors to New San Francisco Exploratorium*, 2013 promotional brochure, 2013, www.meefog.com/wp-content/uploads/Exploratorium_Web-2.pdf.

36. Else Garmire, "Resume," July 1968, folder 14, box 124, E.A.T./Getty.

37. This was an abrupt change for optical science, a field of physics that before the laser had been relatively moribund. Joan Lisa Bromberg, *The Laser in America, 1950–1970* (Cambridge, MA: MIT Press, 1991).

38. The very first article about Klüver in the *New York Times* described how, "hunched over a big aluminum table, he does modulation experiments with lasers"; Grace Glueck, "Scientist Brings Art to His Work," *New York Times,* December 17, 1965, 48.

39. Materials on the Moon Landing Celebration are in folders 12 and 13, box 29, E.A.T./Getty.

40. Elsa Garmire, "Elsa Garmire and Art," unpublished document, August 2013, copy in author's personal papers.

41. "E.A.T. Report 1970: Los Angeles," September 18, 1970, folder "Documents 6/1/70–5/30/71," E.A.T./AAA.

42. Elsa Garmire, "Art and Technology: Ruminations of an Engineer," *E.A.T.L.A.*, no. 1 (January 1970): 5.

43. Garmire also wrote an excellent technical overview of the entire Pavilion; this essay appeared in Klüver, Martin, and Rose, *Pavilion*, 173–206.

44. "It's 2001 and a 'Drugless High' as Ivan Dryer Sets Laser Beams to Music," *People,* January 26, 1976, www.people.com/people/archive/article/0,,20066089,00.html.

45. Ivan Dryer, "Applications Pioneer Interview: Ivan Dryer," *Laser and Applications,* October 1986, 53–58.

46. The idea of live laser shows did not originate with Dryer et al. Lowell Cross, a multimedia artist, claims to have performed the first "public multi-color laser light show" in May 1969 at Mills College. Cross would go on to collaborate with Berkeley physicist Carson D. Jeffries and composer David Tudor to create a laser light show for the Pepsi Pavilion; see Lowell Cross, "The Laser Systems: Timeline," 2005, www.lowellcross.com/timeline/laser/, as well as material in Klüver, Martin, and Rose, *Pavilion*.

47. Dryer, "Applications Pioneer Interview," 54. For spectra-physics, see Bromberg, *Laser in America*, 119–21.

48. Gloria Sutton, *The Experience Machine: Stan VanDerBeek's Movie-Drome and Expanded Cinema* (Cambridge, MA: MIT Press, 2015).

49. Box 128 of E.A.T./Getty contains materials for this and the other technical presentations the organization sponsored.

50. "Mayor Proclaims 'Laserium Month,'" *Los Angeles Times,* December 25, 1974, F17.

51. Dale Pelton, "'Death of the Red Planet' Filmed in Laser Images," *American Cinematographer* 54, no. 7 (July 1973): 842–43, 902.

52. Dan Slater, Ivan M. Dryer, and Charles W. McDonald, "Laser Light Image Generator," U.S. Patent 4,006,970, filed July 14, 1975, issued February 8, 1977.

53. Iwan Rhys Morus, *Frankenstein's Children: Electricity, Exhibition, and Experiment in Early-Nineteenth Century London* (Princeton, NJ: Princeton University Press, 1998); Jordan D. Marché, *Theatres of Time and Space: American Planetaria, 1930–1970* (New Brunswick, NJ: Rutgers University Press, 2005).

54. Andrew Kagan, "Laserium: New Light on an Ancient Vision," *Arts Magazine,* March 1978, n.p., www.laserium.com/laserium_origins/pr-ArtsMagazine197803.pdf. This article describes Laserium with references to Thomas Wilfred's Lumia works, Moholy-Nagy's light-based art, and so forth.

55. The figure of seventy people comes from a 1975 brochure, *Experience Laserium: The Cosmic Light Concert,* copy in author's possession.

56. A point acknowledged on the Web page of the Laserium company, www.laserium.com/culture/index.html (accessed December 15, 2014).

57. Brian Wirthlin, one of the early operators of Laserium, wrote in 2002: "The term Laserist used to bother me. Laser Artist, how pretentious can you be? It was just technology—wasn't it? I loved Laserium, but it wasn't Art. I mean Art is . . . well of course I mean Real Art, not some modern self indulgent crap . . . but on the other hand, I've seen self-indulgent crappy Laser Shows. . . . They definitely weren't Art. . . . Of course the first Laserium Show's technology was lightyears (pardon the pun) behind even Laserium II, but I'd travel to see it again . . . Hell what is Art anyway?" Brian Wirthlin, "Digital Graphics and Laserium Remembrances," post to Laserist List mailing list, July 9, 2002, www.famous-company.com/pm_laseristlist-histories.htm#bw_digital-laserium. While Laserium was certainly a pop application of laser light for entertainment purposes, there were several "serious" efforts to make laser-based art in the 1960s and 1970s, including notable work by artist Rockne Krebs that LACMA featured in its 1971 Art and Technology show. According to the 1971 catalog, at least four other artists considered using lasers in some fashion, and, of course, lasers were central to the emerging art form of holography.

58. Wisnioski, *Engineers for Change*; Kelly Moore, *Disrupting Science: Social Movements, American Scientists, and the Politics of the Military, 1945–1975* (Princeton, NJ: Princeton University Press, 2008).

59. Discussed in De Fay, "Art, Enterprise, and Collaboration," 64–66; see also chap. 2 of Mark W. Rectanus, *Culture Incorporated: Museums, Artists, and Corporate Sponsorship* (Minneapolis: University of Minnesota Press, 2002).

60. This argument is stated in Paul Forman, "Behind Quantum Electronics: National Security as Basis for Physical Research in the United States, 1940–1960," *Historical Studies in the Physical and Biological Sciences* 18, no. 1 (1987): 149–229.

61. There is some ironic symmetry here. In a 1992 article, Forman also decried scientists' efforts to pursue patents and commercialization in the postwar era. The object of his opprobrium was Charles Townes, Elsa Garmire's adviser and a co-inventor of the laser. Paul Forman, "Inventing the Maser in Postwar America," *Osiris* 7, no. 1 (1992): 105–34.

62. Some historical context for this backlash appears in Goodyear's "Relationship of Art," but there is room for further examination.

63. Max Kozloff, "The Multimillion Dollar Art Boondoggle," *Artforum* 10, no. 2 (October 1971): 72–76. Critics' reaction is well covered in chap. 6 of Goodyear, "Relationship of Art."

64. Kozloff, "Multimillion Dollar Art Boondoggle." One wonders, however, to what degree these critiques were aimed specifically against artist-engineer collaborations and to what degree they served more as proxies for larger critiques of corporate power, militarism, and so forth.

65. Steven Shapin, *Never Pure: Historical Studies of Science as If It Was Produced by People with Bodies, Situated in Time, Space, Culture, and Society, and Struggling for Credibility and Authority* (Baltimore: Johns Hopkins University Press, 2010). More recently, the "Focus" section in the September 2012 issue of *Isis* examined the issue of "applied" versus "basic" science.

66. Daniel J. Kevles, "Cold War and Hot Physics: Science, Security, and the American State," *Historical Studies in the Physical and Biological Sciences* 20, no. 2 (1990): 239–64.

67. Obviously, there is much more complexity and nuance than these two positions, staked out twenty-five years or more by historians of science, suggest. Forman's position is limited in its assumptions of a natural trajectory, while Kevles's tautological rejoinder ultimately fails to satisfy or explain.

68. On this point, I've benefited a great deal from suggestions from my colleague Michael Gordin.

69. Two obviously important areas beyond the scope of this essay are the use of computers to make art and electronic music. For example, Ken Knowlton patented the language BEFLIX that he developed at Bell Labs (filed 1965, granted 1971) and that he and Lillian Schwartz used to make a series of computer artworks in the late 1960s. The literature here is quite large; one point of reference is the recent but flawed book by Tom Sito, *Moving Innovation: A History of Computer Animation* (Cambridge, MA: MIT Press, 2013). Meanwhile, Andrew Nelson's recent book notes how profitable computer music patents were for Stanford University; *The Sound of Innovation: Stanford and the Computer Music Revolution* (Cambridge, MA: MIT Press, 2015). Likewise, Peter Sachs Collopy notes that it was artist/engineer efforts to make video synthesizers that led to patents and commercialization; see his "Video Synthesizers: From Analog Computing to Digital Art," *IEEE Annals of the History of Computing* 36, no. 4 (October–December 2014): 74–86.

70. What I have in mind here are ventures like MIT's Media Lab, Xerox PARC's PAIR program, and Interval Research. The term *third culture* comes from C.P. Snow when he revisited his "two cultures" idea in 1963; Snow, *Two Cultures*. In more recent years, the idea of a "third culture" has been promoted by people such as editor-publisher John Brockman, cyber-libertarian Kevin Kelly, and artist Victoria Vesna.

DAWNA SCHULD

4

BEYOND METHOD AND WITHOUT OBJECT

Subject as Inquiry in the Irwin-Wortz Collaboration

IN 1968, UNDER THE AEGIS of the Art and Technology (A&T) program at the Los Angeles County Museum of Art (LACMA), artist Robert Irwin was paired with Ed Wortz, a psychologist studying the disorientations of astronautic flight. For both, what began as an empirical examination of visual perception evolved into a lifelong phenomenological inquiry into the nature of subjectivity. Each abdicated his position as specialist in order to explore the tacit dimension—knowledge that is unaccounted for by modernist disciplines and their methods.[1] Irwin's career transitioned from one of making paintings to one of conditioning space, while Wortz went from observing the behavior of others to learning and mastering Buddhist meditative techniques. The collaboration—which for a time also included artist James Turrell—involved the use of sensory deprivation methods such as extreme noise reduction (anechoic chamber) and light dissemination (Ganzfeld sphere). But their experiments were not subject to the rigors and protocols of scientific method; nor did they produce any art objects or performances. Neither functioning as science nor recognizable as art, the experiments were hybrid technologies of

experience that on a fundamental level call into question what it means to be the subject of our own perceptions.

 This essay describes the evolution of the relationship between Irwin, best known today for his site-specific "light and space" installations, and Wortz, with whom he collaborated both within and beyond the A&T program at LACMA. The pairing was unusual not because it brought together two men who had trained in different disciplines using different methods but because each ultimately abandoned his prior training in order to contemplate perception from a new posture of inquiry, one that cannot be easily characterized as either distinctly artistic or scientific and is instead phenomenological and personal. At the time, their collaboration was the realization of some of the most radical aspects of a new systems aesthetic, in which "pure form became pure experience."[2] But theirs was not a partnership born of the need to innovate or to displace one aesthetic theory—formalism—with another, namely systems aesthetics. Rather, both Irwin and Wortz were interested in something more fundamental: they were looking to achieve a level of inquiry uncorrupted by theories or methods of any sort. In this way, theirs was not so much a hybrid inquiry as an attempt at *pure* inquiry, or what inquiry is before it becomes science or art. The hybrid nature of their collaboration is thus present only in the orthodox habits each participant casts off. Irwin's encounters with Wortz inspired a philosophical detour in the early 1970s followed by a period of "being available in response"—as a speaker and as an aesthetic interventionist of sorts, conditioning selected spaces in the built environment so as to enhance their perceptual presence.[3] For his part, Wortz took his own introspective inquiry further by integrating Buddhist meditation practices (elements of which had also been pollinating Irwin's practice for some time) with Gestalt psychology and biofeedback technologies to develop a therapeutic practice where many artists became his clients.

 In creative questioning—or curiosity—Irwin and Wortz saw a convergence between artistic and psychological concerns. To achieve this, both adopted a deliberately phenomenological methodology, shifting their primary emphasis from observable reality to the immediacy of perception. In this regard, their interests are in keeping with a broader development that art historian Alex Potts has described as the "phenomenological turn," characterized by a shared enthusiasm for, if sometimes only approximate understanding of, the writings of Maurice Merleau-Ponty among minimalist artists such as Robert Morris and Donald Judd and critics like Michael Fried and Rosalind Krauss.[4] Importantly, Merleau-Ponty offered a significant counterargument to the strict visuality of Clement Greenberg's formalism, and Irwin's later reading of Merleau-Ponty similarly served to confirm a conviction that art is embodied and contingent.[5] On the other hand, his less usual interest in Husserl's writings is more directly reflective of his relationship to Wortz than to developments in the art world, insofar as Husserl's method of "phenomenological reduction" or "bracketing" effectively describes their joint methodology.[6] In this regard, their shared posture of inquiry can be seen as a kind of practical naïveté in which the inquiring artist or scientist remains open to investigating unforeseen, idiosyncratic, and/or deeply subjective data. It is important, however, to distinguish Irwin and Wortz's hybridized practice of phenomenology from the

philosophy that came beforehand. Though they can be seen as taking a willfully practical (at times literal) approach to some of the same questions that Merleau-Ponty raises about art or Husserl about psychology, from the beginning their collaborative efforts were aimed at something they thought to be more essential, that is to say, creative inquiry itself, before it hardens into a discipline.

Every great collaboration has a point of origin, and prior to these later developments, there was Art and Technology. In 1966, Maurice Tuchman, the new chief curator at LACMA, launched an ambitious program that would extend into the next five years, at venues throughout the vast urban, suburban, and industrial reaches around Los Angeles, and would involve hundreds of participants, including some eighty artists and forty corporate collaborators, as well as industrialists, scientists of various stripes, engineers, fabricators, and numerous overextended museum assistants. By the time of the exhibition in 1971, however, only sixteen artists had produced tangible works of art. Yet the curator deemed the project an achievement of the cybernetic age, one that privileged experimentation over skill and systems over objects.[7]

At the time of the program's inception, Robert Irwin was an established artist experimenting with nontraditional materials. His latest paintings were made from aluminum spun into discs at a metal shop and then air-brushed. When lit, the outline of the central-disc object appears to dissolve into haloes of light emanating from four lamps directed at its surface (figure 4.1). Perceptually, these light-forms acquire more salience than the art "object" itself, a dematerializing effect. Knowing that Irwin was collaborating with industrial fabricators, Tuchman approached him to consider participating in the A&T program. Irwin agreed, but with reservations about what he perceived to be an implicit promise made by Tuchman to the corporations involved that they could expect to acquire works of art for their pains. Irwin felt that the plan Tuchman laid out was therefore geared toward exhibiting manufactured art objects rather than toward prizing and encouraging experimentation for its own sake.[8] Irwin's concerns were pivotal in prompting Tuchman's shift in emphasis from making things at the beginning of the project to one of doing things at the end—a change reflected in the fact that LACMA ultimately published a report outlining the various successes and failures of the A&T program rather than a traditional exhibition catalog. Indeed, by 1971 Tuchman asserted that the most important work to come out of the A&T program was the series of psychological and parapsychological experiments conducted by Irwin and Turrell, along with their psychologist collaborator, Wortz, who was working in the Life Sciences Department at Garrett Corporation, a subcontractor for the Defense Department and the National Aeronautics and Space Administration (NASA) (figure 4.2).

Tuchman's interest in bringing art and industry together reflected a national trend in art. The A&T program was conceived during a technophilic moment in the late 1960s when the possibilities for cross-pollination between disciplines seemed not only possible but somehow inevitable. "In the past," wrote critic Jack Burnham, "our technologically-conceived artifacts structured living patterns. We are now in transition . . . from an *object-oriented* to a *systems-oriented* culture. Here change emanates, not from *things,* but from the *way*

FIGURE 4.1
Robert Irwin, *Untitled,* 1966–67. Aluminum, lacquer, light. Collection of the Los Angeles County Museum of Art, M.68.34. © Robert Irwin/Artists Rights Society (ARS), New York. Digital Image: © Museum Associates/LACMA, Licensed by Art Resource, NY.

things are done."[9] The new "systems esthetics," as Burnham described it, was a forward-looking "counter-trajectory" to the media specificity of Greenbergian formalism, a dominant model in American art criticism whose ideals were nevertheless being challenged by new concerns with networks and engineered experience.[10]

Citing Burnham, LACMA assistant curator Jane Livingston described the Irwin-Turrell-Wortz endeavor as a clear manifestation of this new aesthetic, writing that all three "not only made it their business to explore and assess the dynamics of their interchange, but

FIGURE 4.2
Artists James Turrell and Robert Irwin with Garrett Corporation psychologist Ed Wortz, 1969. Photo: © 1969 Malcom Lubliner.

were explicitly engaged in researching aspects of perceptual psychology," and added that their "mutual investigations . . . continued to develop," a point made explicitly in the catalog with a description of Irwin and Wortz's involvement in the subsequent NASA-sponsored National Symposium on Habitability.[11] The Irwin-Turrell-Wortz collaboration, described as the "Invisible Project" by artist and critic Douglas Davis, produced no single art object, yet their work together significantly shaped the career paths of all three participants.[12] While the trio did propose a largely untenable and unrealized installation for Expo '70 in Osaka (partially achieved by Turrell when he began making his one-person "perceptual cells" in the 1990s), there is little indication that any one of the three had embarked on the project with the intention of producing art to begin with.

Irwin in particular had become increasingly aware of and subsequently agnostic about the role of critical and art-historical methodologies in conditioning perception, and he was more interested in undoing engrained habits of viewing than in reinforcing them. "The discipline Art," he wrote, "its methodologies: painting, drawing, sculpture; its systems: colleagueship, community, art school, gallery, museum; are each an historically established context that serves to underwrite the connecting dialogue between that open inquiry that is art and that cultural practice that we communally identify as art."[13] Irwin's insistence on openness—according to Wortz, a main point of difference between Irwin and Turell, whom he saw as more goal oriented—meant not only that the collaboration produced no object but also that it had no objective other than inquiry itself.[14]

Since they were neither proper science nor intended as art, the experiments conducted by Irwin and Wortz—both with Turrell and after his "abdication" from the program in 1969—might more usefully be thought of as technologies of experience that challenge the participant to question the reliability of his perceptions.[15] These destabilizing circumstances undermine his reliability as a psychological subject and his authority as a disinterested

viewer, eliciting conscious awareness of the contingent nature of perceptual phenomena. At Garrett, where his primary concern had been the potentially claustrophobic and disorienting experiences of astronauts in space, Wortz had been studying the effects of sensory deprivation, using two devices that were of particular interest to Irwin and Turrell: the anechoic chamber and the Ganzfeld. The interior of the anechoic chamber was soundproofed so that words, coughs, and sneezes "stuck" to their source, having failed to resonate. The trio conducted a number of experiments on volunteer college students but—eschewing scientific protocol—experimented primarily on themselves, noticing how time spent in the chamber "conditioned" perception. Most of the time, they would turn the lights out as well, so as to experience absolute silence coupled with utter darkness. Sitting in these stimulus-reduced surroundings was exhausting: rather than depriving the subject/observer of the senses of sight and hearing, the lack of focal markers proved to heighten them, causing him to strain his eyes and ears, searching for something upon which to focus his attention. Most remarkable of all were the effects subjects felt when they reentered daily life and had to readjust to its staggering array of stimuli, all of which seemed to demand that the now sensitively attuned subject *pay attention*.

The Ganzfeld was the visual equivalent of the anechoic chamber insofar as it reduced sensory input as much as possible. The "whole field" of a sphere several feet in diameter sufficient to encompass the viewer's field of vision was uniform in color and finish, so as to distribute light evenly throughout. When contemplating this shadowless stimulus, the experimental subject could experience the paradoxical sensation of seeing what nothing looks like. With no horizon or clearly defined object of any sort by which the viewing subject could orient himself, the most salient characteristic of the space—light—registered as a physical presence of illimitable dimension.

Though the group proposed a project for exhibition, it was never realized. Plans for the piece described combining the experiences of the anechoic chamber and the Ganzfeld in three stages. First, the visitor would enter a sound-dampened preparatory area where he would "cleanse" his perceptions for five to ten minutes. Then he would enter a lightless anechoic chamber where he could recline while subject to subthreshold light flashes and sound flashes. After a further five to ten minutes, these stimuli would increase to "a point between hallucination and reality." The reclining chair, constructed of movable parts, would then slowly flatten into a bed and hydraulically lift the individual to a third, upper chamber where he would lie beneath a Ganzfeld of shifting color spectra accompanied by pulsing sounds.[16] Visitors would leave through a darkened tunnel. Contrary to the purported open-endedness of a new postformal aesthetic, where fulfillment of the work is placed in the hands of the viewer, this proposal necessitated total viewer capitulation. One of the program's most vociferous critics, Max Kozloff, who dismissed it as "techno-fascism," was less scathing about Irwin and Turrell's involvement.[17] Had their proposal been realized, however, he might have had a very different outlook. In the context of rapidly rising anti–Vietnam War sentiment, this leveraging of control can be seen as having sinister political implications, evoking allusions to CIA mind control tactics. With visitors subject to "conditioning" (a term

that later became central to Irwin's practice), the military-industrial background of Wortz's earlier research also comes to light. One cannot help but think that Turrell's departure was especially fortuitous for Tuchman, since it spared him additional criticism for a project that would surely have been a logistical nightmare to set up and administer.

Irwin and Wortz took the work in another direction, collaborating to produce the First National Symposium on Habitability, held in 1970.[18] Wortz had been approached by NASA to explore potential avenues of research concerning "habitability," a reflection of newly emerging environmental approaches to psychological research.[19] Wortz invited both Irwin and Turrell to participate, and according to Irwin the artists had a "corrupting" effect on the NASA initiative by persistently questioning the terms of engagement and the parameters of the project.[20] Having established a rigorous means for consciously contemplating the perceptual effects of one's immediate environment with their A&T experiments, the collaborators saw in the symposium an opportunity to implement their findings in a practical and possibly practicable way.

"What Burnham conceived, they found, by necessity," wrote Davis, reflecting on the LACMA project: "These dialogues thus record the philosophical death of art, while Burnham merely imagines it."[21] It is interesting that Davis couches the "death of art" in such a positive light, which is in keeping with Irwin's desire to do away with the methodological constraints of capital-"A"-Art and to establish a newly relevant kind of aesthetic inquiry. The habitability symposium was truly interdisciplinary, including participants from behavioral science, urban planning, ecology, engineering, medicine, and the arts. Irwin took an almost perversely literal approach to the problem of habitability, suggesting that the best way to explore the problem was to inhabit some spaces and make a study of the experience. Rather than hold the symposium in a hotel or corporate boardroom, he hosted it in his Venice studio, a space he "conditioned" for the event in consultation with his colleagues—artists Larry Bell and Jack Brogan and architect Frank Gehry. Using lessons learned from the anechoic chamber and Ganzfeld, Irwin obscured many of the room's most salient architectural features by covering the walls and windows with scrim and bathing everything in artificial light: "They entered through a blind door and found themselves in near-complete isolation, with no sense of the outside," Irwin reported. "It was a sound-dampened room, and all light was indirect. They were extremely unhappy, but they persevered."[22] Wortz found the results "very interesting," noting that "when you were in there you had to pay attention to people."[23] On the second day of the symposium, Irwin removed the industrial cardboard columns that had muted the street noise and opened up the skylights to bring in natural light (figure 4.3). It was "like being in a mosque," he later wrote, "a really uplifting environment."[24] On the third and final day of the symposium, he opened the entire space out to the street—a conspicuously rough and run-down part of the city—so that discussions were taking place in a public forum.

Often elided in histories of phenomenal art, the Symposium on Habitability contradicts interpretations of the A&T experiments—and California light and space art more generally—as mere exercises in solipsism. As Wortz pointed out, Irwin's perceptual conditioning of the studio-symposium space not only drew attention to the participants' physical

FIGURE 4.3
First National Symposium on Habitability (second day), 72 Market Street, Venice. Robert Irwin studio, Market Street, Venice, CA. 1970. Photo: © 1970 Malcom Lubliner.

surroundings but also heightened their attention to one another. Moreover, such perceptual conditioning had the effect of drawing attention to how attention itself is paid. If Irwin were to make access to the studio too easy, that would perpetuate participants' habits of overlooking their surrounding environment—in this case seedy, rundown 1970s Venice California. As Wortz described it, "Drunks and beach bums and young kids—just drifted right into the symposium."[25]

Both Irwin's and Wortz's insistence that knowledge is embodied and contingent upon the lived environment anticipates contemporary situated models of consciousness. In discussing his work, Irwin uses the phrase "posture of inquiry" as a means of describing an individual's open-ended and open–minded questioning stance, a mind-set that begets creative thinking regardless of and prior to disciplinary distinctions such as "artistic" or "scientific."[26] This is fundamentally an enacting of phenomenological "bracketing," assuming an attitude that is, in Edmund Husserl's words, "'free from all theory,' just as it is in reality experienced, and made clearly manifest in our experiences."[27] Irwin attempted to effect such a mind-set by using defamiliarizing tactics that would break habitual behavior and thereby dislodge the participants' preconceptions. In addition to conditioning the central meeting room, he also subtly manipulated the spaces where breakaway discussions were taking place so that a space was "slightly off," either too big, "too reverberant," or "too dark," et cetera.[28] Each of these situations was a means for facilitating the phenomenological stance that Husserl prescribes, of drawing awareness to the phenomena that shaped the participants' surroundings and thus their knowledge of them. But many participants, when asked how they responded to these interventions, said that they hadn't noticed. "Which told us something about the 'experts' we were dealing with," Wortz later noted.[29]

Irwin seems not to have been especially bothered by this. As seen in his subsequent site-responsive work, he observed that physical alterations to the environment noted at an

unconscious level can still inform viewer perceptions and expectations. Subtle to the point of near invisibility, Irwin's 1970 intervention at the Museum of Modern Art in New York—*Fractured Light-Partial Scrim Ceiling-Eye-Level Wire*—divided a small gallery space into volumes delineated by light using theatrical scrim, alternating cool and warm white fluorescent bulbs, and wire. The work went unnoticed by most visitors who passed through it, but they would nevertheless carry its effects with them like a perceptual virus, remarking on the poor lighting in neighboring galleries. As Irwin later put it, "I went away feeling that a point had been made and the point had to do with simply paying attention."[30] As is evident with both the "habitability" meeting rooms and the MoMA installation, a position of disinterest comes at a price. The questions asked by such interventions necessitate a renewed consideration of the value of first-person experience in one's experimental methodology—whether that of the astronaut or that of the art viewer.

In querying what it means to be a subject who is simultaneously perceiving and observing, both Irwin and Wortz shared a posture of inquiry at the outset of each experimental endeavor. As both have claimed in subsequent interviews, this state of "pure research" was what they shared when they embarked upon the A&T projects.[31] Their collaborative efforts took root during a period when the field of psychology was undergoing a shift similar to that in the art world, where methods once considered objective or disinterested were emerging as contextually determined. Wortz's involvement with the A&T experiments at Garrett was indicative of a broader overall subjectivization of experiment—a phenomenological turn—taking place in neuroscience and psychology (or cognitive sciences) at the time, as is evident with NASA's interest in issues like habitability.[32] His growing interest in the feeling of what happens—as opposed to what could merely be *observed* to be happening—was characteristic of a late 1960s "cognitive revolution" that especially took hold in California, a development particularly applicable to artistic practice in that it could accommodate the artists' intuitive approach.[33]

Irwin and Wortz's collaboration was open-ended, shifting from the semiformal structure provided by the A&T program to a decades-long involvement in what Wortz described as "mutual activities," or "games we enjoy playing together."[34] These "games" seem to have involved little more than fine-tuning their awareness of the aesthetics of everyday experience, so that potentially they encompassed everything. We may term the partnership something both more familiar and elusive than "collaboration," and that is "friendship." Still, these games of awareness carry with them a latent scientism. Wortz described one particular "game" where he would stare at a pencil with one eye closed, aiming at a moment when he registered two pencils perceptually while sustaining conscious awareness that there was only one, thus playing sensory awareness against conscious knowledge. A minor thing—the sort of game we distract ourselves with every day. But Wortz noted that he repeated the action in order to determine whether his results were predictable and furthermore, had his observation confirmed by Irwin and others. Wortz described a shared interest in "trying to understand the characteristics of awareness and observing the transformation of its content."[35] In other words, he was bringing scientific methodology to an introspective activity.

How very like a behaviorist to wish to confirm his findings through outside observation; how very *unlike* one to make his own thoughts the objects of inquiry.

It is important to note that neither Irwin nor Wortz seems to have been concerned that one master the other's discipline. This is in keeping with their interest in the writings of Michael Polanyi, the onetime chemist turned philosopher who asserted that the knowledge articulated and examined through disciplinary methodologies is grounded in *tacit* or *personal* knowledge.[36] Take, for example, Gestalt psychology, the methods of which both Wortz and Irwin adapted to their own practices at this time. As Polanyi noted, the ontological groundwork for Gestalt rested in the "active shaping of experience performed in the pursuit of knowledge."[37] Similarly, for Irwin and Wortz pure inquiry or the pursuit of knowledge had a personal dimension. More than anything, their activities together seem primarily to have been driven by *curiosity*—a favorite word of Irwin's that appears throughout his notebooks from the period immediately following his involvement with A&T (ca. 1970–77). Indeed, we might characterize the mutual activities in which Irwin and Wortz engaged as exercises in curiosity. But it is not *idle* curiosity. Contrary to interpretations of such activities as merely self-indulgent games, they play an important role in reassessing how being and circumstance give rise to experience. Using the tool of phenomenological reduction, Irwin and Wortz were able to isolate their encounters with the world from their preconceptions of it, to return to the "real"—not in a Lacanian sense but in the sense that Merleau-Ponty posits when he writes: "The real has to be described, not constructed or formed. Which means that I cannot put perception into the same category as the syntheses represented by judgements, acts, or predictions."[38]

In an interview with Douglas Davis published in 1973 where he assessed the effects the A&T experiments had had on his practice, Wortz stated that he was more certain that "changes had taken place" in his outlook than he was in his ability to describe those changes.[39] His response is in keeping with Irwin's findings at the Habitability Symposium and at the Museum of Modern Art—that, as Polanyi had put it, "we know more than we can tell."[40] "I think I'm aware of many things in a slightly different perspective," Wortz noted. "It's like the old Zen story: Everything is still the same as it was, but it's different. Because that's the way it is."[41] Wortz's koan-like description raises an important question regarding the "hybridity" of his collaboration with Irwin. Undoubtedly, there was cross-pollination in their methods, but it seems that their dialogues over the years revealed a latent kinship between their respective practices, if not their respective disciplines. Some of this may have been rooted in a shared interest in Buddhist thought and practices.[42] At the foot of the path into the Central Garden (1997) at the Getty Center near Los Angeles, which was designed by Irwin, a similar sentiment is inscribed in stone: "Ever present, never twice the same. Ever changing, never less than whole." For his part, Irwin was similarly concerned that efforts to articulate how Wortz had influenced his development as an artist could be misleading. Even while acknowledging the formative effects of their work (and play) together, he wrote: "I worry that what has been a speculative process while carried out in dialogue, in writing has become almost rigid."[43] This friendly collaboration turned collaborative friendship contin-

ued until Wortz's death in 2004. As Irwin noted in a later interview, even the process of dying—"just another in a series of activities or experiences" to and in which we are made subject—became a shared object of curiosity.[44] Inquiry does not get much purer than that.

NOTES

1. Michael Polanyi, *The Tacit Dimension* (Garden City, NY: Doubleday, 1966). Irwin read and quoted Polanyi extensively in developing his aesthetic philosophy.

2. Jack Burnham, *Beyond Modern Sculpture* (New York: George Braziller, 1968), 172.

3. Lawrence Weschler, *Seeing Is Forgetting the Name of the Thing One Sees,* 2nd ed. (Berkeley: University of California Press, 2008), 166–70.

4. Alex Potts, *The Sculptural Imagination* (New Haven, CT: Yale University Press, 2000), 206–34.

5. Though translations of Merleau-Ponty were available by 1962, Irwin's self-directed study of phenomenological philosophy took place in the mid-1970s. Weschler, *Seeing Is Forgetting,* 179.

6. Edmund Husserl, *General Introduction to a Pure Phenomenology,* vol. 1, trans. Fred Kersten (The Hague: M. Nijhoff, 1980), §49.

7. Maurice Tuchman, introduction to *A Report on the Art and Technology Program of the Los Angeles County Museum of Art 1967–1971,* ed. Maurice Tuchman (Los Angeles: Los Angeles County Museum of Art, 1971), 9–29.

8. Ibid., 12.

9. Jack Burnham, "Systems Esthetics," *Artforum* 7, no. 1 (September 1968): 31 (emphasis in original).

10. Caroline Jones, "System Symptoms," *Artforum* 51, no. 1 (September 2012): 113–16.

11. Jane Livingston, "Thoughts on Art and Technology," in Tuchman, *Report,* 46.

12. Douglas Davis, *Art and the Future* (New York: Praeger, 1973), 161.

13. "Continuing Responses" (Fort Worth), 1975, Robert Irwin Papers, 1970–2004, Getty Research Institute, Los Angeles, Research Library accession no. 940081.

14. Ed Wortz, interview by Jane Livingston, in Tuchman, *Report,* 139.

15. On Turrell's abdication, see Irwin's comments in "Robert Irwin, James Turrell," in Tuchman, *Report,* 139.

16. Ibid., 130.

17. Max Kozloff, "The Multimillion Dollar Art Boondoggle," *Artforum* 10, no. 2 (October 1971): 72.

18. Ed Wortz, ed., *First National Symposium on Habitability,* 4 vols. (Venice, CA: Garrett Airesearch Manufacturing, 1970).

19. J.J. Gibson, *The Senses Considered as Perceptual Systems* (New York: Houghton Mifflin, 1966).

20. "Robert Irwin, James Turrell," 141.

21. Davis, *Art and the Future,* 162.

22. Robert Irwin, "Media Study," *Artforum* 51, no. 1 (September 2012): 45.

23. Wortz, *First National Symposium,* 4:126.

24. Irwin, "Media Study," 45.

25. Ed Wortz quoted in Weschler, *Seeing Is Forgetting,* 136.

26. Robert Irwin, *Robert Irwin* (New York: Whitney Museum of Art, 1977), 25.

27. Husserl, *General Introduction,* vol. 1, §32, 59.

28. Irwin, "Media Study," 45. In addition, Larry Bell and DeWain Valentine, both of whom had studios nearby, had transformed *those* spaces into distinctly disorienting environments.

29. In Weschler, *Seeing Is Forgetting,* 137.

30. Robert Irwin, statement made at the seminar "The Spirit in Art," Graduate Union Theological Seminary, Berkeley, CA, April 21, 1979, cited in Jan Butterfield, *The Art of Light + Space* (New York: Abbeville Press, 1993), 24.

31. Weschler, *Seeing Is Forgetting,* 131–33.

32. George A. Miller, "The Cognitive Revolution: A Historical Perspective," *Trends in Cognitive Sciences* 7, no. 3 (2003): 141–44.

33. This is also evident in the ubiquitous presence of new Gestalt psychology texts in university studio programs throughout the country. See Howard Singerman, *Art Subjects* (Berkeley: University of California Press, 1999), 67–79.

34. Ed Wortz, undated note, ca. 1975, Giuseppe Panza Papers, 1956–1990, Getty Research Institute, Los Angeles, Research Library accession no. 94004.

35. Ibid.

36. Michael Polanyi, *Personal Knowledge* (Chicago: University of Chicago Press, 1958, 1962).

37. Polanyi, *Tacit Dimension,* 6.

38. Maurice Merleau-Ponty, *Phenomenology of Perception,* trans. Colin Smith (London: Routledge, 1962), xi.

39. Ed Wortz, in conversation with Douglas Davis, in *Art and the Future,* 165.

40. Polanyi, *Tacit Dimension,* 4.

41. Wortz, in Davis, *Art and the Future,* 166.

42. In the 1950s Irwin was especially interested in the Kyoto School Zen Buddhism. Robert Irwin, interview by Frederick S. Wight, December 29, 1975–March 24, 1976, transcript, Oral History Program, University of California, Los Angeles, 1977, 16–17.

43. Irwin, "Notes toward a Model" (1977), reprinted in *Notes toward a Conditional Art,* ed. Matthew Sims (Los Angeles: Getty Publications, 2011), 165.

44. Irwin, in Wechsler, *Seeing Is Forgetting,* 290.

CRAIG RICHARDSON

5

MONUMENTS TO THE PERIOD WE LIVE IN

N*IDDRIE WOMAN (1976)*, **BY JOHN LATHAM** (1921–2006), consists of partially protected oil shale "bings" (Norse: heaps). These were initially the voluminous waste by-product of Scotland's energy production industries, but they were reconceived through a synthesis of methods originally developed by the Artist Placement Group (APG) between 1965 and 1989 and allied to concepts within Gustav Metzger's manifesto of auto-destructive art and the proclivities of Latham's renowned but often controversial practice.[1] In this chapter I explain the methodology of Latham's reimagination of the site he renamed *Niddrie Woman* (1975–76), which he described as "monuments to the period we live in,"[2] and why it has resonance. In doing so, I look forward to how the future conservation of these remarkable forms as sculptural monuments is increasingly dependent on their assessment as hotspots of biodiversity. The academic context that I provide for the work draws on archival items within the Artist Placement Group Archive (acquired in 2004 by Tate Britain's Hyman Kreitman Research Centre), curatorial research, and onsite environmental research.[3]

A METHODOLOGY OF ENGAGEMENT

The APG was founded in London in 1966 as both a collective and an agency. Barbara Steveni, John Latham, Anna Ridley, Barry Flanagan, David Hall, and Jeffrey Shaw hybridized business, science, and civil service practices with socially engaged art. The art world's initially skeptical response to the APG's seemingly aberrant rationale for what Pauline van Mourik Broekman and Josephine Barry have called "tangling with the dirt of commerce and the public sector" eventually gave way to acceptance as the APG example, in the words of a 2002 *Mute* magazine article, came "to define large swathes of artistic practice. The APG worked hard to formulate a rigorous methodology of engagement."[4]

Barbara Steveni's recollection of the APG's founding asserts her pivotal early role in its inception:

> The Fluxus group came to stay in our house [in London] and they were going to do an exhibition, they wanted some material. And I said, I'll go to the outer circular road, to the industrial estate, and I'll pick up some material [from a factory]. So I went there. It was dead of night, but the factory was absolutely booming away and I thought: well why aren't we here? Not to pick up buckets of plastic, but because there's a whole life that we don't touch. This is what people go on about—academics, artists, politicians—but they get nowhere near it.[5]

The APG's fluctuating membership comprised mostly sculptors and those with an intermedial practice. Their central meeting place in the early years was the Lathams' Notting Hill house, in which regular "think tanks"—discussions on alternative forms of artistic production—identified the ways and means for artists to relocate their practices to other workplaces (figure 5.1).[6] In time, these meetings increasingly turned toward examining the social and economic roles conventionally assigned to artists, and these discussions became increasingly informed by a direct and viable engagement with industry and commerce. The APG's approach to policy change within the operation of UK and European government departmental responsibilities would later become increasingly notable.

The APG's innovation was their proposal to private companies and public sector organizations that they should work directly with artists but forgo the conventions of artistic patronage. Instead, artists would work within the everyday environment of the host organization with an "open brief," so that the organization would benefit from the artists' insights. These insights would accrue through this open-ended process, the results of which would be discussed and summarized in a feasibility study, authored by the artist, and outlining proposals that could be developed within a long-term, host-funded placement. In turn, APG artists would, as Hudek and Sainsbury suggest, "benefit from a 'real world' context" as a developmental resource.[7] The APG's tenet that "context is half the work" underpinned the rationale for their placements, augmenting the joining of two kinds of productive capacity: that of the industrial and managerial realm and that of the individualistic artist.[8]

FIGURE 5.1

"Think Tank," 22 Portland Road, London, 1968. Clockwise: B. Steveni, D. Hall, G. Evans, B. Flanagan, J. Latham, S. Brisley, M. Agis, D. Lamelas, I.M. Munro. Photo: Barbara Steveni.

The artistic foci of the early industrial placements tended to be industrial entrepreneurial capabilities, industry's labor division, internal communications, and production linkages as well as the artist's innovative reuse of physically resident materials. Barbara Steveni listed these areas of interest for Organization and Imagination (O+I) in 1989 when she was leading the APG's reconstitution under that new name as an independent artist consultancy and research body.

The APG's approach, an offer to "serve as a catalyst for change," was grounded in the idea of the "open brief."[9] The industry hosts were typically offered a short list of artists established by the appropriateness of the materials or media in which the artists normally worked, and each artist, from closer interaction with the industry, drew up a "feasibility study" or artistic proposal for a long-term placement. The industry's chosen artist then had carte blanche to do open-ended work that evolved with further interaction at the industry site and was not required to produce tangible results.[10] The artist's freedom in this regard was essential to the APG's operation and the group's subsequent success. It was implicit within the development of feasibility studies that the APG method would position the importance of the artist's imagination, without necessarily prioritizing conventional artistic skill in the use of visual imagery and media. This might entail the artist's ways of seeing and an ability to discover forms, but more importantly, it was his or her generalist presence that was intended to generate discussion, innovation, and discovery. In some organizational engagements, the host might invite the artists to consider a topic or access a resource, but effectively artists formed their own research problems. The open brief privileged the artist's capacity for the unexpected, as a note from a government memo supporting a 1974 placement demonstrates: "[An individual] . . . might show us solutions to problems we do not know to exist."[11]

The second essential element in the viability of the APG method was how the results of the artist's research would be presented as solutions to problems that had been formally submitted to the host organization in the aforementioned feasibility study. Feasibility studies would outline ideas for what were hoped to be mutually agreed-on projects, activities, and even realizable artworks. While correspondence in the Tate Britain APG archive shows that some organizations were dubious regarding some feasibility studies' concepts of art, they still allowed the artists to do the work, and other organizations considered the studies important enough to be further developed within a salaried artist's placement.

APG artists were attracted to the open-ended nature of the emerging methodology and were open to new technological or contextual challenges. Several members retained high-profile individual careers across a number of forms, with some included in significant exhibitions curated by Kynaston McShine among others. The APG as an organization also underwent changes in its collaborative foci as it developed through different phases. In the emergent period, 1965–68, APG's functioning role was to facilitate artists' access to industrial materials: for instance, Steveni obtained PVC film that the Australian-born multimedia artist Jeffrey Shaw, cofounder of the APG, used, in collaboration with the Dutch artist Theo Botschuijver, to make one of his *Waterwalk* (1969) inflatable "eventstructures." Shaw later designed the inflatable pig flown over London's decommissioned Battersea Power Station and used by Pink Floyd on the cover of their 1977 *Animals* album and subsequent tour.

The APG's second phase, 1968–72, included their earliest placements. One of the better known was the offer to sculptor Garth Evans of a two-year placement at British Steel Corporation. Evans, a part-time lecturer of the innovative "A" course emerging from the Undergraduate Degree Sculpture School of Saint Martins School of Art, visited a steel fabrication works, where he photographed steel construction exercises made by the apprentice welders. These were constructions comparable to those Evans himself began to make during his placement, including the sculpture *Frame* (1970–71). Notably, in the United Kingdom at this time and beyond, successive Labour and Conservative governments wrestled with serious industrial relations issues. Crucially, while Evans studied the production of steel at the corporation's facilities he was just as interested in the corporate culture, later reporting on ways for employees to more meaningfully engage or identify with their work and in the corporation's social organization.

An even better-known placement is the pioneering video artist David Hall's *10 TV Interruptions* (1971), later released as *7 TV Interruptions*. Hall was included the seminal *Primary Structures* (1966) exhibition at the Jewish Museum, New York. *10 TV Interruptions* developed from a short placement with Scottish Television, the regional variant of the United Kingdom's independent national broadcaster, which with Hall produced and broadcast a series of intriguing television films: on the screen a television is seen on fire; or a water tap is turned on, and the waterline is seen rising noisily up the screen to create an illusion that the television set is now like a fish tank. These were broadcast without explanatory announcement, or a title or credit, interrupting the viewing pattern and audience's expecta-

tions. As Scottish Television was a commercial broadcaster, these interventions would have been initially misread as advertising.

Concurrent with industrial placements, the APG took part in the exhibitions *Between 6* (1970) at the Kunsthalle Düsseldorf and *INN70* (1971), also known as *Art and Economics*, at the Hayward Gallery, London. The latter was "convened" in the sense that the APG experimented with a debate-based exhibition format: the main exhibit was a boardroom table entitled *The Sculpture,* where APG members hosted live discussions between artists, industrialists, and government representatives. Representing the APG in any exhibition format was often problematic; the diversity of APG placements resulted in publications and art objects, collages and appropriated objects, and also other less obvious artistic documentation in photographs, films, and video and sound recordings. Since the APG artists were primarily process-driven practitioners, on an aesthetic level the success of their exhibitions in popular public venues, particularly *Art and Economics*, which consisted of context-specific objects and documents, was elusive.

The third phase in the APG's history, of most relevance to my case study below, followed the devising in 1972 of a civil service or Whitehall memorandum. The APG received the support of civil servants, nonelected governmental officials with careers in developing and implementing the policies of the government of the day's policies. The APG now had champions who held operational responsibilities across a broad array of organizations. The memorandum paved the way for offers from national government departments including Health and Social Security, the Environment, and, via the Scottish Office, the Scottish Development Agency in Edinburgh. One undated archived note described the APG approach as perceived by a civil service department chief: "Their working methods would be likely to take forms of alternative periods of information-gathering, work on sites, studying different types of interests individually and in conjunction with voluntary groups in the area with whom rapport has been established."[12]

Other aspects of the correspondence, building on the civil service memorandum, articulated the clear operational arrangements supporting the initial open brief / feasibility study phase. For instance, John Latham's Scottish Development Agency (Edinburgh) research was supported with an office, secretarial assistance, agreed-on lines of communication, and a "link man" in each of the department's divisions. Crucially these arrangements also included an introductory seminar, at which the object of the feasibility study could be introduced; here, according to the civil servant Jim Ford, "the artist will be able to give the departmental staff concerned some idea of his objectives and methods."[13] In Ford's view, the Scottish Development Agency could benefit from "explor[ing] areas of our departmental functions [by] employing an artist for about a year to work alongside departmental staff and make his own distinctive contribution to their work."[14]

Such arrangements could be contentious but had the potential for thought-provoking and politically far-reaching outcomes. Concurrent with John Latham's feasibility study phase in Scotland, the diary artist Ian Breakwell began a placement at the Department of Health and Social Security in 1975. As Antony Hudek later summarized, he "produced a slide

sequence for members of a 'Special Hospitals Internal Seminar,' which graphically portrayed the ignominy of the patients' living standards, after which he was asked to join an interdisciplinary team tasked with improving not only Broadmoor's [a high-security psychiatric hospital in England] physical structure but also its impact on healthcare."[15]

After this placement Breakwell continued to produce artworks out of his related slide sequence, exemplifying an artist who developed new ideas from the research he did during his APG feasibility study and placement. Later, the APG would redevelop its approach and become a consultancy and research organization working in synthesis with the artists' newly informed practices.[16] Rather than diluting what Latham would later term Barbara Steveni's APG "prescription,"[17] such syntheses had the effect of intensifying and prolonging the APG's significance.

But there were problems with the APG method, a theoretical method that intended a novel, practical application and secured a salary and an organizational status for the artist that was in line with that of other professionals engaged within the organization. By adhering to the open-brief system, the APG insisted on the independence of its artists. As Peter Eleey later observed, APG artists were "bound by invitation rather than by instructions from authority."[18] John A. Walker noted that some potential host organizations viewed the APG method as risky, supporting "a kind of licensed opposition situated within the system,"[19] and in this respect he articulated the radicalism of the APG's methodological ambitions. As Eleey wrote, the APG's "very argument for the value of the artist's presence in the company was rooted in a deliberately outsized view of the artist's role in society."[20]

The APG archive at Tate Britain provides testimony to this outsized view. It consists mostly of organizational and company correspondence. Over a ten-year period, the APG tried to persuade organizations ranging from the National Coal Board to Esso to engage with artists. The volume of correspondence increased when correspondents included the Civil Service and democratically elected officials. The fuller meaning of the APG methodology, with the related details of the works' context, is developed in this correspondence, sometimes about placements, sometimes about artworks, and is defined, not by manifestos, but by dialogue and discourse. Thus the archive is the main resource by which that meaning and the APG's legacy are fully revealed. As well as effective correspondence, the APG relied upon self-critique sustained for two decades. The APG proposition that an artist could meaningfully contribute to commercial or bureaucratic organizations was sometimes met with suspicion and with a forceful critique of such motives. But there *were* contextual and conceptual innovations, not the least of which was how a successful feasibility study would broadly problematize conventional organizational strategies and challenge the institutionalization of the art object.

CASE STUDY: JOHN LATHAM

John Latham's APG governmental host was the Scottish Development Agency. This was a new government body, formed in 1975 and based in Scotland, tasked with the promotion of industrial efficiency and international competitiveness and furthering the improvement of the environment through dealing with, among other things, the problem of derelict land

and urban decay in Scotland. The arrangement of Latham's initial residency in Edinburgh differed from the APG standard in that Latham was the only artist offered to the agency. The feasibility study phase was informed in part by ongoing concerns facing the resident civil servants, and, although the preliminary phase did not result in a more fully funded placement, at a key moment sometime after his initial residency the agency found themselves dependent upon his study's proposals.

In many ways, it was remarkable that this artist was brought into collaboration with any governmental facility. Right up to his death on January 1, 2006, Latham was suspicious of the language of power, and he periodically experienced artistic censorship throughout his mature career. After serving on a minesweeper in Britain's Royal Navy and experiencing serious and deadly action in the Second World War, he returned to England and began a life as an artist. His early paintings displayed an interest in metamorphosis and organic processes, with John A. Walker noting that Latham's "imagery and forms were *found* during the activity of painting rather than being pre-conceived."[21] Although his reasoning could be obscure, destruction and transformation were important aspects of his worldview.[22] In the early 1960s, he began to incorporate modified books into his paintings, reliefs, and assemblages, which, as his practice developed, offered significant and troubling challenges to audiences and critics alike.

Latham also participated in Gustav Metzger's *Destruction in Art Symposium* (1966) with a still controversial work, *Skoob Towers* (1964–68). The word *Skoob* is *Books* reversed, and these were set alight in towers of secondhand hardback books, including the *Encyclopedia Britannica*. Book destruction appeared in other key works of his, most notably *Still and Chew / Art and Culture* (1966–67), which led to his dismissal from teaching at Saint Martins School of Art's radical sculpture program. In this work, Latham invited his students at Saint Martins to join him in chewing up Clement Greenberg's *Art and Culture* (1961), borrowed from the school library. The chewed pages were distilled and decanted into a vial, later displayed within a leather briefcase. John A. Walker, perhaps in irony, proposed that Latham "performed an alchemical-like transformation in order to distil the book's essence in such a way as to neutralise its potency."[23] Perhaps not coincidentally, when Latham was invited in 1975 to participate in an exhibition entitled *Structure and Codes* at the Royal College of Art in London he asked that a text decrying academic fraudulence be displayed, which to their credit the Royal College exhibited (figure 5.2).

John Latham's feasibility study (1976) for the Scottish Development Agency included proposals for energy production from tidal movement and the local community application of portable video technologies for emergent community broadcast channels. Its core concept was his argument for reconceiving postindustrial waste, previously designated "derelict land," and the enumeration of relevant sites for such a project. The waste, huge heaps of red colored shale waste, or shale bings (Norse: heaps), littered the nearby west and mid-Lothian regions.[24] The shale bings originated from a redundant mid-nineteenth-century waste-producing mining process that was designed to extract and distill products for use as paraffin oil from oil-bearing shale. Most bings have a steep frontage, formed from slow inclines upon which large vehicles deposited burnt shale after their ascension up the bings'

FIGURE 5.2
John Latham, *Senior Academic Institutions*, 1975.
© Tate, London 2015.

> **JOHN LATHAM**
> Senior academic institutions have been defrauding the public and students for 300 years. They are not concerned with education, still less with truth – they are run for the benefit of the staff.

characteristic long "tail." One of these bings rises to a height of ninety-five meters; it resembles an extinct volcano, and its volume of oxidized mining waste evidences how this type of shale mining offered significant employment until midway into the twentieth century. Nineteen shale bings remain in the region.

The UK government had tasked the Scottish Development Agency to devise a plan for the removal of such shale bings within a ten-year time frame, and the problem Latham was asked to confront—while retaining an open brief—was their seeming unsightliness. Civil servants wondered if Latham had ideas about the use of this distinctive rock material. In his resultant feasibility study, whose thirty-six plastic folders contained photographs, illustrations, and detailed commentary, Latham proposed to "preserve a select few, which will be presented as monuments to the period we live in . . . to bring them by various means into common use again."[25] Generally, he argued that the bings were not derelict land and were deemed problematic only because of their scale. As they were so vast, they could easily be mistaken for naturally occurring terra-forms, but Latham re-represented them as a type of sculpture that could provide vital tourist-based benefits to this economically depressed region of the Scotland and could generate other artistic placements.

For one set of shale bings Latham also proposed a somewhat complicated schema but one that can claim to be the largest artwork in the United Kingdom. Latham's open brief began with his review of the Scottish Development Agency's aerial photography archive, which provided him with a first informed glimpse of a West Lothian shale bing constellation near Broxburn, known locally as "Greendykes" and its adjoining bings. Latham determined these were not waste at all but in fact were documents of value in terms of cultural history, and, given the manner in which they were originally produced, were also a process sculpture, made through the unconscious acts of the many. Using the aerial perspective afforded by a single surveillance photograph (figure 5.3), Latham anthropomorphized Greendykes bing as the "Torso" of a torn figure alongside the other bings—the Faucheldean bing, now named the "Limb"; Niddry bing, designated the "Heart" (although too large to fit inside this approximately scaled body); and Albyn bing, called the "Head." Together these constituted the fictive female figure that he named *Niddrie Woman* (figure 5.4).[26] The prehistoric carving *The Venus of Willendorf* (ca. 28,000–25,000 BCE) was cited, and *Niddrie Woman*'s aerially visualized form was intentionally redolent of ancient images cut into England's chalk hillsides such as the Uffington White Horse in Oxfordshire and the Cerne Giant in Dorset.

At this moment of aerially envisioned intuition, Latham, having been granted access to and a future responsibility for these derelict terra-forms, also decided that the proposed

FIGURE 5.3
Aerial surveillance photograph of *Niddrie Woman* bings, ca. 1975, from APG Files, box 11, Tate Britain archives. © Tate, London 2015.

work shared with a number of his previous ones a processional transformation or context through destruction. In *Conversations on Science, Culture, and Time,* Michel Serres notes, "Discussion conserves, invention requires rapid intuition and being light as weightlessness,"[27] and it was Latham's previous practice that enabled him to achieve such weightlessness and such freedom to decontextualize the bings and newly contextualize them. After this intuition in the archive, Latham began an exhaustive series of terrestrial visits, photographing the sites of shale bings, including *Niddrie Woman* (figure 5.5).

Then, in addition to the site of *Niddrie Woman,* Latham became enraptured by another distinct bing to its west. Westwood bing has five separate peaks on one base but is known locally, in another anthropomorphism, as "Five Sisters." In the mid-1970s the surfaces of shale bings were relatively raw and made for a harsh terrain.[28] At the time, this vast array of singular raw materials and the destructive process that led to the bings' formation conformed to Latham's principles (as he saw them) of sculpture, as well as those informed by Gustav Metzger's manifesto of auto-destructive art, a "public art for industrial societies."[29] On an undated single sheet of paper (now in the APG's Tate Britain Archive), Latham wrote of their idiom:

MONUMENTS TO THE PERIOD WE LIVE IN 99

BINGS AS SCULPTURE/MONUMENTS:

Idiom: The better conceived Bings conform to classical sculptural principles, viz.:

 i. They are form in a single material
 ii. The singular material is linked to a singular process
 iii. Their scale is unique—less than geological but greater than other artefacts.
 iv. They have both proportion, in classical terms and
 v. Multiple evocative associations both visual and legendary.
 vi. Added to these there is the link to be made with the book-relief idiom, to which is attributed a new contribution to philosophy.

In all of these aspects the Bing is unique, although the circumstance has had to be overawed [sic] in the past—the public having a fixed view of dirt danger and dereliction.[30]

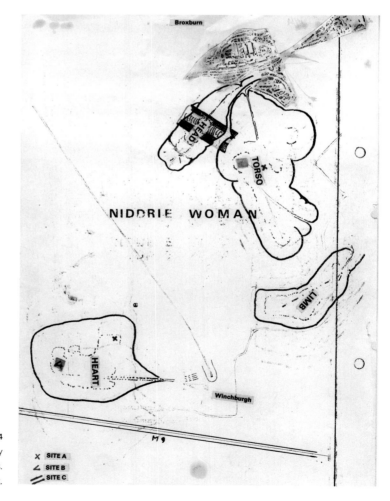

FIGURE 5.4
Page from John Latham's "Feasibility Study," 1976, Tate Britain archives.
© Tate, London 2015.

For "Five Sisters" Latham made modest proposals for access to the site, including environmental vantage point markers, steps, and notice boards, and the preparation of historical records for the sites. For *Niddrie Woman* he proposed a different degree of consciousness-raising, including the incorporation of further artworks. Latham cited the garden environment *Stonypath*, by the Scottish artist and poet Ian Hamilton Finlay, as the region's exemplar, an environmental garden artwork into which further artworks are incorporated. Latham also proposed his own beaconlike twenty-four-meter-high sculpture, *Handbook of Reason*, in the cruciform shape of one giant vertical closed book being intersected by another partially open book laid horizontally (figure 5.6). Further mock-ups and illustrations in his feasibility study, as well as some recent additions to social networking websites, have provided glimpses of the dynamic quality such a towering monument would have brought to the site if it had been engineered.

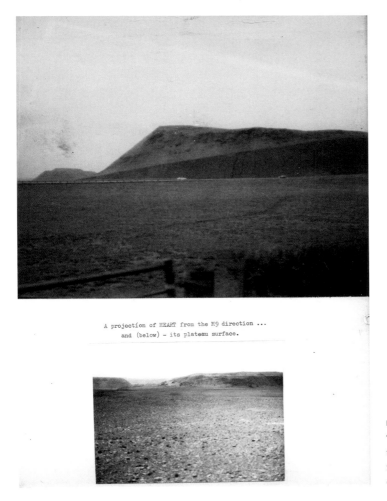

FIGURE 5.5
"Heart of Niddrie Woman," page from John Latham's "Feasibility Study," 1976. Tate Britain archives. © Tate, London 2015.

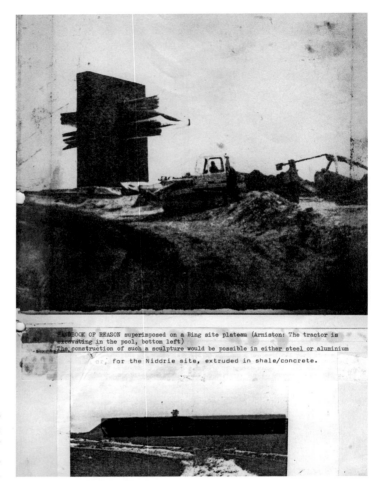

FIGURE 5.6
"Handbook of Reason," page from John Latham's "Feasibility Study," 1976. Tate Britain archives. © Tate, London 2015.

In 1976 Latham submitted his feasibility study to his hosts, and his relationship with the Scottish Development Agency seemingly ended. Latham and the APG had developing European priorities, including their participation in 1977's *Documenta 6* and verbal jousts with Joseph Beuys on the meaning of artist-with-government placements. However, this was merely a starting point in Latham's argument for the full conservation of *Niddrie Woman* within the scheme of its reconceptualization. Latham became convinced that he had solved the Scottish civil servants' nearly impossible operational quandary regarding the vast bing's material disposal and continued to insist that these monumental process sculptures were materially unique and should remain tethered to their sites. Their context had included their historical associations but now included his intuitive reconceptualization, which should be celebrated and concretized. His subsequent arguments continued to emphasize the possibility of all shale bings' "derelict land" being reclaimed as sculpture, but he confused his case

by shifting quickly from rational argument (in the sense of the development of sculptural thinking in twentieth-century art history) to sometimes elliptical, but always wondrous, commentary.[31]

What are the environmental and art-historical legacies of Latham's feasibility study? The "Five Sisters" bing is now entirely preserved under the Ancient Monuments and Archaeological Areas Act of 1979. Latham and the APG played a central role in its preservation via its designation as what is known as a Scheduled Ancient Monument. In the early 1980s, the site's owners wished to mine "Five Sisters" for its inert shale, which could be useful as infill for motorway construction. The Scottish Development Agency resisted, arguing that "Five Sisters" was a monument to industrialization. The site's owners then disputed the formalization of its monumental status, and the Scottish Office invited Latham to make a public argument for the case that such bings were indeed "monuments" produced through a unique process, namely process sculpture. But Latham's argument was not reiterated in public. At the last moment the owners withdrew their appeal against its status as a scheduled monument, but this left Latham unable to make a public case for the preservation of either "Five Sisters," as invited, or *Niddrie Woman*. Some of *Niddrie Woman*'s sections are now preserved under the same Ancient Monuments and Archaeological Areas Act, but not Niddrie Heart, which continues to be top-mined for motorway infill material.

The art-historical legacy is less definitive. An obvious precursor to the social aspects of Latham's feasibility study relates to the social aspect of the mining industry in the United Kingdom. Bernd and Hilla Becher's 1966 scholarship from the British Council and other assistance provided by the National Coal Board later enabled them to eulogize this type of declining industrial environment in an interview. "We worked in the mines of Wales," said the Bechers, "which, if you want to describe them visually, run along the valleys like a string of pearls."[32] However, it is not useful to compare the Bechers' documentary methodology with Latham's poetically inflected practice. The Bechers produced elegant and technically precise artwork from a dismal situation, whereas Latham produced documentation and concepts that were consciously diffuse and ponderous, unlike their site, which has a profound sense of scale and meaning. The qualitative comparison is with isolated landmarks such as Michael Heizer's *Double Negative* (1969–70) or Christo and Jeanne-Claude's *Valley Curtain* (1970–72), works that are critically reappraised through photographic modes of aerial and terrestrial documentation.

Latham went further than simply to emblematize the economics and history of the region; he recognized that the shale bings are rapturous sites. As for their originating process, Latham reiterated the fascination of the randomness of postindustrial landscapes that Robert Smithson had described earlier in his essay "A Sedimentation of the Mind: Earth Projects" (1968): "Dump trucks spill spoil into an infinity of heaps.... Processes of heavy construction have a devastating kind of primordial grandeur."[33] Nontoxic weathered shale is formed through rapid oxidation, gray-blue turning red; that beauty can be found in such accumulated material is not unusual (figure 5.7). A postindustrial evocativeness is often found in Latham's feasibility study, which says of the bings that "their scale and

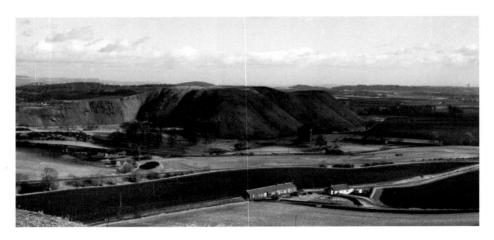

FIGURE 5.7
"Niddrie Heart" (color), APG Files, box 11, "Niddrie Heart," Tate Britain archives. © Tate, London 2015.

disposition ... would be widely recognized as monumental" and that they constitute "an important antidote to a totally planned, owned, exploited land, and to the prim orderliness of urban parkland."[34]

From waste to monument may have seemed an improbable reversal, and little by little, without investment at their sites, art-historical knowledge of *Niddrie Woman* has drifted into the realm of conjecture. A lack of scholarly records led critic Lucy Lippard to refer to *Niddrie Woman* in *Overlay* (1983) as a "pun on female earth, rebirth, modern society's treatment of women's bodies as castoffs, and so forth," tapping into a strain of 1970s art, the "upsurge of interest among avant-garde artists in 'primitivism.'"[35] While Latham's reconceptualization of derelict land predates Robert Morris's role as lead artist in the King County Art's Commission *Earthworks: Land Reclamation as Sculpture* (1979) in Washington State, both Latham and Morris investigated the capacity for art practice to rehabilitate technologically abused land. Although Morris realized the rehabilitation of an actual county gravel pit, a critical reference can be applied to Latham's earlier project using excerpts from Morris's revised keynote delivered for the *Earthworks* symposium in 1980. "Notes on Art as/ and Land Reclamation" gently mocked, "Every large strip mine could support an artist-in-residence. Dank and noxious acres of spoil piles cry out for some redeeming sculptural shape."[36] Morris warned against land reclamation as art practice making acceptable the "continuing acceleration of the resource-energy-commodity-consumption cycle."[37] However, Latham's feasibility study and his subsequent correspondence presage Morris's environmental questioning of an aesthetics of pollution, as well as Morris's pressing concerns for the sustainability of the planetary ecology.

Far from being sites of ecological devastation, shale bings now hold an important assessed environmental and social value. Barbra Harvie's *West Lothian Local Biodiversity Action Plan—Oil Shale Bings* (2005) report states that they "are a unique habitat, not found

TABLE 5.1 THE SHALE BINGS FORMING *NIDDRIE WOMAN* (1975–76)

Recognized designation	Latham's "Feasibility Study"	Status in 2006 (under the Ancient Monuments and Archaeological Areas Act, 1979)
"Greendykes"	Torso	Intact bing where extraction is resisted—*now scheduled monument* (north part)
"Faucheldean"	Limb	Intact bing where extraction is resisted—*now scheduled monument*
"Niddry"	Heart	Bing where extraction is encouraged with planning permission
"Albyn"	Head	Bing where extraction may be encouraged but where planning permission is required

elsewhere in Britain or Western Europe," a vital recreation area, and "the focal point of community identity in a population whose common culture of mining is slowly being eradicated."[38] Her report maintains that the "best management of oil-shale bings is no management."[39] This exactly correlates with Latham's own study and similarly seems to describe a magical place inhabited by brown hares, red grouse, badgers, skylarks, foxes, and showy species, mainly butterflies. Their habitats are "island refugia for wildlife in a primarily agricultural and urban/industrial landscape,"[40] and they hold a considerable diversity of very rare and nationally scarce plant species.

Latham's feasibility study continues to provide a compelling example of an artist's influence in political decision making in the operation of regional government. The Scottish Office palpably developed a sense of respectful curiosity and in time engaged with Latham's well-argued resolution of these previously disregarded sites of dereliction. But Latham realized, and the Office accepted as much, that political recommendation does not by itself immediately result in meaningful art. And so a gap remains: the difference in appreciation that has opened up is between the site's current recognition as *heritage* and Latham's earlier proposals for *sculpture,* which meant in his view that his ideas had not been fully conveyed, that the meaning of process sculpture is superior to received ideas of heritage.

And so *Niddrie Woman* remains an uncompleted project. As if to underline the importance of these bings and their importance to Latham, the final act following Latham's death in 2006 was the scattering of his ashes on the currently mined plateau atop Niddrie Heart within sight of a restored Niddry Castle, amid the red colored oil-shale he documented in 1975 (figure 5.8). In 2007, I hitched a lift on a monstrous mining vehicle to the top of Niddrie Heart and gained access to the mined crater. This crater affords distant views of Edinburgh Airport and the rest of *Niddrie Woman,* whose torso and limb are idyllic, protected sites. Looking inwards to the mined core of Niddrie Heart, one can see the grandeur of its devastation as a profound metaphor for centuries of industrialization and despoilation.

Latham and the APG have left us with a challenge that asks us something about our future. Is *Niddrie Woman* a landscape, industrial monument, heritage site, or process

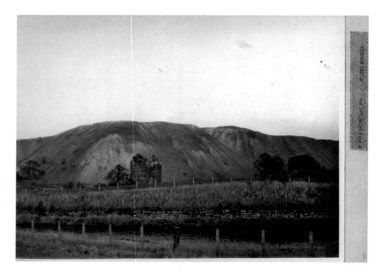

FIGURE 5.8
Niddry Castle / *Niddrie Woman*, page from John Latham's "Feasibility Study," 1976. Tate Britain archives © Tate, London 2015.

sculpture? The APG method, which led to Latham's well-argued preservation of *Niddrie Woman* in its entirety, was a reconceptualization of a site that pushed beyond the boundaries of Rosalind Krauss's famous "Sculpture in the Expanded Field" (1979).[41] But is it socially relevant to ponder its status as land art, or to ask whether Latham's insistence upon a figurative reference for *Niddrie Woman* distinguished it as separate from minimalist earthworks derived from crosses, circles, cubes, spirals, and tubes? Is the conservation problem with which it presents us best dealt with in an art-historical context? Is it in fact now the case, as the environmental sociologist Daryl Martin recently argued, that the bings occupy "a tensed position within a complex layering of current uses and future trajectories"?[42] Above all, Latham anticipated the imaginative ways in which twenty-first-century industries and communities will have to find new uses for past energy-producing transformations in the landscape and environment. And such imagination has a role in society's move out of the carbon age as we develop much-needed new technologies and abandon environmentally destructive processes of energy production.

NOTES

1. Gustav Metzger, "Manifesto: Auto-Destructive Art," handbill accompanying Metzger's exhibition *Cardboards*, London, November 4, 1959, repr. in Andrew Wilson, "Gustav Metzger's Auto-Destructive/Auto-Creative Art," *Third Text* 22, no. 2 (2008): 188.

2. John Latham, "Feasibility Study," 1976, box 9.2, no. 28, Documents of APG Feasibility Study, Scottish Office, Artist Placement Group Archive, Hyman Kreitman Centre, Tate Britain (n.p.).

3. John A. Walker, "APG: The Individual and the Organisation: A Decade of Conceptual Engineering," *Studio International* 191, no. 980 (March–April 1976): 162–64, and John A. Walker, *John Latham: The Incidental Person—His Art and Ideas* (London: University of Middlesex Press, 1994), draw on the APG Archive. For curatorial research, see Antony Hudek and Alex

Sainsbury, *The Individual and the Organisation: Artist Placement Group 1966–79* (London: Raven Row, 2012), www.ravenrow.org/texts/40/. For environmental research, see Barbra Harvie, *West Lothian Local Biodiversity Action Plan—Oil Shale Bings* (Linlithgow: West Lothian Council, 2005).

4. Pauline van Mourik Broekman and Josephine Barry, "Countdown to Zero, Count Up to Now (An Interview with the Artist Placement Group)," *Mute* 25 (2002): 80.

5. Broekman and Barry, "Countdown to Zero," 83.

6. A later APG member, Ian Breakwell, recalled that "everything turned into a meeting." Ian Breakwell, interview by Victoria Worsley, 2004–5, in *National Life Stories: Artists' Lives*, British Library Sound Archive, London.

7. Hudek and Sainsbury, *Individual and the Organisation*, 1.

8. The APG became Organisation and Imagination (O+I) in 1989 and formalized the APG tenet as the first of its axioms.

9. Walker, "APG," 163.

10. Ibid.

11. Derek Lyddon, 1976, quoted in Appendix 3 in Latham, "Feasibility Study," n.p.

12. Undated and unheaded sheet, doc. no. 20042/1/3/55/19 (identified as "5 of 13"), Artist Placement Group Archive, Hyman Kreitman Research Centre, Tate Britain.

13. J.A. Ford to Barbara Steveni, November 7, 1975, doc. no. 20042/1/3/54/28, Artist Placement Group Archive, Hyman Kreitman Research Centre, Tate Britain.

14. Ibid.

15. Antony Hudek, "Exhibition Guide," in *The Individual and the Organisation*, 6.

16. After 1979, the APG engaged with organizing high-level governmental and other meetings in Germany, France, and the Netherlands. It renamed itself O+I (Organisation + Imagination) in 1989, later dissolving in 2008.

17. John Latham, interview by Melanie Roberts, in *National Life Stories: Artists' Lives* (London: British Library Sound Archive, 2000).

18. Peter Eleey, "Context Is Half the Work," *Frieze* 111 (November–December 2007): 154–59, https://frieze.com/article/context-half-work.

19. Walker, "APG," 163.

20. Eleey, "Context Is Half," 154–59.

21. John A. Walker, *John Latham: The Incidental Person—His Art and Ideas* (London: University of Middlesex Press, 1994), 16.

22. While theories of material transformation and entropy continued to be present in many of his later works, his later scientific theories and his pursuit of a visual theory of "least time" meant that Latham's work was increasingly described as relating to the new theories in physics, with one major exhibition entitled *Art after Physics* (1992) in Oxford's Museum of Modern Art perfectly summing up Latham's intent.

23. Walker, *John Latham*, 85–86.

24. Latham's Scottish affiliation was enduring. He visited briefly during the summer of 1964 in the company of Scottish author Alexander Trocchi, stayed with the Edinburgh bookshop owner

Jim Haynes in 1964, and went with his wife Barbara Steveni to speak at Edinburgh College of Art's now forgotten art event *Participation Art* in 1972.

25. Latham, "Feasibility Study."

26. Ibid.

27. Michel Serres and Bruno Latour, *Conversations on Science, Culture, and Time* (Ann Arbor: University of Michigan Press, 1995), 37.

28. A comparative image of "Five Sisters" that I documented from the nearby Addiewell bing in 2008, using the same vantage point as Latham's in 1976, shows that the surface ecology covering these bings has continued to add to their naturalistic appearance. But while the terrain of *Niddrie Woman* has begun in some ways to harmonize with the surrounding hilly terrain, the relatively flat terrain surrounding "Five Sisters" makes the bing stand out dramatically. Unlike the shale bings that form *Niddrie Woman,* the form of "Five Sisters" is balanced and visibly unnatural and has been adopted by various agencies including the local council as the emblem for the region.

29. Metzger, "Auto-Destructive Art."

30. John Latham, undated, untitled document, TGA 20042/1/3/54/33, Artist Placement Group Archive, Hyman Kreitman Research Centre, Tate Britain.

31. "Sculpture may be able to stir a new approach.... The inertia that seems to grip our capabilities (politics of power (maintenance or exercise), beaurorcracy [sic] the growth industry, absence of a coherent vision) [sic] has either to be defied or submitted to. The Sculpture addition [*Handbook of Reason*] is to state this—we refuse to be buried by bing formations, we are a different kind of being." Ibid.

32. Bernd Becher and Hilla Becher, "Industrial Landscapes," interview by Susanne Lange, in *Bernd and Hilla Becher: Life and Work*, ed. Susanne Lange (Cambridge, MA: MIT Press, 2007), 196.

33. Robert Smithson, "A Sedimentation of the Mind: Earth Projects," *Artforum* 7, no. 1 (September 1968): 83.

34. Latham, "Feasibility Study."

35. Lucy R. Lippard, *Overlay: Contemporary Art and the Art of Prehistory* (New York: New Press, 1983), 145, caption 18c, and 45. Lippard later advocated a related pedagogical program: "There are few courses, much less full-scale programs, in this country that train artists to work in social contexts. Most tend to come to a piece of land with an idea in their head, with their approach already formed. Few artists are working in park systems or allying themselves with farmers, ranchers, cultural geographers, archaeologists, national park bureaucrats, and wilderness advocates, or even know about the new field called 'environmental interpretation,' which should be made-to-order for artists." Lucy R. Lippard, "Land Art in the Rearview Mirror," in *Art in the Landscape* (Marfa, TX: Chinati Foundation, 2000), 6.

36. Robert Morris, "Notes on Art as/and Land Reclamation," *October* 12 (Spring 1980): 102.

37. Ibid., 98.

38. Barbra Harvie, *West Lothian Local Biodiversity Action Plan—Oil Shale Bings* (Linlithgow: West Lothian Council, 2005), 1, 19, www.era.lib.ed.ac.uk/handle/1842/846.

39. Ibid., 22.
40. Ibid., 11.
41. Rosalind E. Krauss, "Sculpture in the Expanded Field," *October* 8 (Spring 1979): 30–44.
42. Daryl Martin, "Translating Space: The Politics of Ruins, the Remote and Peripheral Places," *International Journal of Urban and Regional Research* 38, no. 3 (May 2014): 1102–119, doi:10.1111/1468-2427.12121.

PART TWO

AFFECTIVE FEEDBACK

Time, Play, and Contagion as Systems of Participation

———

ERICA LEVIN

6

SOUNDING *SNOWS*
Bodily Static and the Politics of Visibility during the Vietnam War

CAROLEE SCHNEEMANN'S KINETIC theater performance *Snows* was produced as part of the Week of Angry Arts, an artist-led protest against the Vietnam War that took place in New York City in the winter of 1967 under the threat of blizzard warnings.[1] Promoted as a festival of dissent, the program included more than forty performances, concerts, plays, films, and exhibitions by some five hundred artists.[2] These formal events were punctuated by an impromptu "Be-In" at Lincoln Center and a poets' caravan that braved the cold to stage confrontational readings on street corners across the city, from the Village to Harlem.[3] Schneemann's *Snows* brought the wintry weather inside, if only as mise-en-scène. Grainy footage of skiers spilled onto the walls of the theater where the work was performed.[4] Artificial tree branches rescued from a department store's discarded Christmas display formed a crystalline fringe around the stage. Fake snow fell gently from above, clinging to the performers' hair and eyelashes.

Schneemann's production also explored "snow" as a metaphor for signal noise. It extended the experimental incorporation of technology

into live performance that had been initiated during *9 Evenings: Theatre & Engineering*, which had taken place in October 1966, just a few months before *Snows* went into production. *9 Evenings* brought together artists and engineers from Bell Telephone Laboratories for performances that involved radio waves, infrared television, sonar, and other technical elements. After the series ended, the organizers of the event, including Robert Rauschenberg and Billy Klüver of Bell Laboratories, established Experiments in Art and Technology (E.A.T.). *Snows* became the first work officially to receive the group's support.[5] Many of the performances staged during *9 Evenings* approached technology as a novelty to be explored for its own sake. The impetus for the collaboration, according to Klüver, was not simply to humanize unfamiliar technologies but to involve engineers in new kinds of problems unlike the "rational problems" they were typically called upon to resolve.[6] For the artists who participated in *9 Evenings* the opportunity to work with these technologies opened up the possibility of creating images and sounds by way of automated mediation. For example, in Alex Hay's *Grass Field,* electrodes placed on a performer's body relayed biological data as signals to a central sound panel. In *Vehicle,* by Lucinda Childs, sonar waves bounced off objects and bodies on stage.

Robert Rauschenberg's *Open Score* presented an especially vivid exploration of the technology featured during *9 Evenings*. The performance began with a volley between tennis players surrounded by a halo of bright light. Sensors connected to each racquet created a loud resonant pong whenever the ball made contact with the racquet's strings. This sound was sent by way of a hidden transmitter in the grip of each racquet to FM receivers placed at various spots on the court. Amplified, the sounds were to trigger one light after another to go out until the entire performance space was bathed in darkness. (In the first of two performances, this automatic aspect of the lighting design failed, and lights were turned off by hand to simulate the intended effect.) Once the lights were entirely extinguished, a large crowd entered the darkened space. Filmed live by infrared video cameras hooked up to projectors, they appeared as ghostly images on screens suspended from above. As military technology repurposed for art, the use of these cameras signaled (if only obliquely) a desire to counteract the excesses of instrumental reason. *Snows,* performed a few months after *9 Evenings,* but in the context of explicit antiwar protest, also made use of sensors and circuits but troubled this attempt to reclaim such technologies and their attendant logics of mediation and control.

While a work like *Open Score* made the cueing of lights into a spectacularized display of a live feedback mechanism, *Snows* did the opposite, obscuring and dispersing the source of lighting cues created through feedback so that they appeared automatic or even invisible. In *Snows,* sensors and transmitters were scattered throughout the theater, attached to the underside of randomly chosen seats. The restless shifting or movement of a person sitting in one of these seats would trigger a contact-microphone, which fed its signal into an SCR (silicon-controlled rectifier) switching system designed to control the flashing of colored lights. In turn, these modifications of the lights served as cues for a change of action on stage.[7] Schneemann was less interested than Rauschenberg and many of the other

9 Evenings artists in the spectacle of technology than in its capacity to create an environment in which looking might be registered via these relayed signals as an embodied activity. Though *Snows* made use of a technological feedback circuit in the staging of the work, it ended with a meditation on the limits of feedback as a model of social action, making room for reflecting on vulnerability, loss, and the difficulty of acting in the face of the uncertainty provoked by reports of distant war.

The performance began with six performers—three women and three men—gathering on stage to watch a found newsreel from 1949 depicting a series of catastrophes, battles, and acts of violence—what Schneemann described in an interview with Gene Youngblood as "one little horrific element after another."[8] After the newsreel, the male and female performers paired off and slowly circled one another, lunging forward or giving in to the attack rather than resisting it. Later Schneemann would employ similar exercises in a series of workshops she offered focused on techniques for avoiding injury during protests or police raids.[9] Within the context of *Snows* these exchanges allowed the audience to see what bodies look like when intensely focused and attentive to each other's actions. At the same time, each performer played a role as if adopted from the dramas featured in the newsreel. Actions coded one figure as "aggressor" and the other as "victim." The performers' gestures did not directly mirror the events pictured in the newsreel, but the roles they played triggered associations with its images of war, battle, attack, and surrender. As the performance developed, however, their bodies lost this coded legibility.

During the next phase of *Snows* pairs of performers covered each other's faces in white grease paint and took turns manipulating one another's expressions, as if molding them out of clay (figure 6.1).[10] Strobe lights interrupted the action, transforming it into a series of snapshot-like freeze frames. Performers switched roles, but there was no way to know how one interaction fed into the next, since each produced only unreadable, arbitrary changes. The action began under flickering strobe lights that then gave way to softer flashes of light activated unknowingly by members of the audience sitting in the seats wired into a circuit directly connected to the light board. Withholding direct reference to Vietnam, these passages in *Snows* evoked media coverage of the war only indirectly, while providing space for reflecting on discomfort caused by the proliferation of especially shocking images of war's human costs that emerged during the week of artist-led protest.

The Week of Angry Arts was marked by disagreements between artist-protesters about how to address the public at large, fueled by concerns that shocking news images of bodily violence might generate too much emotion, unwanted feelings, or, perhaps worse, not much reaction at all. Throughout the week of citywide protest, photographs of Vietnamese villagers disfigured by napalm and shrapnel appeared at unexpected moments. Posters plastered all over the city confronted passersby with an image of a woman cradling a toddler covered in burns. Slides of napalm-scarred Vietnamese children drawn from William F. Pepper's photo-essay "The Children of Vietnam," published in the New Left journal *Ramparts,* were projected during a poetry reading held in a New York University auditorium. Blown-up enlargements of these same images made their way through the streets of the city attached

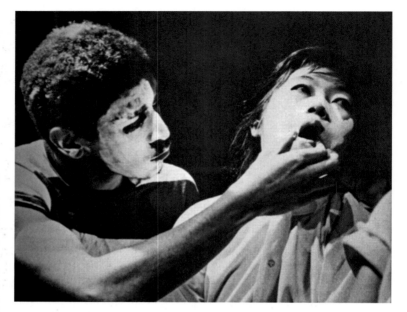

FIGURE 6.1
Carolee Schneemann, *Snows*, 1967. Performance presented as part of the Week of Angry Arts, Martinique Theatre, New York, NY, January 21–22, 27–29, February 3–4, 1967. Photo by Alec Sobelewski. Courtesy of the artist.

to the side of a flatbed truck that traveled as part of the caravan bringing antiwar poetry and performance out into the street.[11] During the readings the poets handed out thousands of copies of a pamphlet with a cover featuring a child whose flesh wounds provided further evidence of the horror perpetuated by the American military's use of incendiary agents against civilians.[12] Throughout the week, and in many protests to follow, images of bodies bearing disfiguring marks of violence were enlisted to convey the urgency of antiwar dissent.

Not everyone who participated in the Week of Angry Arts endorsed the use of spectacularized images of scarred and burned Vietnamese villagers. A full-day event entitled "An Act of Respect for the Vietnamese People" implicitly challenged the impulse to let shocking photographs speak for themselves. Musicians played Vietnamese music. Susan Sontag read Buddhist texts. There were presentations about Vietnamese rivers, villages, food, and families. "Information not emotion was to be the medium," concluded one reporter after interviewing the event's organizers.[13] Seen in this context, Schneemann's contribution to the Week of Angry Arts registered ambivalence about the use of emotionally charged images, while remaining equally uncertain about the efficacy of information overload as a countervailing strategy.[14] Said another way, *Snows* wrestled with the affective fallout produced by protest tactics of confrontation, shaming, and overexposure. It allowed for the significance of certain actions to develop retroactively, and then only at the risk of loss or the failure of vision. Calling forth an impossible form of mediation, it pictured a fleeting image of mutual visibility, however open to manipulation, mobilizing relays between reception and response that were also fraught, forced, and above all uncertain.

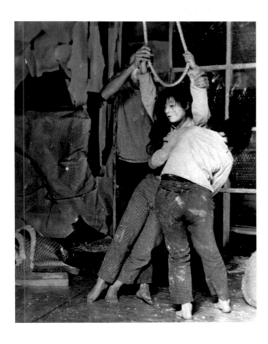

FIGURE 6.2

Carolee Schneemann, *Untitled* (vintage photograph from *Snows* performance), 1967. Gelatin silver print, 12 ¾″ × 10 ¾″. Photo by Charlotte Victoria. Courtesy of the artist and P.P.O.W. Gallery, New York.

As *Snows* progressed, cybernetic forms of response and control, mediated by the technological setup of the wired theater, gave way to seemingly random actions where roles were no longer immediately reversed and repeated. For example, two performers dragged a third across the stage. Then, as directed by the performance score, they "hung" this figure up with a looped length of rope (figure 6.2). Finally, they wrapped her limbs and torso in tinfoil. Specific elements of this tableau anticipated some of the images that appeared briefly during the projection of Schneemann's film *Viet Flakes* at the conclusion of the performance. Suggesting another snowy metaphor for disorienting fragmentation and noise, the film's title evokes the horrific banality of the daily news, reports of aerial bombing punctuated by ads for breakfast cereal. Seen in the context of *Viet Flakes,* actions like the dragging, hanging, and wrapping of limbs staged earlier in the performance become legible belatedly, in sharp contrast to the scenes of immediate action and reaction that open the performance.

Schneemann made *Viet Flakes* with a handheld camera and the improvised use of magnifying lenses, which she used to scan news photographs from reports on the intensifying conflict in Vietnam. In the film, scenes of war come in and out of focus as Schneemann moves her camera over their surfaces. A picture of a Viet Cong soldier dragged behind an American tank, taken by the Japanese photojournalist Kyōichi Sawada for the wire service United Press International and awarded World Press Photo of the Year in 1966, retroactively recodes the act of dragging a body across the stage. Likewise, a glimpse of a photograph of a man strung up by his ankles during an interrogation by South Vietnamese troops (figure 6.3) appears briefly in Schneemann's film. It calls to mind the action of hanging a body by a

FIGURE 6.3
Carolee Schneemann, *Viet Flakes*, 1965–67. Still from 16mm film transferred to video, 7 minutes, distributed by Electronic Arts Intermix. Courtesy of the artist and P.P.O.W. Gallery, New York.

rope earlier in *Snows*. The photo was taken by Sean Flynn for *Paris Match* and was reproduced widely enough that in May of 1966 *Time* ran a story about its role in fueling growing antiwar sentiments. In the eyes of the magazine's editors, the proliferation of indignant captions accompanying the photograph in various newspapers had failed to tell the story behind the interrogation reported by the photographer.[15] *Viet Flakes* does not analyze the image to discern whether the truth of one caption or another can be determined by something that appears in the frame. Through camera movement, Schneemann animates these images with her own distress and desire to transform or turn away from the violent acts they picture. The camera makes this private experience of looking public.

The composer James Tenney, Schneemann's partner at the time, produced the film's haunting soundtrack.[16] Tenney's tape collage for *Viet Flakes* punctuates Schneemann's lurching camera with a jarring mix of pop singles, strains of Vietnamese folk music, and fragments of Bach reminiscent of radio signals coming in and out of range. During *Snows*, this audio collage played independently of the film during the sequence in which performers manipulated each other's faces and bodies—the visual static of their illegible gestures and expressions further amplified by signals that strained against the entropy of noise. Another tape produced collaboratively by Schneemann and Tenney of recordings they made while living together in Illinois as graduate students accompanied the phase of the performance punctuated by the flashing the strobe light. To make this recording, the couple placed a tape deck under the bed, where it picked up the sounds of their lovemaking. Tenney then cut this audio together with a recording of a train whistle that Schneemann describes as "haunting" that period of their life together. The finished collage, referred to in the score for *Snows* as "T&O tape" (trains and orgasms) also verges on noise. Schneemann writes in a letter to Joseph Berke, "You can't believe how many people had no idea what that sound was!" She reports that people mistook it for a variety of other sounds: a baby, a sheep, the sounds of torture, or the electronic manipulation of a classical song.[17] While Tenney's soundtrack for *Viet Flakes* evokes the public domain of broadcast, the T&O tape registers the most per-

FIGURE 6.4

Carolee Schneemann, *Viet Flakes,* 1965–67. Still from 16mm film transferred to video, 7 minutes, distributed by Electronic Arts Intermix. Courtesy of the artist and P.P.O.W. Gallery, New York.

sonal space of intimacy. In the context of *Snows,* the distinction between these two domains begins to break down.

Viet Flakes seeks a form for publicly sharing an otherwise private experience of encountering news images of war. Schneemann's camera in *Viet Flakes* moves over these photographs as if animated by the desire to look closely and the equally powerful desire to turn away. As the camera pans, details are thrown in and out of focus. An image may linger on screen long enough to recall actions staged earlier, or it may flash by too quickly to be grasped. At one point during *Viet Flakes,* an image of a woman lying on the ground in a hospital appears fleetingly. She holds up a hand dressed in tattered bandages while a child nurses at her breast. The photograph was originally published in the same *Ramparts* photo-essay that included graphic images of bodily violence featured prominently in a number of other events staged throughout the Week of Angry Arts.[18] When this photograph comes into view in *Viet Flakes,* a brief glimpse of her face (figure 6.4) is visible before the frame goes out of focus again, cutting to a series of shots that encompass more of her full but blurred figure. Schneemann's camera quickly scans over the details that provide the shock of the original picture—the ragged bandage juxtaposed with a child at her mother's breast—finally focusing on the look that greets the photographer's lens. The woman in the photograph regards the camera steadily and directly, confronting anyone who might prefer to scrutinize her situation, her body, without having to acknowledge first her capacity to look back. *Viet Flakes* makes this impossible and impossibly fraught exchange across time and space into something to see, to share, but in doing so it also acknowledges the urge to look away, to give oneself over to feelings of helplessness.

The scanning camera risks treating the subjects of the film as objects of knowledge to be examined at close range. And yet *Viet Flakes* undermines any attempt to confirm and shore up a sense of control over what is seen. Instead, the movements of the camera suggest the undoing of its operator's own self-possession, even as it leaves open the question of what kind of access to experience this embodied point of view ultimately enables. Vision

in *Viet Flakes* strains against knowing or possessing. The film probes the relationship between looking and being seen, testing the limits of reciprocity and exchange that would undermine a viewer's own sense of visual and self-mastery, while acknowledging the risk of displacing that viewer's own dispossession onto figures marked as othered within the context of war as a way to mitigate the threat of difference. In the context of *Snows, Viet Flakes* reads as the visualization of these risks, a means for reflecting on why such images are as likely to constrain the work of organizing dissent as they are to inspire it.

A number of photographs included in *Viet Flakes* have appeared in print alongside two different versions of the published score of *Snows*. In Schneemann's published collection *More Than Meat Joy,* the photo of the man strung up in a tree to be interrogated is paired, for example, with a picture of one of the performers, Shigeko Kubota, notably the only Asian member of the cast of *Snows,* being "hung" from the looped rope on stage.[19] The photograph of the woman with the bandaged hand originally published in *Ramparts* has never reappeared in any of the published documentation of *Snows*. Though it echoes the extended action in which the body of the "hanged woman" is wrapped in tinfoil, flashing by in *Viet Flakes,* it openly risks failing to register at all. Since this body is made over as a silvered surface, its heightened exposure to light during this action paradoxically causes it to disappear from view. Wrapping is protective; it suggests the process of fostering an image in potential—the possibility of recovery, but also the threat of loss. Schneemann makes much of the associative qualities of her materials. She procured the foil used in *Snows* from the Reynolds Metal Company, a firm then involved in weapons production for the war. While Rauschenberg responded to the mounting violence in Vietnam during *9 Evenings* by reclaiming the military technology of infrared surveillance for art in *Open Score,* in *Snows* Schneemann explored the affective and social dimensions of visibility shaped by military conflict and the dissent it generates. Foil has conductive properties; like many of the other materials incorporated into the production of *Snows,* such as rope and the sensors used in the feedback system, Schneemann used it to draw out relationships between bodies. At the same time her use of foil in *Snows* threatened to obscure the particularity of the distinct bodies of her performers in ways that mimicked the scarring of flesh by napalm. If *Snows* began with a sequence in which these performers responded attentively to each other's micro-movements, then it ended by mobilizing relays between images that were much more difficult to see, and as a result risked never registering at all.

While other artist-protesters during the Week of Angry Arts pursued strategies of obscene exposure and confrontation, Schneemann made space for reckoning with the ambivalence, restlessness, and uncertainty provoked by war reportage. John Berger, in his 1972 essay "Photographs of Agony," offers an account of the redoubled effect of violence perpetuated by photojournalism during the Vietnam War. In his view, this violence enacts "cuts in time" that produce a sense of incommensurability with the everyday.[20] Shame and the desire to "other" the figures depicted in photographs of the war generate depoliticized compensatory reactions that naturalize violence, dismiss it as an age-old human drama, an endless cycle where someone will always play the role of aggressor and someone else the

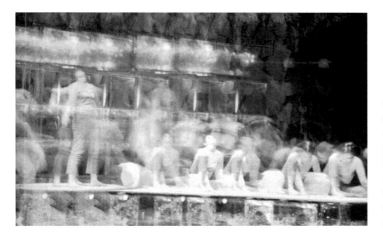

FIGURE 6.5
Carolee Schneemann, *Snows*, 1967. Performance presented as part of the Week of Angry Arts, Martinique Theatre, New York, NY, January 21–22, 27–29, and February 3–4, 1967. Photo by Herbert Migdoll. Courtesy of the artist.

role of victim. The title *Snows* hints at this possibility, a metaphor for violence as random and regular as the weather. The action of bodies coded as "aggressor" and "victim" might seem to reinforce a similar view, particularly when caught in the glare of a flashing strobe light. But by evoking the technological image of television fuzz, *Snows* also suggests a channel conveying no information, only noise—a closed feedback loop without end. This is the sense of the title that comes to the fore during moments in the performance in which contact between bodies becomes more difficult to read, an effect Schneemann underlines in the published documentation of the piece, which includes time-lapse photography (figure 6.5) and other images that confront the viewer with the illegibility of the performers' bodies.

Schneemann's title, *Snows,* could also be understood a third way, as a register of the affective static, the enervation that comes with confronting the pain of others (to borrow the phrase from Susan Sontag).[21] The body wrapped in silvery foil provides a countermodel to photography figured as a flash or a cut in time. It develops in the moving light of *Viet Flakes* but also bears with it the risk of disappearing again without having changed a thing. *Snows* acknowledges the feelings of ambivalence, helplessness, and disavowal that may follow from this possibility. The cybernetic concept of feedback animates fantasies of control, where every action produces a predictable and measurable, which is to say perceptible, reaction. *Snows* reminds us that to participate fully in the actions that bind us together socially and politically, to exercise dissent, we must resolve to put such fantasies aside. We can neither retreat into helplessness nor expect immediate, clear confirmation of how our actions will register and how their meaning will carry forward.

The relentless shifting between fragments of songs in James Tenney's contribution to *Snows* recalls the act of scanning or tuning a radio. Familiar pop songs especially seem to linger; the urge to complete their broken refrains is almost irresistible. Something about this radio effect cuts against the intensely private scanning of the image by Schneemann's camera. It evokes the vague sense generated by broadcast media, not only of other signals

in the air, but also of other people tuning in elsewhere. In this context, a body wrapped in foil reads as a kind of an antenna, an imperfect and makeshift remedy for poor reception, but also crucially, for forms of everyday atomization. While Rauschenberg and many of the other artists who participated in 9 *Evenings* were interested in the possibility of using technological control mechanisms and forms of feedback to create a new kind of cybernetic image, Schneemann's *Snows* takes up images that were already pervading the media sphere, attentive to the way fantasies of control condition collective protest. Schneemann's work visualizes a process that entails moving, acting, and struggling with and alongside others while remaining uncertain about one's own control—or lack of control—over what may result.

NOTES

1. The Week of Angry Arts ran from January 29 to February 8, 1967. *Snows* opened before the program officially began on January 21 and ran a total of eight times (January 21–22, 27–29, February 3–5).

2. The Week of Angry Arts involved artists, writers, poets, filmmakers, musicians, playwrights, dancers, actors, and stage technicians. The breadth of participation is documented in Rudolf Baranik's report, "The Angriest Voice," May 1967, folder 1, Rudolf Baranik Files, PAD/D Archives, Museum of Modern Art Library. The *Washington Post* reported that the week included "13 classical music concerts, a jazz concert dedicated to draft age youths, a folk and rock marathon, some 40 films, two evenings of dance, five evenings presented by Broadway and Off-Broadway actors, a variety of exhibits and panel discussions and other endeavors more experimental in form." More than one hundred artists contributed panels to a 120 × 20 foot "Collage of Indignation." Rasa Gustaitis, "'Angry Arts' War Protest Opens in N.Y.: Unprecedented in Scope," *Washington Post,* January 30, 1967, D8.

3. On the event at Lincoln Center, see Marlene Nadle, "Angry Arts: Aiming through the Barrier," *Village Voice,* February 6, 1967, 3. The poets' caravan is mentioned in Don McNeill, "Week of Angry Arts: Protest of the Artists," *Village Voice,* January 26, 1967, 13. Both are also briefly discussed in Francis Frascina, *Art, Politics and Dissent: Aspects of the Art Left in Sixties America* (Manchester: Manchester University Press, 1999), 117–19, 125.

4. *Snows* ran at the Martinique Theater on Thirty-Second Avenue and Broadway.

5. See Ralph Flynn, "*Snows* Technical Description," *E.A.T. News* 1, no. 2 (June 1, 1967): 17–18.

6. In an interview with Garnet Hertz, Billy Klüver affirms but qualifies the statement that collaborations between artists and engineers could humanize "American technological genius." He states: "The way I see it is that artists provide non-artists—engineers or whomever—a certain number of things which non-artists do not possess. The engineer expands his vision and gets involved with problems which are not the kind of rational problems that come up in his daily routine. And the engineer becomes committed because it becomes a fascinating technological problem that nobody else would have raised. If the engineer gets involved with the kinds of questions that an artist would raise, then the activities of the engineer go closer towards that of humanity." Garnet Hertz, "The Godfather of Technology and Art: An Interview with Billy Klüver," April 1995, Concept Lab, www.conceptlab.com/interviews/kluver.html.

7. Carolee Schneemann, "Snows," *More Than Meat Joy: Performance Works and Selected Writings,* ed. Bruce R. McPherson (New Paltz, NY: Documentext, 1979), 130–31.

8. Gene Youngblood, *Expanded Cinema* (New York: E.P. Dutton, 1970), 368. Schneemann identifies this newsreel as a 16mm Castle Film from 1947, but the events she describes to Youngblood—a fire on a passenger ship, Chinese Nationalist soldiers executing Communist sympathizers in the street, an American Legion Parade, the pope blessing children at the Vatican, an earthquake in Ecuador, the eruption of a volcano in Mexico, and crashes at the Indy 500— actually occur in Castle Film News Parade of 1949. Images from this newsreel have been reprinted along with the score of *Snows* in *More Than Meat Joy.* See note 19.

9. In a letter to Henry Sayre, Schneemann mentions her efforts to translate these kinds of performance tactics into exercises that would help protesters "anticipate police actions against peaceful demonstrations" after the police violently corralled the crowd at the Grand Central Be-In on March 22, 1968. See Carolee Schneemann, *Correspondence Course: An Epistolary History of Carolee Schneemann and Her Circle* (Durham, NC: Duke University Press, 2010), 364.

10. Schneemann first explored this type of action, which the score identifies as the "creation of faces," in *Ghost Rev,* staged in November 1965 with Phoebe Neville in collaboration with the media art collective USCO. It resembles aspects of Reichian therapy designed to dissolve "holding patterns" or "body armoring." Schneemann identifies Wilhelm Reich as an important influence. In her letters, she often uses language that evokes his concept of muscular or character armor. See, for example, Carolee Schneemann, "Letter to Joseph Berke, February 14, 1967," in *Correspondence Course,* 114. For a fuller account of Reich's influence on her work, see Anette Kubitza, "Fluxus, Flirt, Feminist? Carolee Schneemann, Sexual Liberation and the Avant-Garde of the 1960s," *n. paradoxa,* nos. 15 and 16, July/September 2001 and July 2002.

11. Max Kozloff describes the ubiquitous appearance of a poster that confronted passersby with the question: "Would you burn a child?" during the Week of Angry Arts. See Max Kozloff, ". . . A Collage of Indignation," *Nation,* February 20, 1967, 248–51, and Curtis Harnack, "Week of the Angry Artist," *Nation,* February 20, 1967, 245.

12. Frascina, *Art, Politics and Dissent*, 188.

13. Gerald Jonas, "Dissent," *New Yorker,* February 11, 1967, 30.

14. After *Snows,* Schneemann turned increasingly to sensory overload as a strategy in works such as *Ordeals,* staged at the Judson Church in August 1967, and *Electronic Activation Room*, staged at the Happenings & Fluxus Retrospective in Cologne, in the winter of 1970–71. See *More Than Meat Joy,* 163. *Electronic Activation Room* focused more on audio/visual information overload than the kind of bodily experience produced by the torture tunnel in *Ordeals*. Both works suggest that the ambivalence in *Snows* toward overload as a strategy is something that Schneemann continued to explore. For a nuanced reading of the stakes of sensory overload in *Electronic Activation Room*, see Kenneth White, "Meat System in Cologne," *Art Journal* 74, no. 1 (Spring 2015): 56–77.

15. *Time* reported that the man in the photograph had confessed to being a sniper responsible for the death of a small child. According to the photographer who had followed the unit as they searched for the sniper, the man was cut down from the tree unharmed and taken as a prisoner after fifteen minutes of questioning. "Angle Shots," *Time,* May 6, 1966, 43.

16. Tenney played an integral role in many of the *9 Evenings* performances, serving, for example, as a projectionist in Rauschenberg's *Open Score*. He occupied a unique, hybrid position between artist and engineer. In 1961 Tenney arrived at Bell Labs to work as a composer in residence with a focus on what was then called psychoacoustics. While he was there he created a series of collaged compositions using tape recorders and began to write software that used computers to compose music, becoming one of the first experimental composers to do so. Tenney's residency at Bell Labs lasted until 1964, but he remained in close touch with Billy Klüver and played an important part in facilitating E.A.T.'s support of *Snows*. Schneemann has distanced herself from E.A.T., claiming that *Snows* was supported by the group only informally because of Klüver's relationship with Tenney. See "Carolee Schneemann, Interviewed by Kenneth White," *Third Rail* 4 (Winter 2015): 15.

17. Schneemann, "Letter to Joseph Berke," 116. In her diary on January 12, 1967, she writes, "Work with Jim on tape, its coming wonderfully exactly what I hope for . . . analogies and transitions of sound." Carolee Schneemann Papers, Getty Research Institute.

18. William F. Pepper, "The Children of Vietnam," *Ramparts,* January 1967, 45–68.

19. The scenario for *Snows* first appeared in print in 1968 in the small magazine *I-KON* (no. 5). It was later reprinted in *More Than Meat Joy,* 129–44. It is also excerpted in *Happenings and Other Acts*, ed. Mariellen Sandford (London: Routledge, 1995), 219–24. The score also appears in modified form in Schneemann's collected writings, *Imaging Her Erotics: Essays, Interviews, Projects* (Cambridge, MA: MIT Press, 2002), 74–85.

20. John Berger, "Photographs of Agony," in *About Looking* (1972; repr., New York: Pantheon Books, 1980), 37–40.

21. I borrow this phrase from Susan Sontag. See *Regarding the Pain of Others* (New York: Picador Press, 2003).

CRISTINA ALBU

7

CONTAGIOUS CREATIVITY

Participatory Engagement in the *Magic Theater* Exhibition (1968)

UPON ENTERING THE *MAGIC THEATER* exhibition at Kansas City's Nelson Gallery of Art on the opening night, viewers encountered a convivial atmosphere that was quite at odds with the private and contemplative aesthetic experience generally privileged within art museums. Charles Ross's wall of prisms filled with distilled water marked the entry point in the exhibition, inviting visitors to contemplate their self-reflections against its zigzagging surface. Stephen Antonakos's neon platform similarly called for perceptual and kinetic engagement with its gradually changing colored lights across which viewers could take their time to walk. The next stop along the carefully choreographed sensorial path was James Seawright's cybernetic "brain" emitting lights, sounds, and air currents that could be modeled by visitors' movements. To the left of this central exhibition axis was Stanley Landsman's infinity environment, a cubic space paved with myriad lights lined up behind transparent screens, which would ideally trigger states of expanded consciousness. Its quiet and immersive atmosphere stood in contrast to Howard Jones's sonic room, where visitors could activate sounds by waving their arms in front of

sensor-based units. Acoustic engagement became even more intense in an adjacent octagonal pavilion, designed by Terry Riley, which called upon viewers to produce sounds that would then be replayed at different time intervals. Acoustic reverberations formed the basis of Robert Whitman's environment, which could be found across the hall in a curtained room where the vibration of thumping sounds distorted the reflective surface of Mylar disks. At another point along this trajectory, visitors encountered Boyd Mefferd's strobe-lighted floor, which exerted a quasi-hypnotic impact through its flickering effects.

Reviewers of the exhibition remarked on the impulsive behavior of a significant number of visitors, sometimes complaining about the disruptive effect of their raucous conduct, other times praising its liberating potential. Alfred Frankenstein suggested that "the human reaction to all these things was often a better show than the show,"[1] and Jack Burnham wondered if the exhibition was announcing "a more lively and permissive atmosphere," sharply contrasting with "the protocol of silent veneration" preached by museums.[2] The contagious enthusiasm provoked by *The Magic Theater* seemed even more perplexing in light of curator Ralph T. Coe's intent to stage an experience that would turn participants toward inward contemplation. In what follows, I explore the apparent contradiction between the curatorial goals and participants' responses to the exhibition. Relying on theories of affective attunement and contagion, as well as on ample exhibition documentation and reviews, I elucidate the correlations between self-consciousness and interpersonal awareness in the context of *The Magic Theater*. In my discussion of the precarious balance between private immersion and public engagement, I focus on four of the environments in the exhibition that encouraged participants to note that they were acting as part of a dynamic group: Howard Jones's *Sonic Games Room,* Boyd Mefferd's *Strobe-Lighted Floor,* Terry Riley's *Time-Lag Accumulator,* and James Seawright's *Electronic Peristyle.* While the spectatorial modes they generated were quite different, all these environments alerted viewers to the shifting qualities of the artworks, which were significantly less controlled by the artists and increasingly contingent on the creative input of art participants.

"INSIDE LOOKING OUT": PROGRAMMING PSYCHIC EXPERIENCE THROUGH ART

Coe envisioned the *Magic Theater* exhibition as a counterreaction to an increasingly spectacular culture in which individuals' self-awareness was diminishing as their attention was primarily directed toward sensational images or rapidly changing sensorial stimuli. He believed that artworks based on technology could offer insight into the human psyche at a time when materialistic values had come to overshadow spiritual ones and participation in large music concerts had come to supplement the need for collective rituals. Coe's concerns about growing alienation and reliance on palliative events to restore a sense of connectivity to society were shared by many critical thinkers. In *The Politics of Experience,* a book widely read in the late 1960s, psychoanalyst R.D. Laing called for experiences that could inspire a heightened sense of consciousness in the hope that they would push people out of a state of self-oblivious adaptation to social circumstances. He maintained that

people were growing "so estranged from the inner world that many are arguing that it does not exist; and that even if it does exist, it does not matter."[3] Espousing similar views, Coe aimed to commission the design of artworks that would turn viewers' attention inward rather than immerse them in spectacular events that diminished self-awareness.

Unlike other exhibitions from the second half of the 1960s that featured art and technology projects, *The Magic Theater* was purposefully conceived less as a means of promoting the use of new media and strengthening collaborations between artists and engineers than as a means of stimulating an aesthetic experience that generated heightened states of mental awareness. Thus the medium was secondary in importance to the nature of the engagement that it would trigger. Coe concluded his curatorial statement in the exhibition brochure with the statement: "Inside looking out: that seems a more valid station to take in this day and age. Let us hope that the real bombardment of the future comes not horribly from without, but benignly from within, and that the stimulation—the messages—enable us to face inwardly what we can never outwardly conquer."[4] The theater within the mind was more important for the curator than the theater outside, but ultimately, as participation in the exhibition came to show, both theaters were equally necessary if the spectators were to be alerted to their creative potential.[5]

Coe clearly expressed his intent to support the design of new works that stimulated significantly different sensorial experiences and could not be realized without extensive technical support.[6] Out of the selected artists, Howard Jones was the only one based in the Midwest. Most artists in *The Magic Theater* were active in New York art circles and responded enthusiastically to Coe's initiative to assume greater risks and commission new projects rather than display existing works. While making arrangements for the exhibition, Coe consulted with art dealer Ivan Karp about several artist choices and made visits to the studios of Stanley Landsman and Stephen Antonakos in New York. The curatorial decision to feature a work by musical composer Terry Riley in a visual art exhibition may have seemed surprising in the 1960s, but it was not entirely unexpected, given the growing hybridization of media and art genres at the time. Coe avowed that he wanted to include a project by a "non-artist" in order to "demonstrate the validity of intermedia concepts."[7] The experimental character of Riley's musical performances aimed at expanding consciousness through repetitive patterns probably resonated with Coe's fascination with slowing down experience to enhance its acuity.

In contrast to the Art and Technology program at LACMA (1967–71), the museum assumed more than the role of mediator in the relation between artists and industrial companies contributing to the *Magic Theater* exhibition. The Nelson Gallery became the works' site of production, managing to secure donations from local organizations and engaging numerous volunteers in the construction of certain environments. Since the Performing Arts Foundation in Kansas City generously funded the exhibition, technological companies played primarily the role of suppliers of components, having no active involvement in the decision-making process concerning the types of materials the artists intended to use. *The Magic Theater* reached more than a local audience, traveling to four other locations:

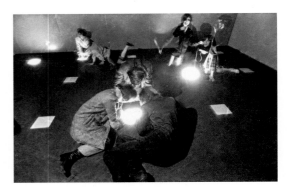

FIGURE 7.1
Boyd Mefferd, *Strobe-Lighted Floor*, 1968.
Courtesy of the Nelson-Atkins Museum of Art.

the City Art Museum in St. Louis, the Toledo Museum of Art, the Montreal Museum of Art, and the Automation House in New York.

Most artists who were selected to contribute to *The Magic Theater* incorporated in their works translucent and reflective materials that seemed to offer the promise of enhanced visibility, yet often had the very opposite effect by multiplying the number of viewpoints or disclosing the mystifying complexity of the electronic systems. For Coe, these media constituted a more direct path toward triggering an immersive mental experience because they did not direct viewers' attention to a detailed examination of the formal qualities of the environments: "These psychic art experiences penetrate more succinctly into our consciousness through a crystalline format (fiberglass, lacquer, bulbs, plastic, electronics) because there is little to impede the path to reaction."[8] The reflective materials fostered viewers' self-consciousness in relation to the work, enabling them to become more actively involved in coproducing the mental experience. As concerns about the manipulative role of television were on the rise in the late 1960s, artists were intent on undermining the passive consumption of images by triggering more embodied modes of spectatorship that entailed active observation and movement. This strategy undermined the "increasing standardization and regulation of the observer," which, according to Jonathan Crary, had started to develop in conjunction with the growing realization of the subjectivity of vision in the nineteenth century.[9] Coe repeatedly emphasized that the selected artists were programming perceptual situations that would invite prolonged reflection on the hidden potential of the human mind. He compared the visit to the exhibition to "a planned voyage . . ., in which transitory psychedelia have been culled out in favor of purer psychic considerations—so that the viewer becomes the subject."[10] Envisioned as an alternative to the psychedelic experiences triggered by hallucinogenic drugs and rock concerts, *The Magic Theater* was conceived as a trip inside the less visible dimensions of the human mind.

Boyd Mefferd's *Strobe-Lighted Floor* (figure 7.1) immersed viewers in a space where physical coordinates seemed just as uncertain and variable as the workings of the human mind. It was composed of strobe lights embedded in square openings in the plywood floor of a completely dark room. Probably the most praised work in the entire exhibition, the

environment offered a perceptual experience that defied the boundaries between objective and subjective vision. The flashes of light appeared to lack color when they fired for an interval as short as one one-thousandth of a second. Their overwhelming luminescence gave way to the formation of colored afterimages, since red, blue, green, and orange filters covered each reflector case. This suspension of patches of color made viewers highly aware of the instability of perceptual processes. The lights took viewers by surprise because they fired at random intervals and made their bodies acquire a ghostly appearance. The environment triggered the "diffuse, scattered kind of attention" described by Anton Ehrenzweig in *The Hidden Order of Art*.[11] Unable to focus their attention on specific visual stimuli that could serve as reference points in space, viewers were compelled to let go of a sense of control over their surroundings and rely on proprioceptive orientation by intuitively sensing how their bodily movements were becoming attuned to the changing appearance of the environment. The flickering shadow projections of others also enabled participants to acquire a sense of their position in space and time. The transient character of the light effects expanded viewers' awareness of corporeal presence and the connections between perception and cognition. In a letter to Coe, Mefferd pointed out that the artist's role was becoming increasingly analogous to that of a "guide" or "relationship proposer" who "must limit himself to *impractical,* but valuable situations, the kind that industry or government would never build."[12] Thus the viewer was assigned the task to form and decode relationships while interacting with an environment that offered no specific behavioral cues or even stable perceptual reference points. For curator Jane Livingston, who reviewed the exhibition for *Artforum,* Mefferd's decision to avoid placing specific demands on viewers' interaction with the environment was what made his work superior to the others on display. She pointed out that in the *Strobe-Lighted Floor* "the spectator was not compelled to move in any specific way or to 'play' the work, in order to fully apprehend it."[13] At a time when numerous art and technology projects asked the viewer to introduce a change in the information system through a specific act, Livingston appreciated the fact that Mefferd did not assign particular tasks to the viewer. This open-ended dimension of interaction contributed to a different experience of duration inside the *Strobe-Lighted Floor* room, especially since it was not clear how much time one should take to observe the effects of the lights. The colored after-images suggested that the mind actively processes visual stimuli beyond the moment when light hits the retina. The disclosed correlations between the exterior and the interior of the body, the conscious and the unconscious, the physical reality and the seemingly illusory construction of it interfered with the desire for spectacular immediacy. In Coe's words, Mefferd's work replaced formal content with "mental contact between the viewer and the time continuum."[14] This heightened awareness of disjunction between the short duration of the light flickers and the time of the lived experience interfered with a contemplative experience oriented toward fixed visual referents and underscored the embodied character of perception.

Terry Riley's *Time-Lag Accumulator* (figure 7.2) also generated a perplexing temporal experience. While observers of Mefferd's environment witnessed color reverberations,

FIGURE 7.2
Terry Riley, *Time-Lag Accumulator*, 1968. Courtesy of the Nelson-Atkins Museum of Art.

visitors to Riley's glass and aluminum pavilion experienced the delayed echo of audio stimuli. Eight transparent soundproof rooms, each equipped with a microphone and a flickering strobe light, were arranged around a central octagonal room that included sound mixing and amplification equipment. According to the initial plans, sounds produced in each compartment would be recorded and mixed with sounds emitted in adjacent rooms, being subsequently broadcast with or without noticeable delay outside the pavilion. The speakers were hidden from view and the sound was dislocated, being projected in a pavilion area that did not correspond to the one in which it was originally produced. Coe's selection of the *Time-Lag Accumulator* was motivated by the "unlocated quality" of Terry Riley's experimental music concerts where spectators were allowed to lie down or move around the performance area.[15] Like Mefferd, Riley had no interest in stimulating a specific mode of behavioral engagement. He originally intended to have cushions and chairs placed outside the octagon in order to enable prolonged observation of the sound effects and the varying degrees of transparency of the glass capsules occasionally illuminated by strobe lights. This plan failed because of the limited space in which the accumulator was inscribed. Art critic Stephen Bann concluded that the environment "conveyed a sensation of oppression more than a sensation of relaxation."[16] The public exposure of participants seemingly trapped in the glass booths further contributed to this impression. The environment paradoxically symbolized both connectivity and disconnection. Participants in adjacent glass capsules could see each other act but could not hear each other. Listeners located outside the octagon could hear the sounds but could not easily identify their source, given the accumulation of multiple stimuli replayed at different moments in time. For them, the installation cultivated a sense of oneness with the ambiental soundscape, which sharply contrasted with the sense of seclusion produced by the compartments of the glass pavilion. The acoustic effect resembled that sought by John Cage in his attempt at establishing "a nonhierarchical field."

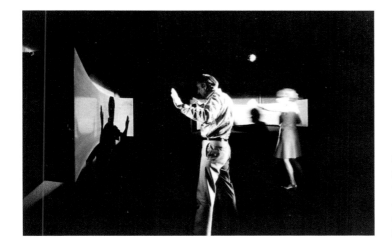

FIGURE 7.3
Howard Jones, *Sonic Games Room*, 1968. Photograph by Howard Jones. Courtesy of the Nelson-Atkins Museum of Art and the Bruno David Gallery, Saint Louis.

According to historian Branden W. Joseph, such a leveling down of hierarchies could enable the listener to "interact as a disinterested equal."[17] Sequentiality and causality were downplayed in favor of immersion, since the synthesis of acoustic stimuli impeded an accurate identification of their point of origin.

This lack of control over the afterlife of sound contrasted with the experience of Howard Jones's *Sonic Games Room* (figure 7.3), which was strategically positioned next to Riley's work. Within Jones's room participants could orient the shadows of their bodies in relation to one of the four aluminum units attached to the walls in order to activate sounds by interrupting the projection of light across the photoelectric cells embedded in them. The acoustic stimuli ranged from low tones and thumps to high-pitched noises and radio broadcasts. If individual agency over sound was somewhat restricted in Riley's environment given its dislocation and integration into an accumulative acoustic system, the visitor's personal acoustic mark, distinct from that of others, was more pronounced in Jones's work, at least at a conceptual level. In his project proposal, Jones suggested the construction of a sonic environment in which visitors could create acoustic "portraits" by staging a playful performance of their shadows across the responsive units.[18] After the environment was completed, Jones realized that visitors were tempted to move in such a manner that they could have a direct impact not only on the photocell unit they were facing but also on the whole chamber. Moreover, the sounds they produced commingled with those produced by others. The environment was comparable to an instrument that could be played individually and collaboratively. Coe emphasized that the *Sonic Games Room* entailed not only spontaneous gestures but also more closely choreographed performances: "By games is meant here not only entertainment, but all connotations of planning in any theory of games: pursuit of sound, gesture with sound, wagers with sound, or the games sound plays with us."[19] For him, it was important to distinguish between the heightened awareness of individual behavior triggered by Jones's work and a

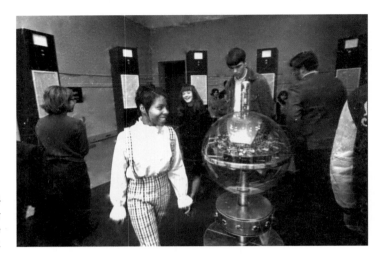

FIGURE 7.4
James Seawright, *Electronic Peristyle*, 1968. Courtesy of the Nelson-Atkins Museum of Art.

more oblivious attitude toward the unique agency one could have in relation to the interactive platform.

If Jones hoped that the *Sonic Games Room* would render visible the personality of the participant interacting with the work, artist James Seawright believed that participants needed to focus more closely on uncovering the personality of the cybernetic system of which they became part. He expressed his confidence in the fact that "the net effect will be that of a clearly apparent 'personality' which is embodied in the piece and to which viewers, depending on their personalities, will react."[20] Seawright's *Electronic Peristyle* (figure 7.4) was composed of a transparent sphere encapsulating electronic circuits that transmitted and received information from twelve black Formica columns surrounding it. By moving around the sphere, visitors could break a series of light beams that linked the central unit to the columns via a network of interconnected lamps and mirrors. As the light flux got interrupted, the intensity of the low-frequency sound emitted by the columns was enhanced. Cause-and-effect relations were not easily readable in this more complex system. As Seawright explained in his proposal, "The breaking of a given beam may produce an immediately apparent change, or it may cause a change of greater degree which will not be apparent for some seconds."[21] This lack of easily perceptible correspondences between a human gesture and an acoustic output of the electronic device frustrated participants. For Seawright, the refusal of *Electronic Peristyle* to perfectly comply with all the performative demands placed on it was supposed to constitute an invitation to spend more time in its presence in order to reflect on its adaptability and become more sensitive to subtle changes in acoustic output.

Coe saw the undeniably playful dimension of *The Magic Theater* as a catalyst for turning inward and considering how consciousness shapes perception. Each and every environment was analogous to a mental space where conscious thought intertwined with unconscious

impulses. Continuing to rely on a system of binary oppositions between body and mind, interiority and exteriority, Coe considered the theater of the mind to be superior to the one unfolding in physical space. However, one could not easily exist without the other since participants' enhanced self-awareness was also triggered by the observation of others interacting with the environments.

AFFECTIVE ATTUNEMENT: ART AS STIMULUS FOR GROUP CREATIVITY

The collective dimension of spectatorship within the exhibition was considered both a source of enhanced aesthetic experience and a detractor from intense psychic engagement. The environments designed by Jones, Mefferd, Riley, and Seawright seemed to gain most from the copresence of multiple participants who would achieve a deeper understanding of the systems they were part of by watching each other's movements and witnessing multiple interactive possibilities. Yet the social dimension of spectatorship also had its limits. While Mefferd's *Strobe-Lighted Floor* and Riley's *Time-Lag Accumulator* allowed for the presence of larger groups, Jones's *Sonic Games Room* and Seawright's *Electronic Peristyle* became quite chaotic when numerous participants tried to solicit a response from them simultaneously. Consequently, art critics' opinions on the social implications of *The Magic Theater* were quite divided, oscillating between admiration for the creativity of visitors who appeared at times to challenge its technological possibilities and skepticism about their ability to become self-aware in the midst of a crowd.

Coe's decision to publish a catalog two years after the opening was undeniably the result of his desire to provide an overview of the responses to the exhibition. The 261-page publication included his responses to art critics' comments, references to visitors' views, and descriptions of a range of participatory modalities. It became apparent that the environments generated affective connections, which often became manifest at the level of spontaneous acts of creativity. Coe's account betrays the contagious effect of responses to the environments: "When symbiosis occurs, when our psyches connect with artistic technology. . . . the excitement communicates not only to the private world of the individual, but by his expressions of participation it carries to the other spectators, in chain reactions which spread across the exhibition area."[22] What Coe overlooked was that the viewer's encounter with the works as part of a collective audience was in itself a trigger of contagious creativity. The correlations between the variability of the technological interfaces and visitors' behavioral responses were more easily revealed at an interpersonal level. The viral participation was not simply mindless, as some of the critics implied. In a review for the *Kansas City Star,* Andrew Tapsony vehemently condemned the fact that artworks triggered irrational impulses and asserted that "a man who exists on the level of perception is a savage for whom, now, a show has been dedicated."[23] While Tapsony harshly criticized the exhibition because it suppressed human will, others adopted a more nuanced perspective, acknowledging the benefits of relinquishing the desire to attain individual autonomy and control. The exhibition highlighted intricate connections between affective experience and cognitive

acts, as participants negotiated more or less consciously their relation to the environment at an interpersonal and collective level. The exhibition made a call for what philosopher Tony D. Sampson names a "rethinking of subjectivity (or subjectivation) as open to the affects of others":[24] that is, a consideration of selfhood as a plastic entity embedded in a social and technological nexus. Participation in *The Magic Theater* implied a connection to a multiplicity and called for becoming attuned to a fluctuating field of empathetic ties, sensorial stimuli, and behavioral modes.

The collective dimension of spectatorship both conditioned and facilitated participants' responses to the environments designed by Jones, Mefferd, Riley, and Seawright. Even though the exchanges between participants were often nonverbal, they were perceptible at the level of behavioral and emotional cues that disclosed the interconnectivity of viewers. These exchanges echoed the three mental states identified by Daniel Stern in his study of relations between mother and child that form the foundation of self-awareness. Participants' reactions to the four environments corresponded to acts of "sharing joint attention, sharing intention, and sharing affective states."[25] In Mefferd's *Strobe-Lighted Floor,* participants intermittently channeled their attention to the projection of other people's shadows in relation to the lights, since these markers of corporeal presence seemingly constituted more stable coordinates than the random strobe flickers. Reassurance often came from the affective connection to others, similarly exposed to variables that eluded control. More of a shared intent could be identified in the sound-based environments when participants started to pursue common goals while exploring how to generate variable acoustic effects. Despite titling his exhibition review "Little Chance for 'Magic' as Crowds Spoil Environment," one of the art critics did not completely discount collaborations between visitors interacting with Jones's *Sonic Games Room*: "You can only begin to understand the set-up of the sound and control devices in a crowd. But alone or with a few friends one can make quite good 'music.'"[26] Similarly, art critic Stephen Bann highlighted the fact that within Jones's sonic environment the movements of others "form a counter-point accompaniment to the sounds" produced by an individual participant.[27] Critic John T. Dauner likewise noted that upon first encountering Riley's *Time-Lag Accumulator* "many persons seem hesitant [...] to speak" but "loosen up as others comment, scream or whistle and soon begin adding their own sounds."[28] The contagious character of participatory impulses may appear to suggest a mindless behavior, but it is quite evident that visitors' responses were not simply imitative but entailed performative variations that enhanced the potential for affective ties and strengthened the desire to spend an extended period of time in the environment. Betsy Broun, an art history student, expressed her enthusiasm for experiencing Mefferd's and Riley's works at times when larger groups of visitors were present, since this contributed to a higher degree of variability of the aesthetic experience: "Especially things like the strobe floor room and the time-delay machine gained by all the fortuitous events going on in and around them.... In the strobe light room you couldn't see your own shadow like you could everyone else's. In that delay machine you didn't hear what you said as much as what went on before, unless you remained right there. It was like listening to someone divorced from

you, or you divorced from yourself."[29] Broun's statements attest to the fact that participants became more conscious of other people's responses to the environments while they simultaneously considered how they themselves would react to the shared field of oscillating light and acoustic stimuli. They became part of an affective group in which they felt intimately connected to others' experience. For example, Broun expressed her admiration for a participant who did a tour jeté in Mefferd's environment but confessed her inhibition to engage in a similar performative gesture. As Stern points out, affective attunement departs from strict imitation of someone else's behavioral acts. He suggests that interpersonal relations develop as long as there is a sense of mutual understanding between the participants engaged in the communicative act. In his view, the affective correlations arise only when there is no perfect coincidence between the behavioral acts of interlocutors, since this implies an acknowledgment of the singularity of the other and a desire for keeping the dialogue open. Thus he asserts that "attunement behaviors . . . recast the event and shift the focus of attention to what is behind the behavior, to the quality of feeling that is being shared."[30] This affective connectivity at the level of similarities and dissimilarities in responses to the environments served as a stimulus for interpersonal inquiry. As they interacted with the works, the visitors were taking not only a trip into the possibilities of the human mind to sense unexpected sensorial stimuli but also a voyage into a microscale model of uncharted social relations that unfolded unpredictably.

In the exhibition catalog, Coe skillfully brought to the surface the tension between certain art critics' frustration with the broad range of responses to the environments and participants' enthusiasm with the heterogeneity of sensorial experiences and participatory acts. While the *Kansas City Star* art critic Donald Hoffman complained that "there is a dreadful lack of coincidence between what different spectators may experience," one of the participants stated that he actually appreciated the fact that there was no perfect correspondence between his experience and that of others: "Another person can tell me what he feels if he wants, and I'll tell him what I feel. That way we share. Besides, there's unity in the thing itself."[31] This comment attests to the affective connections developed thanks to the correlations between experiences that did not perfectly coincide with each other. The enchantment with the viral sensations provoked by the exhibition thus presupposed an acknowledgment of one's otherness and a capacity to come to terms with oscillations between states of keen observation of other participants' responses and states of affective commingling in a collective empathetic experience that interrogated individual autonomy. Above all, *The Magic Theater* cultivated what philosopher Tony Sampson, building on Teresa Brennan's affect theory, defines as "living attention"—"a more imbalanced, in-between state, one in which the maintenance of what constitutes an awareness of self and environment is always open to, even overwhelmed by affect."[32] Art critics found it challenging to assess an aesthetic experience that was shaped by the interconnected voluntary and involuntary responses of fluctuating audience groups. It was not only the newness of the technological media in *The Magic Theater* that upset their criteria of evaluation but also the viral affective ties and creative behavior of participants modulating the sensations.

MAPPING THE AFFECTIVE FIELD: THE FAILURE OF DICHOTOMIC CATEGORIES OF EXPERIENCE

Assessing the value of the works in *The Magic Theater* proved particularly problematic for art critics attempting to establish a hierarchy of responses to the environments by distinguishing between states of pure sensorial enchantment and states of critical reflection on the experience. They were thus enforcing the dichotomies between sensing and thinking, often dismissing the possibility that creative responses that verged on unconventional behavior could also imply intellectual engagement.

In his review for *Art Journal,* art historian George Ehrlich asserted that he could not engage with the exhibition at a psychic level but that he felt compelled to return to it several times to define its relevance. His conflicting experience is best encapsulated in the following question: "Why was there such a difference between what was supposed to happen to me as the viewer, and what did happen to me as the historian-critic?"[33] Intent on drawing sharp distinctions between one's perceptual encounter with the works and one's critical reflection on their significance, Ehrlich was skeptical of the theatrical attributes of the environments because he thought that the performative responses to them were too diverse and undirected. He admitted that the works in *The Magic Theater* made him recollect personal sensorial experiences that he had found intriguing in the past, but he assigned no value to the public acts of spontaneous creativity. Ehrlich's appreciation for the exhibition derived primarily from the fact that it reflected a broadening of the understanding of artistic roles and art objects. He posited that his reflection on *The Magic Theater* after leaving its playful space was more relevant than the actual sensations or behavioral acts it provoked: "There is an after-image of experience which is often more significant than the initial event."[34] Ehrlich perceived the environments as design prototypes that could be reproduced industrially. He cherished the fact that design concepts could attain the status of art but resisted the notion of art as a collectively shared experience.

By contrast, philosopher Rolf-Dieter Herrmann considered that the value of art and technology projects resided primarily at the "preconceptual level" of one's encounter with them.[35] Unlike Ehrlich, for whom technology-based environments were relevant because of the way they questioned the privileged position of the fine art objects, Herrmann thought that they were significant precisely because they did away with prior criteria of art evaluation and highlighted one's self-awareness in relation to fluctuating sensorial stimuli. He associated such an experience with Nietzsche's theory of nihilism and presentism, which posited the collapse of idealism and downplayed the notion that humans are in control of the world. Thus Herrmann suggested that art and technology projects suspended both participants' desire to draw correlations with past experiences and their inclination toward construing future-oriented objectives. He also explained that the individual viewer perceived herself in the context of such playful works as functioning "in the interconnected whole of a communication system" rather than as "an isolated individual."[36] Interestingly, although Herrmann underscored the fluctuating relations between self and others, he fell back on a dichotomic mode of thinking by arguing that the encounter with art and technology

projects would be oriented either toward present sensorial engagement or toward reflection on the meaning and value of the environments.

The works in *The Magic Theater* solicited complex modes of participation that overrode such dichotomies, even though Coe had primarily envisioned a display that would expand the capacity for mental awareness. The physicality of the experience and the affective affiliations prompted by participants' behavioral and emotional attunement complicated the initial statement of curatorial intent. Coe's comments on the exhibition in the catalog proved that he had become increasingly conscious of the indeterminate qualities of some of the environments, which provoked participatory responses that could not have been anticipated even by the artists.[37] Indeed, Mefferd had not anticipated that the shadows of participants in the strobe-lighted environment would become as mesmerizing as the colored afterimages of the lights. Nor did Howard Jones realize that interaction with the photosensitive cells would become even more intriguing, as multiple participants would join in the collaborative production of sound. James Seawright and Terry Riley were probably more acutely aware of the uncertainty inherent in the situations they constructed. Interaction with *Electronic Peristyle* showed that chance played a role in both technological and biological systems. The critics' frustration with the lack of clear patterns of stimulus and response in Seawright's work suggested that accidents and seemingly illogical changes in the pattern of acoustic responses were less easily tolerated in the case of the technological apparatus than in the case of human behavior. The spatial and temporal dislocation of sounds in Riley's *Time-Lag Accumulator* generated a somewhat similar degree of confusion, but the chaotic scenario was less disturbing, since the technological interfaces were primarily retransmitting the sounds created by the participants.

All the above-mentioned environments entailed misalignments between cause and effect that motivated participants to question how they perceived and acted. Sensorial engagement with seemingly disobedient systems stirred cognitive curiosity and heightened affective alliances between participants involved in decoding the creative potential of the works as part of a group. While some critics thought that *The Magic Theater* exemplified the victory of the senses over the mind and the triumph of crowd behavior over individual contemplation, the exhibition implied an interrogation of such dichotomies. Participation within a group sharing an aesthetic experience did not imply a state of obliviousness to one's role in constructing it in relation to multiple others. Reflecting on the growing scale and theatricality of his practice in the late 1960s, Boyd Mefferd asserted that "new public art recognizes the social nature of the exhibition hall, and rather than showing people *pictures* of other people, prefers to *show them to each other*."[38] He added that fluctuating groups of participants modeled such works, thus contributing to their variability. In the process, visitors would also become aware of each other's behavior and form temporary affective relations.

The increased realization of the contingence of emotions, sensorial experience, and cognitive acts upon factors that eluded the artist's control muddled the field of dichotomic relations, which nonetheless continued to inform art critics' responses to the exhibition.

Their contrasting stances on the quality and relevance of the experience prompted by *The Magic Theater* indicated the difficulty of establishing new criteria for evaluating works that disclosed the social context of the encounter with art. The viral transmission of emotions and the more or less voluntary attunement of behavioral responses in the exhibition subverted the possibility of relying on Cartesian modes of assessing the works. As philosopher Teresa Brennan has argued, "The idea of transmitted affects undermines the dichotomy between the individual and the environment and the related opposition between the biological and the social."[39] Upon entering the *Magic Theater* exhibition, visitors witnessed the contagious dissemination of the desire to play a part within an information system that could be modeled but not strictly programmed, being liable to the influx of emotional and behavioral responses of a multitude. While Coe had initially planned *The Magic Theater* as an exhibition that would release the human psyche from all constraints by permitting viewers to explore their inner world, the environments included in the show actually became an invitation for participants to reflect on their capacity to bring about changes to their surroundings together with others.

NOTES

1. Alfred Frankenstein, "Magic Theater in Kansas City," *San Francisco Chronicle*, June 2, 1968.
2. Jack Burnham, "Steppenwolf in Kansas City," *Art Scene*, July–August 1968, 29.
3. R. D. Laing, *The Politics of Experience* (New York: Ballantine Books, 1968), 54.
4. Ralph T. Coe, *The Magic Theater: An Exhibition of Environmental Art*, brochure of the exhibition at the Toledo Museum of Art (Toledo, OH), January 18, 1969–February 23, 1969, Nelson-Atkins Museum Archives.
5. The exhibition was part of Coe's more extended inquiry into how artists use light and sound to trigger a shift of focus from the physical qualities of the artwork to its sensorial and psychic impact. Prior to curating the *Magic Theater* exhibition at the Nelson Gallery in 1968, he organized Howard Jones's *Light Paintings* exhibition in 1965, as well as a group show titled *Sound, Light, Silence* for the purpose of which he was in close contact with New York art dealer Ivan Karp.
6. Ralph T. Coe, *The Magic Theater: Art Technology Spectacular*, exh. cat. (Kansas City: Circle Press, 1970), 84.
7. Ibid., 82.
8. Ibid., 67.
9. Jonathan Crary, *Techniques of the Observer: On Vision and Modernity in the Nineteenth Century* (Cambridge, MA: MIT Press, 1999), 150.
10. Coe, *Magic Theater: An Exhibition*.
11. Anton Ehrenzweig, *The Hidden Order of Art: A Study in the Psychology of Artistic Imagination* (Berkeley: University of California Press, 1967), xii.
12. Boyd Mefferd to R. T. Coe, December 1967, Nelson-Atkins Museum of Art Archives.
13. Jane Livingston, "Kansas City," *Artforum* 7, no. 1 (September 1968): 66.
14. Ralph T. Coe, "Light in Motion," in *Boyd Mefferd: Light in Motion*, ed. Ralph T. Coe, exh. cat. (Dallas, TX: Dallas Museum of Art, 1968).

15. Coe, *Magic Theater: Art Technology Spectacular*, 190.

16. Stephen Bann, "The Magic Theater," *L'Oeil,* nos. 164–165 (August–September 1968): 43.

17. Branden Wayne Joseph, *Beyond the Dream Syndicate: Tony Conrad and the Arts after Cage* (New York: Zone Books, 2008), 116.

18. Howard Jones quoted in Coe, *Magic Theater: Art Technology Spectacular*, 186–87.

19. Ralph T. Coe, "Magic Theater," draft manuscript of exhibition catalog, 1970, Nelson-Atkins Museum of Art Archives.

20. James Seawright, statements in archival documentation of *The Magic Theater*, Nelson-Atkins Museum of Art Archives.

21. Ibid.

22. Coe, *Magic Theater: Art Technology Spectacular*, 15.

23. Andrew Tapsony, review of *The Magic Theater, Kansas City Star,* May 21, 1968.

24. Tony D. Sampson, *Virality: Contagion Theory in the Age of Networks* (Minneapolis: University of Minnesota Press, 2012), 14.

25. Daniel Stern, *The Interpersonal World of the Infant: A View from Psychoanalysis and Developmental Psychology* (New York: Basic Books, 1985), 128.

26. "Little Chance for 'Magic' as Crowds Spoil Environment: Multimedia Exhibit at Montreal Museum of Fine Arts," *Montreal Star,* September 3, 1969.

27. Bann, "Magic Theater," 43.

28. John Dauner, typed statement on "Magic Theater," n.d., Nelson-Atkins Museum of Art Archives.

29. Betsy Broun, viewer response, in Coe, *Magic Theater: Art Technology Spectacular*, 157.

30. Stern, *Interpersonal World*, 142.

31. Donald Hoffman, review of *Magic Theater* for *Kansas City Star*, in Coe, *Magic Theater: Art Technology Spectacular*, 158–59; anonymous viewer response in Coe, *Magic Theater,* 159.

32. Sampson, *Virality*, 183.

33. George Ehrlich, "'The Magic Theater' Exhibition: An Appraisal," *Art Journal* 29, no. 1 (Autumn 1969): 40.

34. Ibid., 43.

35. Rolf-Dieter Herrmann, "Art, Technology and Nietzsche," *Journal of Aesthetics and Art Criticism* 32, no. 1 (Autumn 1973): 102. Herrmann does not mention the *Magic Theater* exhibition in this article, but he addresses projects created by artists Boyd Mefferd and Stephen Antonakos, whose works were included in the show. He offers a critical survey of art and technology projects from the late 1960s and the early 1970s that elicit heightened modes of sensorial engagement while connecting them to Nietzschean thinking on nihilism, play, and presentism.

36. Ibid., 96.

37. Coe, *Magic Theater: Art Technology Spectacular*, 48.

38. Boyd Mefferd, untitled statement in *White Lightning: A Public Situation*, exh. brochure (Milwaukee, WI: Milwaukee Art Center, 1969) (emphasis in original).

39. Teresa Brennan, *The Transmission of Affect* (Ithaca, NY: Cornell University Press, 2004), 6.

JOHN A. TYSON

8

PROGRAMMING AND REPROGRAMMING THE INSTITUTION

Systems Politics in Hans Haacke's *Photoelectric Viewer-Programmed Coordinate System*

> The message of the electric light is like the message of electric power in industry, totally radical, pervasive, and decentralized.
>
> **MARSHALL MCLUHAN,** *UNDERSTANDING MEDIA,* 1964

ON JANUARY 7, 1968, the promotional materials issued for the Howard Wise Gallery's Hans Haacke solo show contained the following: "The *revolutionary principle* is that the viewer is actively involved. If he does nothing, the work will not come to life. These are works for the *homo ludens* of a time when automation makes leisure the rule, work the exception."[1] The Fifty-Seventh Street gallery's text merits further remarks. The potential achievements of new art described in the passage resonate with ideas about the radicality of participation and emancipatory promises of technology espoused a few years prior by the left-wing activist group Students for a Democratic Society (SDS).[2] The projects that occupied the Wise Gallery were, like the actions of SDS, in many ways "revolutionary."[3]

Haacke's *Photoelectric Viewer-Programmed Coordinate System* (1966–68) (figures 8.1–8.3)—a site-specific light installation made for Howard Wise's ludic audiences—is the focus of this essay.[4] I trace *Photoelectric*'s parallels with then-contemporary dance and radical politics, forms in which process (as well as participation) was

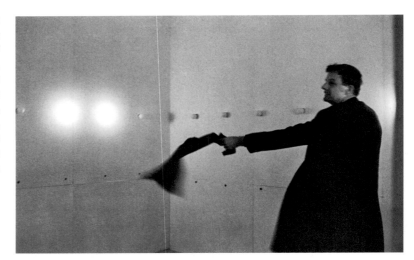

FIGURE 8.1
Hans Haacke, *Photoelectric Viewer-Programmed Coordinate System*, 1966–68. Installation at Howard Wise Gallery. 14 infrared projectors, 14 photoelectric sensors, 28 light bulbs. © Hans Haacke/Artists Rights Society.

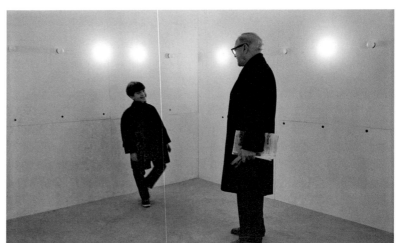

FIGURE 8.2
Hans Haacke, *Photoelectric Viewer-Programmed Coordinate System*, 1966–68. Installation at Howard Wise Gallery. 14 infrared projectors, 14 photoelectric sensors, 28 light bulbs. © Hans Haacke/Artists Rights Society.

FIGURE 8.3
Hans Haacke, *Photoelectric Viewer-Programmed Coordinate System*, 1966–68. Installation at Howard Wise Gallery. 14 infrared projectors, 14 photoelectric sensors, 28 light bulbs. © Hans Haacke/Artists Rights Society.

increasingly valued over the final product. I historically contextualize Haacke's provocative, multivalent, environmental artwork and explore its relation to ludic activity, cybernetics and systems theory, and newly emerging artistic and performative forms.

In his review of Haacke's show, the critic John Perreault surveys the artist's oeuvre, contrasting it with works by others that he considers to be related but inferior. Perreault viewed Haacke's *Photoelectric*—particularly the way the artist used new materials, machinery, and electronics—as a strong, yet discrepant form of kineticism: "full of the kinds of poetry that can be conjured up ... by the skillful manipulation of technology."[5] The critic's sentiments still ring true: surpassing contemporaneous projects, the work critically exceeded categories and put technology to poetic use.

―――

The "hardware" of Haacke's installation consisted of twenty-eight evenly spaced (a body width apart) white light bulbs, photoelectric cells and infrared beams, spectators, and the interior of the Howard Wise Gallery.[6] The process of coupling the aforementioned components could be considered the "software" of *Photoelectric*. The work provided constant haptic feedback. When viewers' bodies intercepted the corresponding invisible beams, bulbs illuminated the otherwise dark gallery, rendering visible the work's mechanisms as well as the beholders. Depending on their relative positions, users of the light environment oscillated between silhouette and figure, their multiple shadows ricocheting around the space. With the lights continually reflecting their presence, users performed together, casting constantly shifting, dappled group portraits on the walls of the white cube. Documentation of *Photoelectric* reveals an older man and a boy playing in Haacke's dark chamber. In another photo, a man of about thirty lets go and turns his scarf into a prop for an impromptu dance; the garment's undulations cause bulbs to clink into life and spotlight the performer, who composes with shadows. From a different angle, the same man and scarf become a single black form.

Collaborations between various agents and actors brought the project to fruition. The "enlightened" host, gallerist Howard Wise, provided Haacke with expensive real estate (on Manhattan's Fifty-Seventh Street) for twenty-one days without the expectation of any sales directly coming from the space the work occupied. Haacke and Wise worked with Standard Instruments Corporation, the firm that provided much of the hardware. The aforementioned parties collaborated again with Garson-Bergman, the contractor that actually built the installation.[7] Some might argue that *Photoelectric*'s spectators are coerced into becoming "temp workers" for Wise, their immaterial labor powering the gallerist's parasitic and seemingly spectacular installation—which could serve as lure for further audiences. The fact that their performances surely yielded promotional gains for Standard Instruments and the gallery does not nullify the critical purchase of the work, which arguably puts the instruments to nonstandard use.[8] As entry into the work was voluntary, there was always a choice about taking a position and alternately withholding labor or playing *Photoelectric*'s game:

"As long as they stay there, it is give and take. One could regard it as a symbiotic relationship," Haacke states.[9]

Haacke's friend and interlocutor the artist and critic Jack Burnham described the installation as possessing a systems aesthetic. There was no tangible art object; instead, its poetics hailed from the complex interaction of art components, spectators, and environment.[10] Furthermore, as indicated by the work's title, the idea of "programming" art, in the way one programs software, must not have been far from Haacke's mind when he was creating *Photoelectric Viewer-Programmed Coordinate System*. Underscoring their dialogical relationship, in September of the year following the exhibition, Burnham proposed the metaphor of art as software in the article "Real Time Systems," a notion he would continue to explore in his ambitious *Software* (1970) exhibition at the Jewish Museum. Software consists of coding, using the binary—apparently rational—mathematical language of 0s and 1s. Art as software converts the white cube into a node in a circuit of corporeal interaction.[11]

Although the actor-beholders were "programmers"—in the sense that they generated operating protocols with their interactions—they were also part of Haacke's programming: made to perform. Haacke's light environment dialectically negotiated liberation, play, and sensuality vis-à-vis rationality and instrumental reason. In *Photoelectric* Haacke employed systems of control as a didactic demonstration of the forces at work in art-spaces (and beyond them). The unruly, ludic bodily actions that occurred within the installation could not be completely predicted or contained.

Since the 1980s, art historians commenting on Haacke's oeuvre typically suggest that his work radically changed in 1969, when the artist began to incorporate language and supposedly shifted away from systems aesthetics; this received idea must be contested. Benjamin Buchloh, one of the leading authorities on the artist, sees works made in 1969 and after as markedly different from earlier projects: he lionizes a selection of Haacke's "mature—i.e. political—works."[12] Buchloh argues that earlier systems artworks are only *seemingly* a "radical departure" from norms of spectatorship. Projects like *Photoelectric* are politically null, "defined by a participatory neutrality that often reduced viewers to the status of participants in a behavioristic experiment."[13]

For Haacke, systems aesthetics and systems politics always intersect. Luke Skrebowski has importantly contested Buchloh's readings. He demonstrates that Haacke's interest in systems continues in the decades subsequent to 1969.[14] Skrebowski fails, however, to adequately consider the politics of the earlier work. He gestures to the "homeopathic" critique of technology mounted by *Photoelectric* (technology used to reveal how technology uses us) and tantalizingly asserts that Haacke's projects require thinking beyond "either an affirmative technophilia or a negative technophobia as the only possible modes of relation between cultural and industrial production."[15] While this is correct, Skrebowski does not ultimately follow the analytical path he signals for the artist's early works.

Comparing projects by Mel Bochner and Haacke made around 1970, Mark Godfrey perceptively states: "Little has been made of what Haacke's art shared with recent art, some would even say that by asking the question one risks deradicalizing the work."[16] Understanding the politics of artworks that have been dismissed as merely "behavioristic experiment[s]" requires an inversion of Godfrey's proposal.[17] To be properly comprehended, *Photoelectric*—and the radicality of project—must be set into a particular cultural field and compared to a range of contemporaneous works.

THE GRID TO EXTEND AND EXCEED RATIONALITY

The grid was key to discussions of systematic art created in the years preceding Haacke's installation.[18] As it would do many times again, the artist's work sits uneasily between tendencies originally hailing from both sides of the Atlantic, dialoguing with each.[19] Variations of grids structure a significant number of modular artworks made by Group Zero and Groupe de Recherche d'Art Visuel (GRAV), contemporary European groups that influenced Haacke as a young artist. Thus his extension of the grid into the real space of the third dimension (and the real time of the fourth) seems like a logical development in his artistic trajectory.

Notably, kinetic and luminous installations by the contemporaneous Italian artists (especially those of the collectives gruppo N and gruppo T) were referred to as *arte programmata* (programmed/programmatic art). The groups asserted that their projects were *opera in divenire* (works in becoming).[20] Gianni Colombo's *Spazio elastico* (1967) (figure 8.4), an environment that renders the form visible in three dimensions, is another notable engagement with the matrix. Colombo's installation consisted of a dark, black-lit space filled with intersecting white strands, which heaved back and forth, forming a "trippy," slightly non-Euclidean grid in the gallery space. Recalling Haacke's idea of a "viewer-programmed" work, gruppo T's creations required and activated beholders. However, the spectator does not produce content in the same fashion as *Photoelectric* in most examples of *arte programmata*.

In the North American context, the grid loomed large too: a leitmotif in Mel Bochner's Xerox exhibition, *Working Drawings and Other Visible Things on Paper Not Necessarily Meant to Be Viewed as Art* (1966), the form structures nearly all of the drawings and diagrams contributed. Another parallel comes in Sol LeWitt's *Serial Project #1 (ABCD)*, which overlays the floor with a latticework of regular units (figure 8.5). Rather like Haacke's installation, which created an invisible matrix, LeWitt's artwork is a system of geometric structures. With the work's alternating closed containers and open frames, he explored numerous permutations of proportional forms. LeWitt's modules come in incremental heights and almost resemble large-scale architectural models.[21] The author of "Sentences on Conceptual Art" was thinking like a surveyor when he designed the artwork. As in *Photoelectric*, shadows and lights—which both register presence and blind visitors—were an important part of *Serial Project #1 (ABCD)*. LeWitt's work also enlisted its host as a collaborator: the lighting and white walls of the Dwan Gallery, "which almost obliterated the white structure,"

FIGURE 8.4
Gianni Colombo, *Spazio elastico* (Elastic space), 1967–68. Elastic cord, black light, electric motor. Courtesy Archive Gianni Colombo, Milan. Installation view: *Ghosts in the Machine*, New Museum. Photo: Benoit Pailley.

FIGURE 8.5
Sol LeWitt, *Serial Project #1 (ABCD)*, 1966. Dimensions: 20″ × 13′ 7″ × 13′ 7″ (50.8 × 398.9 × 398.9 cm). Baked enamel on steel units over baked enamel on aluminum. Museum of Modern Art, New York. © 2015 Sol LeWitt/Artists Rights Society (ARS), New York.

further colluded against retinal spectatorship.[22] LeWitt remarked that with more powerful illumination, "the less one would see of the structure and the more one would see the shadow."[23] Contemplation of an artwork like LeWitt's does not occur just through direct vision. The idea must be grasped by the mind after bodily experience.

———

In *Photoelectric* Haacke imposed a "coordinate system" on the space of exhibition, a convention hailing from cartography. Hence, with the striated space of the installation, he might be seen as mapping the gallery territory. This move anticipates his later sociological projects (such as the Polls or the real estate work *Shapolsky et al., Manhattan Real Estate Holdings,*

A Real Time Social System, as of May 1, 1971 [1971]). In some sense, this real-world, real-time mapping collides reality and representation, indexing the invisible grid lines, which become a degree less imaginary than usual: despite the semiotic relationship I am projecting, there is little danger that the "map" would be confused with the "territory" in Haacke's scenario.[24]

In addition, rather than just underscore the way space could be rationally divided, *Photoelectric* produced a playground. The matrix as ground is common to various kinds of board games. Chess, given Duchamp's famous turn to the game, is perhaps the most metaphorically loaded in relation to art.[25] Not abiding by any particular rules governing movement, the visitor-players cannot merely be considered Haacke's pawns. The well-ordered components of *Photoelectric* catalyzed ludic activity, something that might go beyond or, following Burnham's proposal for tech art in "Art in the Marcusean Analysis," extend rationality.[26] Rather than perform the typical protocols of contemplation—move, pause before the object, adjust to contrapposto, chin stroke—the light environment permits users to exceed them and go boogying around the gallery, playfully flicking lights on and off (joyfully flouting the typical parental mandate: "Don't play with the lights!").[27] Finally, we might think Haacke created a cyborgian matrix—the latter word is a synonym for both "grid" and "womb"—a space for gestating new modes of spectatorship by coupling with technology.[28]

TOWARD A NEW KINETICISM

Jack Burnham and the curator-impresario Willoughby Sharp were two of the most important voices defining kineticism in the 1960s. Burnham and Sharp focused on kinetic and light art in texts composed around the time of *Photoelectric*'s realization. Both featured Haacke's earlier works, locating his projects within a genealogy of kinetic art. Hoping discoveries in art would outpace those of industry, Burnham and Sharp called for continued innovations: "We need an art of total environment.... The old art is an object. The new art is a system." *Photoelectric* explored precisely the directions Sharp and Burnham prescribe. Not an art object that moves, Haacke's installation instead linked beholders, lights, and architecture in concert.

"Motion art can develop through abstract cinema," Burnham claims; he further maintains that there is a spectrum of viable directions in kinetic art.[29] The term *kinetic* is not etymologically so far removed from cinema; both refer to movement. For polymaths and continental Europeans in general, such as Haacke, the connection to the other media of projection would have been abundantly clear.[30] As a result of the shared etymology, *l'art cinétique* and the cinema (*ciné*) (or *ciné* and *cinétismo* or *kinetisk kunst* and *kino*) conceptually link them.[31]

Like many contemporaneous projects orbiting in the universe of avant-garde art, cinema, or performance, *Photoelectric* merged the white cube with the black box of cinema: the rays of light converted the architectural surrounds into screens. Haacke's environment was kino-kineticism—almost a primitive version of Anthony McCall's filmic installations, in which projected lines of light take on a semblance sculptural materiality. Projects such as *Line Describing a Cone* (1973) (figure 8.6) yield luminous forms that cut through the dark-

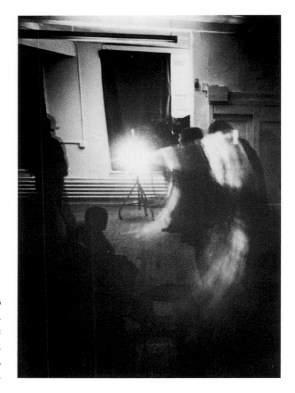

FIGURE 8.6
Anthony McCall, *Line Describing a Cone,* 1973. 16mm film, 30 minutes. Projection: 3000 × 4000 mm, overall display dimensions variable. Tate Modern, London. © Anthony McCall, courtesy Sean Kelly Gallery, New York.

ness of the gallery space. As in McCall's work, spectators interrupting the cones of light and the projection all formed part of the experience. Because of its medium, film, McCall's work is to some extent preprogrammed. In contradistinction, the beholders of *Photoelectric* created their own director's cut—selecting when beams would slice through blackness.

Haacke underscores his awareness of the potential (surely acquired through *Photoelectric*) for collaborative "cinema" in the proposal for *Environment Transplant* (1969) (figure 8.7). The never-realized artwork—an attempted collaboration with Ampex Corporation—formed part of LACMA's Art and Technology program, and, if the technological demands had been less ambitious, would have employed projections of recordings from a vehicle onto walls. Outlining the work in his proposal, Haacke writes: "Visitors will sometimes stand between projector and 'screen.' Consequently their shadows will appear on the wall and they themselves become the 'screen.'" Similarly, in the environment of *Photoelectric,* the walls turned to pictorial ground for the spectators, who simultaneously orchestrated the process of figuration with their silhouettes even as they too became screens.

Although Haacke's early oeuvre was often read as kinetic art, the artist explicitly questioned the taxonomy in 1967: "I have doubts about the proclaimed common basis for all examples of kinetic art. The only common denominator, naturally, would be something that moves."[32] Despite the artist's disavowal, his artworks continued to be read by others in relation to the art-critical taxonomy. It would not be incorrect to think that in the right circum-

ENVIRONMENT TRANSPLANT

A large white room in the shape of a vertical cylinder. In the center equipment for visual projection mounted on a slowly turning turntable so that projections would sweep over the curved walls like the beams of a light house. Loudspeakers are situated behind the walls all around the room so that sound emission can actually follow the sweeping of the projected images (a less desirable though cheaper version would be to mount a single loudspeaker on the turntable).

Corresponding to this set-up in the museum sound and image recording devices are mounted on a truck. Like the projection equipment the recording equipment is fixed onto a slowly spinning turntable. It continuously scans the "horizon". During the exhibition hours the truck drives through the entire Los Angeles Metropolitan Area constantly recording the sights and sounds of the streets it goes through.

The recorded material is immediately without any time lag transmitted into the museum and projected onto the walls or emitted through the loudspeakers of the room. Visitors will sometimes stand between projector and "screen". Consequently their shadows will appear on the wall and they themselves become the "screen". Whatever noises they make will also mingle with the streetnoises piped from the truck into the room.

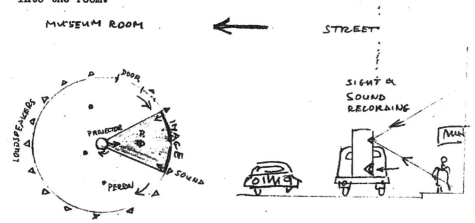

FIGURE 8.7

Hans Haacke, plan for *Environment Transplant,* 1969. Unrealized proposal for Maurice Tuchman's "Art and Technology" program at LACMA. © Hans Haacke/Artists Rights Society.

stances bodies performing with machines could constitute a kind of corporeal kineticism.[33] Disciplinary boundaries regarding genre and medium have been stumbling blocks for scholars, preventing considerations of Haacke's work in relation to performance. However, in the 1960s and 1970s the artist regularly attended events at Judson Church as well as other venues in Lower Manhattan. He was hence very much abreast of developments in avant-garde performance art.[34]

Burnham argues that a wide range of "kinetic constructions" provoke performance; they are "not an object but . . . the matrix for a possible event or 'happening.'"[35] Burnham's use of Allan Kaprow's term for the performative situations he orchestrated bears remark. In Kaprow's Happenings, as in *Photoelectric,* there is a breakdown of the traditional bounds between stage, audience, performer, and even subject and object.[36] Though a degree removed from everyday life by its situation in the gallery, the elimination of spectators beyond the participants in Haacke's project resonates with Kaprow's guidelines for Happenings: "There should not be (and usually cannot be) an audience."[37] Kaprow furthermore asserts that: "Happenings have a freedom that lies in their use of realms of action that cannot be repeated."[38] Similarly, the movements performed by the actors in Haacke's situation are unrehearsed—or in a perpetual state of rehearsal—and tend toward free movement rather than any kind of direct disciplining of bodily motion, whether by Taylorist managers or choreographers and directors.

A "BIG BROTHERLY" GAME OF TAG

The title of *Time*'s 1968 review of Haacke's exhibition, "Kinetics: Big Brother," evoked Orwellian dystopian surveillance. The anonymous reviewer described a sense of entrapment in the system, which was "an ingenious way of getting the viewer to turn on the art without really trying."[39] *Time*'s writer saw Haacke's work as existing in between categories: as ludic surveillance. Specifically, the journalist suggested that the light bulbs "chasing him around the room" in the installation sent the viewer spinning into "a Big Brotherly game of tag."[40]

Skrebowski reprises the period account in his scholarly assessment of the work. It is interesting to consider the role of technology as "it" in the game of tag, vis-à-vis Skrebowski's contention that the beholders try "to catch lag time in the lights, latency in the system."[41] Who was pursuing whom? And is technology always a "Big Brother," surveying and affecting our actions? Acknowledging that *Photoelectric* warned visitors about "advanced surveillance made possible by technological development," the art historian further asserted, "The viewer is . . . ensnared in a highly controlled cell, his or her every movement tracked and scrutinized. . . . Participation amounts to no more than the freedom to live out a completely routinized existence."[42]

Skrebowski's claim that the actions in the light chamber of *Photoelectric* were "rountinized" is difficult to swallow whole. *Photoelectric,* did, in a sense, anticipate (and even alter) the user's every move: the motion-triggered bright lights might even have made some spectators momentarily stop in their paths. Others would have deliberately moved in order to turn on the light and command the machinery that enveloped them. While this operation might feel like viewer agency, it is possible to view it as control as well: the project needed to use the users' energy.[43] But this suggestion is only half the story. The purposeless movements were not totally disciplined.

Moreover, the artwork's evocation of other forms—such as closed-circuit television or security motion detectors—means it was always improper, at a remove from normal encounters with technologies that determine behavior. While it invoked surveillance systems, no one watched over Haacke's project and tabulated data. Skrebowski's concep-

tion of *Photoelectric* as "false" play that ensnared the viewer, inscribing him or her into a system of control, seems like only a starting point.

That the work could inspire two related but opposed interpretations—separated by nearly forty years—implies that *Photoelectric* operated at the interstices of technological determinism and determined technology—situated at this crux of totalizing control and freedom.[44] If it were only the former, Haacke's project would merely have been a tool for reprogramming users and accelerating "technological rationality," philosopher Herbert Marcuse's then-hot idea that with the widespread adoption of new scientific and mechanical forms, societal notions of rational behavior change to keep pace with them.[45] While the installation's motion-sensing technology might have invoked Marcuse's worries, as it seemed to prompt particular actions, it most certainly did not just use users; visitors programmed the photoelectric system as well. The artist was attempting to defy the very processes Marcuse identifies with technology: "The seemingly contradictory nature of" Haacke's work stems from the fact that Haacke "believe[s] that a rational, almost positivist approach, a certain sobriety," can be pushed to the point that it becomes "*very poetical,* weightless and *irrational.*"[46]

"Big Brotherly Tag" deftly describes the effects of *Photoelectric*—which spanned both technological surveillance and play, and hence was properly neither.[47] By its dialectical critique, spectator-participants might realize their own technological entanglement and reflexively consider modes of emancipation. Norbert Wiener evokes both sides of the installation. He argues that communication between humans and between humans and machines can be a form of control, as participants abide by certain protocols; however, in *The Human Use of Human Beings: Cybernetics and Society,* Wiener affirms that interactions can be viewed as games too, possibly driven by play but also possessing winners and losers.[48]

Play enables communicators to exert agency and push back at the rules structuring a situation. However, ludic activity can turn into gaming when it becomes calculating and when predictions about rational decisions and endgames start to enter the field of play. The proximity of play, game theory, and systems weighed on the minds of many in the 1960s. For example, in "Systemic Painting," critic Lawrence Alloway reviews contemporary uses of the term, defining *systemic* in relation to game theory. Similarly, Allan Kaprow was concerned about the proximity of art and systematic analysis and was wary of play sliding into game theory. Kaprow views "play as inherently worthwhile, play stripped of game theory, that is, of winners and losers."[49] Viewing human interactions through the lens of the economic discipline of game theory was undesirable because it would imply both the need to strive for outcomes that were Pareto-optimal—maximizing economic efficiency—and the assumption that social exchanges are always competitions. Furthermore, as game theory was employed to try to outmaneuver the Soviet Union and its allies in the Cold War, the mode of analysis acquired further associations with US jingoism and the military-industrial complex.[50]

Conversely, if ludic activity is disinterested, constantly negotiated, and always in flux, then it is something different from relations governed by game theory. In Haacke's installation gallery-goers' experience was conditioned by a synthesis of apparently opposing forces: constraint and creativity. The exchanges *Photoelectric* catalyzed transcend the apparently

totalizing and rational system that enables them (perhaps again demonstrating commonalities with the logic of LeWitt's contemporaneous constructions). In the art scenarios Haacke and Kaprow produced, play was imagined to be collaborative and not competitive.

A BRECHTIAN ENVIRONMENT

The potential for the beholder to critically analyze the situation begs further exploration. The insinuation into Haacke's coordinate system was not necessarily as smooth and seamless as the *Time* quotation above might have us believe ("getting the viewer to turn on the art without really trying").[51] The charges of technological subterfuge are exaggerated: the viewer was hardly tricked into making the art "without really trying." To start with, the mechanisms the work employed to "ensnare" the viewers were revealed to them. Spectators realized how the piece was produced and perhaps even comprehended the steps taken for its manufacture.

"With *increasing aggressiveness,* one of the artist's functions, I believe, is to *specify how technology uses us*," Burnham asserts.[52] Interfacing with *Photoelectric* was not pure (visual) pleasure. The bulbs stuck out from the wall in such a way that, when illuminated, the lights dazzled the audience. They could not comfortably be looked at head on—the flashes interrupted the gaze (and the sovereignty of the Cartesian subject) and were then retained as the blobby rainbow-hued modulations of the afterimage. Interaction in *Photoelectric* markedly differed from tech artist Roy Ascott's celebratory ideal of a "telematic embrace" between human and machine. Interrupting pleasure, Haacke's antagonistic yet educational dazzlings might even have suggested spectacular representations of discipline: the lamp-lit interrogations of TV police dramas. However, it was the frame that was rendered suspect; shocked by the minor aggressions, viewers ideally considered their role within the system. *Photoelectric* afforded opportunities for the momentarily blinded gallery-goers to free themselves from technologically determined incarceration.

Media theorist Alexander Galloway states: "Any mediating technology is obliged to erase itself to the highest degree possible in the name of unfettered communication, but in so doing proves its own virtuosic presence as technology thereby undoing the original erasure."[53] Viewed in terms of Galloway's theories, *Photoelectric* should be considered a deliberately designed failure. It is an example of unsuccessful mediation. The dazzling lights and other agents added real friction to the system, revealing to users how they were coerced into using it.[54] This collaborative "friction" constituted the poetics of Haacke's installation. The artwork as well resisted the proper operations of "useful" technologies. Jean-François Lyotard argues that "technology is . . . a game pertaining not to the true, the just or the beautiful, but to efficiency: a technical 'move' is 'good' when it does better/expends less energy than another."[55] Though the work did not exemplify traditional beauty, it possessed a systems aesthetic, preventing it from optimally managing participants.

The bright lights interrupted another mediating technology: the white cube. The normally naturalized mode of display was illuminated and thrown into relief by *Photoelectric*. More

than just punctuating sight and thwarting retinal spectatorship, the "nudity" of the light bulbs laid bare was a strategy that evoked the dramaturgical theories of Bertolt Brecht. The German playwright advocated for exposing the lighting grid above the stage as a way of revealing the artificiality of the support structure to the audience. In an only apparent contradiction, the demonstration of real lights elucidates for the public the status of theater as representation and not reality. Brecht was also concerned with teaching spectators about the way lighting might be used to manipulate their feelings and judgment of a scene. As the playwright's work was known in progressive, intellectual circles in New York, Haacke's use of exposed lights would have registered with many as "Brechtian."[56] Haacke's aggressive lights signaled the artificial frame of the gallery. Like Brecht, the artist called upon the viewer to consider the way that illumination can generate value: a simple spotlight in a gallery changes the nature of the material on display from object to artwork.

Additionally, *Photoelectric* upturned standard conventions of architecture. Haacke set fixtures typically found on ceilings horizontally into the wall.[57] This rearrangement of the standard components of exhibition spaces too can be grasped under the sign of Brecht.[58] For, with this separation and improper use (*Umfunktionierung*) of the elements of the institution, the artist rendered strange (*Verfremdung*) the gallery frame.[59] Fredric Jameson defines the so-called "U-effect," often discussed as a co-optation, as a "radical restructuration," which "changes everything."[60] The "V-effect" estranges the everyday and prompts further estrangements in its very definition, Jameson contends. He continues, "It intrudes upon us and our fellow 'actors'; as [Antonio] Gramsci liked to put it, ordinary people are all also revealed to be intellectuals, or theorists, in their own right."[61] Haacke does not specifically mention Brecht and Gramsci in statements from the period; however, Brecht left an indelible impact on him from the time that he first encountered his texts in high school. Further confirming a Brechtian viewpoint, in the late 1960s Haacke maintained that "an estrangement from the normal is indispensable."[62] It was by Haacke's use of the U- and V-effects that spectators were prompted to analyze the systems of surveillance and illumination already active in most art spaces that Burnham points out.

As *Photoelectric*'s grid of sensors and lights were burrowed into the gallery walls, it was environmental and objectless. An instance of parasitic composition, *Photoelectric* was nourished by elements typically proper to the frame—locating the work both within and beyond it. In a 1965 analysis of Happenings, performance historian Richard Schechner claims that "the rejection of packaging" (a kind of framing he sees uniting the consumption of products and ideas) that the new art performs is its most important political function. Schechner views the elimination of the frame as tantamount to liberation, but claims that this move also performs a radical pedagogical function: "forcing on the receiver the job of doing the work usually done by the artist/educator/propagandist."[63] *Photoelectric* represents a deviant strand of the operations Schechner describes. The work obviates the "packaging" by colonizing it; architecture too becomes part of Haacke's machine.

In his classic analysis, Brian O'Doherty describes the white cube display format as a "technology of esthetics," in which "works of art are mounted, hung, scattered for study."[64]

In contradistinction to the traditional mode of display, and extrapolating from Schechner's and O'Doherty's affirmations, in Haacke's installation the viewer became an agent—an actor rather than a beholder or a disembodied eye.[65] Nevertheless, the gallery to some extent retained its traditional message to users: look closely. Within the cube *Photoelectric* inhabits, the aesthetics were systemic and relational. The guests positioned themselves as they chose in order to mount their own show, studying each other and scrutinizing their surroundings.

BODIES AS RESISTANCE

The works of Yvonne Rainer, one of the era's dance pioneers, also illuminate Haacke's projects. *Photoelectric* hails from the same historical moment and cultural milieu as Rainer's dance. Haacke's activated audience, moreover, bears an important resemblance to the performers in Rainer's *Trio A*. The dance consists of a stream of at times choppy or mechanical choreographed movements that flow without gaps into one another. The dance is notable for rejecting standard conventions of performance: there are no legible breaks, it can be performed in regular clothes, some movements are pedestrian, performers are not perfectly synchronized, and there is no musical accompaniment. *Trio A* is as well significant for the way it explicitly foregrounds the bodily presence of the performer. The authorship of her dance is democratic: Rainer permits all those she has taught the rights to further disseminate *Trio A* as "semi-official" choreographers.[66]

Rainer described *Trio A* as an assertion of the materiality and temporality of the body. It is a pedagogical work that functions as a rejection of televised images of the Vietnam War and fictional violence—which were consumed in the same manner.[67] Performance art historian Carrie Lambert-Beatty affirms that *Trio A* maintains a dialectical relationship with spectacular images: "The body's obdurate physicality is meant to act as ballast in a 'disintegrating' world of insubstantial images."[68] While Rainer's dance could seem remote from politics by its lack of explicit content, the dancer did not view it as politically void. *Trio A* is an artistic meditation on mediation.

Rainer holds that her work is a reaction to "the horror and disbelief upon seeing a Vietnamese shot dead on TV—not at the sight of death, however, but at the fact that the TV can be shut off afterwards as after a bad Western. My body remains the enduring reality."[69] The politics of the body's "enduring reality" are central to *Photoelectric* as well. The press release that accompanied *Photoelectric* reads: "He [the viewer] is always in the center of the lights. Without the viewer the work does not exist."[70] Coupled with bodies in space, the complex of technological components in Haacke's installation registered physical presence, asserting the continued existence of the material realities of corporeal being.

Beyond art, demonstrations of corporeality, especially the body's unruly growth and flows, implied a resistance to the status quo in the 1960s. As the film *Easy Rider* (1969) and the Five Man Electrical Band's "Signs" (1970) reveal, liberated bodies—especially the long hair of the hippies—signified a particular political platform (or at least opposition to one).[71] The growth of hair that accompanied the counterculture indicates that politics can be made

manifest corporeally; belief systems are not solely located in the mind. The activist Carl Oglesby of SDS decried the left-leaning voters and politicians who continued to permit the waging of the Vietnam War in a speech called "Trapped in a System"—dubbing them "a nation . . . of beardless liberals."[72]

REBEL-PROGRAMMED PROCESS: SYSTEMS AESTHETICS AS SYSTEMS POLITICS

Demonstrating parallels to radical politics, *Photoelectric* enabled the audience to participate in the art process and self-organize.[73] The work possessed an underlying logic shared with that of SDS. SDS advocated for the need to reform, reorganize, and democratize institutions.[74] The group's mode of running meetings was adapted a year later for reunions of the Art Workers Coalition (AWC), a revolutionary art organization of which Haacke was a core member. *Photoelectric*, then, might even be considered to anticipate the radical, politicized activities he would participate in less than twelve months later; the installation's alterations of the gallery predicted the AWC's thirteen demands to "reprogram" the Museum of Modern Art.[75]

SDS was very much in the public eye at the historical moment. In 1969 it and the Black Panthers "were dramatic examples for the artists to follow" according to Therese Schwartz, writing in the pages of *Art in America* on the politicized art scene around the time of Haacke's exhibition.[76] Schwartz's assertion should be taken in tandem with Susan Leigh Foster's argument that protest is performative and that dance can be a way of modeling coalition and community.[77] Thus Haacke's performance-provoking installation was made *after* SDS.

I quote sociologist Stanley Aronowitz at length on the characteristics of SDS, as various parallels with Haacke's work emerge in Aronowitz's assessment: "Historians of this 'new left' have frequently mocked the SDS for spending the first half of any meeting adopting the agenda and defining the rules of debate, and even sympathetic observers have sometimes ascribed this strange ritual to inexperience or to the absence of a viable political culture. This criticism misunderstands the nature of the New Left, summarized in a single word: *process*."[78]

Aronowitz's description of the "rite" or constant negotiation of rules as part of the game resonates with play, and certainly also with the improvised dynamic of *Photoelectric*. Aronowitz asserts that one of the goals of SDS's unstructured politics was to allow members of the population to "'control their own lives'"—exactly what Haacke's title proposes for the spectator within the field of art.[79] An interest in collective process and change—vis-à-vis institutionally determined permanence and the celebration of individual genius—undergirded artwork and exhibitions made during the same decade. In his account of the New Left in the 1960s, activist Todd Gitlin affirms that to form part of the "'expressive dramaturgy' of the movement," "you put your body on the line. Actions were . . . the guarantees and preconditions of ideas."[80] Being in *Photoelectric* required a similar corporeal positioning: the placement of bodies in the coordinate system.

An interest in process and change—as opposed to timelessness—certainly undergirded many of the artworks and exhibitions made during the same decade. Moreover, following

historian Christina Larocco, the issues SDS grappled with in politics were directly related to those in art.[81] It was necessary to alter political dynamics and get the citizens President Nixon dubbed "the silent majority"—who by their reluctance to speak out tacitly endorsed the president's policies in South Asia—to act. The audience activation that occurred in experimental art installations was a corollary to political activation and the continuation of the Vietnam War: "The silent majority, participatory democracy, and an aesthetic that blurred performer and audience member—were fundamentally interrelated."[82] Larocco argues that the same underlying questions were at stake in the interwoven fields of art and politics: "Should its [a democratic society's] members sit quietly and watch the drama unfold . . .? Or should they raise their voices and demand to be a part of the action, as in the New Left vision of participatory democracy?"[83]

The Port Huron Statement (1962), one of SDS's most important manifestos, addresses almost the same sentiments regarding the creation of polities. "As a *social system* we seek the establishment of a democracy of individual participation" and a society "organized to encourage independence in men and provide the *media* for their common participation."[84] The elementary social system that was *Photoelectric*—an unfinished project in constant flux—might similarly have served as the medium to rehearse the aesthetics of democratic systems.[85]

Evincing further commonalities, while *Photoelectric* was installed at Howard Wise Gallery, George Kennan attacked SDS in the *New York Times Magazine,* calling them "rebels without a program."[86] Instead, rather than programless, SDS was actually rebel programmed, much as Haacke's work was "viewer programmed." *Photoelectric* activated gallery-goers, causing some rebellion against standard spectatorship. Revolting against norms of presentation and engaging in a politics of representation—more than in the "real" politics of SDS—Haacke's user-participants do create a program for the artwork.[87] Given the resonances, Haacke's installation seems to be an allegory of the political systems of the participatory democracy of the New Left. As it uses technology for aesthetics to provoke a dialectical engagement, the gallery is transformed from being merely a space of reception or control, and "bodies electric" command the process.[88]

NOTES

1. "Untitled Statement," January 1968, Howard Wise Gallery records, 1943–89, Series 2: Artist Files, 1950–84, box 4, folder 14, Archives of American Art, Washington, DC (emphasis added).

2. Similar sentiments were expressed by SDS in the "Port Huron Statement" regarding participation and the emancipatory potential of technology. See SDS, "Port Huron Statement," 1962, http://coursesa.matrix.msu.edu/~hst306/documents/huron.html. Historian Christine Larocco argues that participatory artworks were both inspiring to members of SDS and inspired by New Left politics. See Christine Larocco, "'Participatory Drama': The New Left, the Vietnam War, and the Emergence of Performance Studies," *Cultural Politics* 11, no. 1 (March 2015): 70–88.

3. Howard Wise Gallery, "Untitled Statement."

4. This artwork is also regularly called *Photoelectric Viewer-Controlled Coordinate System*. Commentators, such as Walter Grasskamp or Benjamin Buchloh, who are less sanguine about the

work often use *Controlled*—perhaps suggesting that the work actually tricks users into disciplining themselves.

5. John Perreault, "Now There's Hans Haacke," *Village Voice,* January 25, 1968, 18.

6. Haacke's show at Howard Wise was held from January 13 to February 3, 1968. In the catalog essay for the exhibition *Software,* Jack Burnham, inspired by the ideas of computer scientist and mathematician Marvin Minsky, extends the metaphor to human bodies, which he deems our hardware. See Jack Burnham, "Notes on Art and Information Processing," in *Software—Information Technology: Its New Meaning for Art,* exh. cat. (New York: Jewish Museum, 1970), 11–12.

7. Further linking the work to television and performance (see below), Garson-Bergman Inc. also built the Muppets Studio and did work for Broadway choreographer Jerome Robbins. See "Muppets Studio," *Interior Design,* February 1980, www.rhbpc.com/commercial/muppets/com_mupp_article.htm, and Garson–Bergman maintenance correspondence, 1966–67, box 460, folder 12, Guide to the Jerome Robbins Papers, 1930–2001, Jerome Robbins Dance Division, New York Public Library for the Performing Arts, New York, NY.

8. The Howard Wise Gallery was hardly today's Google—a corporation whose employees are encouraged to play in the name of profit generation. Google employees engage in similar kinds of "free" participation, according to the firm: "Our offices and cafes are designed to encourage interactions between Googlers within and across teams, and to spark conversation about work as well as play." See "Our Culture," google.com, accessed August 1, 2015, www.google.com/about/company/facts/culture/.

9. Haacke quoted in Bititie Vinklers, "Hans Haacke," *Art International* 8, no. 6 (September 1969): 45.

10. Jack Burnham, "Systems Esthetics" (1968), in *Great Western Salt Works* (New York: George Braziller, 1974), 22.

11. According to Burnham, "*Software* is not specifically a demonstration of engineering know-how, nor for that matter an art exhibition. Rather in a limited sense it demonstrates the effects of contemporary control and communication techniques in the hands of artists. Most importantly *it provides the means by which the public can personally respond to programmatic situations structured by artists*. *Software* makes no distinctions between art and non-art" (emphasis added). See Burnham, "Notes on Art," 10.

12. Benjamin Buchloh, "Hans Haacke: Memory and Instrumental Reason," in *Neo-Avantgarde and Culture Industry: Essays on European and American Art from 1955 to 1975* (Cambridge, MA: MIT Press, 2000), 214.

13. Ibid., 214–15.

14. See Luke Skrebowski, "All Systems Go: Recovering Haacke's Systems Art," *Grey Room* 30 (Winter 2008): 54–83.

15. Ibid., 77.

16. Mark Godfrey, "From Box to Street and Back Again: An Inadequate Descriptive System for the Seventies," in *Open Systems: Rethinking Art c. 1970,* ed. Donna de Salvo (London: Tate, 2005), 36.

17. Buchloh, "Hans Haacke."

18. Burnham notes that "the repetitive field structure" has united numerous artists. See Jack Burnham, *Beyond Modern Sculpture* (New York: George Braziller, 1968), 252.

19. Haacke's status in the United States as a "resident alien" is emphasized by the Tate in the brochure that accompanied Haacke's self-titled exhibition in 1984. He became a US citizen at his wife's urging after September 11, 2001. Linda Haacke in conversation with the author, May 30, 2012.

20. Gruppo T, "Miriorama 1," 1959, quoted in Chris Salter, *Entangled: Technology and the Transformation of Performance* (Cambridge, MA: MIT Press, 2010), 308.

21. See Mel Bochner, "Serial Art, Systems, Solipsism," in *Minimal Art,* ed. Gregory Battcock (New York: Dutton, 1968), 101.

22. Sol LeWitt quoted in Alicia Legg, *Sol LeWitt* (New York: Museum of Modern Art, 1978), 65, quoted in James Meyer, *Minimalism: Art and Polemics in the Sixties* (New Haven, CT: Yale University Press, 2001), 202.

23. Ibid.

24. Gregory Bateson also dwells on this analogy in relation to play, noting that with ludic activity "the discrimination between map and territory is always liable to break down, and the ritual blows of peace-making are always liable to be mistaken for the 'real' blows of combat." See Bateson, "Theory of Play and Fantasy" (1955/1972), in *The Game Design Reader,* ed. Karen Salen and Eric Zimmerman (Cambridge, MA: MIT Press, 2006), 326.

25. Hubert Damisch importantly discusses the pastime in relation to art and the rules that govern the contents of its institution. See Hubert Damisch, *Moves: Playing Chess and Cards with the Museum* (Rotterdam: Museum Boijmans Van Beuningen, 1997).

26. See Jack Burnham, "Art in the Marcusean Analysis" (September 1968) in *Penn State Papers in Art Education* 6, ed. Paul Edmonston (Philadelphia: Pennsylvania State University, 1969), 3–21.

27. Turning a lamp on and off is also the program of a George Brecht score for his 1961 *Lamp Event.*

28. Haacke's matrix is not quite Faith Wilding's *Womb Room* (1972), but perhaps not so far removed either.

29. Burnham, *Beyond Modern Sculpture,* 242.

30. Haacke's French was sufficiently advanced that he wrote art criticism in the language. He also taught French at the college level when first living in the United States.

31. The relationship between arts of the fourth dimension—cinema and kineticism—is also explored in texts by Pontus Hultén and Roger Bordier in a pamphlet produced to accompany *Le mouvement* at Galerie Denise René in 1955. The exhibition featured the work of Pol Bury, Yaacov Agam, Alexander Calder, Marcel Duchamp, Victor Vasarely, Robert Jacobsen, Jesus Soto, and Jean Tinguely.

32. Hans Haacke, press release, MIT, 1967, Hans Haacke, Artist File: Miscellaneous Uncatalogued Material, Museum of Modern Art Library, New York, NY.

33. Indeed, the critic Guy Brett read Lygia Clark's works as "kineticism of the body" at the same moment. See Brett quoted in Simone Osthoff, "Lygia Clark and Helio Oiticica," *Leonardo* 30, no. 4 (August 1997): 280.

34. Haacke in conversation with the author, September 30, 2014.

35. Burnham, *Beyond Modern Sculpture,* 264.

36. See Sven Lütticken, "Performance Art after TV," *New Left Review* 80 (March–April 2013): 117. It is further indicative of their compatibility that Haacke and Kaprow would go on to collaborate in 1973 on a two-part project in which students from the University of California, Santa Cruz conducted sociological research on their counterparts at CalArts. The process was then repeated, and the findings became the exhibitions at the locations where the artistic research was undertaken: *CalArts as Seen by UC Santa Cruz Students* (January 19–February 10, 1973) and *UC Santa Cruz as Seen by CalArts Students* (January 18–27, 1973).

37. Allan Kaprow, "Pinpointing Happenings," in *Essays on the Blurring of Art and Life,* ed. Jeff Kelley (Berkeley: University of California Press, 1993), 87, repr. in Lütticken, "Performance Art," 117.

38. Kaprow, "The Happenings Are Dead: Long Live the Happenings!," in *Essays,* 63–64.

39. "Kinetics: Big Brother," *Time,* February 9, 1968, 56.

40. Ibid.

41. Skrebowski, "All Systems Go," 55.

42. Ibid., 76.

43. *Photoelectric* was made at a transitional moment. Following Gilles Deleuze, society was undergoing a shift from being dominated by disciplinary institutions to a kind of self-disciplined control prompted by ideology and technological rationality. Haacke's installation evokes both the tendencies that Deleuze describes. The work employs an institution to teach lessons about indirect control. See Deleuze, "Postscript on the Societies of Control," *October* 59 (Winter 1992): 3–7.

44. For an extended discussion of these terms, see Raymond Williams, "The Existing Alternatives in Communications," originally published as a Fabian Society pamphlet in June 1962 as part of the "Socialism in the Sixties" series and reprinted with permission from the Fabian Society online in *Monthly Review* 65, no. 3 (July-August 2013): 92–106.

45. See Herbert Marcuse, *One-Dimensional Man* (Boston: Beacon Street Press, 1964). Augmenting the possibilities that Haacke was familiar with the theorist's ideas at the time, Marcuse also had recently published a paper delivered in 1967 at New York's School of Visual Arts. See Marcuse, "Art in the One-Dimensional Society," *Arts Magazine* 41, no. 7 (May 1967): 26–31.

46. Hans Haacke, interview by Jack Burnham, June 1966, *Tri-Quarterly Supplement* 1 (Spring 1967), quoted in Buchloh, "Hans Haacke: Memory and Instrumental Reason," 214 (emphasis added).

47. "Kinetics: Big Brother," 56.

48. Wiener specifically states: "Thus an adequate theory of language as a game should distinguish between these two varieties of language, one of which is intended primarily to convey information and the other primarily to impose a point of view against a willful opposition." See Norbert Wiener, *The Human Use of Human Beings: Cybernetics and Society* (Boston: Da Capo Press, 1954), 93.

49. Allan Kaprow, "The Education of the Un-Artist, Part II," in *Essays,* 121, quoted in Sven Lütticken, "Playtimes," *New Left Review* 66 (November–December 2010): 130.

50. For an extended account of game theory and games, see Pamela Lee, "New Games," in *New Games: Postmodernism after Contemporary Art* (London: Routledge, 2013), 97–157. The language of systems and ideas of play infused the New Left and counterculture. Describing Timothy Leary and Richard Alpert's mind-set, Todd Gitlin writes, "All political systems were equal oppressors and power-trippers. Political news was game-playing. . . . Indeed, all social institutions were games; the LSD game was simply the best game in town. The antidote to destructive games was—more playful games." See Gitlin, *The Sixties: Years of Hope, Days of Rage* (New York: Bantam, 1987), 208–9.

51. See "Kinetics: Big Brother."

52. Burnham, "Real Time Systems" (1969), in *Great Western Salt Works,* 38 (emphasis added).

53. Galloway quoted in Alexander Provan, "Gestural Abstraction," *Artforum* 51, no. 7 (March 2013): 128.

54. This understanding perhaps constitutes conceptual friction.

55. Jean-François Lyotard, *The Postmodern Condition: A Report on Knowledge,* trans. Geoffrey Bennington and Brian Massumi (Minneapolis: University of Minnesota Press, 1984), 44.

56. Advertisements for New York performances of Brecht's plays can be found around the same time in the underground paper the *East Village Other.* See, for instance, *East Village Other,* May 14, 1969, 17. See also Michael Fried, "Art and Objecthood," in Battcock, *Minimal Art,* 146 n20. Fried mentions Brecht in the body of the essay with limited explanation in relation to theater that attempts to defeat theater, suggesting that the German's work would obviously be familiar to his readership: "The relevant texts are of course Brecht and Artaud" (139–40).

57. This compositional maneuver recalls those found in the work of Dan Flavin since 1962, which Burnham as well illustrates and discusses in relation to "systems esthetics." See Burnham, "Systems Esthetics," 21–22.

58. Suggesting that the Brechtian aspects of the installation would not have been missed by audiences in 1968, Mel Bochner made precisely this argument about Dan Flavin's fluorescent light installations at the same moment. See Bochner, "Serial Art," 100.

59. Following Fredric Jameson and Ernst Bloch, I translate *Verfremdung* as "estrangement" rather than "defamiliarization." See Jameson, *Brecht and Method* (New York: Verso, 1998), 85–86 n13, and Bloch, "*Entfremdung, Verfremdung*: Alienation, Estrangement," *Tulane Drama Review* 15, no. 1 (Autumn 1970): 120–25. According to Bloch's definition of estrangement, "The strange externality purposes to let the beholder contemplate experience separated, as in a frame, or heightened, as on a pedestal. As has been suggested, this leads increasingly away from the usual and makes the beholder pause and take notice. Thus a faint aura of estrangement already inheres in the kind of spoken inflection that will suddenly make the hearer listen anew" (123). Additionally, following William Burling, *Verfremdung* is best grasped as a subset of *Umfunktionierung* (functional transformation/ refunctioning). See Burling, "Brecht's 'U-Effect': Theorizing the Horizons of Revolutionary Theatre," in *Brecht, Broadway, and United States Theatre,* ed. Chris Westgate (Cambridge: Cambridge Scholars Press, 2007), 166–87.

60. Jameson, *Brecht and Method,* 174.

61. Ibid., 84.

62. Haacke quoted in Burnham, *Beyond Modern Sculpture*, 349.

63. Richard Schechner, "Happenings," *Tulane Drama Review* 10, no. 2 (Winter 1965): 231.

64. Brian O'Doherty, *Inside the White Cube: The Ideology of the Gallery Space* (Berkeley: University of California Press, 1986), 15.

65. Robert Morris's *Finch College Project* (1969), also an installation with projections, similarly marked a major break with solely optical spectatorship. See Morris, "Solecisms of Sight: Specular Speculations," *October* 103 (Winter 2003): 33.

66. See Julia Bryan-Wilson, "Practicing *Trio A*," *October* 140 (Spring 2012): 66.

67. Yvonne Rainer quoted in Carrie Lambert-Beatty, "Moving Still: Mediating Yvonne Rainer's '*Trio A*,'" *October* 89 (Summer 1999): 100. Julia Bryan-Wilson asserts the connection to education and *Trio A* in "Practicing *Trio A*."

68. Lambert-Beatty, "Moving Still," 100.

69. Rainer, "Statement" from *The Mind Is a Muscle*, Anderson Theater, New York, April 1968, reproduced in *Work, 1961–73* (Halifax: Press of the Nova Scotia College of Art and Design, 1974), 71, quoted in Lambert-Beatty, "Moving Still," 99.

70. Howard Wise Gallery, "Hans Haacke January 13–February 3, 1968," press release, 1968, Howard Wise Gallery records, 1943–89, Series 2: Artist Files, 1950–84, Box 4, Folder 14, Archives of American Art, Smithsonian Institution, Washington, DC.

71. "Signs" tells the story of a "long-haired freaky" person who is discriminated against by potential bosses. See Five Man Electrical Band (Les Emmerson), "Signs," *Goodbyes and Butterflies*, Capitol Records of Canada, 1970. In *Easy Rider* the protagonists, a couple of "longhairs," are harassed by locals and local authorities and then attacked by the locals. See *Easy Rider*, directed by Dennis Hopper (1969; New York: Criterion Collection, 2010), DVD.

72. Carl Oglesby, "Trapped in a System" (1965), in *The New Left: A Documentary History*, ed. Massimo Teodori (Indianapolis: Bobbs-Merrill, 1969), 187.

73. For a further discussion of art and self-organization, see Jean Leering in Hans Ulrich Obrist, *A Brief History of Curating* (Zurich: JRP/Ringier, 2013), 74.

74. See SDS, "Port Huron Statement."

75. See AWC, "13 Demands" (1969), Eyeteeth.org, May 5, 2010, http://eyeteeth.blogspot.com/2010/05/art-workers-coaltion-13-demands-and.html.

76. Therese Schwartz, "The Politicization of the Avant-Garde, II," *Art in America* 60, no. 2 (March 1972): 77.

77. See Susan Leigh Foster, "Choreographies of Protest," *Theater Journal* 5, no. 3 (October 2003): 395–412. Similar arguments about the political value of bodies congregating in space are proposed by Judith Butler in "Bodies in Alliance and the Politics of the Street," *Transversal*, September 2011, European Institute for Progressive Cultural Policies (EIPCP), http://eipcp.net/transversal/1011/butler/en.

78. Stanley Aronowitz, "When the New Left Was New," *Social Text* 9–10 (Spring–Summer 1984): 19–20 (emphasis added).

79. Aronowitz affirms that investigating "process" was one of the key goals of the group. See ibid., 19.

80. Gitlin, *Sixties,* 135, 84.

81. Christine Larocco, "'Participatory Drama': The New Left, the Vietnam War, and the Emergence of Performance Studies," *Cultural Politics* 11, no. 1 (March 2015): 75.

82. Ibid.

83. Ibid.

84. SDS, "Port Huron Statement" (emphasis added).

85. With "unfinished project," I evoke Susan Buck-Morss's affirmation, riffing on Jürgen Habermas's claims about modernity, that democracy is an unfinished project. See Buck-Morss, "Democracy: An Unfinished Project," *boundary: A Journal of Theatre and Culture* 41, no. 2 (2014): 71–98, http://boundary2.dukejournals.org/content/41/2/71.full.pdf+html.

86. See George Kennan, "Rebels without a Program," *New York Times Magazine,* January 21, 1968. Very similar critiques were mounted on the pages of the *Times* criticizing the Occupy Movement in 2011. Carl Oglesby wrote a response, "A Program for Liberals," that was published in *Ramparts* in February 1968.

87. This was another goal of SDS. See Oglesby, "Program for Liberals."

88. I refer to Walt Whitman's "I Sing the Body Electric" (1855). Whitman's poem describes the beauty of all forms of human bodies and the interaction of those bodies.

PART THREE

THRESHOLDS OF THE VISIBLE

Technologies of the Everyday

SANDRA SKURVIDA

9

TECHNOLOGIES OF INDETERMINACY
John Cage Invents

JOHN CAGE'S MENTOR IN MUSIC Arnold Schoenberg characterized his former student as "not a composer but an inventor—of genius."[1] Cage subsequently appropriated this possibly ambivalent comment by the modern master for his own purposes—he used Schoenberg's words to announce that he was not only succeeding but superseding his teacher in pursuit of his own invention. His conception of combinatorial indeterminacy was indeed an invention—an apparatus designed to methodically subvert disciplinary and institutional structures and to cultivate equations of differences instead.

Cage's compositional apparatus of indeterminacy went through technological conversions of the twentieth century—from his mechanical tinkering with a piano by inserting screws and bolts into its sound box (prepared piano), to magnetic tape sound collage, to the use of radios as instruments, and eventually to the digital computing of compositions. He seldom used technologies according to their utilitarian purpose, more often going against the grain of their intended, and therefore limited, functions. Cage's attitude toward

multitrack recordings conveys his take on technology at large: "Every time that I've used it, I've been careful not to use it."[2] This is not to say that he was technology-averse—quite the opposite. Rather, he sought to circumvent the purposefulness and use technologies for other means. To cut up and reassemble tape in *Williams Mix* (1953), or attempt to program chance (which of course can occur in computation only as an error)—Cage employed these technical processes to create a procedural jam that would keep intentions and outcomes apart. A resulting composition, albeit calculated, could not be premeditated, thus entwining intention in a paradox of execution. "Ghosts or monsters" that critics conjured up in response to Cage's structural and institutional transgressions, including his use of technology, are specters of this jam.[3] Adverse receptions of technological experiments by Cage and many of his contemporaries haunted their work until advanced technologies entered the mass market and wore off their newness as well as the inception of their use for military purposes, as satirized by Kurt Vonnegut in his short story "EPICAC" about a militaristic computer writing love poetry. Reexamined in this essay from the perspective of the twenty-first century, Cage's technological indeterminacy no longer appears as a "ghost in the machine," but rather seems a precocious acculturation to the networked information environment, which reconfigured the Cartesian mind-body dualism into a binary code.[4]

At the turning point of his career at midcentury (1949 to 1951), Cage devised a chance operations protocol based on the *I Ching* (Book of Changes) and wrote a programmatic text *Forerunners of Modern Music* (1949), in which he defined the structure of composition as premised on lengths of time and proposed a music comprising both sound *and* silence—soon to be demonstrated in his composition *4'33"* (1952). The text put forth a possibility to make such a music using radios as instruments, which would allow the composer to "give up the matter of method to accident," via technological means.[5]

Cage had been familiar with radio broadcasting since his youth—at age twelve he started a radio show on KNX station in Los Angeles, and he continued to write for the radio throughout his long career, including a soundtrack for Kenneth Patchen's *The City Wears a Slouch Hat* (1942, CBS) and a series of plays for Westdeutscher Rundfunk (WDR): *Roaratorio* (1979); *James Joyce, Marcel Duchamp, Erik Satie: An Alphabet* (1982); and *HMCIEX* (1984). In addition to expanding the audience of his music via broadcasting, Cage conceived of radio as a source of readymade sound to be incorporated in a composition. This convergence of transmitter and transmission, or medium and material, can be traced to the figure largely absent from Cage's celebrated circle of references, Jean Cocteau. In Cage's extensive account of acknowledgments, Cocteau is nowhere to be found, despite his key role in the formation of the avant-garde visual arts theater and his advocacy of Satie, as well as his multivalent practice similar in its scope to Cage's.[6] Cocteau's film *Orpheus* (released in France in 1949, during Cage's stay there, and in the United States the following year, upon his return) features a central plot of transmissions via car radio of the poems by the dead poet Cégeste from the beyond; each random transmission is announced with a call for "Silence!" before a disembodied mechanical voice proceeds to recite a new poem, which is duly transcribed by the popular living poet Orpheus and subsequently published to a great

acclaim. Cocteau's cinematic afterlife from which these transmissions ensue resembles a bureaucratic control center, where even the judges are judged by invisible powers that be, and technological means of communication—telephones and radios—are common. At the same time, Antonin Artaud used radio as a potentially "transcendent" medium that could transmit disembodied sounds from beyond empirical reality, exemplified in his radio play *To Have Done with the Judgment of God* (written in 1947, it was censored from broadcast on French Radio in January 1948). Cage's personal affiliations and interests leave little doubt that he knew of both authors and their works.[7]

Cage wrote *Imaginary Landscape No. 4* for twelve radios between April 5 and 27 and premiered it on May 10, 1951, at the McMillan Theater (now Miller Theater) of Columbia University. Twelve RCA Victor radios, advertised as "eight pounds in weight, thirty-five dollars each, with a golden throat acoustical system," took the stage.[8] The radio piece was a much-anticipated finale of the program. Cage conducted the performance from the score written in proportional notation. Two operators were assigned to each radio, among them Julian Beck and Judith Malina (Cocteau was among the supporters of their Living Theater) and writer Harold Norse, who described the piece as similar to "an automobile ride at night on an American highway in which neon signs and patches of noise from radios and automobiles flash into the distance.... Picking up snatches of music and speech, with lengthy silences in between, it had a disturbing effect."[9] "Golden throats" performed as programmed, even though their performance was mostly silent; attempts to explain away the silence as due to the late hour when many stations went off the air have been repudiated by Cage, who pointed out that sound levels of this composition as determined by chance operations are always very low.[10] *Imaginary Landscape No. 4* put front and center the technological variability of sound material in a composition. Emphasis on durational variability equated speed and time. This idea was tentatively introduced but not yet articulated years earlier in *Imaginary Landscape No. 1*, which premiered in spring 1939 in Seattle. In this early electro-acoustic work, realized in a radio studio at the Cornish School, Cage used two variable-speed turntables to play Victor frequency records of constant and variable frequency and to transmit variable sounds of these found records via radio into the theater a short distance away. *Imaginary Landscape No. 2* (1940) was recorded in the same studio; and *Imaginary Landscape No. 3* (1942) used, again, variable-speed turntables and other electronic devices. According to Cage, the title *Imaginary Landscape* conjures up a technological landscape of the future: "It's as though you used technology to take you off the ground and go like Alice through the looking glass."[11]

Cage used technological devices to extract and demonstrate the various qualities—the immediate data—of time, graspable only when accounted for. Antecedents of the musical qualification of time that Cage traced back to Satie's *Vexations* lead us to consider it in the light of the contemporaneous metaphysical psychology of the late nineteenth century, specifically Henri Bergson's 1889 treatise *Time and Free Will: An Essay on the Immediate Data of Consciousness,* which mediated between duration and extensity and between succession and simultaneity. Similarly, qualification of "free" time became the main tenet for Cage, who,

like Bergson, understood that homogeneous time is nothing but space and that pure duration is something different. He refrained from a successive composition—"from separating its present state from its former states"—and moved into the space of simultaneity.[12]

Cage's allies and critics, including composer Henry Cowell, who reviewed the premiere of *Imaginary Landscape No. 4*, were prepared to accept, in Cowell's words, "a concentration on unfamiliar relationships of space and time, and sound and silence, rather than on melodies and chords, and a conviction that all musical relationships, whether arrived at by chance or by design, have potential value and are worth examination."[13] But Cage's total acceptance of chance around 1950, fortified by his studies of Zen, was more radical than his early supporters, including Cowell, Josef Albers, and Pierre Boulez, would tolerate, and beckoned toward the indeterminacy manifest in the groundbreaking complexity of *Music of Changes* (1951).

In 1952, Cage set out to performatively demonstrate the durational variability of sound-producing action. In the spring of that year, he composed *Water Music,* instrumentation of which, in addition to a radio tuned to whatever programming is being broadcast at the time of a performance, called for a piano, four piano preparation objects, various whistles, a deck of cards, containers of water, a wooden stick, and a stopwatch. This composition was precisely notated in a calligraphic score (Peters Edition EP 6770). In the score, forty-one discrete events (piano notes, radio frequencies, actions with whistles and water containers, etc.) are denoted on ten sheets with exact timings in minutes, seconds, and microseconds. The score was to be mounted poster-like in the performance space so that audiences could read it and correlate conception and execution. This display of a score as a visual text object made clear that the actions of a performer—slamming the keyboard lid shut, shuffling the deck of cards and dealing seven of them, pouring water from one receptacle to another, turning the radio on and off, blowing the duck whistle in a bowl of water—were strictly regimented and not random or improvised. The score presided over the performance, asserting that any appearance of absurdity of the actions was incidental.[14] The premiere of this composition in New York on May 2, 1952, was followed that summer by an untitled event at Black Mountain College (subsequently titled *Theater Piece No. 1*) composed of discrete and discontinuous simultaneous actions by a number of participants. There is no surviving score or documentation of this event, except for an oral history related by various eyewitnesses who recall reading of poetry, dancing, a lecture by Cage and/or the playing of his music, phonograph recordings and film and slide projections, paintings suspended from the rafters, coffee being served, and a dog barking throughout the performance. Eyewitnesses' accounts of the event, transcribed by historians, constitute its oral history, variously and continuously interpreted.[15] In the absence of a more reliable record of the untitled Black Mountain event, *Water Music* was one of Cage's first documented performance pieces for the eyes as well as the ears—it occupied a multisensory space that rejected the conventions of a concert hall and was much better suited for a space where the audiences were free to move about. Its deadpan performativity hails from circus and fairgrounds, Buster Keaton and early movies, filtered through the modern aesthetic.

A series of Cage's highly performative compositions related to *Water Music*—including *Music Walk, Water Walk,* and *Sounds of Venice*—aligned with adventurous public television programming at midcentury. In the late 1950s and early 1960s, TV was not only a new medium; it also offered a new venue for art and technology.[16] *Water Walk* and *Sounds of Venice* premiered in 1959 on a popular Italian TV quiz show, *Lascia o Raddoppia,* where Cage performed his music and expertly answered questions about mushrooms, winning the top prize and gaining minor celebrity status. The following year, he performed *Water Walk* in New York on Henry Morgan's show *I've Got a Secret* (CBS).[17] The stage for *Water Walk* resembled an installation of various readymade objects mostly related to water, including "mixer with ice cubes," "stove with pressure cooker," "bath tub 3/4 filled with water," "iron pipe," "ice bucket," "campari," "glass," "soda syphon," "vase with roses," "exploding paper bottle," "garden sprinkler," and mechanical "fish."[18] This colorful installation of everyday objects was activated by a performer who had to move deftly and purposefully around the stage to play these "instruments" in a timely fashion according to the score, which allowed some room as to the timings of actions ("Start watch and then time actions as closely as possible to their appearance in the score"). The context of TV production did not merely capitalize on irrepressible comedy of the piece—it brought up the sociopolitical context that may or may not be stated but always looms large in the presentation of Cage's work. A union dispute over the jurisdiction of plugging in the radios had not been resolved before the start of the show, leaving the radios mute. Cage modified the performance in a way that emphasized the antagonism between the workers and consumers—those employed to execute his artistic intentions did not always share them. This conflict resurfaced time and again in the composer's relations with organized labor, specifically orchestra musicians, who frequently sabotaged his pieces. Cage addressed the change he had made in the execution of *Water Walk* for TV in his introductory remarks preceding the performance—he would hit the tops of the radios with his hand instead of switching them on and would shove them off the table rather than turning them off. This absurdly comical solution stems from Cage's anarchist position in relation to organized politics, which became even more evident in his Circus-type events.

The resulting performance is as calculated as it is amusing in a deadpan manner evocative of Satie. The titles of this series refer to Satie's *Water Music Suite in F Major* (1914), and Cocteau delivers the textual bridge between the two composers. "Is this once more the music on which, as Nietzsche said, 'the spirit dances,' as compared with the music 'in which the spirit swims'?" Cocteau asked. "Not music one swims in nor music one dances on; MUSIC ON WHICH ONE WALKS (emphasis in original)." This "music on which one walks" was for Cocteau—as well as for Cage—like a song by Satie.[19] Cocteau elaborated on his pronouncement: "The impressionists feared bareness, emptiness, silence. Silence is not necessarily a hole; you must use silence and not a stop-gap of vague noises."[20] Cage would soon do so, in his game-changing "silent" piece *4'33",* which premiered in the fall of the same year *Music Walk* was composed, 1952.

Cage called it a "Circus." In his idiosyncratic terminology, *Circus* signifies an open multivalent compositional structure in a social setting, potentially unlimited in scope. Cage's

Circus was predicated on the simultaneity of acts and comprised a multitude of moving parts—typical of a three-ring circus, country fairs, and trade shows—that would come together in an indeterminate performance; a variable assembly of parts would render various performances of the same composition unlike one another. Procedural erasure of authority, authorship, and subjectivity via a near-total reliance on technologically standardized chance operations led toward collectivization of both the production and the reception of Cage's work. For the *Whole Earth Catalog* generation, technology promised a total access to the virtual entirety of information; for Cage in particular, this implied the entire spectrum of sonic occurrences to be mobilized in a machine-made performance—recorders and transmitters, and later computers, were made responsible for the emerging techno-aesthetics of his work. Keen interest among New York–based composers including Cage, David Tudor, Christian Wolff, James Tenney, and Alvin Lucier in electronic sound production provided a strong incentive for the engineer Billy Klüver to establish Experiments in Art and Technology (E.A.T.)—a laboratory for collaboration between Bell Labs engineers developing electronic communications systems and New York's experimental art scene. This initiative culminated in *9 Evenings,* a program of experimental art presented in October 1966 at the Sixty-Ninth Regiment Armory in New York City.

Cage's contribution to *9 Evenings* was *Variations VII* (executed with engineer Cecil Coker), for which he utilized the wireless sound system that was devised collectively for the entire project (figures 9.1, 9.2). It would capture, transmit, and amplify "only those sounds which are in the air at the moment of performance, picked up via the communication bands, telephone lines, microphones, together with, instead of musical instruments, a variety of household appliances and frequency generators."[21] All of the above were arrayed on long tables in the performance area and included a juice blender, fan, toaster, twenty radio stations, two televisions, two Geiger counters, oscillators, a pulse generator, and ten telephone lines open to various locations resonant with Cage's personal soundscape of the city, such as Luchow's restaurant, the Bronx Zoo Aviary, the Fourteenth Street Con Edison power station, the ASPCA lost-dog kennel, the *New York Times* press room, and Merce Cunningham's dance studio.[22] During the performance, moving shadows of people working the equipment created a dramatic visual backdrop, evocative of the shadowy comings and goings in and out of the afterworld in Cocteau's film (see figure 1.2 in Goodyear's essay, this volume).

On the second night (October 16), the audience was invited to join in the performance. Artist and writer Brian O'Doherty described the proceedings: "Cage seeded the audience with people who left the bleachers during the performance and walked around the electronic clutter, frantically serviced by technicians whose shadows were thrown on a white screen—a typically Cagean palimpsest gathering in the evening's activity. The audience followed in dribbles and then in one great flood, ending up clustering and shifting on the floor. This was a major success."[23]

Persistent technical difficulties obfuscated the impression of "success" in the eyes of those involved in its making—engineers, artists, and audiences alike. Technicians were anxious about the misuse of the systems, artists were annoyed that the systems did not do

33, 10, 58, 62, 34, 23, 24, 25
11, 33, 27, 23.

Variations VII

12 remarks re musical performance

seated or unseated (space for
freedom of audience to move ^in
loud-speaker surrounded space, area)
indicating this freedom by
non-verbal means.

no playbacks or used,
now use of, tape machines
i.e. no previously
prepared sds.

catching sds. from air as
though with nets, not
throwing out however the
unlistenable ones.

use of sound generators

modulation means.

telephone lines, radio receivers
sd. generators etc. no special
theatrical or visual activities.
variety of loud-speakers.

Continuous sources triggered
by photo. electric means.

[sideways notes:]
Study map on book itself
info. on spine
Title etc. in blue + orange
on transp. cover.

FIGURE 9.1

John Cage, *Nine Evenings, Variations VII: 12 remarks re musical performance* (two pages), page 1, ca. 1966. Pencil notes on yellow notepad. Experiments in Art and Technology records, Getty Research Institute, Los Angeles (940003). John Cage Trust.

no score no parts free
manipulation of available
receivers & generators by
any number of performers

start and conclusion
determined by circumstances
either program length (if
something else on program)
or ~~absence~~ arrival departure of
audience (1st to arrive;
last to depart).

making audible what is
otherwise silent ∴ no
interposition of intention.
just facilitating
reception

Checking each thing used
to make sure it works.

Collaboration with engineers
using composition socialized.

FIGURE 9.2

John Cage, *Nine Evenings, Variations VII: 12 remarks re musical performance* (two pages), page 2, ca. 1966. Pencil notes on yellow notepad. Experiments in Art and Technology records, Getty Research Institute, Los Angeles (940003). John Cage Trust.

what they wanted to be done, and audiences were mostly bored because of the lack of spectacle.

Following the engagement with E.A.T., Cage sought to further explore the potential of the most advanced computer technology and accepted an invitation to be in residence at the University of Illinois, Urbana-Champaign, from the composer-scientist Lejaren (Jerry) Hiller, who was head of the electronic music studio there and had previously held a professorship in the Department of Chemistry. As part of his residency, Cage was to create two pieces using the mainframe computer housed at the University, ILLIAC II, boasting 53K of memory and capable of parallel processing.[24] Just as he had done at Black Mountain, Cage used his appointment at the university as an opportunity to prototype new work. He called this new form *Musicircus*, and created two versions of it at Illinois. The first Musicircus was an unscored analog composition, structurally similar to *Theater Piece No. 1*. Contrary to the first Musicircus, the second Illinois event, *HPSCHD,* was microscored using the computer.

Facilities at the university, in addition to the advanced mainframe computer lab, provided arena-like pavilions in which to explore new spatial arrangements—the first Musicircus took place in the Stock Pavilion, used for livestock shows (figure 9.3), and *HPSCHD* was presented at the Assembly Hall. Both spaces are free of spatial regimens that clearly separate the outside and the inside, without interior divisions. The organization of multipurpose interiors of such tent-like pavilions is temporary, so the space is not permanently polarized—rather than progression along an established axial hierarchy, lateral movements are encouraged. The porous skins of the pavilions enable circulation between the inside and the outside—lighting and transparent surfaces, reflections and shadow play enable perception of the interior space outside and the exterior space inside, as air, sounds, smells, and visitors travel both inward and outward. Reviewers of *Musicircus* noted the comings and goings of the audiences that blurred the boundaries of the event, especially the high volume of the sound reverberating outside the pavilion. As at the fairgrounds, visitors could not take in the overall setting at once and circulated throughout the space without being able to grasp its overall economy. This physical setting stresses the importance of the relation to time rather than space—the piece takes place in time, whereas its physical boundaries are indistinct.

Even though Cage's theater and circus events were frequently realized in educational settings, such as Black Mountain College and the University of Illinois, they were precisely not made to teach or demonstrate something, or even to show off the capabilities of the new technologies, but rather to confuse and disquiet the mind—as theorist Jean-François Lyotard put it in the notes concerning his own Cage-influenced exhibition making, to question "the idea of the will and intelligence of an all-powerful subject, in order to produce instead a sort of effect of modesty in the anthropological atmosphere in which we live—the problem is that it effectively risks ending up in failure."[25]

The Illinois Musicircus was held at the Urbana-Champaign Stock Pavilion on November 17, 1967, from 8 p.m. Friday until 1 a.m. As one of its participants, then student Bruce Zumstein succinctly recalled it almost fifty years later, it was a "visual sensation with music."[26] He wrote in the student newspaper after the event, "Sounds pervaded the senses and drove

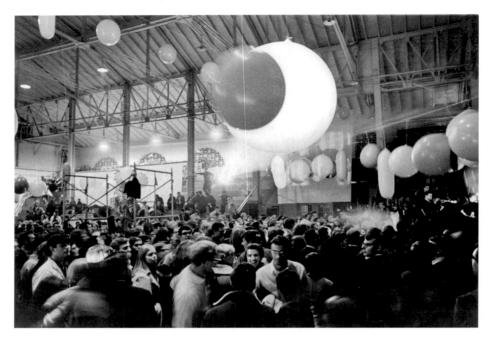

FIGURE 9.3

John Cage, *Musicircus,* November 17, 1967, Stock Pavilion, University of Illinois, Urbana-Champaign. Courtesy of the University of Illinois Archives, RS: 39/2/20, Box 126 EVE, Folder EVE – 14.

headaches into numbness. Lights flashed incessantly and the pavilion was momentarily darkened in relief when lights were turned off. An absurd number of hands played unrelated music."[27] Musicians played whatever they chose simultaneously, taking breaks as they pleased in an open compositional structure similar to that of the 1952 Black Mountain event. In addition to aural overload, there was a visual stream of film projections, including a loop of a color film of a man smiling, frowning, and laughing and sequences of psychedelic light patterns. In the center of the pavilion, a cage of lead pipes enclosed hollow tubes that could be used as an instrument; audiences banged at it until the pipes separated and the structure was removed.[28] A principal dancer in the Merce Cunningham Company, Carolyn Brown, and French mime Claude Kipnis performed their individual routines on a platform. In the same way as during the second night of *Variations VII* for *9 Evenings,* performers and audiences intermingled, and "little boys caught freely flying balloons and carried them off."[29]

Musicircus is an event without a score. Keenly aware of the authority inscribed in and administered by a score, Cage consciously chose to forgo it (not wanting *Musicircus* to be copyrighted), thus defining this composition specifically as an idea for use rather than an authored art product. We can infer what *Musicircus* by Cage was—that is a historical question; what it can be, and the question of attribution of subsequent productions, remain open. Historical reconstructions of *Musicircus* have been based on descriptions and instructions in Cage's correspondence and published writings; commentaries and interviews; local

newspaper reviews; and a film by Ronald Nameth of the first Musicircus (1967).[30] A number of secondary sources continue to contribute to the research and interpretation of this important multimedia work in the context in which it was first produced.[31] Reviews written in the language of the 1960s identify Cage's *Musicircus* as a "happening." Cage unsuccessfully tried to get away from this designation, yet it continues to persist in the scholarship focused on the 1960s avant-gardes and happenings.

In the second Illinois piece, Cage took a different route to create a performance somewhat similar to his first Musicircus, but structurally amplified. Together with Hiller, he undertook a painstaking task of computer-aided microtonal scoring. Nascent computer technology provided testing grounds for Cage's notion of indeterminacy set on a collision course with the determinism of computation—as he realized during the programming phase, a computer did not work if its routine included an indeterminate element, which was read as "fatal" or "nonfatal" error. Similarly, chance—the central tenet of Cage's composition—does not occur in computing, except when it malfunctions. Hiller and Cage's notions regarding the role of chance in computer-generated music differed. Hiller sought to bring order out of complexity, whereas Cage was looking for an alternative to the subjectivist frame of a culturally determinate aesthetic regime. Moreover, Hiller was critical of Cage's "magical" method of generating random numbers using the *I Ching*, which he deemed "ridiculously inefficient" compared to the Monte Carlo method, which he himself used to compose *The ILLIAC Suite* (1957), later retitled *Quartet No. 4 for Strings* (*The ILLIAC Suite*). Since Cage did not know computer language and was disinclined to learn, Hiller became solely responsible for programming *HPSCHD*. Paradoxically, his first task would be to code the ICHING subroutine emulating the *I Ching*, which was used as the randomness model for all subsequent computer programs written for Cage.[32]

The key principle for Cage in the 1960s was indefinite expansion of the field for chance operations and diminishment of the differences between components within a given composition, to the point where they may become sensorially indistinguishable, as in microtonal music. This conveyed Cage's intention to break down the normative relations of parts within a given system, including music composition. The number of potential sounds is greater than the limited computer memory can process, so Cage and Hiller divided the octave into mathematically obtained pitches from 5 to 56; each of these pitches had a field of sharping and flatting by any of sixty-four degrees determined by ICHING. The resulting database included approximately 885,000 pitches. Out of this database, Cage and Hiller made 208 separate tape recordings of computer music representing chance-driven, microtonal divisions of the octave. Because parallel computing was at a rudimentary stage, and because of its limited memory, ILLIAC could be used only for composing linear musical sequences in a great many microtonal divisions and was not able to integrate them in the three-dimensional networks that Cage envisioned. As he explained:

> Rather than having a line of sounds which would go from one sound to the next, one could have a series of sounds which would overlap in various ways. But to accomplish this means

going forward in the program and then going backward and then going on, etc. This would bring out complexities in programming which, in our present circumstances in this particular piece, seem excessive. And so, the overlapping that will take place in this piece will be the natural overlapping of one tape on another—of different things on one another. But the things which are overlapping one another do not themselves have overlaps within them. And yet it is this fact of sounds overlapping that was, in the case of fine harpsichord playing, productive of a musical experience.... I think that it's in that direction of getting the computer to be able to do the kinds of things that we can do—so to speak, without thinking—that's one of the directions that may be taken with it.[33]

In addition to the tapes, *HPSCHD* featured seven harpsichord solos, performed live. Solo I was a transcription within the conventional twelve-tone scale of the computer music of the same type as generated for the tapes, rendering it playable on this historic instrument. Solo VII was stipulated as any composition by Mozart or any other Solo not being played at the starting point of Solo VII. Solos II to VI were derived from existing compositions ranging from Mozart and Beethoven to Cage and Hiller, representing a short survey of Western music. Selected works were processed using ICHING chance operations and a "Musical Dice Game" attributed to Mozart.

After two years in the making, *HPSCHD* opened at the University of Illinois Assembly Hall on May 16, 1969. The free-dimensional computation and synesthesia of sound and image that Cage envisioned was presented—perhaps his ideas were at times only illustrated, in order to be experienced by the audiences—in a performance that included slides and film projections on the theme of outer space, sourced by multimedia artist Ronald Nameth, known for his cinematic homage to *Andy Warhol's Exploding Plastic Inevitable* (1967) and by Illinois graphic artist Gordon Sumsion. On a 340-foot circumference screen, projections of forty films on the theme of outer space and 6,800 slides provided by NASA, some of them hand-painted, provided a counterbalance to the microtonal music (before the Ronald Reagan administration's edict in 1981, satellite information and images from space were treated as a public resource, and scientists working for the government were allowed to freely share them with the public, including students and artists). The consumer dream of the Space Age provided a conduit for artists to absorb military and utilitarian products of the US space program into a new aesthetic, evident in Buckminster Fuller's Dymaxion design philosophy and his prototype of the World Wide Web in the World Game (initiated at Southern Illinois University in 1965);[34] in Robert Rauschenberg's *Stoned Moon* prints of 1969–70 celebrating the techno-optimism of the first man on the moon; and in the Electric Circus.

The darkened cavernous space of the Assembly Hall conjured up an astrophysical analogy with a nebula—a mass of dust, "a focus of energy forming matter, one that excludes the simple opposition between interior scenes . . . and modes of circulation like lines of attraction bringing bodies together."[35] The opposition between the stable habitats and modes of circulation disappears, since performative space invoked in *HPSCHD* was a resounding

space, charged with the overload of photonic and sonic messages transmitted electronically. The mode of spectatorship in *Musicircus* is of a crowd. The audience, estimated at seven thousand people, milled about freely for four and a half hours in the enormous circular space of the Assembly Hall filled with the amplified cacophony of seven harpsichord solos and fifty-two tape recordings that would start and cease and overlap according to the score as well as performers' choices and circumstances. Display of posters, silk-screening of party T-shirts, and the serving of candied apples and popcorn contributed to a psychedelic country-fair atmosphere. By all accounts, it was a grand event.

In this composition, Cage envisioned a potentially limitless multiplicity and virtuality, which had been accomplished despite the limitations of technology—by going against the mode of operations of existing technology. The idea has been realized in performance, via an overlapping sensorium of great quantities of sound and visual material in a social environment. Cage's emphasis on the amount of work required to produce this multiplicity—his precise equation of time and labor, in anticipation of ideas articulated in the accelerationist theory of the twenty-first century by Benjamin Noys, Antonio Negri, and others—is indicative of the direction of Cage's thought as the 1960s came to an end, apprehending the nascent postmodern condition. He indicates his interest in this future condition:

> One thing that has interested me in this, and I hope it will interest more and more people who work with computers, is the large amount of time and painstaking work that goes into making a subroutine operable. For instance, teaching the computer to toss coins as I had been doing manually, following the mechanism of the *I Ching*—to produce that subroutine took six weeks. To produce this whole piece, which is not yet operating, has taken ten months, which is one month longer than I spent on the *Music of Changes* and *Williams Mix*, or on any other piece that took me a long period of time. This work that goes into the subroutine gives it a character that, I think, chords had for composers in the past. The notion that that chord belongs to one person and not to another tends to disappear, so that a routine, once constructed, is like an accomplishment on the part of society rather than on the part of a single individual. And it can be slightly varied, just as chords can be altered, to produce quite other results than were originally intended. The logic of this routine, once understood, generates other ideas than the one which is embodied in it. This will lead, more and more, to multiplication of music for everybody's use rather than for the private use of one person. . . .
>
> Leisure, just from this point of view, is not a problem. The question is, rather, "How is our energy? Do we have as much as we had? And how are we going to get more?"[36]

Cage speaks of his own transition into an electronic paradigm (from tossing coins to coding subroutines of chance operations, as just one example). Within this new technological paradigm, application of informatics procedures to the routines of labor led to what was assessed by theoreticians during the 1970s and early 1980s, in an analysis by Giairo

Daghini, as a semiotization of labor, "that is to say a labour that is applied to add through signs rather than by way of the worker's direct manipulations of the machine. To semiotise thus comes down to coding, and coding means managing."[37] Cage's role in the production of *HPSCHD* was unmistakably managerial, as it had been in his other theatrical productions and in *Musicircus*, and as it would be in the future compositions for museums.

An emphasis on quantitative differences within an accumulation of material as large as practically possible was intended to bring about a qualitative change—in perception, production, and society, as Bergson had hypothesized in his *Time and Free Will,* in its reach beyond the modern paradigm.

In *HPSCHD,* Cage asserted his idiosyncratic notion of anarchy. In his anarchic time, causal relationships are disrupted, not permitting experience of disruption to render an action. Thus what was at stake was the fundamental taxonomy of an art institution: for example, harmony in music composition, grammar and syntax in language, and museological and art-historical canons in visual arts. Backlash to an open-ended social engagement proposed in *HPSCHD* followed soon after its premiere. Already in 1972, this composition from another era—the 1960s—had been met with scathing critique even before its London premiere. Composer Cornelius Cardew in his "John Cage—Ghost or Monster?" denounced Cage's avant-garde appropriation of the popular entertainment for the masses that was the traditional circus and his transference of a circus model onto a classical orchestra—traditionally an instrument of "high class" entertainment.[38] Orchestra musicians sabotaged numerous performances by not following the score, not rehearsing, and even destroying electronic equipment that they regarded as a threat to their training, status, and livelihood. Cardew described this resistance "as spontaneous expression to the sharply antagonistic relationship between the avant-garde composer, with all his electronic gadgetry, and the working musician. There are many aspects to this contradiction, but beneath it all is class struggle."[39] In my view, Cardew is correct by pointing out the antagonism between the classical orchestra as a stronghold of tradition and Cage's attempts to dismantle it, but instead of being his adversaries, musicians became his unwitting allies, sabotaging realization of the work intended to "liberate" them. On the other hand, and against Cardew's invocations of class struggle, the musicians behaved as they did in order to preserve the existing power with its benefits rather than to join the workers' revolution.

Future performances of Cage compositions depended on tempered negotiations between Cage's intentions to expose the structure of power and the practical steps required to accomplish such exposure. Toward the end of Cage's life, his notoriety turned into celebrity, making it possible to realize his most subversive projects at the most prominent institutions. In the world of classical music, *Europeras 1 & 2* (produced by Frankfurt Opera in 1987) and *Europeras 3 & 4* (for the Almeida Festival in the United Kingdom in 1990) dismantled the canon of classical opera, mixing character parts and their visual accouterments according to chance operations, where a character dressed as Figaro might sing a part of Aida in a setting from *The Ring.* Various iterations of *Musicircus* continued to be produced as community festivals, with numerous performers and ensembles appearing in an anarchic array

determined by chance operations; the last iteration of the form directed by Cage himself was at Stanford University in 1992, where, in spite of the intended deauthorization of the production, the author's presence and his celebrity became the center of attraction around which the spectacle revolved.[40]

Cage scholars have maintained that *HPSCHD* "marks the culmination of the most experimental and challenging phase of Cage's career."[41] This assessment largely overlooks the last two decades of Cage's work and his profound influence on contemporary art, expanded curatorial practices, and media art of the post-Internet era. Studies focused on Happenings tend to cast Cage's events of the 1950s, such as the Black Mountain event, as precursors to Happenings; and studies of Fluxus and performance and conceptual art bring forth reflexive affiliations.[42] The discursive frame of the Black Mountain event seems to be capacious enough to accommodate the origins of historical lineages superseding the neo-avant-gardes, asserting its ever-present contemporaneity preoccupied with being within its time.[43]

In his text compositions, Cage orchestrated a nonhierarchical multiplicity of voices via his ongoing mesostic writing through various source texts, such as *I–VI*, presented as the Charles Eliot Norton Lectures at Harvard University in 1988. His entropic mechanism of "writing through" and gradually obliterating intelligibility rendered language into pure vocalization—pure time. In his continuing engagement with visual art—as artist, collector, and curator—Cage developed the Circus model as a "composition for museum," which culminated in *Rolywholyover A Circus by John Cage,* initiated in 1989, produced by curator Julie Lazar, and presented posthumously at the Museum of Contemporary Art, Los Angeles (1993).[44] Cage proposed that it should be "a composition" for a museum, not an "exhibition" in the traditional sense of the term. The conceptual premise of this composition was "to create a dynamic environment where people, art and all would co-exist in a compositional environment, that exemplified a real situation where hierarchies were leveled off as much as possible, and where people enjoyed the opportunity to become more aware of the possibilities of self-government."[45] In short, it would dismantle and expose various aspects of a museum exhibition model. According to Cage's concept and the protocol of its execution in the form of a score, chance-selected objects shifted in placement so that randomization determined the installation. Chance, that unpredictable anathema to the museum's rationalist impulses, here became a structuring device for the making of the exhibition, intervening in "business as usual" and asking the institution to reconcile with the purposeful production of relativity. *Rolywholyover* comprised the formats and modes of chance-generated composition in the four "movements" of its cycle:[46] Museumcircle was made up of decontextualized objects loaned by local museums; Main Circus was a changing display of works by artists of the Cage circle (approximately 160 works by sixty-seven artists, and many more were represented via documents and memorabilia contained in the movable transparent file drawer chests, bringing the total number to 190 participants); Cage Gallery displayed his visual art works; and Media Space was dedicated to various media and performance works by invited artists.[47] The score of *Rolywholyover* was composed using the computerized chance protocol that Cage had practiced since his work with Hiller on

HPSCHD. Composer Andrew Culver wrote a number of computer programs for Cage, including ROVER for *Rolywholyover.*[48] Main programming variables included the number of pieces on display, which pieces, and where and how long they should be displayed. The number of pieces to be changed daily was determined by the workforce—how many pieces can a crew of installers handle during a workday? The time brackets were determined by the exhibition's run, the hours that the galleries were open to the public, and the work hours of the installers—which overlapped but did not exactly coincide with the public hours, since the workday began before the galleries opened and included a lunch hour. The time allocated for the job was generous, but it had to be done within the time brackets specified in the score—something true of all Cage compositions. The objects' positions on walls and floors were mapped on a grid specific to the museum architecture; a variable stipulated that small pieces should be within viewing distance and that they should not overlap. Five unique scores were produced for the touring exhibition (one for each venue—they can be treated either as variations of one score or as one score in five parts). Pages of the score were printed for each day as the installation chart and schedule and were given to the crew of installers. Hypothetically, the computer could generate a score for any exhibition at any venue (figure 9.4).

Specially designed for this Circus were two interactive sound and text file shuffles. "It Is About to Sound," designed and compiled by composer David Rosenboom and realized with programmers at the Center for Experiments in Art, Information and Technology at CalArts, featured three hours of digital sound stored on two 1.2-gigabyte Mac drives and included compositions by Charles Amirkhanian, Joan La Barbara, János Négyesy, Satie, and Schoenberg, among others. Visitors could sample the contents and create personalized playlists, or "musical collages," as they were called. Another computer station carried "Intergrams," conceived by Jim Rosenberg, which allowed users to manipulate text blocks into interactively composed text pieces.

Cage's curatorial intervention emphasized the simultaneity of museum functions. The superimposition of a dual schedule (one for staff and another for visitors), as well as the unveiling of behind-the-scenes museum functions, diminished the division between work (that of museum staff) and leisure (that of visitors). By implication this put viewers to work as work went on display. Conversely, actual workers literally became part of the exhibition. Members of the "invisible" professions—guards, installers, and maintenance workers—testified that they considered themselves to be integral to the structure of the exhibition rather than merely servicing it, while visitors were never allowed to forget how the exhibition-spectacle came about—ladders and hammers were always present in the galleries as was the presence of work actively being done.[49] Museum architecture and its displays are usually designed to "disappear," allegedly in order to focus attention on the objects; the invisibility of the museum-machine makes its role in the production of knowledge appear more potent. And whereas fixed armatures and points of view, taxonomies, and clear chronologies constitute the foundations of the museum, Cage destabilized this foundational logic in his orchestration of multiple perspectives in a multitude of subjects in the changing

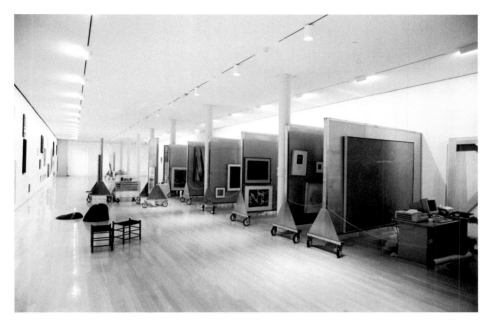

FIGURE 9.4
John Cage, *Rolywholyover A Circus,* Guggenheim Museum Soho, April 23-August 7, 1994. Photo: George Hirose ©SRGF, NY. Courtesy Solomon R. Guggenheim Museum, NY.

display. The museum space was a template, and as such the installation did not seek to harmonize with the physical space (by looking for the "best" accommodation for each artwork) but rather produced a social space within the museum. However, this did not imply a simple switch of positions, as this would only perpetuate the division between production and consumption. Instead, the chronicle of the work itself—the score constituting the central matrix of the composition and simultaneously becoming its record, as well as traces of previous installations left on the unretouched walls—put both labor and the administration of labor on display and made both sides of this social relationship public. *Rolywholyover,* like all Cage's compositions of the late phase, especially those for theater (*Europeras 1 & 2, Europeras 3 & 4,* and *Europera 5*) and for museums, as well as the Norton Lectures, underscores the reflection on governance in his thought and practice.

The sociality that marked Circus compositions by Cage—from the Black Mountain event to *HPSCHD* and *Rolywholyover*—tried to obliterate the difference and distance between the macro and micro, including in the relationship between individual and society, via equalizing technologies of the future. Cage emphasized the role that technology would play in the multivalent, abundant new aesthetic:

> Formerly, when one worked alone, at a given point a decision was made, and one went in one direction rather than another; whereas, in the case of working with another person

and with computer facilities, the need to work as though decisions were scarce—as though you had to limit yourself to one idea—is no longer pressing. It's a change from the influences of scarcity and economy to the influences of abundance and—I'd be willing to say—waste. I think, if we look closely at much of our present work now—not only with computer but even with live electronic music—one could, without criticizing, use the word *waste*.[50]

By planting the author within the changing continuum of simultaneities as a medium, Cage used technology to get rid of a prescribed subjectivity, which, in Bergson's words, "spreads time in space and puts succession at the very centre of simultaneity."[51] In his take on the contemporary, Cage supplanted Bergson's "intuition" with "information," space with time, and scarcity with the potentiality of abundance.

NOTES

1. This pronouncement has been repeated numerous times by Cage and various authors since it appeared in *Conversing with Cage,* ed. Richard Kostelanetz (New York: Limelight Press, 1988), 8–9.

2. John Cage and Richard Kostelanetz, "A Conversation about Radio," *Musical Quarterly* 72, no. 2 (1986): 225.

3. Cornelius Cardew, "John Cage—Ghost or Monster?," *Listener,* May 4, 1972, 597–98, repr. in *Leonardo Music Journal* 8 (1998): 3–4; Branden W. Joseph, "*HPSCHD*—Ghost or Monster?," in *Mainframe Experimentalism: Early Computing and the Foundations of Digital Arts,* ed. Hannah B. Higgins and Douglas Kahn (Berkeley: University of California Press, 2012), 147–68.

4. Arthur Koestler, *The Ghost in the Machine* (London: Hutchinson, 1967).

5. John Cage, "Forerunners of Modern Music" (1949), in *Silence* (Middletown, CT: Wesleyan University Press, 1973), 62.

6. There is no doubt that Cage knew Cocteau's work, given their shared interest in and collaboration with Satie, as well as contextual circumstances. It is likely that Cage consciously decided to "erase" Cocteau in support of Satie's breaking relations with him—Cage treated his sources as personal friends rather than bibliographical references.

7. Mary Caroline Richards, a translator into English of Artaud's *The Theater and Its Double,* was a close ally of Cage from his first summer session at Black Mountain College in 1948; she also translated Satie's play *The Ruse of Medusa* for a performance produced by Cage for his Satie Festival there.

8. David Revill, *The Roaring Silence: John Cage, a Life* (New York: Arcade, 1992), 137.

9. Quoted in ibid.

10. Richard Kostelanetz, *Conversing with Cage* (New York: Routledge, 2003), 159.

11. Cage and Kostelanetz, "Conversation about Radio," 218.

12. Henri Bergson, *Time and Free Will: An Essay on the Immediate Data of Consciousness,* trans. F.L. Pogson (London: George Allen and Unwin, 1910), 100.

13. Henry Cowell, "Current Chronicle: New York," *Musical Quarterly* 38, no. 1 (1952): 127.

14. See William Fetterman, *John Cage's Theatre Pieces: Notations and Performances* (Amsterdam: Harwood Academic Publishers, 1996), 25–32; "Water Music (1952)—John Cage," uploaded July 24, 2013, https://www.youtube.com/watch?v=h_ik4VMcLkA.

15. See Martin Duberman, *Black Mountain: An Exploration in Community* (New York: E.P. Dutton, 1972), 348–59; Fetterman, *John Cage's Theatre Pieces,* 104–12; Eva Díaz, *The Experimenters: Chance and Design at Black Mountain College* (Chicago: University of Chicago Press, 2015), 78–83.

16. See Maurice Berger, *Revolution of the Eye: Modern Art and the Birth of American Television* (New York: Jewish Museum; New Haven, CT: Yale University Press, 2015).

17. "John Cage—Water Walk," TV performance on *I've Got a Secret*, January 1960, uploaded May 4, 2007, https://www.youtube.com/watch?v=SSulycqZH-U.

18. *Water Walk* (1959), score (New York: Henmar Press, 1961). Also see Fetterman, *John Cage's Theater Pieces.*

19. Jean Cocteau, *Cock and Harlequin: Notes Concerning Music,* trans. Rollo H. Meyers (1918; London: Egoist Press, 1921), 21.

20. Ibid.

21. Catherine Morris, "9 Evenings: An Experimental Proposition (Allowing for Discontinuities)," in *9 Evenings Reconsidered: Art, Theatre, and Engineering, 1966,* ed. Catherine Morris, exh. cat. (Cambridge, MA: MIT Visual Arts Center, 2006), 9.

22. Ibid., 10.

23. Brian O'Doherty, "New York: 9 Armored Nights," in *9 Evenings Reconsidered,* 76.

24. For more on ILLIAC computer facilities, see Joseph, "*HPSCHD,*" 149.

25. Jean-François Lyotard, "After Six Months of Work . . . (1984)," *30 Years after* Les immatériaux: *Art, Science, and Theory,* ed. Yuk Hui and Andreas Broeckmann (Lüneburg: Meson Press, 2015), 60.

26. Bruce Zumstein, telephone conversation with author, January 12, 2017.

27. Bruce Zumstein, "Musicircus Rocks Stock Pavilion," *Daily Illini,* November 18, 1967, 1.

28. Ibid.

29. Ibid.

30. For reviews, see Margaret Converse, "Daily Illini News Editor," "Chaotic Order of John Cage," and "Cage Plans Music Circus," *Daily Illini,* November 11, 1967; Patricia Sibbert, "Presenting John Cage's Electric Music Machine," *Champaign-Urbana Courier,* September 29, 1967; Steve Yahn, "John Cage: A Mixed Bag (Like Life)," *Focus on the Arts at Illinois,* November 17, 1967; and Zumstein, "Musicircus Rocks Stock Pavilion." The Nameth film is available as the DVD *John Cage: The 1st Musicircus,* distributed by VisionRainbow, Stockholm, Sweden, 1968/2006.

31. Johanne Rivest, "In Advance of the Avant-Garde: John Cage at the University of Illinois, 1952–69," lecture presented at the University of Illinois, April 22, 1999. Also see Sara J. Heimbecker, "John Cage's *HPSCHD*" (PhD diss., University of Illinois at Urbana-Champaign, 2011); and Guro Rønningsgrind, "Meaning, Presence, Process: The Aesthetic Challenge of John Cage's Musicircus" (PhD diss., Norwegian University of Science and Technology, 2012).

32. John Cage and Lejaren Hiller, interview by Larry Austin, *Computer Music Journal* 16, no. 4 (Winter 1992): 21–28; originally published as Larry Austin, "John Cage and Lejaren Hiller, HPSCHD," *Source—Music of the Avant-Garde*, nos. 2 & 4 (July 1968): 11–19.

33. Cage and Hiller, interview by Austin, 20.

34. "The World Game—An Application of the New Symbiosis for Peaceful Purposes," *Architectural Design 2000+*, February 1967, 93.

35. Lyotard, "After Six Months," 57.

36. Cage, in Cage and Hiller, interview by Austin, 19.

37. See Giairo Daghini, "Babel-Metropole," *Change International*, No. 1 (December 1983), quoted by Jean-François Lyotard in his notes on making the exhibition *Les immatériaux*; Lyotard, "After Six Months," 54.

38. Cardew, "John Cage—Ghost or Monster?" and Joseph, "*HPSCHD*," 147–68.

39. Cardew, "John Cage," 2.

40. According to Charles Junkerman, "There was no center of gravity, or at least there would have been none if John Cage himself stayed in New York. But he was there: the guru/patriarch/elder statesman of the avant-garde, and his presence seemed . . . to orient the randomly dispersed social energy, to center this designedly uncentered event." "Modeling Anarchy: The Example of John Cage's Musicircus," *Chicago Review* 38, no. 4 (Winter 1993): 153–68, quote on 161.

41. Joseph, "*HPSCHD*," 147.

42. A substantial discourse on Cage has been produced within the studies dedicated to the other artists and time period from the 1960s to 1970s. Branden W. Joseph solidified Cage's role in the visual arts context in his monographs on Robert Rauschenberg (*Random Order: Robert Rauschenberg and the Neo-avant-garde* [Cambridge, MA: MIT Press, 2007]) and Tony Conrad (*Beyond the Dream Syndicate: Tony Conrad and the Arts after Cage* [New York: Zone Books, 2008]). Judith F. Rodenbeck addressed his role in relation to Happenings in her study on Allan Kaprow (*Radical Prototypes: Allan Kaprow and the Invention of Happenings* [Cambridge, MA: MIT Press, 2011]). Numerous studies of Cage in relation to Fluxus exist, such as Julia Robinson's work on George Brecht in the context of her curating the important exhibition and its catalog, *The Anarchy of Silence: John Cage and Experimental Art* (Barcelona: MACBA, 2009), encompassing material from 1950s and 1960s. Liz Kotz likened Cage's notation system of the 1950s to minimalism and conceptual art in her *Words to Be Looked At: Language in 1960s Art* (Cambridge, MA: MIT Press, 2007).

43. See Terry Smith, "The Contemporary Question," in *Antinomies of Art and Culture: Modernity, Postmodernity, Contemporaneity*, ed. Terry Smith, Okwui Enwezor, and Nancy Condee (Durham, NC: Duke University Press, 2008), 9.

44. It subsequently toured to the Menil Collection, Houston (1994), the Solomon R. Guggenheim Museum SoHo (1994), Art Tower Mito Contemporary Art Center, Tokyo (1994–95), and the Philadelphia Museum of Art (1995).

45. John Cage to Julie Lazar, February 5, 2010, Julie Lazar Papers, John Cage Trust, Bard College, NY.

46. Musical terms were used throughout: *composition* for *exhibition*, *movement* for a section of the exhibition, *score* for the production concept, and *pages* for installation charts.

47. See Sandra Skurvida, "'Rolywholyover A Circus' for Museum by John Cage (1993)," *Mousse* 42 (February 2014): 19–36.

48. Cage used computer-generated parameter tables from the 1970s on. Special software was created, such as *ic*—a generic command-line *I Ching* number generator written by Andrew Culver in 1984–91 in the C computer language. This software included options—sort, nonrepetition, bias, immobile bias—and involved the generating of data tables based on definition tables of any description, such as duration of sound, its dynamic level, start and finish of the sounds, etc. For the full list of Cage computer programs and a reprint of the number list, see an insert in the exhibition catalog in a box, *John Cage: Rolywholyover A Circus* (New York: Rizzoli, 1993).

49. Julie Lazar to author, February 9, 2010.

50. Cage, in Cage and Hiller, interview by Austin, 21 (emphasis in original).

51. Bergson, *Time and Free Will*, 139.

MAYA RAE OPPENHEIMER

10

DRAMATURGICAL DEVICES AND STANLEY MILGRAM'S HYBRID PRACTICE

STANLEY MILGRAM'S WELL-KNOWN SERIES of psychological studies performed in the 1960s at Yale University established the widely accepted view that the majority of people will obey orders to harm another person despite knowing their actions could be fatal. For decades, social scientists have returned to Milgram's obedience paradigm: to his published results, his data notebooks, and particularly his procedural methodology to probe a study so temptingly sealed behind the Plexiglas display case, a specimen in a history of controversial experiments that measure human behavior. Because of ethical guidelines, Milgram's study cannot be fully replicated, at least not in a science laboratory. Staged varieties appear on reality television, in documentaries, in art galleries, on radio programs, and in popular culture references from teleplays to music videos (see figure 10.1).[1] A growing number of psychologists have recently formed a vanguard who question whether Milgram's paradigm proves anything about obedience at all. Drawing on transcripts and notes in Milgram's personal archive, these researchers suggest that his procedure

FIGURE 10.1
The Milgram Re-enactment, 2002, Rod Dickinson in collaboration with Graeme Edler and Steve Rushton. Courtesy of Rod Dickinson.

was not quite so objective, that his published data were not so comprehensive, and that his attempts at standardization were not so transparent.[2]

My interest in Milgram's experiment-based work bypasses a typical social sciences approach or ethical inquiry: the truth claims surrounding his research—the "what really happened" preoccupations of those who attempt to find order in Milgram's circuitous notes, particularly in the obedience studies—are not addressed here. Instead, I prioritize the dramaturgical nature of the work and look to the rich design of fictions mixed with material realities that enabled Milgram's so-called experiment to become a captivating and, I suggest, powerful critical framework. Simplified, Milgram's original laboratory reality can be reframed and repositioned as a theatrical scenario dressed up as an experiment. My contribution to this volume's theme of hybrid practice follows not only Milgram's methodological approach but also the interdisciplinary model that this area of study provides, one that explores historical relationships across design research, social psychology, and popular representations of science to pose critical questions about structures of knowledge formation in the 1960s and our present theoretical and sociocultural relationship to this period.

Stanley Milgram's simulated shock generator is a bespoke laboratory instrument developed for use in his obedience research conducted at Yale University between 1961 and 1962. Arguably one of the more elaborate specimens of twentieth-century social science instru-

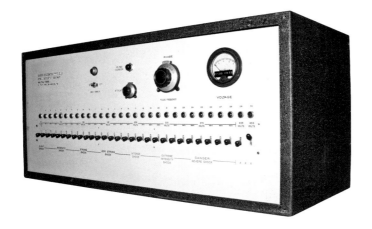

FIGURE 10.2
Stanley Milgram's simulated shock generator. Courtesy of the Archives of the History of American Psychology, The Drs. Nicholas and Dorothy Cummings Center for the History of Psychology, The University of Akron.

mentation, it is little considered as an influential laboratory device—a curious omission not least because it is the only constant, standardizing feature across all twenty-five variations of Milgram's study (see figure 10.2). It also provides an interface for critiquing several interactions in this work, such as the relationship between the subject and the experiment, which extends to the individual and authorities, the public and professionals, and—key for this situation—the social and the technical. The generator is an essential and invaluable component within the overall apparatus of this experiment and its subsequent representation beyond the disciplinary enclave of behavioral psychology. Milgram's work cannot be imagined without it, resulting in a dual functionality: more than an instrument of quantitative measurement, it is also bound up with Milgram's particular narrative intentions, which a hybrid practice framework makes discernible. Prioritizing the interactions across the fields of design, psychology, and performance that are inherent in Milgram's obedience work not only pays due diligence to his epistemological and creative methods but also goes some way toward clarifying why this work remains the object of such popular—if not always critical—fascination.

A logical starting point for articulating these strands of hybrid practice is Milgram's instrument design, specifically the simulated shock generator: it is at once artifice and agent, prop and evidence, material and metaphor, and laboratory witness. The device—with its many switches, dials, and lights—embodies hybrid practice specifically because it is not a neutral presence either in Milgram's experiment procedure or in its aftermath as an expository model of the behavior it was created to measure. It reveals the dramaturgical bent in Milgram's work and begins to expose the complexity of a compelling process not only behind the procedural design of the study itself but also in its performance and documentation as an experiment with all the appurtenances of laboratory intrigue.

In addition to closely reading the design of the generator, I will introduce notes and quotations from Milgram's personal papers and early publications that establish context for the

dramaturgical impulse inherent in this experiment. I use the term *dramaturgical* in reference to Milgram's thorough and critical knowledge of how situational experiments, particularly those involving deceptive mechanisms, require a theatrical dimension to be successful. The term also refers to Milgram's strategic representation of his research to the public as well as his professional colleagues, which demonstrates his understanding of these audiences' respective expectations of, exposure to, and dispositions toward social psychology as a science. For example, a quick note made in a draft for a grant application—"Stated most simply, the basic command is to hurt another person. (Don't say this in grant)"[3]—offers a perfect window into Milgram's dramaturgy. He is aware of the possible effective presentations of his research, and this reveals a Goffman-esque split between front- and backstage performances of his research methodology.[4] What Milgram does not say in his grant applications, scattered journal articles, interviews, and even his monograph, aptly called *Obedience to Authority: An Experimental View,* is discernible in the careful wording and carefully chosen rhetorical devices of his materials.[5] I will begin by tracing Milgram's intent as investigator in the Obedience to Authority Experiments as it is reified in the peculiar form and function of the shock generator and will extend this critique to his deft and even obsessive framing of his experiment in text, image, and film, notably in a documentary film, *Obedience* (1965), shot, edited, and narrated by Milgram himself. These two critical lines of inquiry lay the groundwork for my interest in Milgram's experiment methodology, which I apply in a design fiction project that demonstrates a pedagogical pathway for considering dramaturgical devices within histories of hybrid practice.

MILGRAM'S EXPERIMENT METHODOLOGY: A MAN WALKS INTO A ROOM

In 1960, Milgram began to tackle what he referred to as a personal and professional preoccupation with obedience to authority. The son of Jewish immigrant parents, Milgram revealed in his personal papers a startling guilt that he had escaped the Holocaust because he was born in the Bronx: several letters and papers admit to seeking a "laboratory analogue of what happened in the gas chambers, in the concentration camps, and the like."[6] Such direct sentiments never appeared in his published work, but he was clear about a link to the Holocaust from the outset. "Studies in Obedience," a page from Milgram's typed notes, lists early iterations of his paradigm, attempts to enliven a scenario that would allow him to measure the conditions in which a subject would carry out harmful instructions against another individual.[7] The page describes twelve possible variations, some with more detail than others: presenting a choice of obedient action using a dial to indicate increasing scales of shock rather than specific voltages; testing subjects in a tranquilized situation versus in a free situation to measure the "relationship between obedience and anxiety"; shocking oneself versus shocking another; considering the effects of social pressure, shame, retaliation, and conformity on the subjects' behavior. What we see from this list are possible enactments of a model Milgram encountered in the work of Bertrand de Jouvenel, which Milgram quotes only once in an early article for *Yale Scientific Magazine,* and there via C. J. Friedrick's 1958 edited volume, *Authority:*

An agent A formulates an imperative statement; thereupon the action indicated in the statement is performed by an Agent B or a set of Bs. Compliance of the Bs establishes for the observer an empirical relation, namely, that for the complying Bs. A's statement has proved an efficient imperative. If we find this process regularly repeated between the same agents, we shall feel inclined to say that A has a certain power to move the Bs or again that he enjoys a certain authority over them. . . . I believe that nothing is more important to our science, that here we come to the fundamental element upon which the whole complex fabric of society is reared.[8]

This is where the dramaturgy enters. What became known as the Obedience to Authority Experiment was, Milgram claims, "one concrete expression of the many particular forms this question may assume."[9] For Milgram, it was the best setting in which to enact a model.

Milgram designed an experiment scenario in which a volunteer subject (the teacher) was assigned the task of administering a word association memory test to another complicit subject (the learner). In his first publication on the work, "Behavioral Study of Obedience" (1963), Milgram explains that the teacher is instructed to use "a simulated shock generator . . . with 30 clearly marked voltage levels that range from 15 to 450 volts. . . . As the experiment proceeds, the naïve subject is commanded to administer increasingly more intense shocks to the victim" by way of punishment for each incorrect response.[10] Artifice works its way through this arrangement: not an investigation into memory at all, the procedure was designed to study the subject's behavior, namely his or her compliance to the dilemma presented. Would the subject obey the experimenter's instructions, including a scripted set of prods to encourage him or her, or would the subject defy the seemingly harmful requirements of doing so? I say "seemingly" because the shock generator was a fake, performing everything from flashing activator lights to sounding a buzzer connected to the bank of switches but not actually administering shocks. The learner and experimenter roles were filled by rehearsed actors following scripts: prerecorded audio implied victim pain, a sample shock affirmed the reality of the electrical punishment, and the role of the teacher was rigged by a double draw of pieces of paper. These features were meticulously designed and tested to mask the situational investigation but also to yield the sought-after behavior, which was then captured on film, witnessed by invited specialists, and—ingeniously for Milgram—quantified via the generator's control panel. This was his data-evidence. In Milgram's successful baseline variation, the famous voice-proximity variation that was only one of twenty-five situations, twenty-six out of forty subjects completed the experiment.[11]

THE LABORATORY REALITY

Over a decade after completing the obedience studies, Milgram reflected upon his work in an interview with a friend and former graduate student, Maury Silver. Draft responses exist in the archive in Milgram's characteristic reworking of his communications where one page often documents the same sentiment expressed in different ways. These answers offer

candid descriptions of his work process: "It is not quite that simple," he begins in response to a query on methodology, "Research makes its own demands, sometimes requiring that you be methodical, at other times that you be lax and imaginative."[12] This suggested balance is intriguing and the two approaches are not always easy to prise apart, particularly in Milgram's work. Milgram seems to claim he is a mere facilitator that brings knowledge into being by accommodating the quicksilver demands of research—a sort of intellectual divining rod. As poetic as Milgram's concept may sound, he certainly wielded much more agency in the process than he allows in this statement: his experiment is not a typical one, and he makes several methodological decisions that weave in fiction with empirical process and evidence with artifice.

Elsewhere in these same interview notes, Milgram claims that by personal disposition he has a "slightly thinner line between imagination and reality and behavior, than one finds in many people. For me," he explains, "imagination translates very readily into reality." He then reworks this statement into "The imagined has a great potential for becoming real. And I don't find the barrier between them very difficult to surmount. I suppose most people in an artistic vein have that kind of experience. In the case of social psychology, it's all disciplined by the method—by the scientific method."[13] I am also fond of the imaginative in method, but Milgram certainly downplays his transmissions between the two and affects a sort of ventriloquism, allowing his apparatus to speak its own truths, embedded as they are in the history of empirical experiment, and he disguises his input and his particular designs on how the scientific method emerges as a claim to objective clarity.

THE SIMULATED SHOCK GENERATOR

As a bespoke, fit-for-purpose object, the simulated shock generator has agency: it conveys intent and meaning via its formal elements, specifically the unique interface between subject and experiment, which becomes one of behavioral evidence. As a scientific instrument it is particular, even peculiar, because it elicits and demonstrates the very behavior sought for measure. Very quickly, I wish to delineate how significant not only the use but also the specific design of an instrument is in the experiment procedure. According to Thomas Sturm and Mitchell Ash, instruments "serve to represent, to simulate and imitate, to manipulate or control, and even to produce phenomena that do not normally appear in human sciences."[14] Measuring devices, according to this schema, lie between marks (such as data or calculation, evidentiary inscriptions) and ideas (theories, hypotheses). "We are making a straightforward—and hardly deniable—empirical claim," they continue, "that both conceptual assumptions and available tools may reflect . . . the ontology of the practicing psychologist, or his or her commitments to certain phenomena and theoretical concepts."[15] An instrument is not merely a means of presenting objective effects that verify and stabilize empirical claims: it also coaxes forth the investigator's ideas about phenomena—his or her *intentions*. Rather than a site of calculation, therefore, the laboratory becomes a cultural institution where objects not only are designed but also become symbolically and politically significant, enmeshed in powerful networks of ritual, performance, and even reverence.

The simulated shock generator polarizes psychologists and historians of science, particularly concerning its believability. Milgram claimed that no subject suspected the fakery of the device, a view dismantled by recent research.[16] However, in his published work Milgram referred to the technical gravitas of the device, citing duped electronic engineers and the careful handling of all design and assembly "to insure an appearance of authenticity."[17] Regardless, given my argument that Milgram was engaging in hybrid practice, framing this device as a theatrical prop as well as an instrument does imply that he is leading his experimental subjects to suspend their disbelief via the imaginative setting and narrative that he provides.

Early sketches in Milgram's archive document quick design closure on particular aspects of the generator: horizontal alignment of switches, labeling of volt strengths in numerical and descriptive terms, an etched nameplate claiming a fake brand identity (the most expensive aesthetic feature of the control panel). If we apply contemporaneous human factors engineering principles to Milgram's design, what emerges across these sketches and the 1960 pilot trial conducted with Yale students is a prototyping process resulting in an instrument that not only records but in fact elicits the very behavior sought for quantification and generalization. Consider three categories of the user-machine interface according to this visualization by Alphonse Chapanis, who moved in circles that, like Milgram's, crossed behavioral laboratories with human factors industrial applications (see figure 10.3). The control panel features an unnecessary number of switches; such volume for efficient user interaction should be accommodated via a dial or thumbwheel. The cavity of the device is hollow and enormous because of its primarily deceptive machine operations: there is no generator inside, and of course the buzzing, vibrating, illumination, and dial twitching that animates the control panel mask this simulation. Its size reflects the need to spatially arrange so many switches in a straight line. Finally, the display feedback of the device is over-resourced as well, with its multiple information meters and indicators that reinforce the efficacy of the machine and user interaction. There is no need for more than one such feature, but Milgram provides five, including the auditory feedback. This, of course, has nothing to do with obedience, but it has specific rewards in successfully fulfilling what is known in human factors research as the "device affordance," resulting in commitment to the experiment and the resulting projection of the experiment task—what Milgram defines as obedient behavior—onto the instrument interface.[18]

Milgram himself explained that his generator "constitutes an important buffer, a precise and impressive instrument that creates a sharp discontinuity between the ease required to depress one of its thirty switches and the strength of impact on the victim," but it would not pass a human factors checklist because of its inefficient and redundant control features.[19] That said, its formal presentation of switches and dials affords a coercive interface not only in an interaction/operation sense, where the sequencing of switches provides a "foot in the door" interface (referring to ease of continued use via the simple repetition of one gesture), but also in the sense that it evokes push-button modernizations that changed the agency and consequences of device commands at a particular time in product

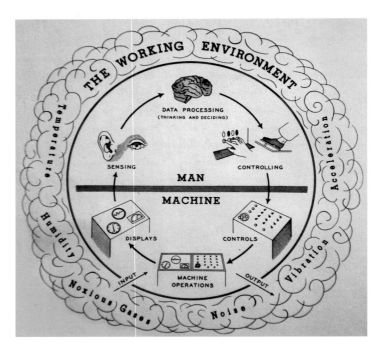

FIGURE 10.3
Reproduction of Alphonse Chapanis's Man-Machine Environment Graphic, 1962

consumption. While the "depression of a switch is precise, scientific, and impersonal," it is also a gesture with representational import, alluding to 1960s American modernization, push-button consumerism, and nuclear anxieties.[20] Following this argument, Milgram does not spontaneously discover an explanation of law of behavior, although he purports to be surprised by what he sees in his publications; rather, he watches his setting play out like a simulated model reality where the apparatus at once invokes, reinforces, and supports his interpretive claims.

CONDITION 25: DOCUMENTING THE EXPERIMENT

Milgram saw value in the "theatrical sense ... of *mise en scene* whenever experiments are conducted in which face to face interaction is involved. As you know," he continues in reply to Silver in the aforementioned interview, "I sometimes see the psychologist as a person who creates scenes of revelatory power and brings participants into them. He [the psychologist] differs from the dramatist in that the resolution of the drama is left up to an individual subject, and the outcome varies from subject to subject. Moreover, by altering aspects of the scene (or situation) we note how the outcomes vary in some rough quantitative fashion. You simply cannot execute a psychological experiment without having a keen directorial sense, or employ someone who does."[21] Akin to outtakes layering the cutting-room floor, some of Milgram's most challenging variations yielded data that he never published. Six more variations are present in Milgram's experiment notebook than in his

published monograph, but it is Condition 25 that extends this volume's exploration of hybrid practice in a particular way.

In 1962, Milgram applied for further National Science Foundation funding to pursue more data, more variations. He received a grant with a significant caveat: he should concentrate on the analysis and communication of what he had already amassed. Consequently, Milgram began work on his documentary film *Obedience* in May of that year, or Condition 25, as the 16mm film reel labels indicate.[22] This title suggests a layering of documentation worth critical investigation. In a clever maneuver around the conditions of his grant, Milgram reenacted his most successful situational variation, the aforementioned voice-proximity variation (also known as Condition 5, the baseline condition), to gather more data, specifically of a qualitative nature. A compelling representational campaign that pollinated Milgram's publications as film stills and transcripts and that illustrated lectures and conferences, Condition 25's edited performance is a key contributor to the iconic status not only of Milgram's work but of this specific variation as a metonym for a larger and more complex series of behavioral encounters. It goes some way toward explaining why popular references to Milgram's obedience studies also endorse a streamlined version: subjects will harm another individual if ordered to do so.

Unpublished notes for a rare study guide for the film explain how these select subjects (fourteen rather than the usual forty) were recruited in the "normal manner" (i.e., following the baseline condition protocol) and were greeted in the basement lab, not the famous Yale Interaction Laboratory as stated in the film's narration.[23] The notes also explain some formal qualities of the documentary film. Only one camera was available, meaning "certain ancillary materials," such as close-ups of equipment, setting, and cast, "were filmed separately and edited into the film." All sequences "involving the (1) arrival of subjects, (2) performance of subjects at the shock generator, and (3) debriefing were spontaneous, and unrehearsed."[24] Milgram emphasizes the candid scenario encountered by subjects as if this absolves him of coercion, but he also concedes that the experimenter and learner played to the camera and "talked more than usual." The result is a curious blend of implied authenticity and the invisible, influential processes of editing and framing of what took place in the laboratory.

Milgram was not only eager to collect footage to document the experiment itself but was concerned that audiences would not believe the degree of stress and drama expressed by subjects: "It is difficult to convey on the printed page the full tenor of the ... responses, for we have no adequate notation for vocal intensity, timing, and general qualities of delivery. They can be communicated fully only by sending the interested parties the recorded tapes."[25] Thus a certain framework for content was necessary: an opening credit roll, for example, affiliates the footage with Yale, the NSF, and Milgram himself as "Chief Investigator." Film scholar Kathryn Millard mentions a line later dropped by Milgram—"In the interests of coherence, the experiment has been greatly condensed and some staged material has been included. The performances of subjects, however, are spontaneous and unrehearsed"—only the latter part of which made it into the study guide.[26]

The finished film contains brief sequences and image stills interspersed amid four lengthy performances from compelling obedient and defiant subjects. Participants who exhibited "a more routine, matter of fact" obedience are not included because of time constraints and also entertainment value. Milgram received editing advice from a former graduate student who recommended that he not appear on screen, that he use close-up shots of the generator, and that he select the "best subjects" for dramatic appeal. One such subject dominates on account of his "unusually high degree of externalised conflict, an example of the type of extreme tension sometimes observed in subjects."[27] This subject had been rated as having the best performance out of the fourteen subjects in a secret audition for the staged compilation, framed as a documentary of "authentic footage."

I am not suggesting the film is a fiction; rather, it is a production committed to documenting a specific version of events. Condition 25 adds another layer to Milgram's drama: it is an interpretive, expository documentary and not an observational glimpse into an experiment event. As a documentary, the film is misrepresented, and by Milgram's instigation, for he does make wanton use of the film's imagery and dialogue when explaining his research. He illustrates publication reprints with film stills to make the text more compelling, despite mismatched variations, and likewise with written transcripts from the reenactment interspersed for dramatic effect. Stella Bruzzi warns of the conflation between the real and the representation in her work on documentary traditions; she explains that there is a "perpetual negotiation between the real event and its representation.... The two remain distinct but interactive."[28] There is no negotiation in this case, for *Obedience* purports to be one version of events, Milgram's publications another, and his unpublished notebooks a third still—with personal notes revealing the strategic loops that knit it all together. These narrativizations, arranged by Milgram, are important to note and distinguish.

By the 1970s, Milgram was in the vanguard of a growing field that used film to teach experiment methods. Notes for a paper delivered at a 1977 American Psychological Association conference panel, "Film in Psychology," provide clues to Milgram's respect for film as a pedagogical tool and as a tool for presenting research: juxtaposition, slow motion, time lapse, and cut-editing comparison for long-term behavior are among the advantages of translating "certain psychological functions into filmic form" to achieve narrative flow.[29] By this time Milgram had made several educational films, but he focused on *Obedience* in his talk, joking that "even I forgot what happened."[30] Because considerable attention was given to the subjects' physical as well as verbal reactions in the laboratory situation, the medium of film was a particularly fruitful option for reexamining behavior, not only for Milgram's own reference but also as an "aid to other investigators who wish to replicate the experimental procedure."[31]

Taken as "authentic" footage, the film is problematic. As a representation, it reveals less about the experiment inscription than it should. But as a documentary film, using Bill Nichols's view of the "organizational backbone of documentary," it conveys "an argument about the world, or representation in the sense of placing evidence before others in order

to convey a particular viewpoint."[32] Granted, this approximates the scientific method from Steven Shapin's history-of-truth perspective, but what is particular about *Obedience* as a film is how it opens up a propositional view using a small section of qualitative data, narrated and edited by Milgram, creating a metonymic device for the entire experiment run.[33] Milgram becomes spokesperson as well as expository agent as well as experimenter. "The world as we see it through a documentary window," explains Bill Nichols,

> is heightened, telescoped, dramatized, reconstructed, fetishized, miniaturized, or otherwise modified.... Documentary presents us with an image of the world as if for the first time; we see things anew, in a fresh light, with associations we had not consciously realised or attended to.... An expository documentary ... mask[s] or diminish[es] its own shaping and modifying activity so that it seems self-evident that the world is indeed cast in the image that the film proposes. This apparent naturalness of a given image of the world may be a rhetorical ploy, but it is also a vital aspect of how we come to hold views of the world that may guide subsequent action.[34]

Obedience is best described as a reenactment, which cements but also distinguishes its relationship to the spectrum of variations that make up Milgram's full study: two separate but inextricably linked events are bound by the reality of the full study, which is strengthened in turn by the strategic representation of the film. Reenactments are authentic revisitations that nevertheless harbor an essential difference setting them permanently apart from the original event. In this case the differences are ones of intent, communication, edited sequencing, and documentation application. This space between the original and the reenactment is extremely rich: Bruzzi calls it an *interaction*, while Nichols prefers *proximity*. By recognizing the interaction between *Obedience* and the data experiments we can see how Milgram was interested less in presenting the "facts of the matter" in the experiment than in representing its procedure as a model of situational obedience to authority in a compelling and convincing manner. This reflects his intent and his hybrid practice, evidenced in the conflation of staged documentation and laboratory experiment: authorship, agency, and direction were his alone, and subjects were left to navigate the set and improvise in their ignorance of both the nature of the experiment and the nature of its documentation. Milgram edited their performances to serve his particular aim, what Jan De Vos calls a "psychotainment-show scene."[35]

Decades later, references to Milgram's study cannot be conceptualized without his film and its visual representations, including the shock generator, McDonough (the learner) strapped into the electric chair, and various anonymous subjects who toiled through the performance. The subjects' tension was generalized as obedience, not such a fitting label upon reflection, but this is not the point. Rather, Milgram's framework, his designed environment, and his expository art direction created an experimental methodology that is useful outside the laboratory enclave and in other experimental spaces of cultural production, including art galleries, reality television studios, and theater sets.

BENIGN FABRICATIONS: APPLICATIONS FOR HYBRID PRACTICE RESEARCH

> A majority of the experiments carried out in social psychology use some degree of misinformation.... Such practices have been denounced as "deception" by critics, and the term "deception experiment" has come to be used routinely, particularly in the context of discussions concerning the ethics of such procedures. But in such a context, the term "deception" somewhat biases the issue. It is preferable to use morally neutral terms such as "masking," "staging," or "technical illusions" in describing such techniques, because it is not possible to make an objective ethical judgment on a practice unless it is described in terms that are not themselves condemnatory.[36]

Perhaps even more eloquent in nomenclature than Milgram's above declaration is sociologist Erving Goffman's categorization of experiments involving situational deceit, hoaxing, and staging. He calls them "benign fabrications" and upholds their place in study because they conceal experiments to safeguard against contaminated responses.[37] This, of course, is in good faith and for the beneficent advancement of science.

There is something particular about the context in which Milgram worked, not only for this study of hybrid practice but also for the wider landscape of the discipline he inherited and subsequently influenced: a postwar America that embraced an empirical discipline capable of measuring, assessing, and organizing human capability. Instruments were invaluable in this task, and the scientific method was adapted to the needs of psychologists pursuing investigations into behavioral phenomena, character traits, and aptitudes. But what of the experience of subjects in this landscape? Of Milgram's subjects specifically? What kind of material and visual culture exposure primed their physical encounter with the simulated generator, their participation in an experiment, and how would that influence the subject-device interface? Trust in these encounters is created not only by scientists but by engineers, industrial designers, and businesses that distribute said technologies. This is a moment in design history worth unpacking: trust and the application of emerging push-button technology, as well as human subject testing, particularly testing that involved benign, theatrical fabrications.

The late 1950s and early 1960s witnessed the psychologization of everyday life routines, from family life or social relationships to industrial design, the workplace, and advertising. A useful, relevant resource comes in the form of a three-part essay published in *Life* during January and February 1957. "The Age of Psychology in the U.S." introduced subscribers to the nature and uses of psychology; "Less than a century old, the science of human behavior permeates our whole way of life—at work, in love, in sickness and in health," continues the byline. The essays, written by a psychologist-turned-journalist named Ernest Havemann, unpack the history of the discipline in America and go on to describe specific tests, instruments, and influential experiments or treatments. Havemann presents a fictional scenario, a

day in the life of John Jones, a typical *Life* subscriber, to explain how subtly ubiquitous the contributions of psychologists have become. Jones's encounter begins as early as his morning shave, using a razor "he had bought on the strength of a magazine ad approved by the head psychologist of an advertising agency."[38] He then reads the morning paper, which contains two articles of interest: "One told him that women were absolutely not more intuitive than men . . . the other invited him to find his 'happiness quotient' by answering a series of 10 questions." Next Jones, guided by road signs designed using sensory perception research, drives to his new job, awarded after he has passed several personality tests, and so on throughout the day until his return home to family and leisure activities. Havemann claims that "all these things might have happened to any American last week. They could not have happened in any previous generation and they could not have happened even last week in any other country, for widespread use of psychology as an applied science of everyday living is brand-new and strictly American. . . . For better or worse, this is the age of psychology and psychoanalysis."[39]

American psychology promised to help the modern individual navigate and make sense of the world, "particularly in a free-wheeling democratic country like the US where the individual is confronted day after day with all the bewildering advantages of freedom and is under strong competitive pressure to make the most of them."[40] There is clearly a manipulative potential here, one Milgram demonstrates quite well, if not very reflexively. In the attempt to critique authority, he exposes the mechanisms of his own discipline and also pokes at the vulnerable bruises of "a seemingly lost or enfeebled American 'character.'"[41]

Critical readings of hybrid practice rely upon sound consideration of the relation between the practice itself and its context of application and activity. However, what are the goals and outcomes of this kind of analysis? Are they pedagogical, like Milgram's avocation of film in teaching experiment practice? Or are they anthropological in that they attempt to mine the intent and nature of inter- and transdisciplinary collaboration or creative work? I have gone some way toward articulating Milgram's design rationale, laboratory methods, and visual representation to suggest the latter, but there is also potential for exploring the pedagogical benefits of studying as well as enacting past hybrid practices as methodological experiments.

After reading Milgram's work and researching contemporaneous laboratory instruments and procedures, I started building Dramaco Instruments, a reenactment of Milgram's experimental methodology and his particular brand of benign (technological) fabrication. I use the term *brand* quite literally: Dramaco is a specialist branch that I invented within Milgram's Dyson Instrument Company, of Waltham, Massachusetts—the fake brand applied to the original simulated shock generator to imply verifiable production. Dramaco usurps and enlivens Milgram's experiment methodology as a springboard for exploring the context and reception of his obedience study, how it sustained such interest and has since assumed metaphorical potential. It also probes Milgram's tactics beyond the disciplinary enclave of social psychology, itself performing a hybrid practice that includes design fiction, graphic design history, and alternative material culture.

FIGURE 10.4
Maya Rae Oppenheimer, cover page from Dramaco Instrument Catalog, 1963 (2014). Property of the author.

Dramaco Instruments spreads a fictional—albeit plausible—history around Milgram's context of practice by exploring a possible commercial market for the simulated shock generator. While Milgram abuses the *interactions*—to recall Bruzzi's term—between the reality of the experiment and his "documentary" film, Dramaco follows suit and reenacts the sociohistorical context of the obedience study by furnishing a fake line of domesticated laboratory tests marketed to typical Milgram subjects (see figures 10.4 and 10.5). Fake advertisements and product catalogs support this counterfactual fabrication and put forward a different, critical way of reading Milgram's device and its contributions. The project also suggests a critical approach to object histories not only in the history of science but also in design and cultural history. Dramaco is a plausible result of branding, language (the prevailing DIY imperative found in mid-twentieth-century advertising), a particular blend of the marketing of

For Recording, Communication and Everyday Precision

Wrist-Mounted Recorder *
Want the benefit of having a recording device at hand, but don't want the hassle? Put one up on your neighbors by putting it on your wrist! Dramaco's Wrist-Mounted Recorder looks like a watch, but it's a secret recorder with a helpful 2 hour audio capacity in case you're too busy to stop what you're doing. Also comes with timer for playback so you can set daily reminders.

MODEL SDWM01 • O/S • $75.00

Special Feature: New and Enhanced Design!
Mobi-Com portable distance intercom
We understand that you need to communicate in difficult, diverse scenarios. Communicate on the move with the MOBI-COM two-way transceiver sets. Up to three-mile capabilities on an encoded channel for guaranteed privacy. Use auxiliary port KI and enable recording with the PAR 1200. Mute/Hold/Transmitting indicator helps you stay in control of your handset. Comes with safety shoulder-strap. Durable casing.

MODEL SDMoC200 • 12.5 x 6.0 x 4.5 • $80.00

Speaker Sets
Pair of book-size, walnut-enclosed speakers compatible with audio recorders and intercoms from the Standard Device Range. Comes with auxiliary port KI for compatibility with other Dramaco products. Cable sold separately. Available in sets of two.

MODEL SDSpk150 • 10 X 7 X 7 • $60.00
MODEL SDSpk151 • 21 x 14 x 5 • $85.00

Dictation Recorder
Still a new technology, this model uses a flexible belt tape to capture your thoughts and reactions with razor sharp clarity. Easier to use than a reel-to-reel recorder. Jump speed playback and spring-loaded pause button for precise play back. Never be misquoted again. Built in belt cleaner. Magnetic assisted stop.

MODEL SDDR • 12 9 x 6 x 3 • $205.00

Dramaco HeadCam
Another example of cutting edge technology put to good use: harness the documentary power of video recorders! The Dramaco Headcam features a clever, adjustable cloth harness that secures a 16mm hand-held video camera to your head! Record a first-person view of your day or mount the Dramaco Headcam on your husband or friends so you can see what they're up to. Even use it on your pets! Psychologists have been researching the power of the situation for years, and now you can do it too with irrefutable video data. Not suitable on children under 7 years of age.

MODEL SDDR • 12 9 x 6 x 3 • $205.00

Timers and Event Recorders

Hand Counter *
Keep track as things happen. Up to 9 999 ticks, this device is as comfortable to hold as it is easy to use. A spring-powered thumb push-button accommodates sensitive administration. Index reset button. Durable metal casing. Rustproof.

MODEL SDMCN01 • 3" diameter • $15.00

Trackmaster 5000 *
Sometimes it's useful to know how often something gets used... and for how long. The Trackmaster 5000 can monitor your electrical appliances, including telephones and televisions. It feeds off the current generated by the on switch and tells you when a device was activated and when it was stopped. Useful to know who really works when they say they do or if the kids are sneaking in TV time! Comes with Auxiliary Port KI for printer compatibility. Built in clock feature for timed on/off feature.

MODEL SDTM5000 • 6 x 3 x 2.75 • $100.00

FIGURE 10.5

Maya Rae Oppenheimer, sample page from Dramaco Instrument Catalog, 1963 (2014). Property of the author.

FIGURE 10.6

The Biofeedback Game, ca. 1970. Courtesy of the Archives of the History of American Psychology, The Drs. Nicholas and Dorothy Cummings Center for the History of Psychology, The University of Akron.

scientific instruments to amateur audiences, and the marketing of modern household push-button appliances, respectively claiming trustworthy scientific and technological wonder or reliability.

The Biofeedback Game, a real device (figure 10.6), modeled the tone and nature of the Dramaco product line, which reimagines laboratory devices and household appliances into amateur psychological experiment applications. A flyer promoting the game (discovered in the Archive of the History of American Psychology) attests to a heritage of product marketing that supports the commercial release of tenuous devices and instruments. Its claim, "Everyone's a winner when you learn to relax and enjoy life," is a triumphal simplification of physiological response invasion common in psychology tests: galvanic skin pressure, pulse, and body temperature number among the intimate measurables that reveal data long since generalized to reflect personality traits such as reliability, truthfulness, and intelligence. The game is cleverly marketed to emphasize how the features operate according to users' needs and leisure, making its otherwise judgmental and alarming data seem distant and benign. The device now embodies fun, easy, and helpful science and capitalizes upon a desire to be complicit with psychological awareness, purchase and direct its advantages, and gain the upper hand in life (over one's subject-opponents).

Dramaco's 1963 instrument catalog advertises three fictional product lines that indoctrinate the consumer in personal and social measurement: the Standard Device Range pro-

vides recording and measurement devices required for the more sophisticated Testing and Aptitude Range (see figure 10.7a and b). The Dramaturgical Device Range, the most specialized of products, reimagines Milgram's devices, invented prototypes like radio consoles that function as stress or truth evaluators, and real lie detectors in order to critique the tendency to believe in the possibility of these machines' functionality rather than understand their true product operations or consequences. Conflating fact and fiction becomes complex here as well as key.

Dramaco, as a critical writing and analytical tool, provides a structure for organizing and acknowledging this sinister little shop of products that forms a cultural impression and highlights transactions across science and the everyday so prevalent and particular in Milgram's period of activity. Devices became reliable accomplices in everyday tasks. By juxtaposing Milgram's simulated shock generator with real instruments such as the lie detector, it questions what entered consumer markets and simultaneously pushes Dramaco's product line toward plausibility and absurdity. Therein lies the dramaturgical element surrounding how we encounter, research, and explain human behavior—on the control panels of props wielded in credible contexts.

It is important not only to illuminate the centrality of instruments in these contexts but to probe the potential for these nonverbal devices to harbor functions, hopes, and ideals beyond their designed purpose. If an important theoretical assumption is reified in the control panel of an instrument or enacted by its use, then viewing the object itself differently, as Dramaco does, poses different questions, questions related to intent: the intent of designers who make them, investigators who wield them, researchers who critique them. Writing becomes a critical approach here, and one that can be employed pedagogically too: What role does fiction play in narratives of science and history, and how can exploring counterfactual object stories reveal new critical understandings of these? If benign fabrications are accepted in laboratory practice, how can they be transplanted to different disciplinary enclaves, and what effect would this have on archives and documentation? How can object-centered analyses reorient our understanding of histories of hybrid practice?

Instruments are real objects with considered operations, interfaces, and standards. They cannot be neutral presences. The simulated shock generator can easily enter the American cultural psyche because of its material design history and its metaphorical potential to project meaning as a critical model. This rhetoric of association is very powerful and can go too far, a grievance directed at Milgram when he linked his laboratory results to the Holocaust. Even so, Milgram's model has sustained a broad spectrum of applications: American conflict overseas (Vietnam, Iraq), race relations, nationalism, and conformity, or, as Mary McCarthy puts it, "coercion coming seemingly from nowhere and expressing nobody's will."[42] His work has been successful because it possesses those features that make for compelling drama: rhetorical and material devices conduct an effective feedback loop of stable representational relationships between events determined in the lab (structure) and those that are subsequently abstracted, communicated, and consumed as a causation or

TESTING AND APTITUDE RANGE

REALIGNMENT

INCENTIVE INSTRUCT-O-MATIC *

Because sometimes we all need a little incentive! The INCENTIVE INSTRUCT-O-MATIC makes the most of our human nature by facilitating learning with prompt rewards for correctness. Simply fill in the reward of choice - be it candy, dimes or something more sophisticated - then press the button on the top of the device to reward your test-taker! An interior ramp delivers the treat down a side-shoot and reinforces their behavior. The INCENTIVE INSTRUCT-O-MATIC can be used to reward good behavior, compliment test results or incentivize an otherwise unpleasant task. Behavioral scientists have been using such devices in laboratories for years! A consistent rewards scheme can have a remarkable influence on subjects' impulses and actions. Now you can too. Try it yourself... or even on yourself!

MODEL TAMoMI • 5 x 6 x 2.5 • $25.00

DRAMACO COORDINATION MAZE*

Much more than a simple maze game, the DRAMACO COORDINATION MAZE is a training tool that with continued practice will improve your hand-eye coordination and help you master tasks in any situation! Never be clumsy or slow again! The walls of this maze are equipped with super-sensitive electrodes that emit a gentle shock upon contact, so as you navigate the maze using the provided stylus, you will be careful not to touch the edges! Routes and times change with increasing levels of difficulty.

MODEL TAPt2x • 5 x 8 x 2.5 • $35.00

POSITRON 5000, POSITIVE FEEDBACK GENERATOR *

You're forgiven if you think this device is a normal radio! With a range of audio programs, the POSITRON 5000 combines positive-reinforcement techniques with invisible radio waves that charge the air with positive energy. Now that's electro-therapy! With purchase, we send you three starter programs (CONFIDENCE AND CONVICTION; AM I HAPPY IN LIFE?; CONQUERING SADNESS EASY AS 1-2-3!) and a free POSITRON 5000 Guide with tips, testimonials and more program options. Safe for the whole family!

MODEL SDPosi5000 • 3 x 7 x 2.5 • $475.00

GREAT NEW PRODUCT!

SHOCK-O-MATIC *

Who knew a shock of electricity could be so useful? Scientists in laboratories use shock generators in experiments to train animals or test humans, and as these studies show, the results are extremely promising for behavioral adjustments and training. We have developed the SHOCK-O-MATIC for home use, harnessing this useful method for many (unexpected!) applications.

Simply set the dials for volt level and frequency and apply the finger electrode and you're ready to unleash the power of the SHOCK-O-MATIC.

Our customers have used it to discipline naughty children, help quit smoking (with additional purchase of a smoke sensor) or electrify common items such as doorknobs when away from home or staying in motels, personal filing cabinets or even the cookie jar! The conductor clip can also be discreetly attached to appliances, automobiles or gun cabinets making an immediate deterrent for invading hands. Give unwanted snoopers or disobedient children the shock treatment! First-time customers will receive the SHOCK-O-MATIC Handbook free of charge with a helpful insert explaining the unique accessory components available from electrode tips, smoke detectors and timers. (Device pictured here with finger electrode and arm restraint)

MODEL SDMCN01 • 12 x 12 x 4 • $550.00

I am an experimental psychologist and have been practicing in the lab for over twenty years. There is no doubt that electric shocks are important tools in the search for what makes us tick. The potential for their application in behavioral re-development is a growing area of research. Already used in hospitals with psychiatric patients, I believe devices like the SHOCK-O-MATIC have the invaluable potential to help in the pursuit of a better, fairer world where instruments help us learn and internalize where social barriers lie.

- Dr Daryl Short, Department of Psychology, University of Long Island

FIGURE 10.7a

Maya Rae Oppenheimer, sample page from Dramaco Instrument Catalog, 1963 (2014). Property of the author.

DRAMATURGICAL DEVICE RANGE

Truth Detection!!

TRUTH DETECTOR 4000 *

Wish you had a crystal ball? Or could see people's thoughts so you knew the full story? Or wish you had a Golden Truth Lasso, just like Wonder Woman? Well, now you can, thanks to DRAMACO'S TRUTH DETECTOR 4000. This amazing little gadget consists of four stylus pens that correspond to different physiological attributes, or 'channels' as the experts call them. Each pen draws a line that communicates something revealing about that physiological reaction. Matching all four against a test scenario means you really know what's going on inside your target's head. Select your preferred data yield or take in all four!

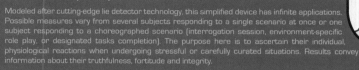

- Pneumatic channel measures abdominal and chest respiration
- Blood pressure, arm cuff transducer included
- Finger electrode measures galvanic skin pressure
- Electric operated pulse timeline

Modeled after cutting-edge lie detector technology, this simplified device has infinite applications. Possible measures vary from several subjects responding to a single scenario at once or one subject responding to a choreographed scenario (interrogation session, environment-specific role play, or designated tasks completion). The purpose here is to ascertain their individual, physiological reactions when undergoing stressful or carefully curated situations. Results convey information about their truthfulness, fortitude and integrity.

This device condenses the full-spectrum functions of its laboratory cousins, halving the mechanism and components. But it certainly doesn't cut down on the results! We've condensed the technology and fit it into a handsome chest, so it looks just like a regular piece of furniture. Just open the cupboard top and pull up a chair.

First time customers will receive a question pack and manual with helpful hints on how to compose your question scripts, how to act during the test, and how to interpret your test results. Take advantage of our introductory offer: if you buy one question pack, get two free! Also, as part of our special gift, you will receive a complementary replacement kit with extra recording pens, ink cartridges and finger electrodes and thermometer attachment. A retail value of $100!

Easy to use sloping panel for access to controls and pens. All electrodes and required tubing included. Storage space for accessories built into unit.

MODEL DDDetTx4000 • 30 x 10 x 10 • $800.00

DRAMACO TRUTH TELLER *

You might think this product is too good to be true. Or that someone is pulling a fast one. How can you possibly tell if someone is telling the truth just from a voice recording? Well, don't take our word for it. Take it from George O'Toole, a retired private investigator, who has written a whole book on his experience using a prototype version of the DRAMACO TRUTH TELLER, which he calls a Psychological Stress Evaluator. O'Toole explains:

> because it can detect deception in the voice, it can be used without the subject's cooperation or even his knowledge. Because it works quite well over the telephone, it does not even require the subject's presence. And because it works from tape recording, it can be used to probe the past. It is the first lie detector that can be used on a dead man...There are scores of mysteries from the past hundred years which could be cleared up once and for all.

Golly! This technology was developed by three retired counter-intelligence officers, so you can be sure this 'invisible lie detector' cracks the case every time. The technology is so reliable that O'Toole (as he hinted exclusively to us at Dramaco) is using his model to investigate growing testimony in the tragic assassination of our beloved president John F Kennedy this year. Just imagine all the opportunities for the truth you could pursue too! See if talk show hosts are saying what they mean! A fun activity to liven up television time with the family. Record office conversations and check on those fellas downstairs in accounting. The DRAMACO TRUTH TELLER comes with all you need to get started on your own important investigations. AUXILIARY CABLE XV allows you to connect to standard electronic equipment including home stereos and televisions. Purchase with AUXILIARY CABLE XI to print your results and use with audio recorders and microphones from the STANDARD DEVICE RANGE and make all of DRAMACO's instruments work for you!

MODEL DDTTx • 30 x 10 x 10 • $550.00

FIGURE 10.7b

Maya Rae Oppenheimer, sample page from Dramaco Instrument Catalog, 1963 (2014). Property of the author.

law with a political agenda. Milgram used vocabularies and structures of laboratory investigation to project empirical truth claims upon a carefully (if obsessively) designed and deftly managed public performance piece. I argue that the true contribution of such a work lies not in its reality but in its reenactment, the "lax and imaginative" aspect of Milgram's hybrid practice.

NOTES

1. For example, Rod Dickinson, *The Milgram Re-enactment,* Center for Contemporary Art, Glasgow, 2002; Griselda Gambaro's play *Information for Foreigners* (1973); and "How Violent Are You?," May 12, 2009, episode from the BBC show *Horizon.*

2. See, for example, Gina Perry, *Behind the Shock Machine: The Untold Story of the Notorious Milgram Psychology Experiments* (Brunswick, Australia: Scribe, 2012), and contributions to Augustine Brannigan, Ian Nicholson, and Frances Cherry, eds., "Unplugging the Milgram Machine," special issue, *Theory and Psychology* 25, no. 5 (October 2015).

3. Stanley Milgram Papers, Yale University, series II, box 46, folder 165, ca. 1961, subsequently documented as SMP series/box/folder.

4. Erving Goffman's work contributed to the sociological field of frame analysis. His well-known text *Presentation of the Self in Everyday Life* (1956) argued that social contexts must be considered in any examination of behavior. He presented an analogy of "front-stage" performances as distinct from those "backstage" by contrasting a restaurant server's behavior in the dining room versus in the kitchen.

5. Stanley Milgram, *Obedience to Authority: An Experimental View* (New York: Harper and Row, 1974).

6. Stanley Milgram, "Obedience Experimental Studies," unpublished note, n.d., SMP III/70/290.

7. Stanley Milgram, "Studies in Obedience," unpublished note, SMP II/46/165.

8. Bertrand de Jouvenel quoted in Stanley Milgram, "Technique and First Findings of a Laboratory Study of Obedience to Authority," *Yale Science Magazine* 39 (1964): 9.

9. Stanley Milgram, "Some Conditions of Obedience and Disobedience to Authority," *Human Relations* 18 no. 57 (February 1965): 57.

10. Stanley Milgram, "Behavioral Study of Obedience," *Journal of Abnormal Social Psychology* 67 (1963): 371.

11. Completion required using all volt switches, including depressing the final 450-volt switch three times: X X X.

12. Stanley Milgram, notes for interview by Maury Silver, ca. 1977, SMP I/21/327.

13. Ibid., SMP I/23/382.

14. Thomas Sturm and Mitchell G. Ash, "Roles of Instruments in Psychological Research," *History of Psychology* 8, no. 1 (February 2005): 18.

15. Ibid.

16. Perry, *Behind the Shock Machine,* is a case in point.

17. Milgram, "Behavioral Study of Obedience," 373.

18. For a more detailed argument on the specific design affordance of the shock generator, see M. Oppenheimer, "Designing Obedience in the Lab: Milgram's Shock Simulator and Human Factors Engineering," *Theory and Psychology* 25, no. 5 (November 2015): 599–621.

19. Milgram, *Obedience to Authority*, 20.

20. Ibid. Ian Nicholson's 2011 article extends this contextualization to a critique of American gender roles through Milgram's experiment scenario; see Ian Nicholson, "'Shocking' Masculinity: Stanley Milgram, Obedience to Authority and the 'Crisis of Manhood' in Cold War America," *Isis* 102, no. 2 (June 2011): 238–68.

21. Milgram, notes for interview by Silver, SMP I/21/327, emphasis in original.

22. As labeled in the Sterling Memorial Library Stanley Milgram Archives finding aid.

23. Stanley Milgram, unpublished study guide, SMP III/73/381. Milgram's book implies that subjects were recruited using a newspaper advertisement placed in a local New Haven newspaper, but assistants eventually used the phone book—followed by a formal letter—to solicit participants, and it is likely that the filmed subjects were also recruited in this way.

24. Ibid.

25. Milgram, "Some Conditions," 62.

26. Kathryn Millard, "The Window in the Laboratory," *Psychologist* 24, no. 9 (September 2011): 659.

27. Stanley Milgram, *Obedience* (1965; University Park, PA: Penn State Media Studies, 2008), DVD.

28. Stella Bruzzi, *New Documentary: A Critical Introduction* (London: Routledge, 2000), 9.

29. Stanley Milgram, "A Discussion on the Potential and Limits of Film in Psychological Research and Teaching Illustrated with Excerpts from Several Films Stanley Milgram Has Written and Produced," paper listed in conference program, annual meeting of the American Psychological Association, San Francisco, August 19–22, 1977, SMP III/73/381.

30. Ibid.

31. National Science Foundation, "Completion of Obedience Experiments," April 1963, SMP II/45/160.

32. Bill Nichols, *Representing Reality: Issues and Concepts in Documentary* (Bloomington: Indiana University Press, 1991), 125.

33. Steven Shapin argues that truth provides a platform for determining an agreed-upon reality but that this process contains unavoidable bias. See Steven Shapin, *A Social History of Truth: Civility and Science in Seventeenth-Century England* (Chicago: University of Chicago Press, 1994).

34. Nichols, *Representing Reality*, 133.

35. Jan De Vos, "Now That You Know, How Do You Feel? The Milgram Experiment and Psychologization," *Annual Review of Critical Psychology* 7 (2009): 227.

36. Stanley Milgram, "Subject Reaction: The Neglected Factor in the Ethics of Experimentation," in *The Individual in a Social World: Essays and Experiments*, 2nd ed., ed. John Sabini and Maury Silver (1977; repr., London: McGraw-Hill, 1992), 181.

37. Erving Goffman, *Frame Analysis: An Essay on the Organization of Experience* (London: Harper and Row, 1974), esp. 138–43.

38. Ernest Havemann, "The Age of Psychology in the U.S.," *Life,* January 7, 1957, 68.

39. Ibid., 77.

40. Ibid.

41. Nicholson, "'Shocking' Masculinity," 239.

42. Mary McCarthy, "America the Beautiful: Humanist in the Bathtub," *Commentary* 4 (September 1947): 252.

SHEPHERD STEINER

11

PROSTHESES OR TECHNICAL EXTENSIONS

Rereading the Work of Bernd and Hilla Becher

AT FIRST THOUGHT, ONE would not characterize the photography of Bernd and Hilla Becher as a hybrid practice. Rather, one thinks of a positivist drive to document subject matter pure and simple: winding towers, lime kilns, framework houses, water towers, blast furnaces, cooling towers, and gas tanks. More succinctly, their corpus contains many hundreds of photographs (and literally thousands of negatives) of industrial structures—what the Bechers, in their earliest book, *Anonyme Skulpturen,* call *technischer Bauten* or "technical buildings."[1] The structure depicted is distinct, always centered, well lit, and wholly visible. The camera records only what is before it. The mood is cool. The photographers are aloof and distanced from their subject. No hybridity here, with the exception perhaps of overlaps between the objectivity of what we take to be documentary photography and the parameters of a scientific classification of things. Yet this is far too general a point of entrance into this corpus and already a misstep. As I go on to argue, the Bechers' work is shot through with desire for identity with the technical object, and nineteenth-century scientific classification appears only in the

presentational method they developed for the display of their technical buildings. Furthermore, I suggest their work is an early example of collaborative practice, and, given the instability of scale relations their systems aesthetic puts into play, that this collaboration takes on collective (i.e., political) dimensions. But in a corpus containing so many photographs of "technical buildings" where does one locate hybridity as a technical extension of the artist-photographers?

A first place to look is outside the work. Documentation of the collaborative team in the act of taking a picture is rare, but at the ragged edges of this corpus, where work and life intersect, there are a few precious and useful examples. One is a small print of Bernd Becher taking a photograph of a winding tower in Bully-les-Mines near Calais. In the photo the couple's young son, Max, stands beside his father and looks back at his mother as she snaps the family picture (figure 11.1).[2] An old Volkswagen Beetle, to be cropped out of the final photograph (which will appear in *Anonyme Skulpturen* under the title *Winding Tower, ca. 1925, Fosse "Grenay" no. 1, Bully-les-Mines, North France*, 1967), is parked under some trees that line the boulevard leading to the main pithead in the camera's field of view. The scale and concrete construction of the winding tower provide an index both of the depth from which the coal is extracted in the Pas de Calais region and of the French prohibition against building with steel. The photographer is presumably framing and focusing the shot while standing on what appears to be the case of the antiquated camera. Although the tripod looks new enough, the case suggests that the camera is from another time. We see the camera in a second, surprisingly idyllic shot of the family on the banks of a dike overlooking three lime kilns on the so-called Paradijsweg near Meppel, Holland (figure 11.2).[3] The final photograph, titled *Lime Kilns, ca. 1860, Meppel, Holland* (1968), will appear in the first series of twelve images of *Anonyme Skulpturen*. The choice of location imbricates a system of production, namely the network of commerce and industry linking Holland, Düsseldorf, and the Ruhr via the Rhein, while the exterior shape of the kilns is pretty much determined by the high temperature processes that transpire within. The symbolic correspondence between inside and outside or above ground and below ground instanced in both the French and Dutch examples is a mainstay of the Bechers' practice, as is the comparative analysis of regional varieties of technical construction. And the view camera with bellows, set to capture what will become the tightly framed lime kilns, engineers a third trope by virtue of proximity—the apparatus as a metonym of the industrial subject.

We know that in 1963 the artists switched out their nineteenth-century wooden plate camera, on which Hilla Becher had learned her trade as a photographer's assistant in Dresden, for a Plaubel Peco view camera.[4] But judging from the only other document of the pair taking a picture, a short segment from a film made by their son in the mid-1980s, if the Peco's image quality was exceptional, its basic design and construction were decidedly nineteenth century.[5] In the film sequence the collaborative team laboriously set up the inconvenient camera, fiddle with the height of the tripod, slowly frame the shot, adjust the bellows, and look to the sky for cues as to exposure. Finally, and most revealingly, one of them holds a black cloth over the lens to prohibit light from entering the camera, a photographic

FIGURE 11.1

Max Becher and Bernd Becher photographing *Winding Tower, Fosse "Grenay" no. 1, Bully-les-Mines, North France*, 1967. © Estate Bernd & Hilla Becher.

FIGURE 11.2
Becher family in front of *Lime Kilns, ca. 1860, Meppel, Holland,* 1968. © Estate Bernd & Hilla Becher.

plate is slid into position, and then the bunched-up cloth (with the film holder tab within) is taken away from the lens for an exposure lasting fifteen to twenty seconds. This is a shocking reveal for those of us who grew up with SLRs, because the camera does its work during the long seconds of exposure without any human interference. One can only come away with a feeling of just how out of step the Bechers' practice was with the photographic norms of 1959–2000, the period during which they would take the main body of their work. I mention this because the apparatus that the Bechers used should be understood as somehow integral to the historical system of nineteenth-century industrialism that was their primary object of study. More broadly speaking, we should see both the camera and the industrial apparatus pictured—in *Anonyme Skulpturen* lime kilns (primarily on the coast of Holland), cooling towers (mainly in the Ruhr district), blast furnaces (throughout Germany, northern France, Belgium, Luxembourg), winding towers (especially in South Wales, but all across the region of coal-rich Europe), water towers, gas tanks, and silos for coal and ore (mainly in Germany but also in the Midlands)—as parts of a system of technological production that was coming to an end.[6] Thus the slight nostalgia we feel on the banks of the Paradijsweg, where industrialism, 1860s style, might be seen as something of a sweet spot in the relations between human agents, technology, and the environment.

What I take to be the crucial point of these few private documents that supplement the public works is the identity always struck between subject and object. Not unlike the Kalkovens on the coast of Holland, whose product was transported up the Rhein for the process of steel making in the blast furnaces of the Ruhr district, the camera is one of a number of technical prosthetics of the system in question. More than that, a certain mirroring between

the apparatus for picturing and the apparatus pictured forces these things into a strange equivalence. In the picture of *Fosse "Grenay" No. 1* all of the figures present (man, boy, camera, pithead) become odd extensions of the system, including Hilla Becher herself, who in spite of being outside the frame cannot help but be pulled into the structure of the *mise-en-abyme*. As is the case in the work of their friend Robert Smithson, the play of mirroring is totalizing. In Meppel, a similar equivalence is struck though with a different kind of historical elbow room built into the pairing. My point here is that in the Bechers' version of documentary photography the set of oppositional binaries we expect to exist between a subject and an object give way to a far more unstable relationship in which the apparent objectivity of the camera bends back on the subjectivity of the photographer behind the camera. Referring to this very instability, in an interview Hilla Becher states: "For me the purpose of photography is to see in an objective way. Why should I try to project my sentiments or state of mind onto something that is already expressing itself? Of course, objectivity is the opposite of subjectivity, we have trouble separating the two. One beginning where the other leaves off. And objectivity doesn't mean that the truth has been found. Far from it. It means that the object represented is allowed to speak for itself."[7] More complexly, if the camera, as grammatical subject of the Bechers' photographs, is a prosthetic extension of the object, then we must also admit that the object—the industrial structure in the photo—is a technical extension of the camera, and further a kind of prosthetic limb or arm linked to the body of the photographer(s) behind the camera. With this set of snap-on/snap-off attachments between subject and object we brush up against the deepest and most perplexing logic of the Bechers' system of photography, for the dialectical notion of attachment not only grounds the logic of the system but folds within it a whole range of semidetachable variances where minor disjunctions between subject and object are readable as the traces of historical change, regional difference, national preoccupations, the broadening of networks for the sourcing of raw materials, upgrades in transportation, and so on.

Take *Zeche "Graf Bismarck," Gelsenkirchen*, 1967 (figure 11.3), photographed in the same year as *Fosse "Grenay" no. 1*. Placed side by side, the two winding towers afford the basic tools of readability characteristic of all typologies. Through the play of compare and contrast, elements such as shape, silhouette, size, context, closed or open construction, number of wheels in the headframe, and building materials used all become grist for an analytical mill. But nothing remains on the level of empty abstraction—these are all indices of real content.[8] Together *Fosse "Grenay" no. 1* and *Zeche "Graf Bismarck"* take up a specific place in the history of steel production. They bracket a geographical region in western Europe that is rich in coal but where that resource is not easily accessible. The huge scale of the towers, and the corresponding depth at which the ore is mined, link the flat landscape of the North Ruhr to the Pas de Calais region. These are features of an extraction process typical of an accelerated moment of early twentieth-century industrialism, and they provide a context very different from the surface mining typical of the nineteenth century and earlier, and not even possible in the steep valleys and hill country of Pennsylvania, Wales, and Siegerland, where the Bechers also documented winding towers. The tree-lined boulevards that

FIGURE 11.3
Bernd and Hilla Becher, *Zeche "Graf Bismarck," Gelsenkirchen,* 1967. © Estate Bernd & Hilla Becher.

would have greeted workers coming off the job offer a picture of one of the high moments of productivity and profitability for the industry. That said, we also know that the late 1960s were especially busy years for the photographers. In fact, when the Bechers took the photograph of *Zeche "Graf Bismarck"* the plant was in the process of being decommissioned. They had rushed up to Gelsenkirchen to document it before it was lost forever. Something similar had happened in the Pas de Calais. The day before taking the picture of *Fosse "Grenay" no. 1* they had missed an opportunity to photograph a unique winding tower in the vicinity. It had already been leveled.

The ephemeral nature of the structures is one of the crucial features of the technical architecture that was the Bechers' subject, and of pitheads in particular. These technical buildings have a very short life span. They live and die according to the changeable fortunes of an essential yet unpredictable industry. History of a very specific kind is at stake here. Given that the Bechers never photographed industrial architecture that had fallen into disrepair, nostalgia was certainly not their interest. What was of interest was something approximating the philosophical notion of historical consciousness, the realization that history or indeed nature was not a stable category but a changeable thing. On this point Bernd Becher's oft-quoted remarks concerning the closing down of steel mills in his native Siegen as the original motivation for documenting these structures in the first place intersect with Hegel's notion of "historic time," Nietzsche's valorization of "becoming" over "being," and Marx's call "to elaborate a theory of technical evolution" on a par with Darwin's *Origin of Species*.[9] Shaping, developing, and refining a technical language that could register the special vicissitudes of historical time in and as photographs of *technischer Bauten* became the goal. Images such as *Zeche "Graf Bismarck"* bring to visibility the processes of change and constant becoming first made tangible during the industrial revolution. They are dramatized by the funereal procession of lampposts all with heads bowed; staged by the parking infraction of the white Opel; writ large on the road by equipment blocking the entrance. Finally, and perhaps most spectacularly, becoming is given a face by the glass and steel construction itself, which resembles nothing less than "the *facies hippocratica* of history," which Walter Benjamin identifies as "a death's head."[10] Beyond this, *Zeche "Graf Bismarck"* is a unique stop on Germany's historical road map of industrialism.

This play of sameness and difference, the glimpse of historical time and the tethering of subject to object that is at the heart of *Fosse "Grenay" no. 1, Zeche "Graf Bismarck," Lime Kilns, Meppel,* or indeed the larger narrative of *Anonyme Skulpturen*, did not emerge out of thin air. It took a while for the Bechers to engineer. For instance, we know Bernd Becher spent some time drawing these technical buildings in his native Siegen before actually photographing them. We know that it was Hilla Becher's special skills acquired first as an architectural photographer in Potsdam and later as a product photographer in the advertising industry in Düsseldorf that would ultimately ground their commitment to photography. Finally, and most importantly, we know that the Bechers had amassed a large collection of photographs of technical structures before they actually knew how to display them; that it took a good deal of time for the collaborative team to work out the presentational form

they called typology; that this was mediated by an interest in nineteenth-century scientific illustration; that the form of the photo-book offered a crucial spur for thinking about the display of photography on the wall; and that the larger discourses of minimalism, systems aesthetics, and conceptual art had a part to play in framing things. These important angles on the Bechers' system of photography aside, one typology of objects in particular provided the foundation upon which the Bechers built the expansive logic of their practice. It is the subject of their second book, from 1977, *Fachwerkhäuser des Siegener Industriegebietes* (Framework houses of the Siegen industrial region).[11] The framework houses are noticeably absent from *Anonyme Skulpturen*, and yet some of the earliest photographs in the Bechers' corpus from the late 1950s are of these houses, which are unique to the Siegen region. The artists have always freely admitted that these houses were the most accessible of their subjects, so it is strange that they do not show up in their first book. In any case, the framework houses are very close to the heart of the Bechers' project. Not only do these houses exist thanks to the iron production for which the region has been known since the sixth century BC, but they are also technically inseparable from the integrated system of high-quality steel production and land management for which Siegerland became famous from the seventeenth century on. More than this, the framework houses allowed the Bechers to root their practice in the singular logic of the Siegen region and then to uproot and reroot (hence technically extend) their project in different industrial microcultures across continental Europe, in Wales, and finally in Pennsylvania. The timber-and-chalk houses, with their unique construction deriving from a complex network of technical, governmental, economic, environmental, and geological factors, conserve the memory, life-world, and experiences of a social formation as close to an egalitarian society as the Bechers believed possible.[12] In spite of conjuring up images of gingerbread and folk tales, the facades of the framework houses should not be thought of as in any way decorative. Like the often dramatically cantilevered concrete of a number of French water towers—which seem to display that nation's flair for style but are actually built to simply stand and focus the tremendous pressure of the water—the houses are similarly functionally wrought. The essential aesthetic of these houses, which lies somewhere between that of technical buildings and that of domestic structures, is the product of a long and complex history specific to the region and centered on a system of sustainable forestry that supported the production of steel—the so-called *Haubergswirtschaft* system established in the sixteenth century. The surrounding hardwood forests were divided into sections to be cooperatively harvested for charcoal for the blast furnaces.[13] As early as the seventeenth century the delicate balance between industry, farming, leather making, and forestry struck by this cooperative system allowed Siegen to keep producing charcoal, and hence steel, long after many other steel-producing regions had squandered their resources. Laws passed in the eighteenth century to restrict the use of wood for house building institutionalized the *Haubergswirtschaft* system and set conditions for the design of the framework houses. As a result, the houses use an absolute minimum number of timbers for the exterior walls. They are completely unlike the many fancifully designed houses with ornate or decorative woodwork that one also sees

in the region. In the framework house proper, form follows function, inasmuch as each of these houses is a prosthetic extension of the system of relations supporting steel production in the Siegen region. They depend on the same mirroric logic that links *Fosse "Grenay" no. 1* or *Zeche "Graf Bismarck"* to the view camera the Bechers used to document these structures.

Equally compelling, and again linked to the complex web of technical functions unique to the region, is the fact that these are workers' houses shaped by a workers' aesthetic; they are typically constructed over a very short period of time (three days), for very little money and by the owner-occupant. The basic circumstances of home tenure in Siegerland made for a situation rare in Europe at the time—miners and ironworkers could own their homes. In the Bechers' book *Framework Houses,* this fact is underlined by a demographic index that compiles the results of a door-to-door survey of the names and professions of the inhabitants.[14] Miner, tanner, steel worker, baker, slater, farmer: these were the principal occupations of the typical owner-occupants. Also relevant is that the majority of houses pictured were all built between 1870 and 1914: that is, after the region was linked to the Ruhr through railroads and at a moment when the broader apparatus of European industrialism had modernized the process of steel making by providing a ready supply of coke to replace the less refined charcoal for the blast furnaces. If this altered the general scale of production in the region, other traditions did live on. For instance, the practice of communal clothes washing in the river Sieg, which runs through Bernd Becher's home village of Mudersbach, went by the wayside only in the 1950s. The practice of collective bread making on a specified day was even longer lived.

The palimpsest-like folding of the general into the particular and the old into the new that is the trace of historical change happens within the confines of single photographs as well. The earliest framework houses included in the series, like *Hauptstrasse 36* (1960), date from 1600, and we can see the outline of a much older and smaller structure within the newer and larger one (figure 11.4).[15] Or consider *Bogenstrasse 8, Freusburg* (1963), from 1680, with its characteristic sparse uprights and functional style on the right-hand side, which we must assume to be an extension of a more archaic form of building using wood alone on the left-hand side.[16] Presumably the barn-like feel and features of both houses point precisely to the fact that farming, animal husbandry, and steel production coexisted within the local economy. Or take *Krottorfer Strasse 48* (1965; figure 11.5),[17] situated in Freudenberg, which has the highest concentration of framework houses in a single area. The house in question was built in 1911 and was owned by a baker by the name of Robert Meyer. It is located on the high road leaving town—perhaps the old Dutch trade route—and is catalogued in Section II of *Framework Houses* under the heading "Slated Gable Sides." Because of cost, slating, which protected against humidity, was usually restricted to the weather side of the house, but it was also typically found in houses with high gables—to eliminate maintenance—and on busy streets for show, so it was also an indicator of class.

The house at Krottorfer Strasse 48 is built to fit the corner lot and to accommodate the steep hill upon which it sits. This organic relationship between the house and the lay of the

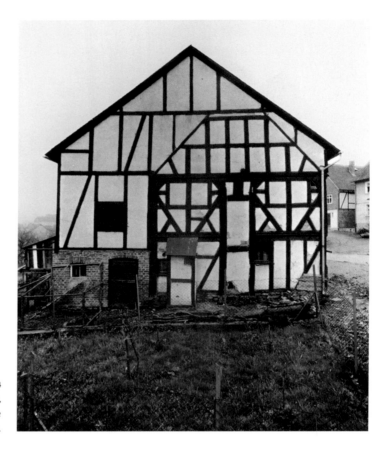

FIGURE 11.4
Bernd and Hilla Becher,
Hauptstrasse 36, 1960. © Estate
Bernd & Hilla Becher.

land was certainly one of the Bechers' criteria for selection. But the aesthetic of rebuilding, adding on and improving things over time (note the addition of the awning to cover the door), is as important. Furthermore, simply getting the picture also mattered. Because of the tight spacing of houses in the town, any house the photographers could clearly isolate and frame without distortion or obstacles was a potential subject. This is undoubtedly the reason why the pair resorted to photographing the main concentration of framework houses pictured in *Freudenberg* (1962; the final picture of *Framework Houses*) from the vantage point of a hill known as Kur Park.[18] This townscape, which was later featured on a postage stamp, and which helped trigger a vogue for the upkeep of the local patrimony, is the best of a number of early groupings of houses from 1959 to 1962 that should be seen as a typology *avant la lettre*. The photograph perfectly captures the startling individuality of these houses: each in black-and-white daub, each with a pitched roof, each with the so-called *kniestock* (or half story beneath the roof), each observing the prohibition against the excessive use of wooden uprights in absolutely singular ways, and each popping up from its own particular patch of turf as if it were a daisy.

FIGURE 11.5
Bernd and Hilla Becher, *Krottorfer Strasse 48*, 1965. © Estate Bernd & Hilla Becher.

Or take the two gable side views of *Kölner Strasse 4, Freudenberg* (1969) and *Kölner Strasse 4a, Freudenberg* (1972), found on facing pages of *Framework Houses* (figure 11.6).[19] With building starts from 1860 and 1862 respectively, these extremely modest houses date from the very beginnings of industrialization in the region. Located on the perimeter of the main concentration of examples, these houses would have been documented not only because they could be isolated and framed but also because these exceedingly tiny dwellings, located on what was once presumably a single property, instance the trace of the first wave of settlement brought on by the railroads. This distinguishes these two tiny framework houses from the other examples in Freudenberg, all with housing starts from closer to the turn of the century. *Kölner Strasse 4* and *Kölner Strasse 4a* need to be seen in the context of the other framework houses, with their variations of scale and width, asymmetrical rooflines and many additions—framed, in other words, by those houses in possession of gardens, access to a street, two or more windows, a cellar, more or less mottling in the white daub, or shifts in the placement of diagonal timbers. Further, *Kölner Strasse 4* and *Kölner Strasse 4a* have to be distinguished from the other houses glimpsed in each picture yet not chosen to

FIGURE 11.6
Bernd and Hilla Becher, *Kölner Strasse 4, Freudenberg*, 1969, and *Kölner Strasse 4a, Freudenberg*, 1972. Facing pages of *Framework Houses*, plates 22–23.© Estate Bernd & Hilla Becher.

be photographed because of various obstacles to capture, and from the many other houses in Freudenberg that the Bechers did not photograph because their decorative finish did not fulfill the criteria of the basic functional logic of the system. This content is what we might term an education at the hands of the signifier, something that bleeds outward from the singular photograph in possession of a unique ontology into the broader signifying field of the photographs in any one typology. Still further, these houses, which, as I suggested, were likely built to accommodate an increased population of steelworkers attracted by industrial expansion catalyzed by railway building, are also framed by the houses of Freudenberg's merchants, communal treasurer, bricklayers, tanners, railway employees, mine-master, clockmaker, physicians, slaters, locksmith, and bakers. The lessons learned might be understood as a kind of consciousness-raising performed within and as every interpretative encounter with the Bechers' work, but real points of friction between a Marxist reading and the Bechers' work rear up around issues that border on the ascription of class.

To paraphrase conversations with Hilla Becher on a number of these issues, by the time Marx had finished his work, northwestern Europe already had the beginnings of unions, safety laws, child labor laws, free education and health care, and in some areas communal ownership. Furthermore, she would have us mark the fact that Marx based his societal divisions on English garment factories, which employed unskilled labor, whereas the steel and coal industry required very highly skilled labor, and thus conditions in those industries were better.[20] Finally, it is important to remember that Bernd Becher's perspective came from the mind-set of the Siegen area, where workers had purchased the various factories from the

nobility centuries before and consequently had long practiced a kind of communal production; by the period in question they saw no benefit in communism. They were both workers and management, and were organized democratically, a point that usefully spotlights the long argument between the Bechers' perspective and the Marxist perspective of Benjamin Buchloh.[21] *Kölner Strasse 4* and *Kölner Strasse 4a* were positioned on the very threshold of the old industrial complex at Freudenberg. This is also the case in the pictured series of houses in Niederschelderhütte, located a few kilometers further up the valley from the Becher family home in Mudersbach. *Adolfstrasse 36 Niederschelderhütte* (1973) was owned by a miner named Karl Elzner, *Am Gosenbach 3, Niederschelderhütte* (1972) was owned by Wilhelm Hoffmann, another miner, and the same goes for Josef Sehr, the owner-occupant of *Karlstrasse 4, Niederschelderhütte* (1973).[22] All of these workers collectively owned the means of production and built the houses they lived in. *Friedhofstrasse 11, Niederschelden* (1970), built around the turn of the century and apparently only a stone's throw from the top of one of the chimneys of the factory at Niederschelden, is another example.[23] Though one of the rare abandoned houses included in the Bechers' book, one cannot but equate its size with a communal function.

In *Ziegelstrasse 7, Niederschelden* (1973) we see another worker's house, this time a single-family dwelling, somewhat dilapidated but certainly lived in and cared for.[24] A ladder leaning up against the wall speaks of the continual repairs required by all of the daub walls in the Siegen region. Like the blast furnaces that the Bechers also photographed, this house was built and fine-tuned over generations though trial and error, and by virtue of the accumulated wisdom of a fairly organic community with minimal divisions between merchant, communal treasurer, miner, bricklayer, railway employee, mine master, clockmaker, locksmith, and baker.[25] In short, Marx is far less important here than the rhetoric of science itself, for in attending to any one typology of framework houses we perform an empirical act that we ultimately believe will open up the world of framework houses that exist outside the frame. The promise is that if we adopt the language of the object and treat the system of classification with ethical fidelity we will position ourselves on the threshold of a potential science of industrial structures.[26] Negotiating the truth effects that come attached to the Bechers' mode of typological display has presented tricky problems for interpreters.[27] The general tendency of critics is to accept these truth claims in some form, not only because of the strong grounding of the typological method in our scientific worldview but equally, I would say, to mark the apparent distance of the Bechers' project from the irony that leaks out of so much conceptual art from the same period. The flat rhetorical register of the Bechers' black-and-white photography squashes any and all of these frivolities, even if framing a framework house is a curiously ironic act. The mock scientificity of Robert Smithson's work is perhaps the best counterexample, but the mimesis of scientific method one sees in the pointlessness of Mel Bochner's measuring pieces from the 1960s, or Ed Ruscha's systematic cataloguing of humorously banal subjects, is equally to the point. The important difference between these examples and that of the Bechers' project is that a typology of framework houses actually puts the rhetoric of science to work for a constructive purpose.

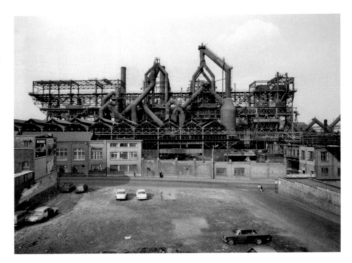

FIGURE 11.7
Bernd and Hilla Becher,
Liège-Ougrée, B, 1968. © Estate
Bernd & Hilla Becher.

It provides an expansive analytic for investigating the world that cannot but position us on the threshold of a profound remapping of the known. Look at *Terre Rouge, Esch-Alzette, L* (1979), one of a number of housing projects set in an industrial landscape, from the perspective of the framework houses of Siegen. We see three-story district housing with adjoining gardens built for the convenience of workers by the company that owns the blast furnaces in the background.[28] In *Homecourt Lorraine* we see a more expansive workers' suburb, and on the horizon the blast furnaces where they work. In *Völklingen, Saarland*, we see the longevity of the same system, with workers' houses built in the year 2000. Who knew?

In two photographs of *Liège-Ougrée, B* (1968) we see a rather more haphazard integration of work and life.[29] In the first panorama, with hills in the distance, blast furnaces in the middle ground, and mixed housing in the foreground, we see what appears to be less of a comprehensive attempt by company management to provide for workers. In the second picture, taken from one of the small hills in the background of the previous picture, we see three blast furnaces of increasing size arranged parallel to the picture plane and all fairly integrated into a steel armature (figure 11.7). In the foreground we see a street scene, a parking lot with a few cars—one abandoned—and the facades of small factories that undoubtedly served the main complex. Two young children are riding their bicycles to see what the fuss is about, and, directly facing the camera, standing against the factory wall, are Hilla Becher and son. They had walked down the hill to look for something to eat, but there was nothing. The photograph represents one moment among many in the corpus of public works when subject and object intermingle, when subjective interests undermine objectivity, and when interpretative work on single images depends on both the leverage offered by the photographic system and the technical use of images. Without the supplementary logic

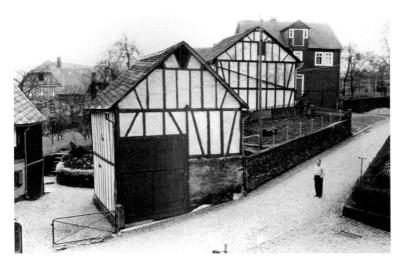

FIGURE 11.8
Bernd and Hilla Becher,
Hohlweg 5, Mudersbach, 1961.
© Estate Bernd & Hilla
Becher.

of the larger system of photography, *Liège-Ougrée* could fall hopelessly into the traps of biography as easily as it could be failed by our insufficient notions of objectivity. The photograph is much more than merely a moment in a life lived or an object captured. *Liège-Ougrée* takes up a place within a complicated linguistic system keyed first and foremost to an identification with the technical object but primarily working to determine the differential elasticity of the system.

In this sense, the figures of mother and son in *Liège-Ougrée, B* (1968) are interchangeable with those of the two workmen shown in *Winding Tower, Zehe 'Eiberg', Essen, Ruhrgebiet* (1967). They merge with Bernd Becher's motorcycle that appears in the lower left corner of *Cooling Tower, Kraftwerk Victoria Mathias, Essen* (1966); the team's Volkswagen bus parked beneath the blast furnace in *Gary Indiana, USA* (1982); the figure of farmer Ferdinand Utsch, who appears on the roadway in front of the framework house at *Hohlweg 5, Mudersbach* (1961), which is just down the street from Bernd Becher's family home (figure 11.8); or the tops of the trees that spring up in the foreground of *Winding Tower, Grube "Wolf," Herdorf bei Siegen* (1963), which mark the continuance of the *Haubergswirtschaft* system. They are literalized in the human scale and junky intimacy that never fails to be felt in the Bechers' winding towers from South Wales, or the sense of livable proximity that grips one when looking at the Bechers' water towers with adjoining houses and workers' gardens as in *Bochum-Langendreer, Ruhrgebiet* (1965). Finally, the figures of Hilla and son are endlessly substitutable for the familiarity of old haunts; when we see two photographs of the gas tanks in *Oberhausen, Ruhrgebiet*—both full and empty—we know very well the photographers have visited the site more than a couple of times to get their picture.[30] Like all good documentary photography, the Bechers' work makes something otherwise invisible visible and further offers the viewer a heuristic for identifying comparable processes beyond the

frame. The Bechers' photographs also showcase the artists doing the showing. They are always in their photographs, and not only by virtue of metonymy but through the photographer's gaze, a confounding variable that insinuates itself into the presumed objectivity of the photographs. The object is half subject; looking becomes reading; what we have come to understand as a paradigm of pure photography turns out to be a hybrid form of conversation with politics, science, and culture all front and center.

NOTES

1. Bernd and Hilla Becher, *Anonyme Skulpturen: A Typology of Technical Constructions* (Düsseldorf: Art Press, 1970).

2. See Susanne Lange, *Bernd and Hilla Becher: Life and Work,* trans. Jeremy Gaines (Cambridge, MA: MIT Press, 2007), 37.

3. Ibid., cover.

4. Ibid., 30. Bernd Becher also mentions using a Linhof 6x9. In Jean-Pierre Krief, "Contacts: Bernd and Hilla Becher" (2002), video uploaded to YouTube October 2, 2011, https://www.youtube.com/watch?v=8sy9dXWkC8Q, quote at .54 min., trans. Clara Cahen-Kunde.

5. See an extract from Marianne Kapfer's documentary *Die Fotografen Bernd und Hilla Becher* (2013), uploaded to Vimeo October 1, 2013, https://vimeo.com/75848741, German with French subtitles. The film by Max Becher is at 8:05–9:00 min.

6. More succinctly, and given the boom and bust economics of the industry, we might say that these technical structures were continuously coming to an end.

7. Krief, "Contacts," at 12:47 min., trans. Clara Cahen-Kunde. On this topic, it might be worth mentioning that what we would call in English the "subject" of a photograph, the thing represented, is in German called the "object."

8. On this point I strongly disagree with the arguments of Michael Fried. See especially his "'Good' versus 'Bad' Objecthood: James Welling, Bernd and Hilla Becher," in *Why Photography Matters as Art as Never Before* (New Haven, CT: Yale University Press, 2008), 303–34.

9. See Bernard Stiegler speaking of "man and technics" in the film *The Ister*, clip uploaded to YouTube February 16, 2011, https://www.youtube.com/watch?v=Znvdk5cq9f4, quotes at 3:05–3:14 min.

10. Walter Benjamin, *The Origin of the German Tragic Drama,* trans. John Osborne (London: Verso, 1977), 166.

11. Bernd Becher and Hilla Becher, *Framework Houses of the Siegen Industrial Region* (Cambridge, MA: MIT Press, 2001).

12. This ideal has complicated relations with the politically problematic tradition of Heimat, but the Bechers' version of Heimat is by no means the antimodern rural idyll that is often put forth in film and television. It is a modern version of Heimat with a built-in logic that emphasizes the systems of production, land management, and collective ownership inherent to the Siegen industrial region.

13. Becher and Becher, preface to *Framework Houses*, 7.

14. Index to ibid., 10–17.

15. See ibid., illus. 80, 303.
16. See ibid., illus. 83, 302.
17. See ibid., illus. 114.
18. See ibid., illus. 350.
19. See ibid., illus. 22, 23.
20. Max Becher, e-mail to author, January 24, 2015.
21. See Benjamin Buchloh, "Hilla Becher: 1934–2015," *Artforum* 54, no. 5 (January 2016): 53–56.
22. See Becher and Becher, *Framework Houses,* illus. 138, 85, 139, 39, 127, 218, 243, 253.
23. See ibid., illus. 29, 145, 306.
24. See ibid., illus. 160.
25. See Bernd Becher and Hilla Becher, *Blast Furnaces* (Cambridge, MA: MIT Press, 1990).
26. In this sense we find an exit out of the closed and self-sufficient system of language, for the truth claims of each and every photographic typology serve as a starting point for discovering further truths by confronting as yet undocumented industrial structures or negotiating unmapped regions of the industrial world.
27. The best and closest of the Bechers' critics recognize this hypostasis and have found different ways of naming the tension implicit to it. Thus Thierry de Duve's reading of the Bechers' project as "monumentary photography," or more recently Michael Fried's version of the project, where ontology looms up as a special category of objecthood that can be showcased only by the singularizing focus of photography. Finally, in Benjamin Buchloh's Marxist account we see the totalizing imperative of the Bechers' practice as part and parcel of what he describes as a "disturbing" depoliticization characteristic of all "singular artistic achievement(s)." See Thierry de Duve, "Bernd and Hilla Becher or Monumentary Photography," in *Basic Forms of Industrial Buildings*, by Bernd Becher and Hilla Becher (New York: Te Neues 1999); Fried, "'Good' versus 'Bad' Objecthood"; and Buchloh, "Hilla Becher."
28. See Bernd Becher and Hilla Becher, *Industrial Landscapes* (Cambridge, MA: MIT Press, 2002), illus. 94.
29. See ibid., illus. 89, 92.
30. The photos *Zehe "Eiberg," Essen, Ruhrgebiet* (1967); *Kraftwerk Victoria Mathias, Essen* (1966); *Grube "Wolf," Herdorf bei Siegen* (1963); *Bochum-Langendreer, Ruhrgebiet* (1965); and *Gastanks, Oberhausen, Ruhrgebiet* (1968) all appear in *Anonyme Skulpturen*.

Proceedings

OF THE

ESTHETICAL SOCIETY

for TRANSCENDENTAL *and* APPLIED REALIZATION
(*now incorporating the* SOCIETY *of* ESTHETIC REALIZERS)

New Series, Part VI, Vol. II

"*Periodic Reports from the Editorial Subcommittee*"
(Continues "*Contributions on the 'W' Cache and Related Sources*")

Documents Ostensibly Pertaining to the Origins and Development of
"The Order of the Third Bird"

The Editorial Board of ESTAR(SER) would like to acknowledge the support of its founding benefactors (Nasco Bass and Anonymous), and the faithful subscribers to the Proceedings *in its recently resurrected form. Correspondence should be addressed to individual authors.*

THE HALE EXPERIMENTS: OBJECT-ORIENTED VENTRILOQUY DURING THE COLD WAR

The Prosopopoeia Working Group[1]

We write to bring to the attention of discerning readers of the *Proceedings* a recent discovery in the W-Cache that appears to bear on a fascinating (if troubling) episode in the history of the Order of the Third Bird. A full historical airing of these materials and their implications must await further research, but the initial investigations of our working group permit us to surface a number of claims at this time. To wit, we have evidence:

- that a group of New York based Birds cooperated with a CIA funded investigation in 1961 (they may have been compensated for their time, though this is not clear);

- that this work was "whitewashed" through the "Society for the Investigation of Human Ecology," and took place in New York City, nominally under the research umbrella of several university-based psychologists (then engaged in a larger program of inquiry into "dissociative states"), but in fact largely under the scrutiny of a career CIA officer, Willard James Coppleston "Copse" Hale;

- that this work was linked to the (notorious) MK-ULTRA program;

- that this program was short-lived, and ultimately unsuccessful.

1. The Prosopopoeia Working Group (2014-2017), consisted of the following ESTAR(SER) researchers: D. Graham Burnett, Jeff Dolven, Catherine L. Hansen, Jac Mullen, Len Nalencz, Sal Randolph, David Richardson, and two contributors who prefer to remain anonymous.

The documents that have led us to these early conclusions are known as the Hale Transcripts, a portion of which will be presented below. In toto, the surviving transcripts consist of a sheaf of 117 letter-sized sheets of paper, all of which appear to be photocopies of typescript documents secured through a Freedom of Information Act. Some redactions and stamping suggest US government provenance. Associated documentation (in the form of similar photocopies of letters and several articles), and internal clues appear to date this body of sources to the years 1960-1962. This bundle as a whole (collated within an acid green pasteboard sleeve tied with twine and labeled "K") came to light two years ago in the "W-Cache."[2]

It would seem that this bundle (the "K-File") represents a portion of the written records of a series of experiments conducted in the summer of 1961—experiments in which a group of putative associates of the Order of the Third Bird appear to have cooperated with psychological researchers interested in assessing the techniques of the Order, and more specifically in understanding if "Birds" were in fact capable of attaining "metempsychotic" union with objects.[3] Which is to say, these researchers wished to establish if individuals trained in Bird methods could in fact (as they claimed) answer the Wordsworthian injunction to "see into the life of things," and, by means of Birdish protocols and practices, enter the subject-being of an

2. The "W-Cache" will be known to most readers of the *Proceedings*, as it forms the basis of the majority of publications in this forum. The W-Cache consists of a large (and arguably infinite) body of primary source material bequeathed to the Editorial Committee of ESTAR(SER) some time ago—apparently the cullings of an erstwhile Historian of the Order, who seems to have collected this vast trove of rare documents in the hopes of eventually writing a definitive history of the Birds. It was not to be. But the archive was saved from oblivion by an enterprising patron, and it has been, as readers of the *Proceedings* will know, the primary labor of ESTAR(SER) over these last years, slowly to issue scholarly editions of the W-Cache sources, in the hopes of placing the Order's true history upon a sure and critical foundation. For details on the provenance of the Cache and its structure, consider: "Presenting and Representing the 'W-Cache': Problems of Selection, Access, and Documentation in Relation to the Material Culture of the Order of the Third Bird," *Proceedings of ESTAR(SER)*, New Series, Part VII, Supplement (2016).
3. Metempsychotic union with the attentional object is a hallmark of Birdish practices, which, while geographically and historically diverse, quite consistently set some form of "inwardness" with objects as the aspirational *telos* of a collective "Action." Modalities of access (and degrees of mania) vary, but something of the general program is captured by one of the touchstone catchphrases of the Order, "Temporary metempsychosis may occur, but must not become permanent," commonly used as a valediction in internal communication.

object—returning therefrom able to speak meaningfully of its perspective, memories, experiences, and general lifeways.

Needless to say, this in itself would be interesting for any student of the Order and its doings. The interest is all the more intense when we discover that this small group of Bird-Associates appear to have been making use of a protocol—the "Protocol of the Prosopopoeia," or "Action of Ventriloquy"—not previously recorded in the annals of the Order. This protocol, reconstructed out of these sources, is reproduced in the Appendix below.

But imagine our surprise, on beginning to reconnoiter these sources, as it became increasingly clear that these "experiments" were not merely being conducted by psychologists curious about aesthetics, say, or scientists curious about the physiological responses of individuals undergoing intense, meditative concentration upon some inanimate object. Indeed, it seems increasingly difficult to deny that these experiments were being conducted at the peripheries of the unsettling world of the Cold War sciences of mind and behavior. Indeed, it appears that this group of Birds, wittingly or unwittingly (and this is not entirely clear), were in fact participating in an enterprise indirectly linked to the notorious work of MK-ULTRA, the CIA's elaborate and highly secretive skunk-works program to explore the far reaches of the paranormal and the psycho-dynamic in the service of US clandestine operations.

Project MK-ULTRA, led by the spymaster/"dirty trickster" Sidney Gottlieb, reached into terrible zones before its final collapse in the early 1970s.[4] Across its twenty-year history it was responsible for some of the strangest projects of a very strange period. In the 1960s, MK-ULTRA explored everything from hypnosis to sensory deprivation to psycho-pharmaceuticals like LSD in a ranging and largely unsupervised smash-and-grab through the mind-sciences of cold-war subjectivity. It has been the task of the Prosopopoeia Working Group to investigate what possible interest the spymasters of MK-ULTRA might have had in a bohemian club of histrionic aesthetes such as the Order.

4. For a discussion, see the classic study: John Marks, *The Search for the "Manchurian Candidate": The CIA and Mind Control* (New York: Times Books, 1979). For more recent critical perspective, consider the articles gathered in a special issue of *Grey Room* published in the Autumn of 2011 (issue number 45) under the collective title: *On Brainwashing: Mind Control, Media, and Warfare.*

FIGURE 1

Our sources suggest that this work was conducted as the pet project of one Willard James Coppleston Hale—a career OSS/CIA man, known to his friends in the Yale class of 1938 as "Copse." Despite our researches, Hale remains something of a cipher, but the lineaments of his biography may be dimly descried in the half-light of a shadowy historicity. It would seem he left Yale shortly before graduation under uncertain circumstances (Figure 1). After a brief stint teaching at Robert College, an American missionary school in Bebek (just outside Istanbul), he found employment with an American insurance company closely associated with a Greek shipping magnate based in London. Postings after the war in Ankara and Jakarta sketch the trajectory of this WASP-spy, who wound up back in Washington, DC, by the mid-1950s (Figure 2). Was he a member of the Order of the Third Bird? It appears not. But it seems he knew of a "volée" of the Birds (a "flock," the intramural term for a practicing community) who were associated with the Elizabethan Club at Yale in the interwar period. We must assume that it was this brief encounter that stayed with Mr. Hale, as he watched certain parts of the CIA, across the late 1950s and early 1960s, drift into increasingly experimental territory.

It is in this context, then, that Hale conceived the work that became the Hale Experiments. Recalling the rumors that circled around the Birds of his acquaintance in the 1930s, Hale doubtless seized on the notion that Bird-adepts claimed to be able to achieve that much-bruited "Metempsychotic Union" with objects. If they could, in fact, commensurate their minds and bodies with a painting or sculpture, he appears to have reasoned, then why not with some other object presented to them—perhaps any object at all?

FIGURE 2

And if indeed the Birds knew how to enter things, and return from this psycho-physical sojourn with intimate knowledge of them, was this not the proverbial "Holy Grail" of spooks everywhere? Bird techniques would literally be capable of turning every object in the world into nothing less than a perfectly undetectable "bug." Everything could serve as a recording device—better yet, maybe everything in the world had already been recording everything that had ever happened, and awaited only Birdish solicitation to be tapped as a source. Each scrap of paper, each doorknob, each cigarette butt, each fingernail paring could be made to tell everything it had ever seen or heard. It was nothing less than the ultimate forensic fantasy: everything would speak; nothing could hide.

The odds might be low, but the upsides were stratospheric. Pushing that logic, Hale appears to have persuaded his paymasters to fund a small series of experimental investigations into the power of the Birds. How Hale found his experimental subjects, we cannot say. And exactly what they did across the weeks of experimental Actions that were conducted in a safe house in Forest Hills, Queens—this too we cannot account for with certainty.

What we do know, however, is that four apparent Birds did indeed do Bird Actions under controlled observation as part of a more general research program into "psi-aportation"—an investigation coordinated through the Society for the Investigation of Human Ecology, Harold Wulff's Cornell-based front operation which funneled CIA money into the human sciences in these years.

FIGURE 3

A copy of the grant-application through which the Hale Experiments were funded (Figure 3) provides invaluable insights into the undertaking. A full copy of this surviving document has been reproduced in the Appendix that follows the transcript text below. The excerpts here cited will give a sense of the general project:

> Extreme state physiologists have repeatedly documented that stress conditions (reduced calorie intake, dehydration, extreme anxiety) and mechanical/chemical/electrophysiological disruption of cognitive functions can generate dissociative psychical effects commonly called "out of body experiences." Subjects thusly affected report, inter alia: visual apperception of their own bodies seen from without; coenesthetic memories of ascension or flight; and/or a general sense that the personality-bearing components of their persons (sensory capacities, memory, bearing, general mental life) have been "liberated from" or made autonomous in regard to their physical bodies. The motility and (apparent) integrity of this abstracted human person — its bodiless free-agency — has been the subject of several studies, and seems to be well established as a psychological datum. Less well understood are the documented instances of this abstracted human person coming to rest, subjectively, in a body not its own. But this phenomenon

is by no means uncommon. Accounts of such "episodes" are ubiquitous in the annals of ethnographers, and these "transmigrations of souls" play a central role in shamanistic practices in many parts of the world. We propose the term "psi-apportation" for this psychological effect, which is known to include the relocalization of the subject position into animals, corpses, and, significantly for the purposes of this investigation, objects.

The general project proposed to explore this topic various ways, including by means of:

1) collation of field reports of the phenomenon as witnessed among primitive tribes, ascetics, and religious fanatics; 2) documentation of elicited psi-apportation under laboratory conditions, permitting general physiological and specifically neuro-psychological monitoring of relevant indices; 3) experimentation with and inquiry into techniques (psycho-pharmaceutical, eusocial, operant regulatory) for stimulating, directing, and focusing these experiences.

It would seem that Hale's work with the Birds fell under the third of these subheads. Reading on in the document, we find that:

the investigators propose to work with a community of individuals trained in formal techniques of psi-apportation. [REDACTED] engages in a practice they call "temporary metempsychosis" and adepts claim to be able to achieve states of psychic conciliation with particular classes of objects, notably works of art. Their techniques are not widely known or well understood, but [REDACTED] without the use of psycho-active agents, collective consonant dissociative states of remarkable intensity in which they claim [REDACTED]. The internal loyalty structures of the group have made evaluation of these claims difficult, but the investigators have secured access to a small community of these practitioners, who appear willing to collaborate in laboratory analysis of their putative abilities.

All of which brings us to the Hale Transcripts themselves. These transcribed recordings document several experimental sessions led by Hale in June of 1961. The sessions were conducted in an observation room outfitted with a

one-way mirror across one wall. It is apparent that Hale would stand behind this mirror (off-stage, as it were), though it would seem that he made use of some sort of two-way sound-link to the room to direct discussion among the experiment participants in the main room. In this sense, he functions as a kind of invisible interlocutor in what those familiar with Birdish rites will recognize as a "Colloquy"—the semi-formal round-table discursive "outro" by which practitioners cycle narratively through what occurred in the course of their Action, recovering both the experience and, in a manner of speaking, themselves.

In the transcript portion reproduced below, Hale engages four (apparent) Birds in parley concerning the metempsychotic reveries out of which they have just emerged. A word about the participants, whose biographies we have been at some pains to reconstruct:

The first individual to be quoted, and by far the best known to posterity, is the Estonian-born sound engineer Rein Narma. Forty-five years old at the time of recording, Narma was an émigré/refugee from Soviet Russia who worked for the U.S. Army as a broadcasting and recording technician during the Nuremberg trials.[5] Later, he immigrated to the New York area (he was based in Bergenfield, NJ) and took a job at Gotham Recording. Narma and several others subsequently founded Gotham Audio Developments to build and sell recording gear, some of which remains highly prized by audiophiles to this day. Les Paul hired him to modify his first 8-track, and later Narma built consoles for Rudy Van Gelder, Olmsted Recording, and others.

The second, we believe, is one David Mindle, who in the early 1960s worked as an assistant editor for the *Partisan Review*. Mindle graduated from Berkeley in 1958, having switched majors in his junior year from physics to religion and writing a senior essay inspired by the work of Carl Jung.

5. Narma's work in relation to the Order will be familiar to those who have consulted "The Narma Tapes: Polyphony and Politics in the Cold War," an ESTAR(SER) brief report presented at Art in General and the Vera List Center in the Spring of 2015. This text presents another "W-Cache" artifact: a reel to reel audiotape labeled "Beckmann, MoMA, 12/19/1964" (and initialed "RN"), which contains nine minutes and three seconds of lyrical cacophony in three discrete "movements." Overdubbing and even (apparently) reverse playback characterize these challenging and layered recordings. Internal evidence suggests that this unprecedented acoustical source represents an elaborately manipulated *sound recording of six associates of the Order of the Third Bird engaged in a "colloquy."* The object? One of the Max Beckmann paintings on display at the MoMA exhibition that opened in mid December of 1964. This revelation will be aired in full in a forthcoming issue of the *Proceedings*.

His first Bird contacts seem to have been in San Francisco, and it appears that he was linked to Narma's *volée* by San Francisco-based jazz critic Ralph J. Gleason.[6]

The third participant on the recording, and the only female participant in this portion of the transcripts, is almost certainly Ellen Montesquieu, then aged twenty-nine. Montesquieu was an American Airlines stewardess and poet living in the West Village in Manhattan. We have been able to determine that she flew Caribbean routes, and spent time in Cuba before 1958. Montesquieu had Birded almost a dozen times by 1961, and she is thought to have been responsible for an Action that has entered the annals of Bird lore, namely an all-night vigil of sustained attention to the American flag in front of the Centre Street state court house (there remains a great deal of ambiguity around the precise nature of the gesture). Her father, Achille Montesquieu, was a professor of physiology at Cornell.

The fourth and final interlocutor recorded during the session in question is Douglas Naxos Armatreading. Born in 1923, in Coney Island, Brooklyn, to a family in the amusement park business (his father was a barker, and his mother made costumes), Armatreading eventually secured a reasonably steady job on Broadway, where he worked as a carpenter and stagehand. A familiar denizen of Times Square after dark, Armatreading's Bird-connections have not been traced, but his biography suggests a demimondaine affiliation. Interestingly, he moonlighted as a psychic medium, a field in which he was deeply self-educated (as a frequent reader at the New York Public Library). Out of these independent researches, he came to think of himself as a medium for the spirit of Amanda T. Jones (1835-1914), an American psychic, inventor, and author.[7]

The reader of the transcript will wish to correlate these biographies with the stenographer's abbreviations: Narma (RN), Mindle (DM), Montesquieu (EM), and Armatreading (DNA). Additional context will be of use to those attempting to makes sense of the material that follows. We can presume that the four participants were seated around a table for the duration of the Action itself (which was not recorded, and was apparently silent, in keeping

6. Gleason, who attended Columbia University as an undergraduate, maintained Bird connections on both coasts. There have long been rumors that the San Francisco underground band and vaudeville act, "Wanda and Her Birds," (about whom Gleason wrote) were splitters from the Order.

7. Amanda T. Jones, *A Psychic Autobiography* (York, PA: York Printing, 1910).

with standard Bird habits), and it would seem that they have remained in that configuration for the sequential, phased debriefing for which we have this remarkable verbatim documentation. The discussion appears to follow the ordinary pattern for a Colloquy: ad seriatim rapportage around the group, phase by phase; hence, in this version of the "Protocol of the Prosopopoeia," four circuits of the four participants. We present here below as an extract only the fourth circuit of the group, in which the four experimental subjects describe their experiences during their fourth and final phase of the protocol ("Channeling"). Those familiar with the traditions of the Order will be aware of the very strict Birdish injunction against performing Colloquy in the presence of the object itself—which presents, in this case, something of a mystery, in that the closing exchange of the transcript alludes to the object in direct terms, as if it is still lying on the table. We surmise, therefore, that the object was covered immediately upon the close of the actual Action, and that it remained so for the duration of the exchanges captured on tape.

As for the protocol itself, it is otherwise unknown in the W-Cache, and no complete copy of it exists—which is to say, we have no copy of it that elaborates its movements or prompts. Indeed, there remains some ambiguity as to whether it ought be given as a three- or a four-phase protocol. In the full Hale Transcripts we clearly discern four rounds of Colloquy, corresponding to four phases, which are explicitly named: Greeting; Parley; Hypnotic Interval; Channeling. No information about the timing of these phases is given, but they are similar enough to the "canonical" protocol of the Order (the so-called "Protocol of the First Day") that one feels confident assuming a standard duration.[8] Uncertainty as to whether the Protocol of the Prosopopoeia might have been practiced in three phases derives from the existence of a single, unique leaf in the K-File materials that actually inscribes the phase prompts themselves: there, one finds the "Greeting" phase struck through (Figure 4), which has led some ESTAR(SER) researchers to speculate that the Greeting and Parley phases were sometimes

8. There is evidence (albeit not perfectly clear) in the Hale Transcripts that this same group also performed the canonical protocol on objects under Hale's observation, and indeed that the whole series of experiments began with a series of standard Actions conducted with works of art (three oil paintings) borrowed by Hale from the wife of a well-to-do Yale classmate then resident in McLean, Virginia.

collapsed into a single overture/introductory phase.⁹ Until further sources come to light, it is impossible to resolve this matter definitively, and the best that can be offered at present is that the Hale Transcripts themselves offer incontrovertible evidence that in the Summer of 1961, in New York City, the Protocol of the Prosopopoeia was practiced in four discrete phases.

FIGURE 4

9. Figure 4 reproduces a detail from page 157 of "The frequency of naturally occurring 'hypnotic-like' experiences in the normal college population" (*International Journal of Clinical and Experimental Hypnosis* 8, no. 3 [1960]:151–63) authored by Ronald E. Shor, one of the principle investigators on the "Induced Objective States" project proposal (reproduced in the appendix below)—under which the Hale experiments transpired. This copy of the article displays a set of marginal annotations which reprise the key prompt phrases for the Protocol of the Prosopopoeia.

We may put these questions aside in a research article like this one, which is intended for a nonspecialist audience. Of greater importance to the general reader is that veiled object lying at the center of the table. *Upon what object did the Hale experimenters actually practice in this Action?*

It is a very important question, one that frames the inherent drama of the transcripts that follow. And here is what we know: at the end of several weeks of ambiguous results, Hale's direct superiors appear to have begun to mistrust his enterprise, and it would seem that they decided to put it to the test. In this experiment, then, which would prove the final one, Hale's group was set to work on an object sent from Washington, an object presented to them (and to Hale, it appears) as one of Fidel Castro's personal effects—a small piece of technology smuggled from his boudoir; to wit, a 29-centimeter-long, steel, Soviet-manufactured shoehorn. As will be discerned in the final document presented in the Appendix, there is excellent evidence that the object did not, in fact, belong to Fidel Castro.

Be that as it may, the following text permits us a rare glimpse into the inner life of those who pursue the inner life of things. The scene is set: We enter the flow of the conversation in the opening of the final phase of an Action of Ventriloquy, Protocol of the Prosopopoeia, performed upon a Soviet shoehorn (steel, about eight inches in length) and said to be the property of Fidel Castro; our four Birds sit around it on chairs in a semicircle. There is, we can establish on the basis of internal evidence elsewhere in the transcripts, wine on the table—glasses and no fewer than three bottles.

THE HALE TRANSCRIPTS

(an edited extract)

WH: OK, final round of colloquy here -- the "Channeling" phase. Rein, I think you are up ...

[SOUND OF TAPPING]

RN: So, man, I snap out of it, you know? And there it is on table, just a "whatchamacallit" ... KING-AS-LUDICRUS [inaudible] ... is what my father he said.[10]

WH: A shoehorn.

RN: Shoehorn, shoehorn -- yeah. And I'm kind of waiting, like just trying to focus my audio, you dig? And then I'm like, "ahhhhh."

WH: It says something?

RN: Is singing something! I mean, look, is just the shape for listen, no? Cup like your hand, when you tune in, like ear, like cup of your ear -- the sound, she sworls there like drop rum in glass. So smooth, you dig? And the KINGASS ... the shoehorn ... like an ear but POOOALEM [inaudible], long and silver also like a tongue, you say silver-tongue, yes?[11] And I am thinking, man, the engineer [that] made this really knew his groceries, ear is tongue is tongue is ear: no wires no tubes, is something else, man! Or no: not is something else; I am hearing singing in here! Is me!

WH: Can you remember what it was singing?

RN: Singing like sea, hi-fi, baby; like sea and palms, and you hear tocororo, singing ko-ah, ko-ah: highs are real sweet,

10. Presumably *kingalusikas*, Estonian for "shoehorn."
11. We surmise that this articulation, which clearly threw off the transcriber, may have been *püha lehm*, Estonian for "sacred cow."

real clear, like you are in house by the sea, you dig? Oh baby: like a microphone headphone all in one, like my head was headphone, shoephone. Man, somebody know his groceries, is all I can say. A real zonk on the head, yeah.

WH: OK, Rein, did you hear anybody *say* anything? Any words?

RN: Oh yeah, Daddy-O, lots of words; real good pick up in mid-range. Treble, bass, everything plus, baby. Attack: pow! [static; inaudible] Nice sustain, decay, release. And sometimes he is singing, dum dum dum, like for marching. Cut that disc, yeah! You know what crazy? Who knew everything listen like this? Listen all the time? Noodle it out, man: who needs LP, man; who needs fancy tape recorder we work so hard to make? Is like we live in big studio make perfect recording of itself all the time, needles jump day and night all you do is gotta ask, baby, but you gotta ask the right way.

WH: Rein, can you remember anything that was <u>said</u>?

RN: You know what's really crazy, man? I'm like: I can hear so clear, I mean, it can hear so clear -- O man, is off the cob, you know what I mean? Every time -- is so clear, is like I can hear the smoke, you dig? The cigar smoke, is like real LOPESAKASIAS.[12] Oh man.

[CREAKING]

WH: Thanks, Rein, thanks. Interesting. Let me see, where are we? David? You want to pick up on that for us? We still have your hypnotic stuff ringing in our ears. Where did it go for you? What were you picking up in the final phase?

DM: Yeah, well, sure. Yeah. Well, I thought. I thought, well, the whole situation. It's almost like an interrogation, man. The whole <u>scene</u>. The way you fellas have us going at this. I mean, I have done this Protocol before, but I never thought about it that way before. It's being interrogated, and in this way, I am being interrogated too. You know: the room, the one-way mirror, you out there, Mr. Hale, watching -- trying

12. We must take a guess here, but we suspect the phrase was "*lopsakas äikest*" — Estonian for "plush thunder." Interestingly, this was the name of nightclub in Tallinn in the 1920s. It has been impossible to establish any direct connection.

to figure it all out. So I am thinking, 'OK, you and me, we are in this interrogation <u>situation</u>.' Under the hot lights. They're gonna make us talk. We have to make up good alibis. Make sure our stories line up. And right away, without even checking with me, it starts talking. It blabs. It starts doing that thing they do -- saying absolutely ANYTHING. Giving me the hustle -- like a Times Square junky -- spinning, talking fast. It's all wound up. Out of its mind. It's terrible. I gotta get it out of here. We have to escape, both of us. So I tried to ... I tried to kind of lull it ... into a fantasy, a kind of escape fantasy. Both of us, letting ourselves go ...

RN: Yeah, you gotta <u>let go</u>, man.

DM: Right, right. So I tried to help it relax -- to lull it into comfort, into a kind of familiar space, trying to get it to summon memories, sensuous memories -- of the shape of the socked heel, the soft silk of the sock against its mouth, the lip of the leather shoe on length, the smell of ... the smell of shoeshine. And I am lulling myself, too. Going there, with it. The memories. And I realize we need a place, a place to go, together. A place where we can reside in this place of suspension, and in this way achieve, what felt like, to me at least, a kind of mutually present pure togetherness -- a place where we can lose ourselves.

RN: That's it, man -- now you are cooking!

DM: Yeah! I do! We do. And where else but the shoe? Pow! There I am. There we are! I'm in the shoe with her, basically, I'm in the shoe, and the foot's in the shoe, and the shoehorn's in the shoe, and there's a hand on it, maneuvering it, up and down, up and down, sliding the heel into the shoe, and I seized on that rhythm --

EM: The rhythm -- ?

DM: Of the "up and down," of the levering of the heel into the shoe.

[Many voices: "Mmmm" in affirmation.]

DM: So in the rhythm of the, of the ... the rhythmical insinuation of the heel into the shoe, by means of the shoehorn ... [trails off] The oscillation, up down, up down -- create what I could only really call a permanent binary present. A

sustained bipartite current-ness. An enduring be-split of now-ness. There. With the shoehorn. Levering.

RN: Now you swinging like sixteen, man!

[BREAK]

DM: And so at this point: we are really there, together, and we are safe. It feels safe. And I, I even hear it, it is speaking to me, but I realize: I don't need to hear it. Yeah: I just don't need to hear it. Or rather, it didn't need me to hear it. Rather, it just wants me to be there -- to be there with it, in the shoe.

WH: David, hold up for a moment. Stay with it. Did you say it was speaking to you and you didn't want to hear it?

DM: Yeah, that's right.

WH: OK, but we need you to try to push past that. We really need to hear what it is saying, remember? That's what we are aiming for here. This is key ... we are trying to gain intelligence from its speaking ...

RN: Hey man, we gotta let him do his thing, you know?

WH: Sure, sure. OK. I just don't want us to lose the thread ...

DNA: It is coming, I feel it: the speaking, it will speak.

EM: I am a tongue. Lengua, lenguaje, language.

DM: Yes, yes! The tongue! It was talking, that shoehorn, yes, it was talking -- but it was cooing, it was babbling, the way a child babbles, the way a child talks merely to be present, to be present and engaged, in engaged presence with the adult. It -- the shoehorn -- it was babbling like a child. It wasn't talking; it was learning how to talk.

[BREAK]

WH: Did you try to understand it? Did you understand any of what it said?

DM: "_Diga-me_," I told it. "_Diga-me_," I whispered. Getting close. Talk to me. At first, it was silent: but then I heard a whisper. A murmur, a murmur somewhere in the belly of the shoehorn itself. And then it spoke: its first words.

WH: It did?

DM: It did. And then, the bell rang and it was over.

WH: ... What ... What did it say?

DM: Sorry?

WH: What did it say? You said it spoke: what did it say?

DM: Oh. [PAUSE] It was ... private.

WH: What?

DM: I can't -- it wouldn't be right.

WH: Not again ... Really?

DM: Really. I promised. Anyway, it was very much for me -- personal. Like a kiss, really. Hard to share.

EM: A kiss. Exactly. That was my whole phase. A deep kiss. For I was the tongue. The mother tongue. A _lengua_, _lenguaje_, language. I'm just going to read what I wrote here ...

Bluster. Blister. Don't burn your tongue. Don't put your foot in your mouth. Put your tongue in your shoe. I hang on a nail in a closet. There is no "scene" in my closet. No intruder. The rest is silence. There is work. There is _tarea_. I am suitable for my task, my _tarea_. I dispatch my office. I underhear. A world of gutturals. The readiness is all. Daily, early: _madrugada_. Late afternoon, post-interlude, I am called on to perform my function. My dreams are olfactory: tobacco, rum, the sweat of labor in kind. Leather, cilantro, sugar cane. His dreams are of the tongue: salmon and sorrel, cream and champagne. You know about palm reading and subliminal perception. You know about phrenology. What you need to know is what I have learned: the epode of the ankle; the villanelle of the subtalar joint. These can be read. I have read them. I can speak them: the sonnet of the talus;

the sestina of the calcaneus. These can be read, and spoken. They are genres that can be known.

[BREAK]

DM: I think I am feeling something for you.

EM: That was the shoehorn. I had nothing to do with it.

DM: That's what I meant: for the shoehorn. For you as the shoehorn. I felt you were the shoehorn, and I love the shoehorn.

RN: He's the shoehorn. You're the shoehorn. He's you. You're him. You are IN IT, my friends! ... We were ALL in it -- in the last phase -- We jump together, like one cymbal crash -- The vibes!

[BREAK]

WH: OK lovebirds -- great. Ellen. Thanks for that. Lovely. Nothing exactly actionable in there, I think. But a lot of atmosphere. Can we keep moving? Doug? We're on phase four, did you dock with the object?

DNA: We met on the docks. And I began to reach toward the object, the shoehorn, I reach towards it, and ... [PAUSE] I'm in the BETWEEN.

You know all this but bear with me -- I'm in the BETWEEN, that pinkish everywhere like an infinite fog or mist of possibility. And I hear Amanda's voice, her thready voice, and she whispers "I'm here," so I know its going to work, she'll be able to guide me through the layers, the sediment of images. You guys know the first things we'll be tuning into are the most recent.

"Get ready," she says and ...

Yes, it comes in, the first picture. From the NOTHING ...

[BREAK]

It's dark. Dark and terribly cold. Oh, the bitterness of that cold. I am frozen and cannot move. I know this is weird, guys,

but I think this is because the shoehorn is, like, metal. I think it's about 80 or 90 degrees but to the shoehorn it seems desperately cold.

I seem to be dangling from a cliff face.

RN: Like on the hook, man?

DNA: Yes. There is a smell, the smell of smoke. I hear murmuring, deep sounds, voices. I can tell I'm in my familiar place, a usual place, that I dangle like this in the dark and cold, day after day, with nothing but muffled noises to amuse me. Ah! it's a closet! Then, a sudden rattle and bang. A vertical crack of light appears, and more smoke billows in. Light! I am reflecting that light. Oh, it feels good, silvering up and down my body. I am beautiful, I am beautiful! There are deep voices, human voices, speaking a language I don't know. A man laughs. HA HA HA! Another sounds angry. I hear something like "ply," "ply" "ply-ah?" "rohn" and some names I can't quite make out. "Ahnder." "Bark." They are arguing. They are angry. Then the light is blocked by a behemoth figure. A thick roll of leaves, on fire at one end, giving off smoke, protrudes from its hairy maw.

WH: A cigar? A beard?

DNA: SILENCE! SILENCE! The monster looms forward toward where I hang against my dark cliff, passing its giant hand over things below -- over the shoes, I see now. Then there is a bang and I am back in the dark again, in the waiting, in the silent, terrible waiting that is my existence.

I knew you wanted everything I can get, so I go back in.

So I'm in the fog again, the sound as if of wind but there is no wind. No up or down in this place. I still feel the pain of that unbearable waiting, the frozen helpless chill. Amanda chides me, a new memory won't form unless I purge myself of all the emotion. I rub my fingers against my palms in the cleansing gesture, calming the mind. "Yes," Amanda says, "yes."

[BREAK]

Now, there it is! I'm shaking all over, vibrating down a chute, dropped clanging into a heap. Oh, we are all alike! Brothers!

Sisters! Like silver fish! Hundreds of us, thousands. Quick hands pluck us up. We are stacked, nestling against each other. The shivery feeling as we hit against each other, ringing like bells.

The shock of that ringing sends me out of the scene and back to the place between worlds. Amanda wants me to stay there and talk to her, keep her company, but I press on. "More," I tell her, "I need more."

Slowly another impression appears. We're moving back in time. At first it's hard for me, me Douglas, to understand, because I can't feel my body -- it's as if I'm in a sea, but I am a sea. But it's not a sea of water, it's dense, intimate, sliding against itself constantly. I sense red and darkness at the same time, and weight and pressure, and then I realize I'm MOLTEN, I'm metal flowing, I'm LAVA, deep under the earth. I'm warm, I'm finally warm, oh GOD, finally, this is what I have wanted, this heat. It feels good, finally! I'm hot. This is how I'm meant to be! Liquid! I'm burning with delicious sensation all through myself, alive with heat, I'm free, I can move and dance! I'm nothing, I'm everything, I'm free, I'm free!

[BLOWS OUT AIR] That was it, that was it -- that's everything I got. Wow. So ecstatic, give me a minute, just a minute, yes, wow.

[BREAK]

WH: Doug, that was majestic. I'm shivering. But I wonder ... um ... I wonder if I could pull you back for a moment to one of those sort of more, um [gingerly], recent memories of shoehorn. You know, the stuff after the formation of the Earth and all that. You remember: The bearded figure, the Spanish phrases. I heard "Playa" in there. Beach. Could you get back there, maybe? Remember that we have some really heavy stuff that has gone down in the Bay of Pigs. It would be just incredible if ...

DNA: You want me to go back in? Oh, I don't know, I don't know, that was a sleigh-ride into the primordial inferno. I am still fighting for air. I'm singed.

WH: Of course, Doug. But there's so much at stake here. You all are American heroes, in a way, fearless soldiers

making night excursions into enemy territory -- fighting for this country in the terrifying realms of the spirit. Gird yourself, Doug. Go back in. With Amanda, she's invincible, Doug. She'll protect you ...

RN: You can do it, Douglas! Out of fire into frying pan again, daddy-o!

DNA: I don't know. Maybe Amanda can help, but I think my circuits are all burned up. I don't know if I can do any more.

[PAUSE]

Alright, alright, I'll try, but give me a minute here.

[BREAK]

Ok, Amanda help me now! Ok, I am seeing the BETWEEN, I am in the space, I'm waiting ... I'm waiting ... Ok, something's coming, here it is.

I'm flipped on my back. Helpless. I can't move. And the terrible chill, the chill is back. I'm on ... I'm on ... I don't know what I'm on. I can look up and see a kind of a pole, white, a cylinder or a rod, ah! I think it's a candle, yes, and it's lit. If I could get to the flame! Too tiny, too far, the little bit of fire way up there can't help me. I'm just completely frozen and lying there.

WH: Can you hear anything, Doug? Can you hear anything?

DNA: Voices, voices ... yes! yes! A barking, a kind of rhythmic bark. [Participant makes a barking sound] It sounds like some kind of ... animal ... OH MY GOD, they are FUCKING! ... Jesus H ... Ok, ok now they seem to be finished. There is smoke, oh yeah! A cigarette and a cigar ... And they are saying ... something ... two voices ... the girl ... she is saying "par" ... "see" ... no, oh: "<u>siempre</u>," "<u>para siempre</u>." They are saying "forever," both of them, while I lie there helpless, unable to move. OH GOD! They know NOTHING these two, their pathetic "forever" doesn't last more than a breath. I'm cold with my bitter anger, my anger that will outlive everything they've ever known or imagined. I hate them! Oh, but I will have my revenge, my release. I know that in time, in time, I will be free again, in the great blazing fire of the sun as

it finally explodes and consumes all of us into its molten ecstasy, when the fire comes, when the fire comes!

[BREAK]

RN: Wow, man.

EM: Magnificent.

[BREAK]

DM: I will never forget it. I will never look at a shoehorn the same way again ...

[BREAK]

WH: OK, well. I guess that's it for today. We'll have to go over the tapes and see what can be made of it all.

[PAUSE; TAPE BREAK; NOISES]

I, uh, I can't say as I know exactly how much of this will be of, uh, use, exactly -- but then, well ... I've heard stranger things. You know, talking to defectors, to agents, double agents, triple agents, God knows. In comparison to all that -- all the crazy crap that people will say when they have a gun to their heads -- well, in comparison to all that, this is downright tame. [PAUSE] I mean, in a way, this is just a hop, skip, and a jump from good old-fashioned forensics: Look at the object. Figure out what it has to say. At least we know that objects don't lie.

RN: Is lying there, though, Mr. Hale.

WH: "Is lying there." Yeah. You know what I mean, Rein.

RN: I do man. Is lying there. Is object lying there.

DM: That's all they do, all the objects. They lie around.

EM: And we lie with them, sooner or later.

[PAUSE]

DNA: *Para siempre*.

DM: Yes, para siempre. "And so I lie with her, and she with me ..."

EM: "... And in our faults by lies we flattered be."[13]

RN: We lie with them! And they lie, Baby! They lie off the hook! That's what it's all about man.

WH: Come again on that, Rein?

RN: Mr. Hale. Objects, they lie. That is the main thing. That's the whole think.

[BREAK]

WH: Really?
But I've been so patient here. At moments, despite all the craziness, I even kept feeling what it would be to believe. To believe it all. I even felt ... And now you're telling me that the objects lie?
[BREAK]

But that was the whole project here: find something, some thing we could trust. If the objects lie too, what makes them different from people, then?

RN: Nothing, Mr. Hale.

13. The participants allude here to Shakespeare's Sonnet 138: "When my love swears that she is made of truth / I do believe her, though I know she lies." Which concludes, of course: "Therefore I lie with her and she with me, / And in our faults by lies we flatter'd be."

APPENDIX

ITEM A
Protocol of the Prosopopoeia; Action of Ventriloquy

As reconstructed from the Hale Transcripts and supplementary material in the K-File, as discussed in the text supra (see Figure 4).

```
          Protocol of the Prosopopoeia
              (Action of Ventriloquy)

                     Greeting

                     Parley

                 Hypnotic Interval

                     Channel
```

ITEM B
Project Proposal

The original Human Ecology Fund research program under which the Hale experiments were conducted (see Figure 3 and the text supra).

```
              Project Proposal:
        Induced Objective Dissociative States
         Submitted to the Human Ecology Fund
                 September, 1960
                       by
       R. Shor, J. M. Schneck, C. Monroe, and L.J. West
```

```
                     INTRODUCTION
Extreme state physiologists have repeatedly documented that stress
conditions (reduced calorie intake, dehydration, extreme anxiety)
and mechanical/chemical/electrophysiological disruption of cognitive
functions can generate dissociative psychical effects commonly called
"out of body experiences." Subjects thusly affected report, inter
alia: visual apperception of their own bodies seen from without;
coenesthetic memories of ascension or flight; and/or a general sense
that the personality-bearing components of their persons (sensory
capacities, memory, bearing, general mental life) have been "liberated
from" or made autonomous in regard to their physical bodies. The
motility and (apparent) integrity of this abstracted human person —
its bodiless free-agency — has been the subject of several studies,
and seems to be well established as a psychological datum. Less well
understood are the documented instances of this abstracted human
person coming to rest, subjectively, in a body not its own. But this
phenomenon is by no means uncommon. Accounts of such "episodes" are
ubiquitous in the annals of ethnographers, and these "transmigrations
of souls" play a central role in shamanistic practices in many
parts of the world. We propose the term "psi-apportation" for this
psychological effect, which is known to include the relocalization
of the subject position into animals, corpses, and, significantly for
the purposes of this investigation, objects.

                      OBJECTIVES
A broad inquiry into psi-apportation is here proposed, including but
not limited to: 1) collation of field reports of the phenomenon as
witnessed among primitive tribes, ascetics, and religious fanatics;
```

2) documentation of elicited psi-apportation under laboratory conditions, permitting general physiological and specifically neuro-psychological monitoring of relevant indices; 3) experimentation with and inquiry into techniques (psycho-pharmaceutical, eusocial, operant regulatory) for stimulating, directing, and focusing these experiences.
[ELLIPSIS]

METHODS

[ELLIPSIS]

> Sub C) Induced Dissociative States in Trained Subjects: For this portion of the inquiry, the investigators propose to work with a community of individuals trained in formal techniques of psi-apportation. [REDACTED] engages in a practice they call "temporary metempsychosis" and adepts claim to be able to achieve states of psychic conciliation with particular classes of objects, notably works of art. Their techniques are not widely known or well understood, but [REDACTED] without the use of psycho-active agents, collective consonant dissociative states of remarkable intensity in which they claim [REDACTED]. The internal loyalty structures of the group have made evaluation of these claims difficult, but the investigators have secured access to a small community of these practitioners, who appear willing to collaborate in laboratory analysis of their putative abilities.
> [ELLIPSIS]
> ... these sessions of recounting/reporting (known to the members as "Colloquy") will be recorded for subsequent analysis, and it is expected that, as in previous work, the SIHE (Society for the Investigation of Human Ecology) "friendly room" in New York city will be the right environment for these meetings, affording as it does an ideal architecture for unobtrusive observation by the investigators of the social dynamics of these interactions, together with valuable means for securing and archiving the relevant content.

[ELLIPSIS]

Rapid access to familiar medical facilities...

[ELLIPSIS]

TIMELINE

[ELLIPSIS]

BUDGET

[ELLIPSIS]

RELEVANT AND RELATED RESEARCH

[ELLIPSIS]

psychometry, etc...

REFERENCES

[ELLIPSIS]

ITEM C
Project "Choke the Flamingo"

Memorandum from Agent R. Lashbrook to MK-ULTRA leader Sidney Gottlieb, dated 13 June 1961.

```
13 June 1961

Memorandum for:    Mr. Sidney Gottlieb
                   Supervising, etc.
                   Washington, DC

Subject:           The Birdhouse, New York

Just received this note from Hale:

        "Spent the morning lighting DR-made Cohibas from the
        deli down the block. The smell seems to help the Bird
        subjects 'catch a vibe.' These guys are serious: subject
        DM notes he had a dream just last night about Marx
        eating a mixto with extra pickles. Will forward full
        report by close of the week."

Seems our man in Queens has gone native on Birdshit. I want that
quack pushing paper in basement on E Street. Proposal: mission "Choke
the Flamingo." With your consent, going to send him a piece for
analysis: a shoehorn -- you know, the one F.C. personally forwarded
from Havana. We'll pass on his test results to finance. Should be a
yuk for the boys.

One stone,

R. LASHBROOK
```

ACKNOWLEDGMENTS

WE ARE GRATEFUL TO NUMEROUS individuals and organizations for their support of this book, which emerged from the interdisciplinary conference Hybrid Practices in the Arts, Sciences, and Technology from the 1960s to Today. Held at the University of Kansas (KU), March 10–13, 2015, the conference was organized by the Spencer Museum of Art's Arts Research Collaborative, sponsored by the University of Kansas Research Investment Council with additional support from Randy Gordon. The conference was held at The Commons, an interdisciplinary space operated as a partnership between KU's Biodiversity Institute, Hall Center for the Humanities, and Spencer Museum of Art. Additional funding came from the Terra Foundation for American Art, the Franklin Murphy Lecture Fund of KU's Kress Foundation Department of Art History, and the Richard J. Stern Foundation for the Arts. We extend our thanks to all for their financial support. We are grateful to our colleagues at KU for their stewardship of the ARC project: Saralyn Reece Hardy, Marilyn Stokstad Director, Spencer Museum of Art; Stephen Goddard, Associate Director/Senior Curator, Works on Paper, Spencer Museum of Art; Celka Straughn, Andrew W. Mellon Director of Academic Programs, Spencer Museum of Art; Mary Anne Jordan, Professor and Chair of Visual Art; Perry Alexander, AT&T Foundation

Distinguished Professor of Electrical Engineering and Computer Science; and Leonard Krishtalka, Director, Biodiversity Institute and Professor of Ecology and Evolutionary Biology. We likewise appreciate Rebecca Blocksome, Jilliene Jaeger, Jared Johanning, Emily Ryan, and Ryan Waggoner for their excellent work in helping to organize and run the conference, with further assistance from KU Information Technology. All but two of the papers in this volume were presented in their initial form at the conference; one (Shepherd Steiner's) was delivered at the follow-up colloquium held in May 2015, and another (Steven Duval's) was written for this book. We wish to acknowledge all of those who participated in the conference but whose words do not appear in this volume: Ingrid Bachmann, Zandie Brockett, Mark Dion, Anna Dot, Susan Earle, Kris Imants Ercums, Christine Filippone, Robert Hovden, Robin Lynch, Julie Martin, Benjamin Rosenthal, William Ruggiero, Tyler Stefanich, Celka Straughn, Taylor Walsh, Matt Wisnioski, Dane Worrallo, and Kari Zacharias. A film, *Peer Review,* was also created for the conference by Steven Duval and Ryan Waggoner; the filmmakers thank Elsa Garmire, Jane Livingstone, Julie Martin, John Pearce, Maurice Tuchman, and Robert Whitman for their participation.

We extend our profound thanks to all of the contributing authors for their productive collaboration with us in the editorial process. Special gratitude is due to Rebecca Blocksome and Celka Straughn for their support in helping to shape the book proposal. Thanks are due as well to Mark Olson for lending his expert image scanning skills to the project to Meaghan Walsh for her organizational help in the final manuscript submission process. Finally, we offer deepest appreciation to Nadine Little, University of California Press Art History Editor, for her enthusiastic commitment to this project, and to everyone at the Press for their care and professionalism in guiding this book to publication. They include Jessica Moll, Senior Editor; Maeve Cornell-Taylor, Acquisitions; Aimee Goggins, Senior Marketing Manager; Lia Tjandra, Art Director; and freelance copyeditor Elisabeth Magnus. We could not have asked for better collaborators in bringing to fruition this volume whose keyword is collaboration.

**DAVID CATEFORIS, STEVEN DUVAL,
AND SHEPHERD STEINER**

CONTRIBUTORS

CRISTINA ALBU is Assistant Professor of Contemporary Art History and Theory at the University of Missouri–Kansas City. Her research focuses on crossovers between contemporary art, science, and technology. She is the author of the book *Mirror Affect: Seeing Self, Observing Others in Contemporary Art* (University of Minnesota Press, 2016) and the coeditor (with Dawna Schuld) of a volume of essays titled *Perception and Agency in Shared Spaces of Contemporary Art* (Routledge, 2018).

REBECCA BLOCKSOME is an artist and cultural theorist based in the Kansas City area. Her theoretical work focuses on the relationships between artists and political/cultural institutions, and she has presented her research in conferences at the University of Lisbon, Oxford University, the University of California–San Diego, and Eötvös Loránd University (Budapest), among others. Currently a lecturer in philosophy at the Kansas City Art Institute, she served as writer and editor for the Arts Research Collaboration project at the Spencer Museum of Art from 2013 to 2015.

DAVID CATEFORIS is Professor and Chair of Art History at the University of Kansas. He has published widely on twentieth-century American art and international contemporary art. He is the editor of *Rethinking Andrew Wyeth* (University of California Press, 2014) and *Decade of Transformation: American Art of the 1960s* (Spencer Museum of Art, 1999) and coeditor of *Albert Bloch: Artistic and Literary Perspectives* (Prestel, 1997).

STEVEN DUVAL is an artist and researcher based in Buffalo, New York, who has shown work in the Gwangju biennale, Nuit Blanche Paris, Apexarts New York, and the Fruitmarket Gallery in Edinburgh. He also runs the Independent Arts Research project.

ANNE COLLINS GOODYEAR is Co-Director of the Bowdoin College Museum of Art and President Emerita of the College Art Association. Her scholarship concerns the relationship of American art to science and technology, the construction of personal identity in modern and contemporary art, and the work of Marcel Duchamp. She curates, lectures, and publishes actively, and her essays have appeared in several scholarly anthologies and journals, including *American Art* and *Leonardo,* and she has coedited several volumes, including, most recently, *This Is a Portrait If I Say So: Identity in American Art, 1912 to Today* (Yale University Press, 2016) and *AKA Marcel Duchamp: Meditations on the Identities of an Artist* (Smithsonian Institution Scholarly Press, 2014). During her tenure as President of CAA, she helped oversee the development of CAA's *Code of Best Practices in Fair Use for the Visual Arts* (2015), a document that has helped to clarify the application of the fair use doctrine for creative, curatorial, and scholarly purposes in the fine arts.

SARALYN REECE HARDY is Marilyn Stokstad Director at the Spencer Museum of Art, University of Kansas. She is invested as the first Marilyn Stokstad Director of the Spencer Museum of Art and has led the only comprehensive art museum in Kansas since 2005. During her tenure, she has led the Spencer Museum's Phase I multiyear renovation project, which transformed the museum's galleries, introduced a multiuse object study room, and expanded the teaching, research, and storage facilities. She serves as the primary investigator for the Integrated Arts Research Initiative, an interdisciplinary effort funded by the Andrew W. Mellon Foundation, and engages in ongoing projects relating to the International Artist-in-Residence program.

ERICA LEVIN is an Assistant Professor of Art History at the Ohio State University. Her research focuses on the intersection between avant-garde cinema, postwar art, performance, and visual culture. Her writing has been published in *Media-N, World Picture, Millennium Film Journal, Discourse,* and the collection *Carolee Schneemann: Unforgivable.*

W. PATRICK MCCRAY is a professor in the History Department at the University of California, Santa Barbara. He researches science and technology after 1945. The author of four books including *The Visioneers* (2013), he is currently writing a new book for the MIT Press that explores collaborations between artists and engineers in the "long 1960s."

MAYA RAE OPPENHEIMER is a writer, researcher, and educator with a PhD in humanities and cultural studies from the London Consortium (Birkbeck, University of London). She is Assistant Professor in Art History at Concordia University and lectures, performs, and publishes across topics of intersectional identity politics, histories of design and critical sociologies of science, technology and psychology. Previously, she taught in London at the Royal College of Art, Imperial College, and the Cass School of Art and Design. She is one-third of Operating Manual, a research collective that investigates cultures of risk and is the Head of Research and Development of Dramaco, an ongoing art project that explores transmissions of laboratory procedures and products into consumer markets.

THE PROSOPOPOEIA WORKING GROUP is a project subcommitttee constituted under the auspices of the research collective ESTAR(SER), the Esthetical Society for Transcendental and Applied Realization (now incorporating the Society of Esthetic Realizers). ESTAR(SER) is an established body of private, independent scholars, collectors, archivists, and amateurs who collaborate to recover, scrutinize, and (where relevant) draw attention to the historicity of the Order of the Third Bird. Results of this work frequently see public dissemination through publication in the association's primary organ, the *Proceedings*. For more information, see their website at www.estarser.net.

CRAIG RICHARDSON is Professor of Fine Art at Loughborough University, United Kingdom. An artist and writer, he is the author of *Scottish Art since 1960* (2011) and recent articles in the journals *Visual Culture* and *Visual Culture in Britain*. He is Editor-in-Chief of the *Journal of Visual Art Practice* (Routledge). Since 2004 he has been a recipient of four major awards from the United Kingdom's Arts and Humanities Research Council, including "Retrieving Values in John Latham's Conceptualisation of 'Five Sisters.'"

DAWNA SCHULD is Assistant Professor of Modern and Contemporary Art History in the Department of Visualization at Texas A&M University. Recent publications include *Minimal Conditions: Light, Space, and Subjectivity* (University of California Press, 2018) and, with Cristina Albu, an edited volume entitled *Perception and Agency in Shared Spaces of Contemporary Art* (Routledge, 2018).

SANDRA SKURVIDA is an independent curator, art writer, and Adjunct Associate Professor in the History of Art Department at the Fashion Institute of Technology, State University of New York (FIT-SUNY). She has curated numerous art projects around the world since the 1990s. Her writings have appeared in *Art Journal, Art Papers, Art Practical, Ibraaz, Interventions, Mousse, Dailė*, and the *International Journal of Islamic Art and Architecture*. Her book *John Cage Time* is forthcoming.

SHEPHERD STEINER is Associate Professor of Contemporary Art and Theory at the University of Manitoba. He is the coeditor of *Cork Caucus: On Art, Possibility and Democracy* (Revolver, 2007) and *The New Criticism: Formalist Literary Theory in America and Abroad* (Cambridge Scholars Publishing, 2013). He is the author of *Rodney Graham: Phonokinetoscope* (Afterall, 2013) and the editor of *Mosaic, an Interdisciplinary Critical Journal*.

JOHN A. TYSON is an Assistant Professor in the Art Department at the University of Massachusetts, Boston. Between 2015 and 2017, he was the Andrew W. Mellon postdoctoral curatorial fellow at the National Gallery of Art (United States) in the Departments of Modern and American Prints and Drawings and British and American Paintings. A Helena Rubinstein Fellowship at the Whitney Independent Study Program as well as an American Council of Learned Societies (ACLS)/Henry Luce Foundation Fellowship supported his doctoral research on the work of Hans Haacke.

ILLUSTRATIONS

1.1. Peter Moore, Artists and engineers involved in *9 Evenings: Theatre & Engineering*, 1966 / 30
1.2. John Cage, *Variations VII*, 1966 / 31
1.3. Robert Whitman, *Two Holes of Water—3*, 1966 / 31
1.4. Mimi Kanarek and Frank Stella (tennis players) in Robert Rauschenberg's *Open Score*, 1966 / 32
1.5. Robert Rauschenberg, *Open Score*, 1966 / 32
1.6. Front cover of the catalog published for *9 Evenings: Theatre & Engineering*, 1966 / 34
2.1. E.A.T.'s Pepsi Pavilion at Expo '70, Osaka, Japan, 1970 / 48
2.2. Stuart Brisley at his Hille placement with his sculpture of Robin Day chairs, 1970 / 51
2.3. James Lee Byars, *putting byars in the hudson institute is the artistic product*, 1969 / 54
4.1. Robert Irwin, *Untitled*, 1966–67 / 82
4.2. Artists James Turrell and Robert Irwin with Garrett Corporation psychologist Ed Wortz, 1969 / 83
4.3. First National Symposium on Habitability (second day), Venice, CA, 1970 / 86
5.1. "Think Tank," London, 1968 / 93
5.2. John Latham, *Senior Academic Institutions*, 1975 / 98
5.3. Aerial surveillance photograph of *Niddrie Woman* bings, ca. 1975 / 99
5.4. Page from John Latham's "Feasibility Study," 1976 / 100

5.5. "Heart of Niddrie Woman," page from John Latham's "Feasibility Study," 1976 / 101
5.6. "Handbook of Reason," page from John Latham's "Feasibility Study," 1976 / 102
5.7. "Niddrie Heart" (color) / 104
5.8. Niddry Castle / *Niddrie Woman*, page from John Latham's "Feasibility Study," 1976 / 106
6.1. Carolee Schneemann, *Snows*, 1967 / 116
6.2. Carolee Schneemann, *Untitled* (vintage photograph from *Snows* performance), 1967 / 117
6.3. Carolee Schneemann, *Viet Flakes*, 1965–67 / 118
6.4. Carolee Schneemann, *Viet Flakes*, 1965–67 / 119
6.5. Carolee Schneemann, *Snows*, 1967 / 121
7.1. Boyd Mefferd, *Strobe-Lighted Floor*, 1968 / 128
7.2. Terry Riley, *Time-Lag Accumulator*, 1968 / 130
7.3. Howard Jones, *Sonic Games Room*, 1968 / 131
7.4. James Seawright, *Electronic Peristyle*, 1968 / 132
8.1. Hans Haacke, *Photoelectric Viewer-Programmed Coordinate System*, 1966–68 / 142
8.2. Hans Haacke, *Photoelectric Viewer-Programmed Coordinate System*, 1966–68 / 142
8.3. Hans Haacke, *Photoelectric Viewer-Programmed Coordinate System*, 1966–68 / 142
8.4. Gianni Colombo, *Spazio elastico* (Elastic space), 1967–68 / 146
8.5. Sol LeWitt, *Serial Project #1 (ABCD)*, 1966 / 146
8.6. Anthony McCall, *Line Describing a Cone*, 1973 / 148
8.7. Hans Haacke, plan for *Environment Transplant*, 1969 / 149
9.1. John Cage, *Nine Evenings, Variations VII: 12 remarks re musical performance*, page 1, ca. 1966 / 171
9.2. John Cage, *Nine Evenings, Variations VII: 12 remarks re musical performance*, page 2, ca. 1966 / 172
9.3. John Cage, *Musicircus*, 1967 / 174
9.4. John Cage, *Rolywholyover A Circus*, 1994 / 181
10.1. *The Milgram Re-enactment*, 2002, Rod Dickinson in collaboration with Graeme Edler and Steve Rushton / 188
10.2. Stanley Milgram's simulated shock generator / 189
10.3. Reproduction of Alphonse Chapanis's Man-Machine Environment Graphic, 1962 / 194
10.4. Maya Rae Oppenheimer, cover page from Dramaco Instrument Catalog, 1963 (2014) / 200
10.5. Maya Rae Oppenheimer, sample page from Dramaco Instrument Catalog, 1963 (2014) / 201
10.6. The Biofeedback Game, ca. 1970 / 202
10.7a. Maya Rae Oppenheimer, sample page from Dramaco Instrument Catalog, 1963 (2014) / 204
10.7b. Maya Rae Oppenheimer, sample page from Dramaco Instrument Catalog, 1963 (2014) / 205
11.1. Max Becher and Bernd Becher photographing *Winding Tower, Fosse "Grenay" no. 1, Bully-les-Mines, North France*, 1967 / 211
11.2. Becher family in front of *Lime Kilns, ca. 1860, Meppel, Holland,* 1968 / 212
11.3. Bernd and Hilla Becher, *Zeche "Graf Bismarck," Gelsenkirchen*, 1967 / 214
11.4. Bernd and Hilla Becher, *Hauptstrasse 36*, 1960 / 218
11.5. Bernd and Hilla Becher, *Krottorfer Strasse 48*, 1965 / 219
11.6. Bernd and Hilla Becher, *Kölner Strasse 4, Freudenberg*, 1969, and *Kölner Strasse 4a, Freudenberg*, 1972 / 220
11.7. Bernd and Hilla Becher, *Liège-Ougrée, B*, 1968 / 222
11.8. Bernd and Hilla Becher, *Hohlweg 5, Mudersbach*, 1961 / 223

INDEX

Abramović, Marina, 5
Adeane, Sir Robert, 49
Adolfstrasse 36 Niederschelderhütte (Bechers), 221
Aerojet, 62
Agam, Yaacov, 158n31
"Age of Psychology in the U.S." (Havemann), 198–199
Agis, Maurice, 93*fig.*
Albers, Josef, 168
Alloway, Lawrence: "Systemic Painting," 151
Alpert, Richard, 160n50
Amalgamated Lithographers of America, 35
American Psychological Association, 196, 207n29
Am Gosenbach 3, Niederschelderhütte (Bechers), 221
Amirkhanian, Charles, 180

Ampex Corporation, 148
Andy Warhol's Exploding Plastic Inevitable, 176
Animals (Pink Floyd), 94
Anonyme Skulpturen (Bechers), 209, 210, 212, 215, 216
Antin, David, 71
Anti-Oedipus: Capitalism and Schizophrenia (Deleuze and Guattari), 17
Antonakos, Stephen, 125, 127, 139n35
Aronowitz, Stanley, 155
Art and Culture (Greenberg), 49, 97
Art and Economics. See *INN70*
Art and Technology (A&T) program, Los Angeles County Museum of Art (LACMA), viii, 7, 24, 127; collaborative methods, 8, 46, 47, 52–56; collaborations with scientific bodies or scientists, 64–70, 79, 80,

Art and Technology (A&T) program (*continued*) 81, 82, 85, 87, 88; corporate collaborations and commercial results, 9, 36, 37, 61–65, 148; criticism of, 56–57, 71, 72, 76n57

Art and Technology (LACMA exhibition), 24

Artaud, Antonin, 160n56, 167; *To Have Done with the Judgment of God*, 167

Artforum, 12, 33, 57, 129

Art in America, 155

Artist Placement Group (APG), 5, 7, 18, 48, 49–52 (Duval essay), 91–97 (Richardson essay); collaborations with industry and government, 10, 95; collaborative method and fidelity to site, 8, 92–96, 102–105; criticism of, 56–57; outcomes, 105–106; poetics, 7, 10, 16, 46, 99

Art Journal, 136

Art Workers Coalition (AWC), 155

Ascott, Roy, 152

Ash, Mitchell, 192

AT&T, 27, 36

Authority (Friedrick), 191

Automation House, New York, 128

Banham, Reyner, 7, 24–25, 38n4, 39n4; *Theory and Design in the First Machine Age*, 24–25

Bann, Stephen, 130, 134

Barnes, Clive, 33, 46

Barry, Josephine, 92

Bateson, Gregory, 158n24

Becher, Bernd, 210, 212*fig.*, 215, 217, 220, 223, 224n4

Becher, Bernd and Hilla, 14, 16, 18, 103, 209–224 (Steiner essay), 224n12; *Adolfstrasse 36, Niederschelderhütte*, 221, *Am Gosenbach 3, Niederschelderhütte*, 221, *Anonyme Skulpturen*, 209, 210, 212, 215, 216, *Bochum-Langendreer, Ruhrgebiet*, 223, *Bogenstrasse 8, Freusburg*, 217, *Cooling Tower, Kraftwerk Victoria Mathias, Essen*, 223, *Framework Houses of the Siegen Industrial Region*, 16, 216–222, *Friedhofstrasse 11, Niederschelden*, 221, *Freudenberg*, 218, *Hauptstrasse 36*, 217, 218*fig.*, *Gary Indiana, USA*, 223, *Hohlweg 5, Mudersbach*, 223, 223*fig.*, *Homecourt Lorraine*, 222, *Karlstrasse 4, Niederschelderhütte*, 221, *Kölner Strasse 4, Freudenberg*, 219–220, 220*fig.*, 221, *Kölner Strasse 4a, Freudenberg*, 219–220, 220*fig.*, 221, *Krottorfer Strasse 48*, 217, 219*fig.*, *Liège-Ougrée, B*, 222, 222*fig.*, 223, *Lime Kilns, ca. 1860, Meppel, Holland*, 210, 215, *Oberhausen, Ruhrgebiet*, 223, *Terre Rouge, Esch-Alzette, L*, 222, *Völklingen, Saarland*, 222, *Winding Tower, ca. 1925, Fosse "Grenay" no. 1, Bully-les-Mines, North France*, 210, 213, 215, 217, *Winding Tower, Grube "Wolf," Herdorf bei Siegen*, 223, *Winding Tower, Zehe 'Eiberg', Essen, Ruhrgebiet*, 223, *Zeche "Graf Bismarck," Gelsenkirchen*, 213, 214*fig.*, 215, 217, *Ziegelstrasse 7, Niederschelden*, 221

Becher, Hilla, 210, 212*fig.*, 213, 215, 220, 222, 223

Becher, Max, 210, 211*fig.*, 212*fig.*, 222, 223

Beck, Julian, 167

Beethoven, Ludwig van, 176

"Behavioral Study of Obedience" (Milgram), 191

Bell, Daniel, 3, 17; *The End of Ideology*, 3

Bell, Larry, 85, 90n28

Bell Labs (Bell Telephone Laboratories), 3, 26, 28, 35, 170; experimentation with the arts, 7, 27, 40n16, 40n23, 46, 64, 68, 77n69, 124n16

Benjamin, Walter, 215

Berger, John: "Photographs of Agony," 120

Bergson, Henri, 167–168, 178, 182; *Time and Free Will: An Essay on the Immediate Data of Consciousness*, 167

Berke, Joseph, 118

Between 6 (APG exhibition, Kunsthalle, Düsseldorf), 95

Beuys, Joseph, 102

Biofeedback Game, 202, 202*fig.*

Black Mountain College, 168, 173, 174, 179, 181. See also *Theater Piece No. 1* (Cage)

Black Panthers, 36, 155

Blast Theory, 57

Bloch, Ernst, 160n59

Bochner, Mel, 35, 145, 221

Bochum-Langendreer, Ruhrgebiet (Bechers), 223

Bogenstrasse 8, Freusburg (Bechers), 217

Bordier, Roger, 158n31

Botschuijver, Theo: *Waterwalk* (collaboration with Jeffrey Shaw), 94

Boulez, Pierre, 168

Breakwell, Ian, 95–96

Brecht, Bertolt, 153, 160n56, 160n58, 160n59

Brecht, George: *Lamp Event,* 158n27, 184n42

Breer, Robert, 35

Brennan, Teresa, 135, 138

Brett, Guy, 158n33

Brisley, Stuart, 50–52, 51*fig.*, 93*fig.*

British Rail, 5

British Steel Corporation, 94

Brockman, John, 77n70

Broekman, Pauline van Mourik, 92

Brogan, Jack, 85

Bronowski, Jacob, 27

Broun, Betsy, 134–135

Brown, Carolyn, 174

Bruzzi, Stella, 196, 197, 200

Buchloh, Benjamin, 144, 221, 225n7

Burnham, Jack, 12, 85, 126; kineticism, 147, 150; *Software* exhibition, 38n2, 157n6, 157n11; "systems esthetics," 81–82, 144, 160n57; *Systems* exhibition, 57; technological control, 152, 153, 157n6, 157n11

Bury, Pol, 158n31

Byars, James Lee, 54, 55; *putting byars in the hudson institute is the artistic product,* 54, 54*fig.*

Cage, John, 13, 17, 18, 28, 29–31, 130, 165–182 (Skurvida essay), 182n6, 184n42, 185n48; *4'33",* 166, 169, *I-VI,* 179, *Europeras 1 & 2,* 178, 181, *Europeras 3 & 4,* 178, 181, *Europera 5,* 181, *Forerunners of Modern Music,* 166, *HMCIEX,* 166, *HPSCHD,* 173, 175, 176–177, 178, 179, 180, 181, *Imaginary Landscape Nos. 1–3,* 167, *Imaginary Landscape No. 4,* 167, 168, *James Joyce, Marcel Duchamp, Erik Satie: An Alphabet,* 166, *Music of Changes,* 168, 177, *Music Walk,* 169, *Musicircus,* 13, 173–175, 174*fig.*, 177–178, *Nine Evenings, Variations VII: 12 remarks re musical performance,* 171*fig.*, 172*fig.*, *Roaratorio,* 166, *Rolywholyover A Circus,* 13, 179–181, 181*fig.*, *Sounds of Venice,* 169, *Theater Piece No. 1,* 168, 173, 174, 179, 181, *Variations VII,* 13, 29, 31*fig.*, 170, 171*fig.*, 172*fig.*, 173, 174, *Water Music,* 168, 169, *Water Walk,* 13, 169, *Williams Mix,* 166, 177. *See also* Black Mountain College; *I Ching* (Book of Changes)

CalArts, 159n36, 180

Calder, Alexander, 158n31

Caltech (California Institute of Technology), 62, 67, 68, 69, 72

Cardew, Cornelius, 178

CBS (Columbia Broadcasting System), 35, 43n56, 166, 169

Center for Advanced Visual Studies (CAVS), 4, 24

Chamberlain, John, 54

Chandler, Marilyn, 52

Chandler, Otis, 52

Chapanis, Alphonse: Man-Machine Environment Graphic, 193, 194*fig.*

"Children of Vietnam, The" (Pepper), 115

Childs, Lucinda, 28, 114; *Vehicle,* 114

Christo and Jeanne-Claude: *Valley Curtain,* 103

City Art Museum, St. Louis, 128

City Wears a Slouch Hat, The (Patchen), 166

Clark, Lygia, 158n33

Cocteau, Jean, 166, 167, 169, 170; *Orpheus,* 166–167, 170

Coe, Ralph T., 11; criticism, 132–133; curatorial intentions, 126–128, 130, 131, 135, 138; psychological interests, 132, 137, 138n5; use of multi-media, 129

Cold War, 2–8; "distortion thesis," 71–72, 151; ideology and rhetoric, 14, 16, 17, 46; military-industrial complex, 8, 62, 64

Colombo, Gianni: *Spazio elastico,* 145, 146*fig.*
Columbia University, 167
Conceptual art, 5, 145, 179, 184n42, 216, 221
Conversations on Science, Culture, and Time (Serres and Latour), 99
Cooling Tower, Kraftwerk Victoria Mathias, Essen (Becher), 223
Cornell Aeronautical Laboratory, 65
Cowell, Henry, 168
Crary, Jonathan, 128
Cross, Lowell, 75n46
Culver, Andrew, 180, 185n48
Cunningham, Merce, 170, 174

Daghini, Giairo, 177–178
Damisch, Hubert, 158n25
Dance Constructions (Forti), 4
Dartmouth College, 69
Darwin, Charles, 215
Dauner, John T., 134
Davis, Douglas, 35, 36, 83, 85, 88
Day, Robin, 50–51
Death of the Red Planet (Pelton), 69
Deleuze, Gilles, 17, 159n43
Department of Health and Social Security (UK), 95
Descartes, Rene (Cartesianism), 138, 152, 156, 166
Destruction in Art Symposium (Metzger), 97
De Vos, Jan, 197
Dickinson, Rod: *The Milgram Re-enactment,* 188*fig.*
Disney, 53
Documenta 6, 102
Double Negative (Heizer), 103
Dramaco Instruments (Oppenheimer), 199–200, 200*fig.,* 201*fig.,* 202–203, 204*fig.,* 205*fig.*
Dryer, Ivan, 9, 68–70
Duchamp, Marcel, 27, 28, 53, 147, 158n31
Duve, Thierry de, 225n27
Dwan Gallery, 145

Earthworks: Land Reclamation as Sculpture, 104
Easy Rider (Hopper), 154, 161n71

Ehrenzweig, Anton: *The Hidden Order of Art,* 129
Ehrlich, George, 136
Eisenhower, Dwight D., 7, 25
Electra Lumidyne International, 63, 72
Electronic Activation Room (Schneemann), 123n14
Electronic Music Studio, Radio Sweden, 28
Electronic Peristyle (Seawright), 125, 126, 132, 132*fig.,* 133, 134, 137
Eleey, Peter, 96
Ellul, Jacques, 70
End of Ideology (Bell), 3
Environment Transplant (Haacke), 148–149, 149*fig.*
"EPICAC" (Vonnegut), 166
Esso, 49, 96
Europera 5 (Cage), 181
Europeras 1 & 2 (Cage), 178, 181
Europeras 3 & 4 (Cage), 178, 181
Evans, Garth, 93*fig.,* 94; *Frame,* 94
Experiments in Art and Technology (E.A.T.), 3, 4, 7, 8, 16, 17, 24, 61, 71, 72; anti-nationalism, 48; meteorology and atomization, 9, 26, 48*fig.,* 53–54, 56, 65–67; collaborative method, 46–49; comparisons to A&T, 55; comparisons to APG, 49, 52; computer technologies, 173; interdisciplinarity, 62, 64; laser technologies, 67–70, 114; relationship to Fluxus, 28; residency program and membership, 35–36, 37, 124n16

Fahlström, Öyvind, 28
Filliou, Daniel, 49
"Film in Psychology" (Milgram), 196
Finch College Project (Morris), 161n65
Fine, Ruth, 36
Finlay, Ian Hamilton: *Stonypath,* 101
First National Symposium on Habitability, 85, 86*fig.,* 88
Five Man Electrical Band: "Signs," 154
Flag (Johns), 3
Flanagan, Barry, 92, 93*fig.*
Flavin, Dan, 27, 160n57, 160n58
Fluxus, 7, 28, 40–41n23, 49, 92, 123n14, 179, 184n42

268 INDEX

Flynn, Sean, 118
Fog Bridge (Nakaya), 67
Ford, Jim, 95
Forerunners of Modern Music (Cage), 166
Forkner, John F., 72n3
Forman, Paul, 71
Forti, Simone (Simone Whitman), 4, 28, 29, 33, 35, 40n23
Foster, Susan Leigh, 155
4'33" (Cage), 166, 169
Fractured Light-Partial Scrim Ceiling-Eye-Level Wire (Irwin), 87
Frame (Evans), 94
Framework Houses of the Siegen Industrial Region (Bechers), 16, 216–222
Francastel, Pierre: *Art and Technology in the Nineteenth and Twentieth Centuries,* 39n6
Frankenstein, Alfred, 126
Freudenberg, 218; *Hauptstrasse 36* (Bechers), 217, 218*fig.*
Fried, Michael, 18n12, 80, 160n56, 224n8, 225n27
Friedhofstrasse 11, Niederschelden (Bechers), 221
Friedrick, C.J.: *Authority,* 191
Fuller, Buckminster, 176
Fylkingen, 28

Galloway, Alexander, 152
Gard Blue (Turrell), vii, viii, ix
Garmire, Elsa, 9, 53–54, 56, 67–70
Garrett Corporation, 52, 81, 84, 87
Garson-Bergman, 143, 157n7
Gary Indiana, USA (Bechers), 223
Gasser, Cathy Lynn, viii
Gehry, Frank, 85
General Electric, 63
Getty Center, 88
GFP Bunny (Kac), 57
Ghost Rev (Schneemann), 123n10
Gitlin, Todd, 155
Glueck, Grace, 29, 33
Godfrey, Mark, 145

Goffman, Erving, 190, 198, 206n4; *Presentation of the Self in Everyday Life,* 206n4
Goldin, Amy, 71
Google, 37, 157n8
Gramsci, Antonio, 153
Grass Field (Alex Hay), 114
Greenberg, Clement, 2, 49, 80, 82, 97; *Art and Culture,* 49, 97
Gregory, Clive, 50
Griffith Observatory, 68–69, 70. *See also* Laserium
Groupe de Recherche d'Art Visuel (GRAV), 145
Gruppo N, 145
Gruppo T, 145
Guattari, Félix, 17

Haacke, Hans, 12, 16, 18, 141–156 (Tyson essay), 158n19; *Environment Transplant,* 148–149, 149*fig.*; *Photoelectric Viewer-Programmed Coordinate System,* 141–148, 142*figs.*, 150–156; *Shapolsky et al., Manhattan Real Estate Holdings, A Real Time Social System, as of May 1, 1971,* 146–147
Habermas, Jürgen, 162n85
Hall, David, 92, 93*fig.*; *10 TV Interruptions,* 94–95
Handbook of Reason (Latham), 101, 102*fig.*
Happenings, 123n14, 150, 153, 175, 179, 184n42
Harrison, Newton, 27
Harvard University, 179
Harvie, Barbra: *West Lothian Local Biodiversity Action Plan—Oil Shale Bings,* 104–105
Havemann, Ernest: "The Age of Psychology in the U.S.," 198–199
Hay, Alex, 28, 114; *Grass Field,* 114
Hay, Deborah, 28
Hayward Gallery, 52, 95
Hegel, Georg Wilhelm Friedrich, 215
Heizer, Michael: *Double Negative,* 103
Herrmann, Rolf-Dieter, 136, 139n35
Hidden Order of Art, The (Ehrenzweig), 129
Higgins, Dick, 27–28
Hille and Co., 50–52

Hiller, Lejaren, 173, 175, 176, 179; *Quartet No. 4 for Strings (The ILLIAC Suite)*, 175
HMCIEX (Cage), 166
Hoffman, Donald, 135
Hohlweg 5, Mudersbach (Bechers), 223, 223*fig.*
Homecourt Lorraine (Bechers), 222
Howard Wise Gallery, 141, 142*figs.*, 143, 156, 157n8
HP (Hewlett-Packard), 53
HPSCHD (Cage) 173, 175, 176–177, 178, 179, 180, 181
Hudek, Antony, 92, 95
Hudson Institute, 54
Hultén, Pontus, 27, 158n31
Human Use of Human Beings: Cybernetics and Society (Wiener), 151
Husserl, Edmund, 80–81, 86

IBM, 36, 50, 51
I Ching (Book of Changes), 13, 166, 175, 177, 185n48. See also Cage, John
ICI (Imperial Chemical Industries), 49
ILLIAC Suite, The (Hiller), 175
Imaginary Landscape No. 4 (Cage), 167, 168
Imaginary Landscape Nos. 1–3 (Cage), 167
INNO70 (Art and Economics) (APG exhibition at Hayward Gallery), 52, 95
Institute for the Study of Mental Images, 50
Interval Research, 77n70
Irwin, Robert, viii, 9, 10, 16, 37; collaborative method, 52, 55, 79–89 (Schuld essay), 83*fig.*, 86*fig.*; *Untitled*, 81, 82*fig.*; *Fractured Light-Partial Scrim Ceiling-Eye-Level Wire*, 87; Central Garden, Getty Center, 88
I've Got a Secret (Morgan), 169
Iveković, Sanja, 5

Jacbosen, Robert, 158n31
James Joyce, Marcel Duchamp, Erik Satie: An Alphabet (Cage), 166
Jameson, Fredric, 153, 160n59
Jeffries, Carson D., 75n46
Jet Propulsion Laboratory, 62
Jewish Museum, 94

Johns, Jasper, 3, 27
Johnson, Lyndon B., 26
Jones, Howard, 11, 127; acoustic portraits and audience participation, 125, 126, 131, 133, 134, 137, 138n5; *Sonic Games Room*, 126, 131–132, 131*fig.*
Joseph, Branden W., 131
Jouvenel, Bertrand de, 190–191
Judd, Donald, 53, 80
Judson Church, 123n14, 149

Kac, Eduardo: *GFP Bunny*, 57
Kaiser Steel, 36
Kanarek, Mimi, 32, 32*fig.*
Kaprow, Allan, 27–28, 150, 151, 152
Karlstrasse 4, Niederschelderhütte (Bechers), 221
Karp, Ivan, 127
Kaufmann, William III, 69
Keaton, Buster, 168
Kelly, Kevin, 77n70
Kennan, George, 156
Kepes, Gyorgy, 4
Kevles, Daniel J., 72
Kinetic art, 12, 145, 147–150, 158n31
Kipnis, Claude, 174
Klüver, Billy, 3, 7, 8, 24, 42n35, 47, 48; connections with avant-garde, 26–27, 28, 29, 35–37, 46, 65, 67–68, 124n16, 170; on collaboration, 64, 70, 114, 122n6
Knowlton, Ken, 77n69
Kohlsen, Anita, 50
Kölner Strasse 4, Freudenberg (Bechers), 219–220, 220*fig.*, 221
Kölner Strasse 4a, Freudenberg (Bechers), 219–220, 220*fig.*, 221
Koons, Jeff, 53
Kozloff, Max, 56, 71, 84; "The Multimillion Dollar Art Boondoggle," 57, 71, 84
Krauss, Rosalind, 80, 106; "Sculpture in the Expanded Field," 106
Krebs, Rockne, viii, 53, 54, 76n57
Krottorfer Strasse 48 (Bechers), 217, 219*fig.*
Kubota, Shigeko, 120

Kuhn, Thomas, 71
Kunsthalle Düsseldorf, 95

La Barbara, Joan, 180
Lacan, Jacques, 88
Laing, R.D.: *The Politics of Experience,* 126–127
Lambert-Beatty, Carrie, 154
Lamelas, David, 93*fig.*
Lamp Event (Brecht), 158n27
Landsman, Stanley, 125, 127
Larocco, Christina, 156, 156n2
Lascia o Raddoppia, 169
Laser Images Inc. *See* Laserium
Laserium, 54, 69–70, 76n57. *See also* Dryer, Ivan; Garmire, Elsa; Kauffman, William III; Pelton, Dale
Latham, John, 5, 16, 49, 50, 51–52, 54, 57; collaborative method, 91–96, 93*fig,* 95, 96–106 (Richardson case-study), 98*fig.,* 100*fig.,* 101*fig.,* 102*fig.,* 106*fig.;* *Handbook of Reason,* 101, 102*fig.; Niddrie Woman,* 10–11, 50, 91, 98–99, 99*fig.,* 101*fig.,* 101–106; *Senior Academic Institutions,* 97–98, 98*fig.; Skoob Towers,* 97; *Still and Chew,* 49, 97
Lazar, Julie, 179
Leary, Timothy, 160n50
Leonardo (journal), 62, 63
Levi-Strauss, Claude, 16
LeWitt, Sol, 145–146, 152; *Serial Project #1 (ABCD),* 145–146, 146*fig.*
Liège-Ougrée, B (Bechers), 222, 222*fig.,* 223
Light and space art, 10, 80, 85
Lime Kilns, ca. 1860, Meppel, Holland (Bechers), 210, 215
Line Describing a Cone (McCall), 147–148, 148*fig.*
Lindgren, Nilo, 66
Lippard, Lucy, 23–24, 104, 108n35; *Overlay,* 104
Livingston, Jane, 82, 129
Loebner, Egon, 53
Los Angeles County Museum of Art (LACMA). *See* Art and Technology (A&T) program
Louisiana State University, 65
Lowe, Rick: Project Row Houses, 57

Lucier, Alvin, 170
Lumidyne. *See* Electra Lumidyne International
Lyotard, Jean-François, 152, 173

Machine as Seen at the End of the Mechanical Age, The (Museum of Modern Art exhibition), 24
Magic Theater (exhibition), 11, 12, 16, 125–138 (Albu essay)
Malina, Frank, 9, 62–64, 72
Malina, Judith, 167
Man-Machine Environment Graphic (Chapanis), 193, 194*fig.*
Manning, Erin, 56
Marcuse, Herbert, 70, 147, 151, 159n45
Martin, Daryl, 106
Martin, Julie, 41n25, 41n34
Marx, Karl, 215, 220, 221
Massachusetts Institute of Technology (MIT), 4, 24, 67, 68
Massumi, Brian, 56
McCall, Anthony, 147–148, 148*fig.; Line Describing a Cone,* 147–148, 148*fig.*
McCarthy, Eugene, 62
McCarthy, Mary, 203
McLuhan, Marshall, 7, 25, 141; *Understanding Media: The Extensions of Man,* 25
McReady, Paul, 74n25
McShine, Kynaston, 94
Media Lab (MIT), 77n70
Mee, Thomas, 9, 65–67, 72
Mee Industries Inc., 66, 67
Mefferd, Boyd, 11, 126, 128–129, 130, 133, 134, 135, 137
Merleau-Ponty, Maurice, 80–81, 88
Meteorological Research Inc., 65
Metzger, Gustav, 50, 57, 91, 97, 99; *Destruction in Art Symposium,* 97
Milgram, Stanley, 13–14, 187–200 (Oppenheimer essay), 188*fig.,* 189*fig.,* 203, 205; "Behavioral Study of Obedience," 191; "Film in Psychology," 196; *Obedience* (film), 190, 195–197; *Obedience to Authority: An Experimental View,* 190

Milgram Re-enactment, The (Dickinson), 188*fig.*
Millard, Kathryn, 195
Mills College, 75n46
Minimalism, 12, 80, 184n42, 216
Minsky, Marvin, 157n6
Montreal Museum of Art, 128
Morgan, Harry: *I've Got a Secret*, 169
Morris, Robert, 27, 80, 104; *Finch College Project*, 161n65
Movie-Drome, 69
Mozart, Wolfgang Amadeus, 176
"Multimillion Dollar Art Boondoggle, The" (Kozloff), 57, 71, 84
Mumford, Lewis, 70
Munro, Ian Macdonald, 93*fig.*
Museum of Contemporary Art, Los Angeles, 179
Museum of Modern Art, 24, 87, 88, 155
Musicircus (Cage) 13, 173–175, 174*fig.*, 177–178
Music of Changes (Cage), 168, 177
Music Walk (Cage), 169

Nakaya, Fujiko, 9, 65–67; *Fog Bridge*, 67
Nakaya, Ukichiro, 65
Nameth, Ronald, 176
National Aeronautics and Space Administration (NASA): agency, 6; Artists Cooperation Program, 24, 26, 38n2; art related conferences and "spinoff," 55, 64, 73n16; collaborations with artists, 81, 83, 85, 87, 176
National Coal Board (UK), 96, 103
National Science Foundation (NSF), 49, 195
Nauman, Bruce, 55
Negri, Antonio, 177
Négyesy, János, 180
Nelson Gallery of Art (Nelson-Atkins Museum of Art). See *Magic Theater*
Neo-Dada, 2, 3
New Left, ix, 115, 155, 156, 156n2, 160n50
New York University, 115
Nichols, Bill, 196–197

Niddrie Woman (Latham), 10, 50, 91, 98–99, 99*fig.*, 101*fig.*, 101–106 (Richardson essay)
Nietzsche, Friedrich, 136, 139n35, 169, 215
Nine Evenings, Variations VII: 12 remarks re musical performance (Cage), 171*fig.*, 172*fig.*
9 Evenings: Theatre & Engineering, 3, 5, 30*fig.*, 31*figs.*, 32*figs.*, 34*fig.*, 37, 38n3, 46, 47, 52, 57; corporate collaboration, 26–28, 46, 64, 124n16; criticism of, 33, 35, 170; cultural history of, 7–8, 64, 65; participation, 170; passive consumerism, 11, 114–115; performance, 11, 29, 33, 35, 114–115; space and acoustics, 21, 29, 113–114; temporality, 11, 30–33, 114–115; use of technology, 11, 24, 26–35 (Goodyear essay), 114–115; Vietnam, 5, 120, 122
Nixon, Richard, 156
Norse, Harold, 167
Northwestern University, 65
"Notes on Art as/and Land Reclamation" (Morris), 104
Noys, Benjamin, 177

Obedience (Milgram film), 190, 195–197
Obedience to Authority: An Experimental View (Milgram), 190
Oberhausen, Ruhrgebiet (Bechers), 223
O'Doherty, Brian, 153–154, 170
Oglesby, Carl, 155, 162n86
Oldenburg, Claes, 41n27, 53
I–VI (Cage), 179
On the Origin of Species (Darwin), 215
Open Score (Rauschenberg), 32, 32*figs.*, 114, 120, 122
Ordeals (Schneemann), 123n14
Organization and Imagination (O+I), 93
Orpheus (Cocteau), 166–167, 170
Orwell, George, 150
Overlay (Lippard), 104

Paik, Nam June, 28, 40n23, 57
Patchen, Kenneth: *The City Wears a Slouch Hat*, 166
Pavilion (E.A.T.), 9, 36, 47, 48*fig.*, 54, 56, 62, 65–67, 68, 74n18, 75n46

Paxton, Bill, 48, 49
Paxton, Steve, 28
Pelton, Dale, 68, 69; *Death of the Red Planet,* 69
Pepper, William F., 115
Pepsi (PepsiCo), 36, 43n67, 47, 48*fig.,* 53, 54, 65–68, 74n18, 75n46
Performance art, 12, 179
Perreault, John, 143
Photoelectric Viewer-Programmed Coordinate System (Haacke), 141–148 (Tyson essay), 142*figs.,* 150–156 (Tyson essay)
"Photographs of Agony" (Berger), 120
Pierce, John R., 64
Pink Floyd: *Animals,* 94
Pliny, 14–15
Polanyi, Michael, 9, 88
Politics of Experience, The (Laing), 126–127
Port Huron Statement (SDS), 156, 156n2
Potts, Alex, 80
Presentation of the Self in Everyday Life (Goffman), 206n4
Primary Structures (Jewish Museum exhibition), 94
Project Row Houses (Lowe), 57
putting byars in the hudson institute is the artistic product (Byars), 54, 54*fig.*

Quartet No. 4 for Strings (*The ILLIAC Suite*) (Hiller), 175

Rainer, Yvonne, 4, 28, 154; *Trio A,* 4, 154
RAND Corporation, 54
Rauschenberg, Robert: collaboration with scientists and use of technology, 32–33, 35, 46, 47, 114, 176; involvement with E.A.T., 24, 27, 28, 46; *Open Score,* 32, 32*figs.,* 114, 120, 122; *Stoned Moon,* 176
RCA, 36, 167
Reagan, Ronald, 176
"Real Time Systems" (Burnham), 144
Reich, Wilhelm, 123n10
René, Galerie Denise, 158n31

Report on the Art and Technology Program (Tuchman, ed.), 55
Reynolds Metal Company, 120
Richards, Mary Caroline, 182n7
Ridley, Anna, 92
Riley, Terry: acoustic lag, 11, 126, 127, 129–131; audience participation, 133; criticism of, 134, 137; *Time-Lag Accumulator,* 126, 129–131, 130*fig.,* 133, 134, 137
Roaratorio (Cage) 166
Robinson, Robby, 35
Rolywholyover A Circus (Cage) 13, 179–181, 181*fig.*
Rose, Barbara, 27, 47–48, 72n3
Rosenberg, Jim, 180
Rosenboom, David, 180
Ross, Charles, 125
Royal College of Art, 97
Ruscha, Ed, 221
Rutgers University, 23, 38n1

Sainsbury, Alex, 92
Saint Martins School of Art, 94, 97
Sampson, Tony D., 134, 135
Satie, Erik, 166, 167, 169, 180, 182n6, 182n7; *Vexations,* 167; *Water Music Suite in F Major,* 169
Sawada, Kyōichi, 117
Schechner, Richard, 153, 154
Schneemann, Carolee: feminism and anti-militarism, 6; use of technology and affect, 11, 16, 17, 18, 113–122 (Levin essay), 116*fig.,* 117*fig.,* 118*fig.,* 119*fig.,* 121*fig.;* *Electronic Activation Room,* 123n14; *Ghost Rev,* 123n10; *Ordeals,* 123n14; *Snows,* 11, 113–117, 116*fig.,* 117*fig.,* 118, 119, 120, 121*fig.,* 121–122; *Viet Flakes,* 11, 117, 118*fig.,* 119*fig.*
Schoenberg, Arnold, 165, 180
School of Visual Arts, New York, 159n45
Schwartz, Lillian, 77n69
Schwartz, Therese, 155
Scottish Development Agency, 10, 16, 95, 96, 97, 98, 102, 103. *See also* Latham, John
Scottish Office, 5, 50, 95, 103, 105
Scottish Television, 94–95

Sculpture, The (APG), 95
"Sculpture in the Expanded Field" (Krauss), 106
SDS. *See* Students for a Democratic Society
Seawright, James, 11, 125, 126, 132, 133, 134, 137
"Sedimentation of the Mind: Earth Projects" (Smithson), 103
"Sentences on Conceptual Art" (LeWitt), 145
Serial Project #1 (ABCD) (LeWitt), 145–146, 146*fig.*
Serra, Richard, 36
Serres, Michel, 2, 8, 15, 16, 45–46, 56, 99; *The Troubadour of Knowledge,* 45
Shapin, Steven, 197, 207n33
Shapolsky et al., Manhattan Real Estate Holdings, A Real Time Social System, as of May 1, 1971 (Haacke), 146–147
Sharp, Willoughby, 147
Shaw, Jeffrey, 92, 94; *Waterwalk* (collaboration with Theo Botschuijver), 94
"Signs" (Five Man Electrical Band), 154, 161n71
Silver, Maury, 191, 194
Singer Company, 35
Skoob Towers (Latham), 97
Skrebowski, Luke, 144, 150–151
Smithson, Robert, 103, 213, 221; "A Sedimentation of the Mind: Earth Projects," 103
Snow, C.P., 7, 26, 61, 71; *Two Cultures and the Scientific Revolution,* 26
Snows (Schneemann), 11, 113–117, 116*fig.*, 117*fig.*, 118, 119, 120, 121*fig.*, 121–122
Software (Jewish Museum exhibition), 38n2, 144, 157n6
Sonic Games Room (Jones), 126, 131–132, 131*fig.*, 133, 134
Sontag, Susan, 116, 121
Sorbonne, 65
Soto, Jesus, 158n31
Sounds of Venice (Cage), 169
Southern Illinois University, 176
Spazio elastico (Columbo), 145, 146*fig.*
Spectra-Physics, 69

Spoerri, Daniel, 49
Standard Instruments Corporation, 143
Stanford University, 179
Stella, Frank, 32, 32*fig.*
Stern, Daniel, 134, 135
Steveni, Barbara: origins of APG, 5, 49, 92, 93*fig.*; collaborative method, 50–51, 57, 93, 94, 96
Still and Chew (Latham), 49,
Stoned Moon (Rauschenberg), 176
Stonypath (Finlay), 101
Strobe-Lighted Floor (Mefferd), 126, 128*fig.*, 128–129, 133, 134, 135, 137
Structure and Codes (Royal College of Art exhibition), 97
Students for a Democratic Society (SDS), 141, 155–156, 156n2; Port Huron Statement, 156, 156n2
Sturm, Thomas, 192
Sumison, Gordon, 176
"Systemic Painting" (Alloway), 151
Systems (Burnham exhibition), 57

Tapsony, Andrew, 133
Tate Britain APG archive, 91, 94, 96, 99, 99*fig.*, 100*fig.*, 101*fig.*, 102*fig.*, 104*fig.*, 106*fig.*
Tennessee Valley Authority, 67
Tenney, James, 118, 121, 124n16, 170
10 TV Interruptions (Hall), 94–95
Terre Rouge, Esch-Alzette, L (Bechers), 222
Theater Piece No. 1 (Cage), 168, 173, 174, 179, 181. *See also* Black Mountain College
Theory and Design in the First Machine Age (Banham), 24–25
Thought in the Act (Manning and Massumi), 56
Thousand Plateaus, A (Deleuze and Guattari), 17
Three Ecologies, The (Guattari), 17
Tiers instruit (Serres), 16
Time and Free Will: An Essay on the Immediate Data of Consciousness (Bergson), 167, 178

Time-Lag Accumulator (Riley), 126, 129–131, 130*fig.*, 133, 134, 137
Tinguely, Jean, 27, 46, 158n31
To Have Done with the Judgment of God (Artaud), 167
Toledo Museum of Art, 128
Townes, Charles H., 68
Trio A (Rainer), 4, 154
Troubadour of Knowledge, The (Serres), 45
Tuchman, Maurice, 36, 52, 64, 81, 85
Tudor, David, 28, 75n46, 170
Turrell, James, vii-ix; collaboration with Robert Irwin and Ed Wortz, 9, 37, 52, 55, 56, 79, 81–85, 83*fig.*
Two Cultures and the Scientific Revolution (Snow), 26
Two Holes of Water–3 (Whitman), 29, 31, 31*fig.*

Understanding Media: The Extensions of Man (McLuhan), 25, 141
University of California, Berkeley, 27
University of California, Santa Cruz, 159n36
University of Illinois, Urbana-Champaign, 173–177
University of Southern California, 68, 69
Untitled (Irwin), 82*fig.*

Valentine, DeWain, 90n28
Valley Curtain (Christo and Jeanne-Claude), 103
VanDerBeek, Stan: Movie-Drome, 69
Variations VII (Cage), 13, 29, 31*fig.*, 170, 171*fig.*, 172*fig.*, 173, 174
Vasarely, Victor, 158n31
Vehicle (Childs), 114
Venus of Willendorf, The, 98
Vesna, Victoria, 77n70
Vexations (Satie), 167
Viet Flakes (Schneemann), 11, 117, 118*fig*, 119*fig*, 119–120, 121
Vietnam war, 2, 5, 7; critical responses, 6, 11, 36, 46, 71, 84, 113, 115–118, 120, 154, 155, 156, 203

Völklingen, Saarland (Bechers), 222
Vonnegut, Kurt: "EPICAC," 166

Waldhauer, Fred, 24, 46, 64
Walker, John A., 96, 97
Warhol, Andy, 46, 176
Water Music (Cage), 168, 169
Water Music Suite in F Major (Satie), 169
Water Walk (Cage) 13, 169
Waterwalk (Shaw and Botschuijver), 94
Webb, James E., 64
Week of Angry Arts, 113, 115–116, 119, 120, 122nn1–3. See also Schneemann, Carolee
West Lothian Local Biodiversity Action Plan—Oil Shale Bings (Harvie), 104–105
Whitman, Robert, 24, 28, 29, 31, 40n23; on collaboration, 46–47, 48, 72n3, 126; *Two Holes of Water–3,* 31, 31*fig.*
Whitman, Simone. See Simone Forti
Whitman, Walt, 162n88
Whole Earth Catalog, 170
Wiener, Norbert, 151, 159n48; *The Human Use of Human Beings: Cybernetics and Society,* 151
Wiggen, Knut, 28, 41n25
Wilding, Faith: *Womb Room,* 158n28
Wilfred, Thomas, 63
Williams, Raymond, 159n44
Williams Mix (Cage), 166, 177
Winding Tower, ca. 1925, Fosse "Grenay" no. 1, Bully-les-Mines, North France (Bechers), 210, 213, 215, 217
Winding Tower, Grube "Wolf," Herdorf bei Siegen (Bechers), 223
Winding Tower, Zehe 'Eiberg', Essen, Ruhrgebiet (Bechers), 223
Wirthlin, Brian, 76n57
Wise, Howard, 143. See also Howard Wise Gallery
Wolff, Christian, 170

Womb Room (Wilding), 158n28

Wong, Robert, 37

Wordsworth, William, 7

World Question Center, The (Byars), 54

Wortz, Edward, 9; collaborations with artists, 16, 37, 52, 55, 56, 79–89 (Schuld essay), 83*fig.*

Xerox, 77n70, 145

Xerox PARC PAIR (Artist-in-Residence Program), 77n70

Yale University, 187, 188, 193, 195

Youngblood, Gene, 105

Zeche "Graf Bismarck," Gelsenkirchen (Bechers), 213, 214*fig.*, 215, 217

Zen, 88, 90n42, 168

Zero Group, 145

Zeuxis, 14–15

Ziegelstrasse 7, Niederschelden (Bechers), 221

Zumstein, Bruce, 173–174